The art of interruption

MANCHESTER
UNIVERSITY PRESS

THE CRITICAL IMAGE

'From today painting is dead': a remark made by the French artist Paul Delaroche on first seeing a daguerreotype in 1839.

'I can see it's the end of chemical photography': a remark made by the British artist David Hockney in 1990 on the likely effect of computer generated imagery.

The Critical Image series aims to develop the subject area of photographic history, theory and critisism. It explores the historical and contemporary uses of photography in sustaining particular ideological positions. Photography is never a straightforward 'window on the world'; the meanings of photographs remain unstable, depending always on usage. Chemical and lens-based photographs are now antique forms of image production, while pictures made in computers are not strictly photographic since there is no necessary link between images and what-has-been. The series engages with both chemical and digital imagery, though new forms of representation do not obliterate older forms and ways of looking that persist through custom and practice. The term 'representation' is not simply another word for picture or depiction, but hints at the management of vision. Representation is not just a matter of what is shown but who has permission to look at whom, and to what effect. The series looks beyond the smooth narratives of selected 'masters', styles and movements. It aims to discuss photographic meanings produced within the complex social formation of knowledge. To situate photography in its intellectual context, the series cuts across disciplinary boundaries and draws on methods widely used in art history, literature, film and cultural studies.

SERIES EDITOR
John Taylor
Department of History of Art and Design
Manchester Metropolitan University

Already published
Jane Brettle and Sally Rice (eds) *Public bodies – private states: new views on photography, representaion and gender*

John Taylor *A dream of England: landscape, photography and the tourist's imagination*

John Taylor *Body horror: photojournalism, catastrophe and war*

The art of interruption

realism, photography and the everyday

JOHN ROBERTS

Manchester and New York

distributed exclusively in the USA by
St. Martin's Press

Published by Manchester University Press
Oxford Road, Manchester M13 9NR, UK
and Room 400, 175 Fifth Avenue, New York, NY 10010, USA

Distributed exclusively in the USA by
St. Martin's Press, Inc., 175 Fifth Avenue, New York, NY 10010, USA

Distributed exclusively in Canada by
UBC Press, University of British Columbia, 6344 Memorial Road,
Vancouver, BC, Canada V6T 1Z2

British Library Cataloguing-in-Publication Data
A catalogue record for this book is available from the British Library

Library of Congress Cataloging-in-Publication Data
Roberts, John, 1955–
 The art of interruption: realism, photography and the everyday /
John Roberts.
 p. cm. – (Photography, critical views)
 Includes index.
 ISBN 0-7190-3560-0 (cl). – ISBN 0-7190-3561-9 (pb)
 1. Photography–Philosophy. 2. Photography–History–20th
century. 3. Realism in art. I. Title. II. Series.
 TR183.R63 1997
 770 ' . 1–dc21 97-12650

ISBN 0 7190 3560 0 *hardback*
 0 7190 3561 9 *paperback*

First published 1998
02 01 00 99 98 10 9 8 7 6 5 4 3 2 1

Typeset in Sabon
Designed by Lionart, Birmingham
Printed in Great Britain
by Redwood Books, Trowbridge

Contents

List of figures and plates

Figures

Plates

The plates will be found between pages 212 and 213

Every attempt has been made to obtain permission to reproduce copyright material, If any proper acknowledgement has not been made, copyright-holders are invited to inform the publisher of the oversight.

Acknowledgements

This book has involved the support of many people. I would like to thank Jessica Evans, Steve Edwards, Dave Beech, Andy Wilson and David Evans for reading all or part of the manuscript; Andrew McNiven for his meticulous picture research; Stanley Mitchell, Malcolm Imrie and Esther Leslie for help with translations; the Arts Council of England for awarding me a grant towards production costs; John Taylor for his patience; and Paul Hurford for Sylvian. Thanks also to Barcelona where the first draft of the book was written, and everybody I met there, including Jorge Ribalta, Andrea Uhlig, Rosa Sala Rosa and especially Paul Hammond – the hot tips were invaluable. Finally thanks and love to Elizabeth for being there through it all.

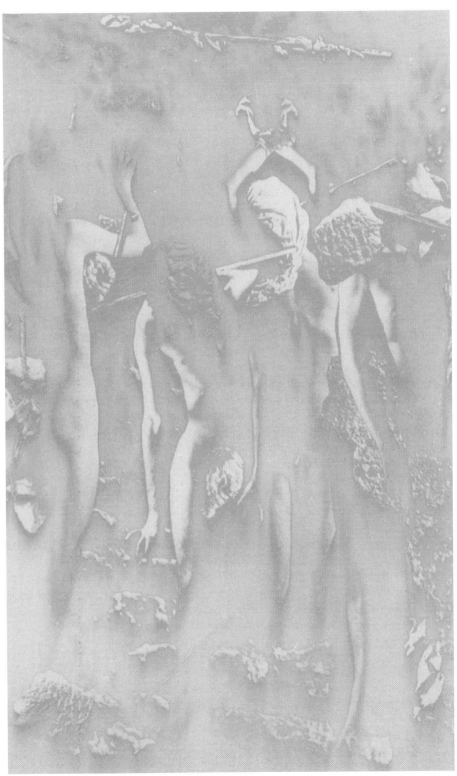

The Battle of the Amazons (Group III), Raoul Ubac, 1939 (© ADAGP, Paris and DACS, London 1996) (detail)

Introduction:

realism, contradiction and interpretation

The Art of Interruption sets out to do a number of things: to defend the philosophic claims of realism in assessing photography in the twentieth century; to recover the critical place of the photographic archive within the avant-garde; and to present a dialogic defence of the documentary image. In these terms the book is not a history of photography, but a history of the *theories* of photography. This is why I focus on the development of photography through the overlapping categories of 'realism' and the 'everyday'. It is the changing philosophic and political claims of these two categories which underwrite so much photographic discourse in the twentieth century. From the Russian Revolution to debates in the 1990s on the body, the radicality of photography is seen to rest on its powers of critical disclosure.

How we define these powers is, therefore, of crucial philosophic and political importance. 'Realism' and the 'everyday', I would argue, offer a greater explanatory power in the discussion of photographic history than the more familiar categories of 'expression', 'identity' and the 'unconscious' (although these categories are not thereby excluded by this claim). This is because 'realism' and the 'everyday' overwhelmingly capture the political and utopian content of early photography, the fact that for the avant-gardist and social documentarist alike photography's naturalistic powers of definition and historical 'recall' were viewed as being on the side of human emancipation and reason. This explicit connection between photography, reason and class-consciousness may have been lost or become muted, but the claims to 'knowledge' and to 'truth' still haunt the social functions of photography today, just as they haunt the wider assimilation of photography into the categories of art. A principal concern of this book, accordingly, is to reinstate 'realism' and the 'everyday' as categories which inscribe the fundamental contradictions at play within photography's relationship to art.

A key instance of what I mean is the question of how we interpret the place of the photographic archive within avant-garde photography. The idea of photography as contributing to the production of an archival knowledge of a particular event or period has been judged by many historians and critics of photography as a valuable empirical

resource. Yet when this comes to a discussion of the use of the photographic archive within art, its referential function is largely demoted and aestheticised, despite the fact that contemporary art theory has given increasing prominence to the place of photography within the development of the avant-garde: for example, the rereading of surrealism as a predominantly photographic movement. This demotion of the referential function of the photograph is due, I would argue, to the increasing theoretical separation between the avant-garde and the philosophical claims of realism – that is, the way questions of social reference have been suppressed in the interests of privileging the avant-garde critique of representation. The rise of post-structuralism has played a major part in this.

Surrealist photography, however, is unimaginable without reference to the realist use of the archive in Soviet and Weimar photography, and the realist claims of photography generally. Notions such as 'making visible', the 'memory of the working class', 'historical consciousness' and 'counter-knowledge' are part of a shared commitment to what are perceived as the 'truth-telling' powers of photography. As such, surrealist politics are opaque without understanding the *counter-archival* ideals of André Breton's and Georges Bataille's use of the photographic document. The title of Bataille's journal *Documents* is not fortuitous in this respect. But such is the strength of the theoretical attack since the 1970s on photographic naturalism as positivist that it has been difficult to retain the intimate connections between the avant-garde and the realist, reportorial ambitions of documentary culture. There is, as a consequence, a wider view of realism at stake here.

To defend 'realism' as a complex historical category is also to defend it as a complex philosophical concept. Reflected in the structure and organisation of *The Art of Interruption* is a commitment to a realist method of critical analysis. That is, in insisting on the shared cultural space of the photographic document and the avant-garde, cultural history is opened up to the dialectical permeation of identities and forms. In this the basic framework of the book – the genealogical analysis of issues and cultural categories – seeks to divest itself of not only the historicism and formalism of traditional approaches to photographic history, but the perspectivalism of so much would-be radical photographic theory. Mindful of the much abused strengths of the social history of art, it sets out to map the historical constellation and interfusion of practices across the institutional sites of 'art' and the 'social'. This places my arguments about 'art' and the 'social' in direct tension with the philosophical revival of aesthetics, specifically the work being done though Adorno. The turn against the social function of art in this writing, in the name of the art's immanent resistance to instrumental reason, subsumes the production of art under an abstract principle of autonomy. This has led a number of writers to an inflated view of art's historical bereavement.[1] Because art cannot be directly politicised, and therefore because aesthetics is socially impotent, art becomes an ethical stand-in for an absent politics. Invariably this ethical commitment is expressed through a defence of an art which is sensitive to its own lack of functionality: art about the 'impossibility' of art. More specifically, this is expressed through what is judged to be in the best position to achieve this: painting. Given painting's would-be residual resistance to the dominant commodified forms of expression in mass culture – its capacity for sensuous particularity – painting about the 'impossibility' of painting allows art to keep faith with an experience of pleasure and human freedom beyond populist calculation and the 'leisure industry'.

This book's understanding of art's historical bereavement, however, takes a different

line. In reconnecting photography to a social history of the avant-garde, *The Art of Interruption* theorises the problems of art's self-definition and autonomy from within the 'post-aesthetic' space of photography. To accept Adorno's judgements on the need for art continually to test its own conditions of production does not thereby mean accepting his judgements on the social dysfunctionality of art. Hence the *corrective* importance of the categories of 'realism' and the 'everyday'. To talk of 'realism', photography and the 'everyday' allows us to insert the history of art into a very different social space from that of Adorno's contemporary followers. Art may be in bereavement for its social function, but the content of this bereavement remains a matter of ideological contest, and therefore is decisively expanded once the 'realist' claims of photography are taken into account. Photography's intimacy with the everyday connects the categories of art to the agency and consciousness of specific subjects, in specific social contexts, faced with specific problems. This is not a false sublimation of art into life – something that Adorno rightly objected to – but the rejection of art's alienation as an abstract ethical principle. In Raymond Williams's great phrase, this book is about the 'ordinariness of culture', which I hold to be one of the central propositions of the early avant-garde's use of photography and which renders unstable all transcendental defences of aesthetic value. This is why *The Art of Interruption* spends a good deal of time defending the dialogic and communicative functions of photography against its aesthetic and psychoanalytic critics. The photograph is not simply an effect of dominant power relations, or evidence of the optical unconscious, it is also a form of *practical* knowledge, an inscription of, and an intervention in, a socially divided world.

Since the late 1970s photographic theory and history have had two main targets: Modernism and positivism. There have been four major subject areas within this: the photography and social power model (John Tagg, Allan Sekula); critical deconstructionism (Rosalind Krauss, Craig Owens, Hal Foster, Simon Watney, Abigail Solomon-Godeau); sociological critique (Pierre Bourdieu); and liberal historicism (André Rouillé and Jean-Claude Lemagny). It is the social power model and critical deconstructionism, though, that have exerted the most powerful influence on the construction of counter-Modernists' photographic practice and studies. Their academic success in the 1980s, however, has been bought at a certain cost. In the attempt to deconstruct the legacy of Modernist photography-as-fine-art and documentary's claims to 'truth', this writing has pursued a strong anti-realist bias in its discussions of the wider social implications of photography. Treating realism and positivism as identical, the attack on positivism has become conflated with an attack on the philosophical claims of realism as such. The result – although one would want to single out some of Sekula's writing from this – is the weakening of a dialectical understanding of meaning. This is reflected in the two main tendencies of the social power model: the insertion of the photograph into an inflexible 'regime of power', and concomitantly the weakening of the causal connection between the photograph and what it is actually *of*. Because the naturalistic or documentary image is constructed as *truth*, it is argued, then the relationship between the photograph and the pre-photographic event is considered irrelevant, or beside the point.

From this perspective this writing tends to reproduce the binary philosophic opposition at the heart of bourgeois culture: the constant oscillation between determinism (the fundamentally closed nature of meaning) and pluralism (the fundamentally open nature of meaning). The social agency of cultural producers is

always being subsumed *under* dominant power relations, or disconnected from them in the name of the 'free-floating signifier'. As a result there is a loss of specificity about the complexities of intention and use. John Tagg's writing on the FSA (Farm Security Administration), for example, emphasises photography's structural relationship to US reformist state policy of the 1930s without addressing how the individual photographers negotiated the ideological constraints under which they worked, nor how the photographs were used in unofficial ways. Similarly both Roland Barthes's and Allan Sekula's condemnations of the *Family of Man* show (1955) – now established radical postions – fail to take account of the political contradictions out of which the exhibition was organised. The *Family of Man* may have celebrated the nuclear family and the American Way of Life but this does not mean that these ideologies were coherent or stable. The affirmative humanism of the show, in fact, can be read non-positivistically as an attack on American Cold War policy.

These tendencies to deconstruct analytically rather than dialectically are not particular to the new photographic histories, but can be seen as a problem within contemporary art history generally.[2] The rise of post-structuralism, and with it postmodernism, has weakened the movement of the diachronic at the expense of the synchronic in the study of art and representation, producing models of historical analysis that are atomistic or perspectival. The effect – as I explain in detail in Chapter 8 – is to produce connections between things without any sense of their social and political constellations. As Roy Bhaskar puts it, dialectics will always strive to cut across disciplinary boundaries, 'to *totalize*, to draw together the intrinsically connected into an internally concrete (= well rounded) whole'.[3] A dialectical theory of photography, therefore, would emphasise the negotiated and constraining relations between social agency and social structure, allowing photographs to speak back from the past in non-objectified ways, at the same time as taking care to respect the determining effects of dominant relations of power on how culture is produced and consumed. Sekula himself has moved closer to this position in his recent writing on realism.[4]

What dialectics testifies to is that realism continues to be a contestable category for photography, and not a synonym for an inert positivism. Indeed, to use the term confidently allows us to discuss fundamental issues about epistemology, cultural democracy and artistic value from a position that avoids the 'endism' and determinism of so much current cultural theory. Thus, first and foremost, we need to be clear that 'realism' as a historical category and a philosophical method is not a monism; realism is not an unstratified theory of fixed things and fixed relations. On the contrary, realism's understanding and recovery of the world is based on the socially produced and self-qualifying nature of signification, in which things and their relations and representations are in *dynamic* movement and tension. For realists the critical understanding of, and critical intervention in, reality is a necessary – and inevitable – part of this process. Realism, essentially, is a fallibilistic account of a transitive, stratified and differentiated world; it is not a window on a homogeneous and present or phenomenal reality. Consequently, claims to the realist content of representations are not governed by the reflection of their objects, even if such objects play a determinate causal role in these claims. For instance, there is no such thing as the realism *of* a photograph, even if we can talk about some photographs containing more iconic (indexical) realist information than another. A clear, well-defined photograph of an elm tree has a greater iconic realism than a fuzzy photograph of the same tree. But this does not entail a value judgement. The

'realist-effects' and cognitive and aesthetic merits of such photographs will always be context-determined.

But on what ontological grounds are we to make these context-determined judgements? On what normative basis is the understanding of the dynamic relationship between reality and its representations to proceed? For dialectical realists there can be no understanding of the dynamic nature of reality without a dialectical realist model of contradiction. Without a model of the fundamental contradictions inherent in social reality the dynamic interaction between objects, relations and their representations is empty and formulistic. Dialectics simply becomes another name for the undifferentiated interconnection between things, or the passage and transformation of objects through time. A dialectical realist model of contradiction, therefore, distinguishes itself from its competitors (neo-Hegelianism and post-structuralism) in two important ways. It refuses to cancel the historical force of contradictions on the present (as in the case of the Hegelian *Aufhebung* and the post-structuralist concept of *jouissance*), and refuses to identify contradictions free from the *grounded unity* of opposites within a structure of domination. In this respect dialectical realism involves itself in the study and criticism of its object as the exposure of contradictions, blocking their premature resolution into speculative reason or free-floating interpretation. Dialectical realism bases its procedures of enquiry on the location of the relations *out of which* phenomena take the forms they do.

On this view dialectical realism distinguishes itself from its competitors by its ontological commitment to a causal or 'genetico-explanatory' method.[5] By exposing the existence of social contradictions in social reality as part of the movement of the totality of social relations, the causal understanding of an object becomes prior to its interpretation. Value judgements are not matters of external consideration, but are actually produced out of the process of causal analysis. Thus, if social contradictions exist *in* social reality, then the ideological contradictions out of which photographs are produced, for example, should be understood as providing the boundary conditions for textual explanation. But, as I have explained, a good deal of recent photographic theory has failed to meet these demands, subsuming causal analysis of the object under the weight of reified structures. The interactive relationality between the producer of the photograph, the ideological and material conditions under which it was produced, and the wants and needs of its audience, are overdetermined by a concern with photography as an 'objectifying' medium. These tendencies to disconnect and reify have, of course, much to do with the wider political settlement of which they are a part: post-structuralism's attack on realism and dialectics as an attack on Marxism. Apart from the obvious loss of a geo-historical or totalising perspective from cultural theory, the practical result for photographic writing has been an increasing distance between historical and theoretical work from everyday reality, specifically, the sense that the routine, commodified and alienated everyday experiences of late capitalism contain the suppressed and unformed potential of emancipatory transformation.

A good example of what I mean by interactive relationality is the way it is possible to read Walker Evans's *American Photographs* as a progressive critique of congealing FSA ideology in the late 1930s, despite the Modernist 'privatised' nature of the work. As Alan Trachtenberg argues in his finely nuanced reading of the period, Evans's book 'disrupts any expectation that its pictures here and now must be "news"; that is topical, or scenes of current events'.[6] In a period when documentary practices were being

defended in highly positivistic ways, Evans's scepticism about documentary's transparent truth-values invades the ideologically stabilising effects of the conventional claims for such practices. Trachtenberg's reading, then, grounds Evans's emergent Modernism in the contradictions of the documentary theory of the time. Or to put it another way, Evans's ideological gambits (his move to the museum in the name of 'poeticised' response to the everyday) are read out of the contradictions of FSA documentary practice – the gap between the organisation's claims for the social role of photography and the power of the state and the market to control how and where the photographs were seen. Evans's work can be read as an implicit critique of the idealisations of the FSA. However, to accept this does not mean accepting the political implications of such a position; an interrelational understanding of these practices produces a critical reading of both practices without collapsing their identity into each other. As such, what is kept in play is how objects and their relations are existentially constituted by, or contain, their relations and connections with other objects. Understanding these relations and connections means understanding the force of the contradictions out of which their identity is constituted. Thus a dialectical realist or 'genetico-explanatory' method allows social practices and their objects to 'speak out' of the contradictions that produced their identities. In short, dialectical realism privileges the *inter*dependent emergence of the social object.

This method, though, is not neo-Hegelian dialectics by another name. Contradictions may constitute all social being, but in some circumstances we need to be clear that contradictions also figure as *defects* and should be recognised and criticised as such. Although Marx's mature writing embraced a dialectical realist method rather than simply criticism, his critique of capitalism does not define the cognitive defects of opposing ideas merely as mistakes or illusions. On the contrary, he criticises the conditions out of which these defects are produced as being corrigible and therefore in need of transformation. In matters of social agency, this would take dialectical realism beyond the inter- and intrarelational dialectics of Adorno, whose work represents the most celebrated of immanent dialectical methods.

Adorno's attempt to theorise the grounded unity of objects is based on the rejection of the abstract Hegelian notions of the 'universal' and 'particular'. For Adorno this binary opposition conceals forms of non-identity and vice versa. This turns on the possibility of shifting the respective positions of the 'universal' and 'particular'. The 'universal' is transformed into the 'particular', and the 'particular' is unmasked as a 'universal'. As with dialectical realism, Adorno's dialectic is concerned with revealing hidden forms of identity and non-identity, of identifying absence in presence and presence in absence. But in Adorno's case this serves a *metacritical* position rather than a dialectically contingent one. The value of an immanent method is that criticism arises from within the object rather than being imposed externally upon it. For Adorno this is less strategic than a transhistorical schema. This is because dialectical criticism cannot escape what Adorno perceives as the fundamentally dominative and coercive structures of modernity.[7] Dialectical critique is irreconcilable, therefore, with a view of history as universal domination. The result of this is not only a weakening of the ideological confrontation with the object, but a loss of connection between causal analysis and the possibilities of social transformation. Adorno's immanent criticism remains tied *to* the grounded unity of its objects of analysis. Or rather, because he sees the grounded unity of objects in terms of their potentiality for coercion and control, the immanent method embodies a kind of moral judiciousness. This is why he has such an undertheorised

notion of art as social practice. Because his theory of art is based on art's inescapable complicity with the forces of domination, he has little interest in the theorisation of art as intervention in, and transformation of, the everyday. Such aspirations, he contends, can only lead to political posturing and sentiment; hence his notorious downgrading of photography.

In contrast dialectical realism reveals our actions, representations and theories as contested presences in a world potentially open to transformation. In the 1950s and 1960s Henri Lefebvre attempted to develop a dialectical theory of culture along these lines in response to the heavily Hegelianised Marxism of the time. Although Lefebvre's writing on art contains a residual positivism – surprisingly he had no time for surrealism – his 'critique of everyday life from within'[8] remains a significant contribution to a realist understanding of culture. Unlike Adorno's and Hegelian Marxism's disdain for the tainted and shared realities of popular culture, Lefebvre's writing on the everyday is some of the first to connect a dialectical analysis of the contradictory identity of the object to the idea of culture as a site of alienated struggle. The 'everyday' is where the ideological struggles over values are fought out and not in any hypothetical realm of aesthetic sensitivity and beauty. In the 1950s Brecht's epic theatre was very important for Lefebvre in this respect. What is valuable about Brecht, he argues, is that he places the contradictions of the 'everyday' in the forefront of our perceptions. 'The spectator becomes the living consciousness of the contradictions of the real.'[9] In response to this Lefebvre calls for an art and criticism which 'immerses itself in everyday life'.[10]

As with Walter Benjamin, Lefebvre begins from the premise that the alienating forms of everyday life contain within them real, if unconscious and fragmented, desires. The job of the dialectical cultural theorist and the job of the artist is to draw out these tendencies and impulses in an imaginative engagement with everyday forms and practices. Effectively, Lefebvre puts back on the cultural agenda the interrelational analysis of the ideologies of a concrete social formation. The outcome is a very different understanding of art, cultural analysis and social change from that then prevailing in Marxist circles. In Hegelian Marxism perceptions of art and social change are invariably couched in terms that deflate the role of art as culture, severing its connection to everyday forms and practices. Art and social change are given an emptily promissary content. The transcendental claims for Modernism *and* social realism in the 1960s clearly conform to this. In contrast, Lefebvre argues that 'socialism (the new society, the new life) can only be defined *concretely* on the level of everyday life, as a system of changes on what can be called "lived experience"'.[11] Hence the 'critique of everyday life' studies the negative and positive aspects of capitalist culture which confront each other on a daily basis. This requires a specificity of analysis in which the concept of the alienation of art and daily life is situated in dialectical tension with the forces of critique and emancipation. In this Lefebvre is concerned to recover what he sees as the abeyance into which Marx's realist dialectic had fallen under Hegelian Marxism and Soviet dialectical materialism. In Marx, alienation is not defined as absolute, but as the necessary aspect of the self-becoming of humanity. The outcome is that, following Marx and Benjamin, Lefebvre reintroduces a sense of social reality as double-sided: as involved in both the realisation and derealisation of human needs and desires. This is very different from the model of dominance and resistance within the Frankfurt School. In contrast to Adorno, Lefebvre advocates a model of critical practice based on art and theory as *practical* forms of knowledge and activity. 'The human eye has formed and transformed itself first through

practical and then aesthetic activity, and by knowledge; it has become something other than a mere organ.'[12] Consequently Lefebvre wants to drive home the point that artistic and theoretical activity is actually *performed out* of the contradictions of everyday life.

Adorno argued for something similar as the core of his immanent model of critical practice. But in Adorno the forces of dehumanisation dominate the possibilities of art's practical content. The result is a dialectic that merely gives a form to art's relationship to the contradictions of everyday life. Lefebvre, however, makes it the basis through which human values are produced. The processes of dehumanisation are not simply the external content of art, but the source of human beings' socialisation. Dehumanisation is the process *through* which socialisation takes place. Art's descent into the everyday, therefore, needs to take this dialectic as primary material. As Lefebvre says: 'There can never be any question of denying anything that exists the right to exist. It is the movement within whatever exists which transforms the world, past, present or future, and not theories about what should be rejected and what should be preserved.'[13]

This is not a defence of cultural relativism, but a recognition – particularly radical in the 1950s – that there can be no prejudgements about the ideological resources out of which art might find its critical resources. This is why at the time he was so committed to photography. Photography for Lefebvre represents the point where art and the categories of the 'everyday' meet. In the 1940s and 1950s his writing has strong affinities with the avant-garde and factographic photographers of the 1920s and 1930s. In this, what preoccupies him is a moral and political commitment to the 'ordinary' and prosaic, that is, to the communal textures of working-class life. As he argues in *The Critique of Everyday Life* (1947), in a polemic against the absence of a documentary ethos in post-war France: 'What about urban life, the life of the people, the life on industrial housing estates? Where, how and in what experiences can its essences be discovered?'[14] But if Lefebvre defends photography as a source of unofficial truths and experiences and thereby the class-consciousness of the realist tradition, he does so in a highly positivistic fashion. Much of his polemic against the absence of a documentary culture in France is taken up with an extraordinary attack on surrealism: 'By abandoning the everyday in order to find the marvellous and the surprising (at one and the same time immanent in the real and transcending it), Surrealism rendered triviality unbearable.'[15] The surreal engages with the unreal, the class-conscious photographic document with the 'facts'. This may have been an understandable criticism of French culture in the 1940s and 1950s, which never underwent the 'documentary revolution' of the 1930s in any fundamental sense, but such points have less to do with dialectical method than with Lefebvre's own taste for naturalism. Unlike Adorno, Lefebvre was not interested in how a politics of culture might be grounded in the non-mimetic. His unqualified faith in the political virtues of naturalism stands, therefore, in obvious contradiction to his dialectical critique of the everyday. Yet all the same this tension is instructive because it still determines the bounds of the critical debate on photography and art today. Lefebvre's assumption that naturalistic photography has a privileged claim on ideological persuasion and democratic dialogue continues to structure the populist critique of avant-garde practice. The modern development of photography invariably presents the artist with a choice between a version of Lefebvre's 'community of the everyday' or Pierre Bourdieu's 'festivity' and an avant-garde model of non-reconciliation and disaffirmation. If this is a false opposition, nevertheless it is the latter that has dominated the theoretical high ground. Value is assigned to those works that self-consciously mark themselves off from 'naive'

naturalism, what I call in this book the *epistemologicalisation of reality* through photography. The point, however, is not to reconcile these positions, to subsume them under a new synthetic concept, but to dialecticise their identities.

Lefebvre's dialectical realist method is let down by its undertheorisation of the need for a *positional* account of realism and the avant-garde. This is not to take anything away from the progressive moves he made in the 1940s and 1950s, but to recognise how much his own method failed him when a dialectical judgement had to be made on the need to separate the real from the phenomenal. Today photographic and cultural theory exhibits a comparable kind of dialectical blindness about realism and the avant-garde, but in this instance as a complete reversal of Lefebvre's position. What was fetishised is now considered irredeemable. As John Tagg concludes in a classic exposition of the anti-realist argument: 'Realism offers a fixity in which the signifier is treated as if it were identical with a pre-existent signified and in which the reader's role is purely that of the consumer.'[16] What Tagg is concerned to emphasise here is that the naturalistic or documentary image is a mode of signification which is unselfconscious about its ideological function; the naturalistic image is never neutral but always inscribed by power-relations at some level. It is true that the idea of the photograph as being contained by, and taken up by, power-relations is something positivist approaches rarely address, and if so only in the most exogeneous of ways. However, Tagg's discourse theory fails to register how the 'realist mode' is itself a contradictory formation; and therefore how it is able to 'speak back' through the voices of its subjects in ways other than those ascribed by a theory of dominant ideology. As I outline in Chapter 8, one of the problems with the social power model of photographic theory is that in locating the objectifying and dehumanising forces at work in documentary practices it also conspires with them. In the move to recognise the production of the photographic subject as object, the subject *becomes* an object. As with Hegelian Marxism a divide is set up between the rationality of a critical method and an 'irrational' world; the result is that the subject–object dichotomy is made opaque or unavailable to dialectical reason.

How might photographic history then be inserted into a general dialectical realist model? Dialectical photo-history implies a dialectic of seeing across social categories; if objects are constituted through their relations with other objects then images are not simply the products of individuated aesthetic traditions, for example 'realism' and 'Modernism', but the outcome of the interdependent processes and contradictions of modernity itself, of which 'realism' and 'Modernism' are internally and externally conflicting manifestations. The historiographical debate over methodology is not about defending 'social history' over formal or aesthetic analysis, or vice versa, but about the need to recognise the *interdependence* of formal and social analysis as part of a deeper causal or 'genetico-explanatory' method. Thus at one level my defence of realist dialectics does retain an important kinship with Adorno's immanent method: grasping the meaning of the historical object lies in exposing how the intentions exhibited in the object participate in a dialectic of enlightenment and disenlightenment. That is, how the decisions and choices of producers are to be read as formal inflections, resolutions or symptoms of the movement of the totality of social contradictions.

In this sense a dialectical realist method at least avoids the trap of 'vulgar Marxism' which so much postmodernist deconstructive theory inadvertently replicates: the construction of a separate progressive 'counter-tradition' from within the history of art and photography itself. It is one thing to reclaim nascent or buried traditions as part of

the activity of counter-hegemonic reconstruction, it is another to write up a separate and autonomous history of would-be radical works. It needs to be reasserted that photo-history is part of capitalist history; dominant practices and subordinate practices, mass culture and avant-garde culture, conflict and interconnect as part of a shared modernity.

Having said this, *The Art of Interruption* is not preoccupied with presenting a 'grand unified theory' of critical photographic practices. What it is concerned with is drawing out the demands placed on cultural practices and their sense of modernity by the contradictions of the capitalist mode of production. What differentiates this claim from similar claims (such as those subscribed to by the critical deconstructionists) is that I believe the categories of 'realism' and the 'everyday' allow us to explore the content of these demands with a stronger historical sense of the cultural and social divisions of modernity. This means taking the discussion of the term 'realism' out of the simplified and enfeebled realm of realist *aesthetics*, and the supersessive logic of conventional art history.[17] Realism is neither an 'outmoded' pictorial style nor an untheorised account of representation. On the contrary, it represents a continuing philosophical commitment to the application of dialectical reason to the problems of cultural production. We should not confuse the term, accordingly, with a defence of empiricism, although, of course, knowledge by acquaintance must play a part in any adequate realist epistemology. This distinction between realism-as-style and realism-as-method is fundamental because it draws attention to the contextual basis of realism in art. The 'realist-effects' of works of art are not reducible to any pre-given set of contents or forms but the product of a discursive reconstruction of a given work of art's claims to 'truth'. The implications of this distinction, however, have been widely ignored in the rush to celebrate a heroic post-realist world of digital technology. The effects of the new technology have been incorporated into the new writing on photography and culture in the most orthodox historicist terms as the supersession of chemical photography and realism *tout court*. This is incredibly short-sighted, and not just on the grounds of confusing realism with empiricism. New forms of image production undoubtedly transform our cognitive expectations about the world (as montage once did). However, they do not embody *new* worlds; that is, they do not transform artistic and cultural relations *en bloc*. There is no doubt that we are at the end of a particular period of photographic culture. But familiar and old problems remain. What is the relationship between the photographic image and 'truth'? How might a critical photographic culture intervene into everyday life in conditions where advanced commodified social relations separate historical knowledge from social practice? What is the relationship between past practices and present ones: is the presence of the past to be construed in a much stronger sense than 'negative presence'? As such, one of the overriding concerns of this book is to address the issue of realism as a continuing source of critical knowledge about representation and the world against the onslaught of technological determinism.

In conclusion, I want to clarify various senses of the term 'realism' being used in *The Art of Interruption*.

Historical method: Dialectical realism entails the construction of concepts capable of grasping the historicity of the phenomenon under discussion. For Marx this involves reasoning from the phenomenal to the *grounds* of their possibility. Or as Derek Sayers argues in his study of Marx's realist method: Marx is able to 'reconceptualise the phenomenal forms ... in terms of the relations demonstrated to underlie them'.[18] Thus

most of this book is concerned with analysing the historicity of the terms 'realism' and the 'everyday' as they affect the development of photography in the twentieth century. This is not an academic matter, for their historical identities are still being contested; the 'everyday' is not an ontological category, but a discursive and tropological one.

Historical interruption and redescription: Dialectical realism here involves photographic theory and history in a process of 'critical recovery' as the basis for a dialectics of remembrance. Thus one of the things *The Art of Interruption* is concerned with, as the title suggests, is drawing out the continuities of those moments within photographic practice since the 1920s that have brought dominant bourgeois concepts of 'truth' and 'art' into crisis. It does not do this, though, by constructing *a history of radical practice*. On the contrary, it demonstrates the historicity of the terms 'realism' and the 'everyday' to show how the development of photography has been constituted through these categories as responses to the absence of freedom, truth and human autonomy. Dialectical realism here is a redemptive historiography 'from below', in which historical objects and events are configured through a dialectic of enlightenment and disenlightenment. In this way redemption involves two principal dialectical moves: the recovery of objects and events from the patina of official histories (either of the left or of the right), and the reassessment of objects and events from the standpoint of their contemporary significance. To examine a particular object or event is to link up its particular causal significance or drag on the present. The dialectical realist as a redemptive historian takes the present to be embedded in the past, although the effects of this interpresence may take different forms: latent, manifest or agentive.[19]

Philosophical category: Dialectical realism here is employed as a theory of the contradictoriness of things. Contradictions are the essential nature of all social objects and their relations; however, dialectical realism explains such contradictions ontologically as the expression of more fundamental divisions. This involves a negative judgement of these divisions. In matters of cultural and artistic history, though, exposing the contradictions out of which an object is produced does not necessarily entail a negative evaluation of that object. To criticise Walker Evans's *American Photographs* for capitulating to the interests of the museum, without addressing the social crisis of the FSA as an institution, is to practice a jejune rationalism. Cultural objects are not social ills that need to be exposed in the interests of their eradication – although of course some cultural objects do produce social ills and these force us to make ethical judgements. The general point, here, is that if dialectical realism's task is to discover and explain the rational potential of an object (after Lefebvre), then the 'genetico-explanatory' method must be sensitive to the specific kind of object under review.

Practice: Here realism as a theory of reference is employed to make distinctions about various kinds of image production. For example, work that consciously foregrounds the contradictions out of which it makes its meanings could be said to be realist *in effect*. Similarly, documentary photographs that 'make visible' certain states of affairs through the countering of mystification or prejudice could be said to produce realist effects. In both instances, though, claims to such effects will be discursively constructed. These claims will then be subject to change and revision given changes in contextual circumstances.

Notes

1 See J. M. Bernstein, *The Fate of Art: Aesthetic Alienation from Kant to Derrida and Adorno*, Polity 1992, and his introduction to T. W. Adorno, *The Culture Industry: Selected Essays on Mass Culture*, ed. J. M. Bernstein, Routledge 1991. For an extensive critique of the new Adorno studies, see also Dave Beech and John Roberts, 'The Spectres of the Aesthetic', *New Left Review* 218 (July/August 1996).
2 For a discussion of these problems see my introduction in John Roberts (ed.), *Art Has No History! The Making and Unmaking of Modern Art*, Verso 1994.
3 Roy Bhaskar, *Dialectic: The Pulse of Freedom*, Verso 1994.
4 See in particular 'The Body and the Archive', *October* 36 (Winter 1986). Reprinted in Richard Bolton (ed.), *The Contest of Meaning: Critical Histories of Photography*, MIT 1989.
5 The phrase is borrowed from Joseph McCarney. See *Social Theory and the Crisis of Marxism*, Verso 1990.
6 Alan Trachtenberg, *Reading American Photographs: Images as History, Mathew Brady to Walker Evans*, Hill & Wang 1989, p. 252.
7 T.W. Adorno, *Negative Dialectics*, Routledge 1973.
8 Henri Lefebvre, *Critique of Everyday Life*, Verso 1991, p. 9.
9 *Ibid.*, p. 21.
10 *Ibid.*, p. 25.
11 *Ibid.*, p. 49.
12 *Ibid.*, p. 174.
13 *Ibid.*, p. 193.
14 *Ibid.*, pp. 239–40.
15 *Ibid.*, p. 29.
16 John Tagg, *The Burden of Representation: Essays on Photographies and Histories*, Macmillan 1988, p. 99.
17 For a historicist treatment of realism see André Rouillé and Jean-Claude Lemagny (eds), *A History of Photography*, Cambridge University Press 1987.
18 Derek Sayers, *Marx's Method: Ideology, Science and Critique in 'Capital'*, Harvester 1979, p. 109.
19 For a discussion of these three different forms in relation to dialectical method, see Bhaskar, *Dialectic*.

1

Photography, the everyday and the Russian Revolution

The construction of the category of the 'everyday' is identifiable with the major changes in social experience that take place in the twentieth century. The impact of photography and film on this process is, of course, decisive. The expansion of the category of the 'everyday' is coextensive with the early assimilation of photography and film into forms of mass social transformation. The origins of the 'everyday', however, do not begin with the impact of modern technological reason. The emergence of the term is also part of that long revolution in the secularisation of bourgeois culture from the middle of the nineteenth century. The ideals of nineteenth-century realism and science fuse with, and feed into, the construction of the category. The modern 'pre-history' of the term, then, can be traced back to those key debates on realism, painting and photography that preoccupied Europe, particularly France, during and after the 1848 revolutions. It was during this period that the 'everyday' as a set of identities possessing a specific aesthetic valency became separated from the everyday as a description of the commonplace. In the process the 'everyday' began to be separated out in art as that which bears the *scars* of modernity.

One of the principal sites of this shift in consciousness was history painting. By breaking with the ossified class rituals of this tradition, Manet codified the ordinary, prosaic and ugly *as* the modern.[1] After the 1848 revolutions and the rise of the industrial bourgeoisie and the new workers' movement, history painting re-enfranchised itself; standing on the shoulders of Courbet and his explicit alignment of the painting of history with the experiences of the dominated, Manet's cast of urban 'types' located the value of art outside bourgeois and aristocratic distaste for the ordinary. That Manet sought approval *from* the bourgeoisie, that he wanted to be seen as a trustworthy and competent artist, does not alter the fact that the category of history painting had become irredeemably poor and attenuated for the artist, and needed to be reinvented from a place outside its official class sites. *Honnêteté*, the term used in seventeenth- and eighteenth-century France to describe the excessive withdrawal by the aristocracy from the world of mundane realities, and which found a new aesthetic voice in the pseudo-

classicism of the mid-nineteenth-century French salon system, had to be confronted and challenged as *dishonest*.[2] Truth had become separated from beauty because the 'truth of experience' was confined to idealised subjects and a framework of etiolated conventions and overelaborate skills. Manet broke free of this not only by laying claim to the damaged beauty of the new industrialised Paris, but by identifying his own work processes (refraction of the contingencies of photography, rough painterly surfaces, flattened space) with a rigorous notion of workmanlike, honest toil. Here was the modern painter providing an identification between the artist and those who labour, in a world where the labour of artists is increasingly market-led and ordinary. However, if the 'everyday' here was being marked out tentatively as the site of art's recovery from bourgeois inertia, etymologically it was the term *la moderne* rather than *la quotidienne* (the everyday) that passed into common use. With its stronger connotations of the 'new', *la moderne* subsumed *la quotidienne* under its more expansive sense of cultural change. For the French bourgeoisie *la quotidienne* was too identifiable with dissident rather than dissonant associations.

This subsumption of dissident notions of the 'everyday' under consensual and dissonant ones, formed the pattern of the reception of the term within bourgeois European life until the beginning of the twentieth century. This changed with the breakdown of *ancien régime* culture. In the first two decades of the century, rapid industrialisation, the deepening crisis of classical culture, the success of the Russian Revolution, the opening up of the hidden world of sexuality through psychoanalysis, brought the term 'the everyday' directly into the spheres of politics, science, art and social theory. The 'everyday' became inflected with an explicit critical content. In short, as the balance of class forces changed in the industrialising West, the term attached itself to the growing demands on the part of the working class for political and social emancipation. When Baudelaire's heroism of modern life, Manet's candid images of proletarian life and the new urban photography (Charles Marville) were beginning to redefine the modern, a cultured section of the bourgeoisie turned to the everyday experience of subordinate classes as a source of exotica and paternalistic indulgence. By the time of the Russian Revolution, after sixty years of intense class struggle in the major metropolitan centres of the West, this bourgeois love affair with urban marginalia and 'low life' had become fraught with political threats. The 'everyday' was not just a matter of defining the boundaries of bourgeois pleasure, but had become the self-conscious possession of the working class and dispossessed.

In 1901 Freud published *Psychopathology of Everyday Life*, one of his first publications. In it he addresses 'the psychic disturbances of daily life',[3] focusing on the imprecisions of meaning and the failure to mean in the form of mistakes in speech, symptomatic gestures and chance actions. The effect was to remove the unconscious from the realm of spiritualism, that is, from the realm of pathology and mystery, and situate it in common experience. The failures of rational consciousness are presented as co-extensive with the subject's view of reality as itself fractured and uncertain. As such, what Freud inherited from the great cultural revolution of the second half of the nineteenth century is an emphasis upon the hidden significance of the prosaic and marginal. In fact, for Freud, this bringing forth of the 'everyday' symptom from the glare of medical condescension is conceived of as a revolution in perception. What appears to be inert or without communicable value (the psychic inconveniences and trivialities of daily life) are shown to have causal significance, to be 'well motivated'.[4] As Freud says: 'my main object

is to collect material and utilize it scientifically'.[5]

In the wake of these fissures, the 'everyday' divested itself of its subordinate position within classical theories of the subject, aesthetics and political economy to reveal that orders of meaning are not confinable to the symmetrical relationship between things or based on the imitation of ideal standards of coherence. It was the Russian Revolution, however, that brought this expanded concept of the 'everyday' into clearer intellectual and political focus. The impact of the Russian Revolution on definitions of the 'everyday' was enormous for one obvious reason: here was the first revolution in the modern period in which the working class was potentially in control of reality. Building a new world out of the ruins of absolutism and industrial backwardness, the working class was in a position to redefine the categories and boundaries of the real. The 'everyday' then became open to an extensive and unprecedented politicisation, insofar as its intellectual re-definition became co-extensive with social transformation itself.

In 1923, echoing Freud, Trotsky published his *Problems of Everyday Life*, in which the daily hardships, conflicts and contingencies involved in the building of socialism are discussed in fine detail across industry, the military, education and literacy and culture.[6] Admittedly Trotsky's book is written on a kind of war footing – one of the overriding concerns of the essays is discipline in the face of counter-revolution and sabotage – but nevertheless it reveals itself to be one of the high points during this period in the understanding of the 'everyday' as a critical category. In Russian there are two distinct definitions of the 'everyday': *byt* and *ezhednévnyi. Byt*, a noun, means more than everyday life, it means everyday *being*, the brute facticity of everyday life or the intractabilities of material life. The adjective *ezhednévnyi*, on the other hand, is closer to the French *quotidienne* and means the 'daily'. It thus has stronger connections to the 'temporal' or 'contingent', and would be used for instance in a sentence such as 'this happens every day'. It is the former definition, *byt*, though, that is used and emphasised in the *Problems of Everyday Life* and in most literature and theory during and after the revolution. For *byt* expresses a stronger sense of the 'everyday' as something to be confronted, manipulated and acted on, as something that is materially, physically present. It is this sense of the word that is beautifully expressed in Mayakovsky's well-known line from his suicide poem: 'the love boat has washed up on the everyday'.[7] *Byt*, accordingly, can be seen as undergoing a change of emphasis during the 1920s and 1930s, as the expectations of revolutionary change gave way to Stalinist closure. Mayakovsky's *byt* is also the *byt* of growing Stalinist reaction.

By the 1920s, however, under the general intellectual prestige of Marx and Freud, the 'everyday' had detached itself from positivistic notions of the ordinary and prosaic, to align itself with a dynamic conception of social reality. To use the term in Trotsky's sense was to see everyday reality as essentially conflictual and contradictory and therefore open to change. The 'everyday' passed from the spectacle of class rituals and customs to the dialectics of class struggle. Failure to recognise this massively important change in consciousness leads to an inability to understand why there is such a huge literature in the 1920s and 1930s on the 'everyday' and photography, the 'everyday' and realism, the 'everyday' and politics.

Definitions of the 'everyday' in revolutionary and post-revolutionary Russia are debated through the framework of 'proletarian culture'. Capturing the 'everyday' and transforming the 'everyday' for a 'true Bolshevism' became the terrain on which the right and left of the party fought out the cultural debate. For Alexander Bogdanov and the

Proletkultists the proletariat had its own autonomous thinking, which found its expression in a distinct proletarian culture. Expressions of the 'everyday' were seen fundamentally as collective ones, given that working-class identity was inescapably rooted in the collective experience of labour. Proletarian culture, it was argued, was the opposite of bourgeois culture and therefore was not in a position to accept the individualist solutions to artistic practice of both traditional bourgeois art and Western Modernism. What was needed were new forms of practice that would capture the experience of socialist construction as a collective activity. At the First All-Russian Conference of the Proletkult in Moscow in September 1918, a resolution was passed declaring: 'The proletariat must have its own class art to organise its own forces in social labour, struggle and construction. The spirit of this art is that of labour collectivism.'[8]

In the early years of the revolution Lenin attacked this kind of thinking in the name of a 'higher', integrationist or Hegelian notion of the 'everyday': the achievements of bourgeois culture were not antithetical to working-class revolution, but part of its historical memory. This naturally created a certain cultural consensus within the Bolshevik Party, in which success or lack of success in art was to be measured by some inherited classical bourgeois notion of artistic achievement. Grounded principally in debates on literature, which Lenin felt more comfortable with, the writings of Gorky became the acceptable or admired role model for progressive artistic practice. The 'everyday' was not something that was to be constructed out of the narrow experience of working-class culture, but out of the resources of world culture, to which the forms of European bourgeois culture were a particularly rich contribution and, along with world culture as a whole, the just inheritance of the working class as the vanguard of humanity.[9] It is important to mention this universalist understanding of the everyday, because we cannot comprehend the intricacies of the avant-garde's commitment to an alternative conception of the 'everyday' without addressing this background. The avant-garde did not sweep all before it in the 1920s; it had to fight a rearguard action against this hegemony, defeating it at certain points, retreating in the face of it at others.

What Lenin objected to in the Proletkult manifestoes and actions was its 'scorched earth' policy of cultural transformation. For Lenin, in conditions of severe material shortage and mass illiteracy, Proletkultism was sheer idealism. At the Adult Education Conference of 1919 he declared that because the dictatorship of the proletariat was inevitable this meant a 'higher level of labour organisation than before ... and that is why I regard all intellectual fantasies of "proletarian culture" with such ruthless hostility ... If we solve this very simple, elementary problem we shall win ... the basic fact of proletarian culture is proletarian organisation.'[10] In one sense Lenin was absolutely right: levels of cultural ability, of literacy and creativity cannot be attained separately from real material transformations. Proletkult proclamations about the collective transformation of 'everyday' life were on the whole empty abstractions, fuelled by a kind of a moral fervour. However, the supposed 'disciplinary' realism of Lenin's contribution brought to the fore the failure of the party to acknowledge the radical implications of the new culture: that is, the overturning of an artisanal set of cultural relations for modern, technological ones. Putting the blocks on Proletkultism made it increasingly difficult after 1921 for both the Proletkult and the left-avant-gardists (constructivists and productivists) to bring debates on aesthetics in line with revolutionary political culture. In effect what Lenin's intervention did was legitimise a conservative construction of the 'everyday' in art, preparing the ground for a reactionary consolidation of the term under Stalinist

socialist realism.

One of the demands of the left wing of the Proletkult organisation was the need to bring 'art' and 'everyday' life together under the auspices of production – production art by another name. As the organisation came under greater scrutiny, debates on production and art found a wider audience not only within the avant-garde community but, ironically, within the party. The party began to take an interest in such ideas because the quality of industrial production needed to be improved dramatically. Production art's focus on the breakdown between 'art' and design for production served to fit the bill. Thus when the Vkhutemas was established in 1920 in order to promote practical design, the state tacitly supported those productivists who set up the institute. Given the depth of the economic crisis, this was held to be preferable to the pure constructivists, abstract painters and agit-prop Proletkultists.[11] An art of the 'everyday', then, was fine as long as it was allied to industrial growth, or created accessible images of social patriotism. The more radical productivists, though, such as Boris Arvatov, wanted more than 'good design'. As Arvatov proclaims in *Kunst und Produktion* (1927),[12] the classic productivist text of the period, bourgeois art has in principle remained artisanal and as a result it has been 'pushed out of general social praxis into isolation and the realm of the purely aesthetic'.[13] The first task of the working class, therefore, is the 'liquidation of the historically determined barrier between artistic technique and general social technique'.[14] For Arvatov, productivist art meant the progressive dismantling of 'expressivist' and individualist aesthetics. Socialism will invest 'artistic activity in everything'.[15] 'Individual artists will become co-workers with engineers, scientists and administration functionaries'[16] in the organisation of a common product. In essence, for Arvatov, technology allows the artist a role as a co-worker *in* the process of social reconstruction.

This was a vision that clearly exceeded Lenin's tactical economism. The technological changes underway in the new Russia prepared the foundations for a radical reorganisation of manual and intellectual labour, of creative labour and necessary labour. Lenin, though, had other problems: how to raise productivity and bring a semblance of order to a chaotic situation. 'The task that the Soviet government must set the people in all its scope is – learn to work.'[17] For the left-productivists learning to work was also, however, about unlearning what work had hitherto been for the vast majority of humanity. Lenin's managerial injunctions may have been necessary and inevitable, but it was the intellectual prestige of the productivist arguments that brought the revolution out of its brute reality into the realm of revolutionary cultural change for so many left-communists both inside and outside the Soviet Union. The avant-garde vision of the 'everyday' as a breakdown between art as an individual practice and production as a collective enterprise gave actual imaginative shape to the egalitarianism of the revolution. It was this vision that so obviously fascinated Walter Benjamin in the 1930s. As Arvatov says, prefiguring the Benjamin of 'The Author as Producer', productivism means the 'melting of artistic forms into the forms of the everyday'.[18]

Arvatov's views had considerable support in the October group which was formed at the end of 1922 to counter the rise of petit-bourgeois aestheticism under the New Economic Policy. In 1920–21 the New Society of Painters (NOZh), run by former pupils of Malevich and Tatlin, was formed. As they asserted: 'We have not started from an artistic or sociological theory; emotions have led us here. Artistic feeling lies at the core of our work.'[19] Frustrated by the material insubstantiality of productivism and constructivism and the increasing distance between the claims of the avant-garde and

everyday life, many artists, such as those involved with NOZh, moved closer to what can be perceived as a more pragmatic notion of art and the everyday. These moves were concretised in the activities of the Association of Artists of Revolutionary Russia (AKhRR). Although the AKhRR had little sympathy for the Modernism of NOZh, nevertheless a defence of painting became a focus of their attack on productivist culture. Faced after the civil war with the massive material problems of social reconstruction, they declared that artists were confronted with a stark choice: either commitment to a generalised war of propaganda for the revolution within the working class and peasantry, or marginalisation through abstract proselytising and utopian gesturing. As AKhRR insisted in a declaration published in 1922, artists should now commit themselves wholeheartedly to 'the life of the Red Army, the workers, the peasants, the revolutionaries, the heroes of labour'.[20] Artists should reflect with 'documentary accuracy in genre, portrait and landscape, the life of contemporary Russia and to depict the whole working life in its multi-faceted national character'.[21]

By 1923 this position was gaining ground. The notion of the 'everyday' as a site of critical intervention was transformed into a defence of 'communal celebration' and patriotic pieties. The left of the avant-garde had to immediately orientate itself towards this growing consensus, a consensus that was becoming increasingly identifiable with party policy and with Lenin's aesthetic conservationism:

> I have the courage to show myself a 'barbarian'. I cannot value the works of expressionism, futurism, cubism and other isms as the highest expressions of artistic genius. I don't understand them. They give me no pleasure ... We don't understand the new art any more, we just limp behind it.[22]

The result was a clear shift on the part of the productivists and constructivists back to *representation*, but on terms that still held to the *non-artisanal* principles of productivism. The widespread turn to photography and film amongst the left-avant-garde during this period became, therefore, a means of keeping faith with avant-garde ideals, at the same time as participating within the demand for a new popular image culture. This shift was negotiated with some sophistication by Arvatov. Although Arvatov had attacked the representational functions of artisanal practices, his conception of an art of the 'everyday' still allowed for certain representational tasks. 'In the society which is still partially unorganized there will always be groups who demand a concretising of tasks and their imagistic realisation, even if that involves using the imagination.'[23] Until socialism, 'the proletariat will have to deploy representational art as a specific professional activity for the organisation of the class'.[24] These statements by Arvatov, and similar statements by others, allowed the left-avant-garde to negotiate a workable space for themselves as the ideological climate got distinctly chilly. As Christine Lodder has said, 'the constructivists' use of the photograph [was] a compromise with that powerful move towards Realism and the attempt to create a popular Soviet art'.[25] With the collapse of productivism/constructivism as active ideologies by 1922–23, photography and film became the central means by which the ideal of an interventionist art of the 'everyday' was carried forward. In the process, the terms of this commitment changed and deepened.

Gustav Klutsis, El Lissitzky and Alexander Rodchenko all moved into the area of photography, and particularly photomontage, in the early to mid 1920s. The effect was a move within left-avant-garde circles to the idea of art as a source of *cognitive*

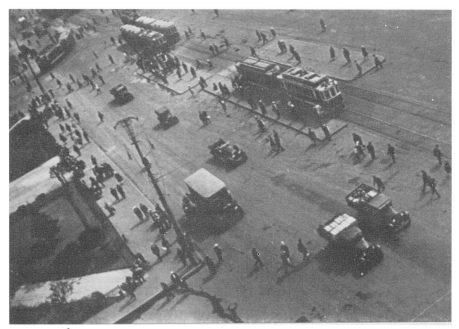

Fig 1 *A Road in Moscow*, Alexander Rodchenko, 1932. (© not known)

transformation. Consciousness-raising, as a constitutive part of the radical transformation of perception, was seen as the means through which intervention into the everyday was to be retained. As Rodchenko says in *Novyi Lef* in 1928: 'In order to teach man to look in a new way it is necessary to photograph ordinary familiar objects from totally unexpected viewpoints, and in unexpected positions.'[26] The recovery of the 'everyday' was elided with its cognitive reorientation. Consequently, it was around 1923 onwards that debates on montage and photomontage began to dominate the left-avant-garde, as an obvious superstructural response to the retreat from the transformation of the technical division of labour within the working class. The setting up of *LEF* (*Left Front of the Arts*) captured this moment. *LEF*'s condemnation of mysticism and formalism in the name of a partisan, mechanically reproducible art of the everyday was the place where leading avant-gardists debated the 'new spectator'. Montage, in effect, was argued to be the synecdochal expression of revolutionary transformation itself.

Across the writings of Dziga Vertov, Sergei Eisenstein, Rodchenko, El Lissitzky and Klutsis, there is a similar refrain during the mid to late 1920s: the activity of montage represents the active making of the revolutionary subject and therefore of a new world.

This, of course, is subject to very different kinds of emphases, but the pattern is fairly similar across all practices. The new photography and film do not simply 'reflect' the world but actively produce our understanding of it. The outcome is an explicit thematisation of an art of the everyday and dialectics.

Subject to the processes of mechanisation, art incorporates the effects of industrialisation (reproduction, speed, simultaneity) as a radical repositioning of the spectator in front of the image. The repeated or montaged photographic image engages the spectator in an active collaboration with the dynamic *technical* relations and motions

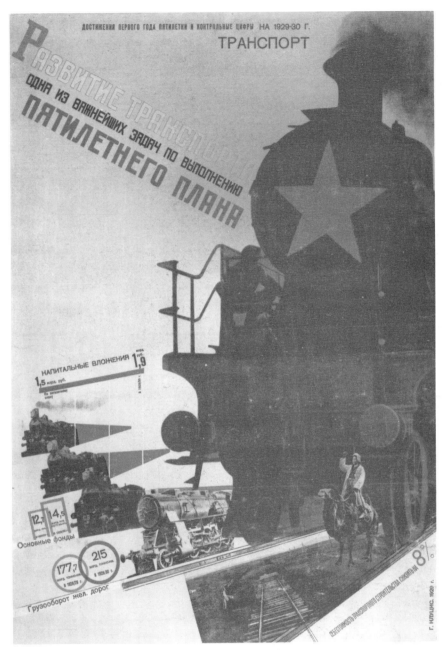

Fig 2 *The Development of Transportation, The First Five-Year Plan*, Gustav Klutsis, 1929 (The Museum of Modern Art, New York. Purchase Fund, Jan Tschichold Collection) (© The Museum of Modern Art, New York)

of modern culture. As Arvatov says in *Kunst und Produktion*: 'LEF is for an up to date, urban, industrial, "Americanized" art'.[27] For Peter Wollen, in his study of this period, this reference to Americanisation is not at all perverse, but actually central to the perceived liberations of the industrialisation of culture.[28] American-style or Fordist mass

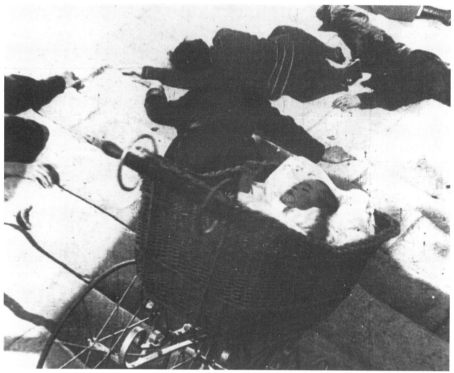

Fig 3 Still from *Battleship Potemkin*, Sergei Eisenstein, 1926 (Courtesy of the British Film Institute)
(© 1996 Contemporary Films)

production was a model to be admired because of the way it seemed to distribute the use-values of art in a non-elitist way. This was to be Benjamin's major theme in 'The Work of Art in the Age of Mechanical Reproduction', which, like the left-productivists, sees the new forms of mechanical reproduction as transforming spectatorship from the realms of the spiritual to the critical and collective.[29] To sequence an image, or montage one image over another, was to suggest that the active intelligence of the spectator was being addressed.

For Eisenstein the effects of montage were akin to 'plowing up'[30] the psyche of the viewer. In his early theoretical writing he categorises this as a montage-of-attractions. The attractor is an image that is inserted into the diegetic flow of the film to undermine the naturalistic identity of events, for example the close-up of vermin in *Battleship Potemkin* before the medical officers are thrown into the sea. As such, the attractor is defined by associative relationship to the theme (and to other attractors) and therefore implies an effort to hold the intellectual attention of the viewer outside the surface passage of events. By 1926, though, Eisenstein had dropped this more activist concept of the attractor for one of association. This had much to do with the change in cultural climate during this period. Eisenstein now began to use such words as 'sentiment' and 'pathos' in a positive light, echoing the prescriptions of the AKhRR. Hitherto such terms had been irredeemably linked to the illusionism of bourgeois theatre and Hollywood film. Now 'plowing up' gave way to, or rather was amended by, desire and pleasure. Whereas the attractor shocked, sentiment and pathos *captivated*. However, Eisenstein makes clear that

pathos and the ecstatic are not passive in their effects, but processes of critical awakening. What this means ultimately is an experience of union with the object on the part of the spectator. The spectator loses himself or herself in the process of identification with the object. If this involves on Eisenstein's part a consideration of the emotional life of the spectator, it also involves a tactical move towards the new populist consensus. Later it was to become an explicit expression of Stalinist ideology, as the leaps and breaks in the diegetic flow of the film began to be read in terms of their place within an organic whole. As he states in 'Montage in 1938', 'each fragment of montage no longer exists as something autonomous, but as one of the *particular figurations* of a single theme which permeates all of the fragments equally'.[31]

In broad outline, though, montage for Eisenstein was not an artistic technique, but the very basis of all psychic processes, and of creative activity as such. The concessions to the Stalinist reconciliation of part to whole did not prevent Eisenstein throughout his career from theorising montage as a dynamic cognitive process. Following Freud's account of psychic life as a set of shifts and displacements, Eisenstein sees thought and montage in correspondence. As he argues in *The Film Sense* (1943), 'in the actual method of creating images, a work of art must reproduce that process whereby, *in life itself*, new images are built up in the human consciousness and feelings'.[32] In this sense Eisenstein defends montage as *unifying cognitive principle*:

> The strength of montage resides in this, that it includes in the creative process the emotions and mind of the spectator. The spectator is compelled to proceed along that self same creative road that the author travelled in creating the image. The spectator not only sees the represented elements of the finished work, but also experiences the dynamic process of the emergence and assembly of the image just as it was experienced by the author.[33]

So, author and spectator experience a common creative process; the interactions, inversions and displacements of the montage method produce in the spectator the means by which he or she actively creates meaning. Following the film as a constructed entity, the spectator takes self-conscious possession of the processes out of which it is made, creating or recreating the work in the act of perception. For Eisenstein montage has a naturalistic basis in human psychology and perception. The spectator connects with what is already present in consciousness. 'At the base of these methods lie in equal measure the same vitalizing human qualities and determining factors that are inherent in every human being and every vital art.'[34] Eisenstein's transformation of montage into a universal, naturalistic principle is clearly fraught with problems inherited from his Hegelianism. The concern with organic structure and meaning, with the aesthetic resolution and unity of materials – 'a formal imperfection is an indication of a lack of precision in the apprehension of the idea,'[35] he declared in 1935 – makes it difficult for montage to act as a process of interruption into the everyday. The disruptive image is always brought back into balanced relation to the whole. This naturally implies a symmetrical relationship between montage and the realities of Soviet life. No image can stand dialectically outside or against the flow of Soviet historical experience, because it is the representation of the greater unity of the revolutionary experience that counts. His naturalistic reading of montage, then, becomes perfectly understandable within the context of Stalinist politics. The consciousness of the spectator moves in flow with the general workerist or national-populist ideology of the film, at the expense of any specific

Fig 4 Still from *Kino Pravda*, Dziga Vertov (Courtesy of the British Film Institute) (© Sovexport Films)

class-consciousness, insofar as the contradictions that produce class-consciousness as a negative state of being have been removed. Consciousness-as-montage simply becomes the expression of montage as a principle of validation. Montage is no longer seen as a means of exposing contradictions, but of transcending them.

However, this does not mean that Eisenstein no longer saw montage as an active principle or no longer held to a view of film intervening in the everyday, but that the symmetry between reality/consciousness/montage was predicated on the *construction* of the everyday, not its critique. And it is this fundamental notion of the everyday as socialism in construction that determined the move to film and photography within the avant-garde. This is particularly evident in the work of Dziga Vertov. Although Vertov was highly critical of Eisenstein's theatricality, like Eisenstein, Vertov's Kino-Eye group was committed to montage as an active process of proletarian consciousness-raising. The leaps and bounds that Eisenstein talks about in terms borrowed from Engels's *The Dialectics of Nature* (1927)[36] – the comprehension of film involves a move from the quantitative to the qualitative – is in Vertov's writing the result of the potential uniting on screen of a collective class-consciousness. 'Workers ought to see one another so that a close indissoluble bond can be established among them' (1925).[37] The possibility of 'plowing up' the spectator's consciousness is coterminous with bringing into focus the unities of working-class experience. This necessitates a 'montage battle' (1925)[38] against the flux of everyday experiences. 'Kino-eye is the possibility of seeing life processes in any temporal order or at any speed inaccessible to the human eye' (1929).[39] That is to say that montage involves organising the 'everyday' into a meaningful collective experience. In

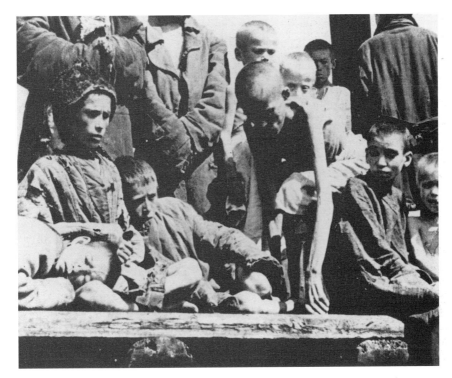

Fig 5 Still from *Kino Pravda*, Dziga Vertov (Courtesy of the British Film Institute) (© Sovexport Films)

contrast to Eisenstein, though, Vertov's singular commitment to the use of newsreel was always a means of resisting what he called 'premature synthesis',[40] the tendency, as in Eisenstein's own use of newsreel footage, to efface the heterogeneity of the image in the interests of allegory. Vertov's version of montage as a metonym of collective experience allowed, and even encouraged, asymmetrical patterns of reference within the film's diegetic flow, and as a consequence the foregrounding of the 'everyday' as contingent. Identifying the movement of collective experience was sought through the discontinuous within the continuous. It was the shared practical realities of working-class experience that defined the form of the film, and not any mythologised 'world spirit'.

It is little surprise, therefore, that by the end of the 1920s Vertov's combative proletarian montage aesthetic found few friends in the bureaucracy, and as a result very few of his film projects were made or found a distributor.

Yet, for all their differences, Eisenstein's and Vertov's iconicised Stalinised Modernism represented a culture of socialist construction that Sergei Tretyakov, Klutsis, Rodchenko and El Lissitzky identified with. With the collapse of productivism and constructivism as viable aesthetic options, what photography and film provided was an ideological reordering of the categories of the everyday: work, leisure, past, present and future. The effect was an extension and dispersal of not only what constituted factuality, but its cultural status. Much has been written in these terms about the impact of photography and film on the development of a factographic culture in the 1920s and 1930s. Photography and film brought the collective experience of industrialisation and the construction of working-class identity into the realm of the aesthetic as part of a

widespread shift within the balance of class forces on a world scale, the Russian Revolution being the crucible of this process. The revolution created the unprecedented conditions for the cultural empowerment of working-class experience. Thus the reclamation and de-hierarchisation of the 'factual' was a means of aligning the 'everyday' with a view of the working class *in movement*. This sense of movement was something only photography and film could produce. Under the demands of consciousness-raising, the indexical functions of photography and film provided access to forms of self-identification for the working class, in as much as workers saw themselves not just represented, but represented as part of a historical process. Photography and film, therefore, had a crucial part to play both in narrating the revolution back to its participants and in transforming, in general terms, people's expectations of the 'everyday'. By bringing into view the minutiae of everyday revolutionary experience and the collective power of the working class, photography and film were seen to be in a position to perform key dialectical, social and perceptual tasks that were just not available to the traditional media. However, it also needs to be made clear that these different tasks actually came to represent different political positions as the fortunes of the avant-garde unfolded. If there was an obvious ideological divergence between Eisenstein and Vertov in the use of the 'factual' (Vertov's *proactive* notion of newsreel), there was a comparable tension in the area of photography. In much of the discussion on photography and the 'everyday' in the 1920s there was a residual opposition between photography as a 'precise record' (Klutsis)[41] and photography as a process of cognitive transformation, or as Rodchenko put it in 1928, 'I am expanding our conception of the ordinary, everyday object'.[42] This was naturally a highly spurious opposition, yet there developed an open polarity in photography debates in the mid-1920s between a 'photography-of-the-facts' and a photography that used montage techniques to produce a Modernist 'realism' of the multiperspectival. The cause and effect of this was the continuing, and increasingly fraught, debate on what constitutes correct revolutionary practice. As in the area of painting, the debate between a 'photography-of-facts' and a Modernist 'realism' turned very much on the conflict between 'accessibility' (ratification of the achievements of the revolution; patriotic self-identification) and the demands of revolutionary transformation itself ('the making of a new world'). Without there being open acknowledgement of this, this debate was in itself an expression of inter-class conflict as the emergent bureaucracy began to support a 'photography-of-facts', along with the new academic painting. Nevertheless, this does not mean Rodchenko and El Lissitzky were marginalised, but that work which openly professed allegiance to a cognitive model of transformation was downgraded at the expense of work which *commemorated the gains* of the revolution. Thus it could be said that the left-avant-garde's turn to a cognitive model was made in the hope of circumventing the growing power of the bureaucracy. But what actually resulted was that Modernist photography, no less than painting, was swamped by the nationalist and statist dictates of building 'socialism in one country'. In issue no. 11 of *Novyi Lef* the contradictions of the situation for photographers is well illustrated by the contributions of Boris Kushner and Rodchenko. Kushner was a defender of the 'facts':

> In accordance with the meaning and character of our epoch, the revolution is precisely a revolution of facts – not of how we preceive them, or how we depict, transmit, render, or pinpoint them.[43]

This positivism, posing as revolutionary 'realism', is dismissed by Rodchenko for its pre-revolutionary sentiments.

> There's no revolution if, instead of making a general's portrait, photographers have started to photograph proletarian leaders – but are still using the same photographic approach that was employed under the old regime or under the influence of Western art.[44]

For all Rodchenko's criticism of Kushner's 'fetishism of fact',[45] Rodchenko's avant-gardism failed, as more obviously with Kushner, to address specific questions of context and reception. His model, for all its dialectical rhetoric, was no less abstract in its proselytising than Kushner's. The debate was a false one, dividing issues of cognition from substantive questions about the relations of cultural production, a division which productivism had sought to rectify. It was Sergei Tretyakov who pointed this out in the same issue of *Novyi Lef*. Tretyakov criticised both Kushner and Rodchenko for setting up a binary opposition between the 'facts' and consciousness-raising. 'The fight against aestheticism is an *incidental* function of modern photography, and it is impossible to begin with this. One has to begin with utilitarian goals – photo-information, photo-illustration, scientific photography, technological photography, photo-posters.'[46] In other words, he positioned himself against Rodchenko's abstract notion of experimentation. For Tretyakov experimentation was not the result of generalised commitment to changing 'everyday perception', but an engagement with 'concrete problems'.[47] Tretyakov was one of the few photographic theorists at the time who developed a positional account of photography and the 'everyday'. Photographers could not talk about 'changing reality' unless they were prepared to transform the relations of their production. Hence, like Arvatov, Tretyakov saw the need for photography to contribute to the transformation of art's technical division of labour, that is, the critical de-professionalisation of art. Photographers were encouraged to co-operate with workers in the workplace on various literary/photographic/political projects that would then form the basis for the passing on of cultural skills from worker to worker. This later became the preferred model of the Photo Section of the October group. Every member of the Photo Section was to be linked with a factory or collective farm circle in order to develop programmes of 'political literacy'.[48]

Under the influence of productivism the idea of the 'everyday' became part of a dynamic that moved photography beyond the construction of a revolutionary subject in the abstract, to the fulfilment of the needs and interests of specific subjects in specific circumstances. The raising of revolutionary consciousness was not confined simply to the representation *of* working-class experience, but extended to an exchange of ideas between worker or peasant and professional as the basis for work grounded *in* the experience of worker or peasant. This overlaps to a large extent with the formation of workers' photo groups in Europe in the late 1920s, although for the Photo Section it was never just a matter of workers taking photographs themselves, but the production of collaborative projects. Nevertheless, the category of the 'everyday' had become thoroughly imbued with the demands of working-class self-activity. The bureaucracy may have soon put a stop to Tretyakov's projects, but as in the case of Arvatov, the imaginative power of these demands far exceeded their actual application. We can see this clearly in the impact productivist ideas had on left-modernist culture in Europe in the late 1920s and early 1930s. With the increasing bureaucratisation of Soviet culture it was

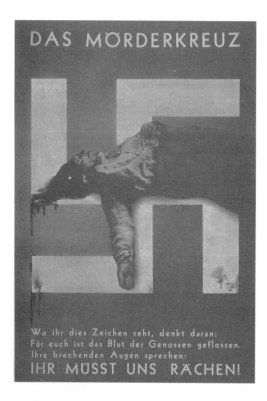

DAS MÖRDERKREUZ

Wo ihr dies Zeichen seht, denkt daran:
Für euch ist das Blut der Genossen geflossen.
Ihre brechenden Augen sprechen:
IHR MÜSST UNS RÄCHEN!

Fig 6 *Das Mörderkreuz* (The Murderer's Cross), John Heartfield, 1933 (from *AIZ*, 12: 30, 3 August 1933. Courtesy of Marco Pinkus Collection, Instituto Valencia de Arte Moderno / Centro Julio Gonzalez)

Europe, in particular Germany, that became the focus for productivist aesthetics.

In 1931 Brecht became good friends with Tretyakov after Tretyakov had visited Berlin. With good reason it could be argued that Brecht was one of the key transmission belts through which a 'productivist aesthetics' emerged in Europe. The major theoretical evidence for this, of course, is not only Brecht's dramaturgy, but Benjamin's 'The Author as Producer' (1934), which reworks Tretyakov's/Brecht's concept of the operational artist/writer within a European capitalist setting.[49] Directing his criticism of leftist orthodoxy at the European appropriation of the new Soviet photography (Renger-Patzsch), Benjamin argues that the role of the radical photographer is not to supply an already existing apparatus with radical content, but to change the nature of the apparatus. As with Arvatov, Tretyakov and the Brecht of Epic Theatre, Benjamin insists famously that the artist/photographer must supply an apparatus that breaks down the barrier between the artist as 'creator' and the spectator as consumer.

Key to Benjamin's reading of productivism is, without doubt, John Heartfield. In 1931 Heartfield visited the Soviet Union, where Tretyakov had involved him in various montage workshops with Red Army officers and peasants on collective farms. Benjamin was to describe such projects as a 'melting-down process' between professional knowledge and the everyday.[50] The conventional separation of genres, and of author and reader/spectator, is rendered unstable. In Germany Heartfield's commitment to this melting-down process was obviously very different from how he had experienced it in Russia. An allegiance to the ideals of productivism was heavily circumscribed by the *oppositional* status of his practice; working under fascism, and in the face of a labour movement whose cultural thinking was largely positivistic, Heartfield's photography had

of necessity to be counter-hegemonic. That is to say it had to contest definitions of the 'everyday' as they were constructed by the fascist state and mass media and a supine social democratic-led labour movement. It was this model of 'semiotic insurgency' that radically extended the proactive relationship between montage, photography and the everyday during this period. Faced with an aggressive and expansive mass media in Germany and elsewhere in Western Europe, artists on the left using photography or film began to define themselves as both part of, and as critics of, these changed technological circumstances. In this respect Heartfield was one of the first artists to appropriate the methods and rhetorics of the mass media, at the same time as critiquing its conflation of temporality with truth. Heartfield saw himself first and foremost as a press-worker, responding in ideologically specific ways to the propaganda of the Nazis and the consolations of the social democrats.[51] Questions of the 'everyday', then, could not be separated from how rulers ruled and how modern communications contributed to and established these processes. The formation of *AIZ* (*Arbeiter Illustrierte Zeitung*) in 1924 by Willi Munzenberg was an attempt by a culturally progressive section of the communist movement to confront these new cultural conditions on the labour movement's own ground. The left, it was argued, could not abstain from the public struggle over cultural values (by thinking it could get by on sentimental appeals to class identity alone), but had to actively intervene in the construction of class identity in response to the unfolding of events.

When Heartfield was recruited to *AIZ* in 1930, a section of the cultural left in Germany realised that a war of ideas on the terrain of mass culture was now a pressing requirement in the face of the rise of the Nazis. To publish anti-fascist photomontages in the mass-circulation *AIZ* was to build and sustain on an everyday basis forms of anti-fascist identification. It has become commonplace, though, to say that Heartfield's photomontages and *AIZ*'s activity, for all their interventionist rhetoric, did not prevent the rise of Nazism and therefore the model of semiotic insurgency they espoused was deeply flawed. Such an argument in broad outline may be true, but it fails to register how such efforts contributed to a contested culture of the everyday. Heartfield and *AIZ* did not assume their work could *prevent* the rise of fascism. What they hoped for was that their work would create amongst workers a sense that the working class was in a position to determine the direction of the political process. Questions of photography and the transformation of the everyday were only functionally meaningful as part of a self-conscious revolutionary working-class movement. Without this the political claims of photography were simply empty. This is why Heartfield, despite the formal and social radicality of his art, was so laboriously loyal to the twists and turns of Communist Party policy through the late 1920s and 1930s.[52] He saw himself above all else as an artist of the Communist Party, and therefore saw no contradiction between his own supposed autonomy as an 'avant-garde' artist and the demands of Communist Party membership.

By the late 1930s, the productivist ideal in either its collectivist pedagogic form in Russia or its semiotic insurgent form in Germany was largely dead. Heartfield was in exile in Czechoslovakia and Stalin's consolidation of power had destroyed or innoculated what was left of the old left-avant-garde. Nevertheless, an interventionist, cognitive model of photography and the everyday still flourished within the European avant-garde through the politics of montage. Montage and a defence of the multiperspectival against naturalism continued to be a source of significant work in the area of photography, as in the case of surrealism. From the early 1920s montage in Europe came to be part of a

shared technological culture in which the aesthetic effects of simultaneity, superimposition and fragmentation were held to approximate or replicate the day-to-day experiences of modernity. However, as we have seen in the writings of Eisenstein and Vertov and in the impact of the Russian Revolution generally, debates on montage became extended far beyond simple notions of the interiorisation of technological rationalisation in the spectator. Montage was seen as a mimetic expression of the processes of creativity and psychic life itself, or as a means of bringing hidden structures and relations into discursive view. As such, what montage focused upon as a dialectical principle was the relationship between representation and 'truth'. In its various interpretations montage was held to recover *more* of the world, or rather was far more capable of 'capturing' the multiperspectival complexities of reality. As a principle of interruption and connection montage embraced the structured and differentiated nature of the real. In this respect Annette Michelson talks vividly about the 'epistemological euphoria'[53] of the early Soviet avant-garde. Consequently, central to much of the debate on montage during this period was the wider dialectical debate on the relationship between part and whole, fragment and totality. All the major writers on montage and photography, montage and film, take this relationship as constitutive of what makes montage philosophically significant. As a method of cojoining and disjoining symbolic elements, of the asymmetrical disruption of the symmetrical, montage's break with the conventional unities of time and space allows art to claim a verisimilitude of the synecdochal, of part *for* the whole, as well as a verisimilitude of the discontinuous, the accumulation of disparate parts into wholes which imply the unfinished/expansive/transitive nature of reality. Effectively, this is what we mean by montage's expansion of the hermeneutic movement of photography and film. To cojoin and disjoin disparate indexical elements is essentially to traverse time and space in new ways. The inertial drag of the discrete naturalistic photograph or filmic linear narrative is decisively broken down in the interests of asynchronic patterns of meaning. Montage, therefore, sees the solution to the crisis of naturalism through the novel spatialising capacities of photography and film; past and present, near and far, living and dead can be brought into instructive proximity. Thus, what montage embarked upon as a reworking of the debate on 'truth', representation and the everyday was the *reconquest* of time and space. For example, through the accumulation of images taken of one thing at different times, or of many – spatially distant – things at the same time, it was argued that a new sense of the connectivity between things flowed from the artwork. This is very much the kind of thinking that stands behind Eisenstein's obsession with film as a dialectically 'balanced' totality, and Vertov's concern with a cinema that would unify proletarian consciousness across temporal boundaries.

This is also the case with Rodchenko and Klutsis. When Rodchenko and Klutsis talk about their photomontage as contributing to the socialist reconstruction of the Soviet Union they take the disjunctive time/space effects of montage as the most adequate and historically specific means of achieving this. Like Vertov in particular, Rodchenko saw this demand as being grounded in the need to replicate the unfolding *transformation* of reality. 'One should shoot the subject from several different points and in varying positions in different photographs, as if encompassing it.'[54] The multiperspectival becomes associated with the 'greater' truth of the object, insofar as it comes to situate the object within the dynamic flow of the world that produced it. Although a critic of the epistemological inflation of the cognitive model, Tretyakov was of a similar mind to

Rodchenko on the multiperspectival possibilities of montage. The multiperspectival for Tretyakov established the 'biography of an object'.[55] Thus, of crucial importance for both Tretyakov and Rodchenko was a view of montage that extended beyond the containment of cojoined/superimposed images within a single frame. In fact the debate on photography looked to film for its aesthetic criteria. For Tretyakov it was imperative, if the multiperspectival 'biography of the object' was to be sustained, that photography embrace the filmic qualities of sequencing, what he called the 'systematic analytic sequence'.[56] These sequences would show 'not the individual human being who passes through the system of objects, but the object which passes through the system of human beings'.[57] A photography of systematic analytic sequence, then, aspires to a dialectic of object and subject. Human relations are shown in all their structured relations. Now, as explained, this argument clearly had different *ideological* implications for Tretyakov by the late 1920s. The systematic analytic sequence was the means by which the 'concrete problems' of the everyday were opened up to scrutiny, making his view of the multiperspectival not so much oppositional as anti-statist. On the other hand, for Rodchenko the systematic analytic sequence was simply a means of extending perceptions of the social totality. Producing a compendium of shots in sequence was very much like his de-familiarisation of the object through the use of an unexpected angle, a means of expanding and collating our experience of the everyday. For example, from 1928 Rodchenko used the multiperspectival sequence technique to examine the everyday activities of the offices of TASS, a car factory and a radio tower. What Rodchenko was creating here was a new form of the social patriotic documentary photo-essay. And it was perhaps this form, more than others, that was to have the biggest influence on the construction of the category 'documentary' outside the Soviet Union: the photo-essay as celebration of proletarian consciousness.

Despite the alignment, then, of what remained active of the avant-garde with forms of social patriotism, the adequate representation of the everyday was linked to the multiperspectival. The complex interactions of human beings and social processes were seen as best reported through the discontinuous and accretive effects of montage. There developed what might be called a 'truth' of the discontinuous and disjoined. How this 'truth' was incorporated ideologically into various photographic and filmic practices was what divided the likes of Tretyakov from Rodchenko, Eisenstein from Vertov, and as such what marked out the ideological tensions between the avant-garde and the party. That Rodchenko, Eisenstein and Vertov were all good Stalinists, then, determined that the ideologically disruptive or interruptive functions of montage would be subject, in the end, to the suasions of organicism. That is, the aesthetic unities all these artists constructed took their departure from a faith in the rationalisation and equilibrium of the Soviet system.

It was inevitable, therefore, that the critique of such premature unities should come from the anti-Stalinist wing of the avant-garde in Europe, in particular Walter Benjamin. Although working out of a similar cultural milieu to the Russian productivists, Benjamin dissolved an art of the everyday and a politics of montage into the *anti*-historicist. Eisenstein's, Vertov's and Rodchenko's commitment to montage was based on a Stalinised view of history as an unfolding, unilinear process, of which the Soviet system was seen as the vanguard. Under Soviet reconstruction class struggle was thus held to be resolved; and therefore the relationship between class subjectivity, the party and everyday consciousness was judged to be in a state of non-antagonism. This does not mean that

the party did not perceive social conflicts as arising, but that the removal of the fundamental contradictions of bourgeois society (capital/waged-labour relations; division of society into two major contending classes) meant that such contradictions were no longer seen as blocks on the historical process. For Benjamin this claim to progress seemed increasingly irrealisable as the forced industrialisation of Russia drove down living conditions and increased the exploitation of workers. Moreover, as the everyday became subject to the stern logic of the non-antagonistic, art became detached from the unassimilable, excessive, unscripted aspects of the everyday. Benjamin's 'Theses on the Philosophy of History' (1940)[58] is very much a response to these conditions of stasis and retreat in Russia, and under fascism, with its image of the everyday as the state sanctification of myth. The emptiness of 'now-time', then, becomes the point out of which the everyday and the future might be refigured; to talk of the future involves more than what *carries* us forward to the next moment, but what *recalls* us to the future through the gateway of the present as the latent point of revolutionary rupture. This is the only realistic sense of futurity for revolutionaries, given that both fascism and Stalinism have driven a wedge between historical development and human emancipation. The dynamic of history is now inescapably entwined with mourning as much as struggle, or rather with mourning and remembrance as a constitutive part of struggle, because without the recognition of the discontinuity between the present and progress there can never be any sense that the passage from present of emancipated future has to be struggled *for*.

Benjamin's opposition to Stalinism was fed by a profound crisis of the everyday as historically 'present' or actual. This is why we can best describe his work on the philosophy of history as the point where Marxism began to temporalise the experience of the working class. The historical or historicist crisis into which the working class was thrown by fascism and Stalinism meant that what was supposedly given in its own identity was no teleological guarantee of the victory of socialism; history is the experience of retreat, and moreover the experience of the loss of memory of the reality of such a retreat, as much as material advance. To recover the space of history as a non-chronological temporal experience means divesting history of the notion that it is something in which events simply occur. Change is not what happens to things, it is a part of what things are, which means for historical materialism the continual interrupting or rupturing of the homogeneous time of historicism.

For Benjamin this sense of homogeneous time is a definable historical experience of modernity, something that has its origins in the development of technology and mass consumerism at the end of the nineteenth and beginning of the twentieth centuries. The impact of new technology on labour, warfare and culture gave rise to a new temporal structure of experience in which the moment of the commodity (its constant turnover) transformed the recent past into the antiquated past; the modern and the new become coterminous. The result is that historical experience is forever marked off from the present and the future as *that which is no longer*. The commodity form, then, is the motive force by which historicism secures its logic: things change, insofar as things disappear. In calling for a redemptive historiography Benjamin argues for the necessary politicisation of historical consciousness. For without uncovering the present as discontinuous with progress and therefore the actual with the real (the assertion of the causal efficacy of the past and its contradictions on the contradictions of the present), history is rendered both unknowable and unrecoverable. The impact of the avant-garde

culture of the 1920s, then, was central to his philosophy of history. The success of surrealism, and the productivism of Tretyakov and Arvatov as practices which destabilised the everyday, allowed Benjamin to think historical experience from within a non-historicist space. The influence of Jewish Messianism on Benjamin has of course been well documented as being of equal importance to his theory of history. This is not to be denied. However, what surrealism and productivism provided (though productivism and Benjamin's reading of Trotsky tend to get left out of the picture for obvious political reasons)[59] was a cultural experience of the discontinuous and multiperspectival, in which the everyday was seen to hold or hide various critical potentialities or interpretative possibilities. Armed with a revolutionary redemptive consciousness, the everyday *lost* its everydayness, thereby figuring its own historicity and thus its potential for suggestive reading and recontextualisation. This is what he saw of strength in montage and what he called the dialectical image: the interruption of the received context in which an object is inserted in order to temporalise its identity. *Photo*montage and film then allowed this to an unprecedented extent. Because they are essentially historical mediums, because they concretise the moment into the *image* of history, they provide the most powerfully spectacular means of opening up the experience of historicism. As the world historical photographic archive grows with the reign of the commodity, the potential for dialectical imagery grows.

According to Susan Buck-Morss, Benjamin's dialectical method is based on the idea of a force-field filled with a constellation of axial co-ordinates in which continuities are dispelled by discontinuities and discontinuities dispelled by continuities.[60] This implies more than the simple disruption of the self-identity of the present and the past. Recovering the past in the name of an non-emancipated present means recovering the past as part of a redemptive whole. As Buck-Morss says, 'The traces left by the object's after-history, the condition of its decay and the manner of its cultural transmission, the utopian images of past objects can be read in the present as truth.'[61] That is, they can be read metonymically as symptoms or failed moments of transcendence of a non-redeemed historical process as a whole. One of historical materialism's crucial tasks for Benjamin therefore – which sets Benjamin off very sharply in the 1930s from the idea of the everyday as being built in the name of socialism – is interpretation as a political act. In conditions of mourning, politics involves an elaborate process of hermeneutic retrieval, insofar as interpretation *names* the hidden or lost emancipatory potential of the past as a reflection on the failure of human emancipation to be achieved in the present.

Consequently, for Benjamin, a commitment to montage becomes a commitment to resisting the reifying constraints of linear system-building. Montage enacts the heterogeneous as the critique of premature synthesis; hence the very different understanding of totality and aesthetics in Benjamin in comparison to that of Vertov and Eisenstein. Given the positivistic status of the totality itself – its current historical identity with unfreedom – the totality of social experience cannot be represented through the metonymic accretion of symbols (Rodchenko's multiperspectivalism). It can only be represented metonymically as an absence, that is, through the discontinuous linking of symbols as evidence of the impossibility of the positivistic representation of the totality as such. Thus, at no point is Benjamin's montage method connected to any straightforward anti-bourgeois narrative. As Buck-Morss argues, 'if bourgeois history writing is to be overturned, then it is not a question of replacing it with a Marxist narrative. Rather the goal is to bring to consciousness those repressed elements of the

past.'[62] Benjamin's montage, in contrast to the synthesising schema of bourgeois aesthetics and Stalinised Modernism, allows the marginal, remaindered and discreet to speak back from the past in all their significant insignificance, opening the past and *its* futures to the possible futures of the present.

This debate on history, the everyday and aesthetics in many respects has its origins in a major work of historiography and philosophy written in 1922, Georg Lukács's *History and Class Consciousness*.[63] Although Lukács does not address questions of aesthetics in the book, and departs from Benjamin on important issues, to understand its influence is to understand the widespread concern in the 1920s and 1930s with the relationship between aesthetics and social agency. Both Lukács and Benjamin were dismissive of the technological determinism and crude causal Marxism of the 2nd International. The fetishisation of modern temporality in social democracy (and later Stalinism) created a view of history in which alienation and class conflict were held to be resolvable through technocratic processes. Lukács and Benjamin saw this as a retreat from politics and therefore a retreat from the contradictions of the everyday. As such both authors, despite their differences, could be said to be involved in a reclamation of the everyday *for* Marxism in response to the initial success of the Russian Revolution, a revolution that blew apart the gradualist theses of the European social democratic labour movement. Consequently, they were also reacting against the philosophical underpinnings of evolutionism in Hegelian-Marxist orthodoxy. In Hegelian Marxism and its variants, individuals are treated not as effective social agents, but as *predicates* of the 'world historical process'. Lukács and Benjamin then reinstate the intensional and agentive subject.

However, it is here their interventions diverge. For although Lukács reclaims Marxism as a theory of the self-emancipation of the working class, his theoretical model is deeply idealistic. Influenced by Weber's theory of the iron cage of capitalist rationality, Lukács sees alienation as an inevitable consequence of modern civilisation, leading to the reification of all consciousness. This makes the self-emancipation of the proletariat difficult to hold on to in any practical sense. Hence Lukács tends to adopt a millenarian notion of social agency, in which the contradictions of capitalism will eventually force the proletariat to take a leap into the future. He counterposes total reification with a utopian full class-consciousness. Any mediation between these worlds is closed off, reducing the place of the 'everyday' in his writing to the status of an abstraction, a void waiting to be filled.[64]

It is this contradiction which eventually leads Lukács to fetishise the party. Because the working class cannot achieve full subjectivity, the party is assigned a model pedagogic role as the means by which it can establish a purchase on reality. The result, naturally, is a bureaucratically inflected account of politics and culture. Because the working class is always alienated, the party has to stand in, in its good name, for its interests. It is no wonder, therefore, that Lukács responded so favourably to the organicist aesthetics of the high bourgeois novel, insofar as its narrative and 'totalising' space could be invested with the imaginative voices of 'full class-consciousness', and thus provide a literature of instruction for the party. In effect Lukács rewrites Lenin's hierarchisation of literature as an embodied space of identification between the inert or latent class-consciousness of the reader and the ideal class-consciousness of the novel's hero. Benjamin, on the other hand, believed such forms of identification were aesthetically premature, generating the conditions for artists' reconciliation with reality *in the name* of the working class.

Benjamin's advocacy of photography and critical journalism, then, becomes the basis for a disjunctive entry into the everyday. Disposed towards the contingent moment, they undermine the separation between 'art' and information or the extra-artistic and therefore weaken the trained aestheticism demanded of the spectator by high art. For Benjamin this aestheticism is always a transcendental move: the experience of art and the experience of the everyday are disconnected in the pursuit of abstract spiritual enlightenment. Lukács's voices of 'full class-consciousness' are the heirs to this bourgeois spirituality. In Benjamin's defence of photography the representation of social agency is not grounded in the transcendence of reified objects and relations, but in the uneasy passage through them. Hence the discontinuities and aporias of the capitalist everyday are not just the ideological materials out of which a critical art practice might be made, but the real space of contradictions in which class-consciousness finds itself. Thus, the representation of the everyday as a montage of disjunctive elements provides a stronger grasp on the fractured contours of class agency than a position which takes up a pre-given (idealised) mastery over them.

Essentially, this debate was about how relations internal to the artwork and the interrelations between the artwork and everyday consciousness might be figured. Benjamin's critical model, unlike Eisenstein's, Vertov's and Rodchenko's, moved the language of dialectics and the image out of the realm of the natural sciences. Most of the debate in the Soviet Union on the everyday and the new technology in the 1920s was couched explicitly or implicitly in terms borrowed from the natural sciences. Engels's, Lev Vygotsky's and Vladimir Vernadsky's organicism provided the models for a psychologically transformative account of the artwork. This was because after the revolution the artwork began to be conceived in avant-garde circles as a *living entity*, as something that is both in transition hermeneutically, and is part of, and permeated by, living social relations. The concepts and metaphors of natural science figured a new sense of the dynamic interaction between the artwork and the 'everyday'. That this became identifiable with Stalinist dialectics (particularly in Eisenstein), and eventually a certain kind of aesthetic closure, did not alter the fact that montage was seen as an 'energy principle'. This was reflected in the interfusion between the visual, linguistic and psychological under the heading of the dialogic. In productivism and constructivism, in Eisenstein and Vertov, montage is construed as a dialogue with 'others' as part of a wider dialogue within the working class and the workers' movement as a whole, the net effect being a continually growing connectivity of consciousness. Montage by dint of its emphasis on cognitive interaction addresses the spectator *conversationally*.

Dialogism, though, does not imply holism. Benjamin steps outside these tendencies to identify dialogism with mourning and redemption, providing in the process an extension of the conversation between the workers' movement and the oppressed to the 'everyday that is no longer'. For Benjamin dialogism is crucially a matter of connection with historical loss and incompleteness. The theorist who came closest to this position in the Soviet Union in the 1920s was Bakhtin, although he hardly published anything during this period, and participated only fitfully in the cultural revolution giving the occasional lecture and contributing to a few public debates. Bakhtin's dialogism was influenced by the natural sciences (language continued the organic life of the artwork beyond the isolated moment of its initial reception), but this interpretive relationship between the self, the work and others was always an unfinished process, i.e. it was not confined to the hermeneutic dictates of party and state. Furthermore, the revolution's commitment to

cultural intervention *into* the everyday disconnected present memory from historical memory. This Benjaminian link between interpretation and mourning is vividly described in a report a Bolshevik journalist wrote on one of Bakhtin's contributions to a public debate on 'God and Socialism' in May 1919 – the only extant evidence of Bakhtin's cultural work from this period: 'At certain points in his discourse, he recognized and valued socialism, but only to cry and worry that socialism shows no concern at all for the dead.'[65]

Bakhtin was later to propose a living energy to events in consciousness (the self can only have a consciousness of itself through the other), thus generating a space for the incorporation of consciousnesses past into the critical dialogues of the present.[66] As perhaps is evident from this, nothing is subject to loss in Bakhtin's model, everything potentially recoverable is able to take part in an endless, transmuting universal discourse. In Bakhtin, a non-holistic Russian organicism meets the philosophy of consciousness: what disrupts the self-identity of consciousness is not an external 'real' but another consciousness. As such, Bakhtin's deconstruction of the Saussurian opposition between history and structure actually weakens the determining effects of structure. Bakhtin's dialogism becomes a theory of *parole* rather than *langue*, inflating the popular forms of everyday language and culture into a creative oppositional force separate from the constraining or coercive power of institutions.[67] Unlike Benjamin, Bakhtin identifies historical transformation *with* discursive struggle, as if the critique of everyday life was an open space of mutually contending communities. This may have been understandable in the face of Stalinist reaction in the 1930s, when the recovery of individual consciousness was a moral and political priority, but ironically it collapses a critique of the everyday into romantic opposition. The material efficacies of *byt* are transcended through the freedoms of the intersubjective.

As is evident from these opening pages, in the wake of the Russian Revolution the concept of the 'everyday' underwent a massive philosophic, political and aesthetic transformation. Between 1917 and 1934–35 the term was 'filled out' with an unprecedented complexity and dynamism. To recap, we can distinguish four major areas to this: (1) social agency (the re-hierarchisation of the representation of the everyday: the bringing into representation of the collective power of the working class); (2) new consciousness of time and space (critique of the conflation of the everyday with the actual: redemption of the 'everyday' of historical memory for emancipatory work in the present; extension of the cognitive experience of the everyday to the geo-political); (3) dialogism (art as a form of everyday dialogue with the 'other': production of photography/art in collaboration with non-professional groups, as in productivism; photography/art as a dialectical moment in the transformation of reality); (4) ideological intervention (confrontation with the everyday through ideological deconstruction: photography as a counter-hegemonic theory of interruption; photography as an analytic 'research programme' into the problems of everyday life).

In short, the 'everyday' was where the world was to be remade, and photography and film were to play an important part in this. The crisis of this culture, of course, is the history of our recent modernity. If a good deal of this revolutionary culture had an international impact by the mid-1920s, by the mid-1930s what remained was a vague commitment to a proletarian dialogic. Stalinist oppression and the rise of fascism sundered the workers' movement from its own radical cultural legacy. Yet it was out of this complex legacy that photographic culture in the 1930s in Europe and in the post-war

world produced its ideological materials. Although many of the debates on the everyday were lost (Benjamin's and Bakhtin's writings of the 1930s of course were not widely known until the 1970s), disavowed, suppressed or materially impossible to engage with, many of the ideals and values of this culture continued to exert a causal pull on photography during this period.

Thus, if I have so far concentrated on interventionist notions of the 'everyday' and photography, I now want to look at the culture of the everyday which both overlapped and ran parallel with Soviet revolutionary culture: documentary practice. The construction of the 'everyday' through the construction of the category 'documentary' is naturally very different from the defence of the factographic moment in Eisenstein, Vertov, Rodchenko *et al.*, even if at times these film-makers and photographers lay claim to being documentary recorders of their culture. Documentary practice outside Russia was essentially a response to the *absence* of revolutionary transformation. But, nevertheless, to understand its popular and political appeal it is impossible to ignore the prestige of Soviet revolutionary culture.

Notes

1 See T. J. Clark, *The Painting of Modern Life: Paris in the Art of Manet and his Followers*, Thames and Hudson 1984.

2 For a discussion of *honnêteté* see Thomas Crow, *Painters and Public Life in Eighteenth-Century Paris*, Yale 1985.

3 Sigmund Freud, *The Psychopathology of Everyday Life*, Comet 1958, p. 11.

4 Ibid., p. 145.

5 Ibid., p. 89.

6 Leon Trotsky, *Problems of Everyday Life: and Other Writings on Culture and Science*, Monad Press 1973.

7 Letter to Lili Brik, 12 April 1930, quoted in Ann and Samuel Charters, *The Story of Vladimir Mayakovsky and Lili Brik*, André Deutsch 1979, p. 351.

8 Quoted in Brandon Taylor, *Art and Literature under the Bolsheviks: Volume 1, The Crisis of Renewal 1917–1924*, Pluto Press 1991, p. 43.

9 See V.I. Lenin, *On Literature and Art*, Progress Publishers 1967.

10 Lenin, quoted in Taylor, *Art and Literature*, p. 83.

11 See Taylor, *Art and Literature*.

12 Boris Arvatov, *Kunst und Produktion*, Carl Hanser Verlag Munich 1972.

13 *Ibid.*, p. 11.

14 *Ibid.*, p. 12.

15 *Ibid.*, p. 13.

16 *Ibid.*, p. 18.

17 Lenin, quoted in Marcel Liebman, *Leninism under Lenin*, Merlin 1980, p. 336.

18 Arvatov, *Kunst und Produktion*, p. 27.

19 Quoted in Taylor, *Art and Literature*, p. 153.

20 *Ibid.*, p. 163.

21 *Ibid.*, p. 167.

22 Lenin, quoted in Liebman, *Leninism under Lenin*, p. 328.

23 Arvatov, *Kunst und Produktion*, p. 34.

24 *Ibid.*

25 Christine Lodder, *Russian Constructivism*, Yale 1983, p. 181.

26 Alexander Rodchenko, 'The Paths of Modern Photography', *Novyi Lef* 9, quoted in Christine Lodder, *Russian Constructivism*, p. 202.

27 Arvatov, *Kunst und Produktion*, p. 48.

28 Peter Wollen, 'Modern Times: Cinema/Americanism/The Robot', in *Raiding the Icebox:*

Reflections on Twentieth-Century Culture, Verso 1993.

29 Walter Benjamin, *Illuminations*, Fontana 1973.

30 Sergei Eisenstein, 'On the Problem of the Materialist Approach to Form' (1925), in Richard Taylor (ed.), *S. M. Eisenstein: Selected Works*, BFI 1988.

31 Sergei Eisenstein, 'Montage in 1938', quoted in Jacques Aumont, *Montage Eisenstein*, Indiana University Press 1987, p. 173.

32 Sergei Eisenstein, *The Film Sense*, Faber and Faber 1943, p. 26.

33 *Ibid.*, pp. 34–5.

34 *Ibid.*, p. 57.

35 Eisenstein, quoted in Aumont, *Montage Eisenstein*, p. 52.

36 Frederick Engels, *The Dialectics of Nature*, Marx-Engels Archive, Moscow 1927; English translation, Lawrence & Wishart 1977.

37 Dziga Vertov, *Kino-Eye: The Writings of Dziga Vertov*, edited and introduced by Annette Michelson, Pluto 1984, p. 52.

38 *Ibid.*, p. 91.

39 *Ibid.*, p. 88.

40 *Ibid.*, p. 20.

41 Gustav Klutsis, 'Photomontage', *LEF* 4 (1924), reprinted in Christopher Phillips (ed.) *Photography in the Modern Era: European Documents and Critical Writings, 1913–1940*, The Metropolitan Museum of Art/Aperture 1989, p. 211.

42 Alexander Rodchenko, 'Downright Ignorance or a Mean Trick?', *Novyi Lef* 6 (1928), reprinted in Phillips (ed.), *Photography in the Modern Era*, p. 247. See also *Alexander Rodtschenko Fotografen 1920–1938*, Wienand 1978.

43 Boris Kushner, 'Fulfilling a Request', *Novyi Lef* 11 (1928), reprinted in Phillips (ed.), *Photography in the Modern Eva*, p. 268.

44 Alexander Rodchenko, 'A Caution', *Novyi Lef* 11 (1928), reprinted in Phillips (ed.), *Photography in the Modern Era*, p. 268.

45 *Ibid.*, p. 264.

46 Sergei Tretyakov, 'From the Editor', *Novyi Lef* 11 (1928), reprinted in Phillips (ed.), *Photography in the Modern Era*, p. 271.

47 *Ibid.*

48 Anonymous Programme of the October Photo Section, Moscow/Leningrad 1931, reprinted in Phillips (ed.), *Photography in the Modern Era*, p. 285.

49 Walter Benjamin, 'The Author as Producer', in Victor Burgin (ed.), *Thinking Photography*, Macmillan 1982.

50 *Ibid.*, p. 25.

51 See David Evans, *John Heartfield: AIZ/V1 1930–38*, Kent Fine Art 1992. See also *Montage Als Kunstprinzip*, Internationales Colloquium, VG Bild-Kunst Bonn 1991.

52 See Evans, *John Heartfield*.

53 Annette Michelson, 'The Wings of Hypothesis: On Montage and the Theory of the Interval', in Matthew Feitelbaum (ed.), *Montage and Modern Life 1919–42*, MIT/ICA 1992, p. 62.

54 Alexander Rodchenko 'The Paths of Modern Photography', *Novyi Lef* 9 (1928), reprinted in Phillips (ed.), *Photography in the Modern Era*, p. 261.

55 Sergei Tretyakov, quote in David Elliot (ed.), *Alexander Rodchenko*, Museum of Modern Art Oxford 1979, p. 111.

56 Sergei Tretyakov, 'From the Photoseries to the Long-Term Photographic Observation', *Prolatarskoje* 4 (1931), quoted in Benjamin H. D. Buchloh, 'From Faktura to Factography', in *October: The First Decade, 1976–1986*, MIT 1987, p. 102.

57 Tretyakov, quoted in Elliot, *Alexander Rodchenko*, p. 111.

58 Benjamin, *Illuminations*.

59 For a discussion of Benjamin's concept of history that overplays his debt to surrealism, see Peter Osborne 'Small-scale Victories, Large-scale Defeats: Walter Benjamin's Politics of Time', in Andrew Benjamin and Peter Osborne (eds), *Walter Benjamin's Philosophy: Destruction and Experience*, Routledge 1994.

60 Susan Buck-Morss, *The Dialectics of Seeing: Walter Benjamin and the Arcade Project*, MIT 1989.

61 *Ibid.*, p. 219.

62 *Ibid.*, p. 338.

63 Georg Lukács, *History and Class Consciousness: Studies in Marxist Dialectics*, Merlin 1971.

64 See Andy Wilson, 'Lukács and Revolution', unpublished 1993. Lukács's 'agentive subject' is neither the individual nor the working class but the party.

65 Quoted in Sergey Bocharov, 'Conversations with Bakhtin', *Journal of the Modern Languages Association* (1994), p. 1021.

66 Mikhail Bakhtin, *Art and Answerability*, University of Texas Press 1990.

67 See Ken Hirschkop, 'Bakhtin, Discourse and Democracy', *New Left Review* 160 (1986).

2

Technique, technology and the everyday: German photographic culture in the 1920s and 1930s

In Western Europe from the early 1920s the new industrialisation and urbanisation produced a photography that saw itself self-confidently as part of a new technocratic culture. This was particularly the case in Germany during the Weimar years (1919–33), which was the leading centre of photographic activity outside the Soviet Union. It was against the technological impact of this culture that Benjamin honed his arguments on photography in the late 1920s and 1930s. As such, German photographic culture provided a highly vivid snapshot of the coming together, and conflict, of the respective claims of the factographic and Modernist. For in the absence in Europe after the mid-1920s of the possibility of revolutionary transformation, the strength of this emergent technocratic culture was able to exert a far-reaching influence on definitions of the everyday. That Heartfield, Höch, Berlin Dada and Brecht resisted such technocratic overtures does not alter the fact that, paradoxically, under the technological impact of the Russian Revolution on art, German photographic culture was able to present technology as an emancipatory force. That is to say, propelled by the advances of revolutionary Soviet culture many German photographers looked to technological change as embodying the promise of cultural change.

The 1920 'Deutsche Fotografische Austellung' in Stuttgart is commonly regarded as a turning point in Germanic photographic history.[1] Since the 1909 national photography show in Dresden – Dresden at the time was the centre of the German photography industry – German photography had been dominated by the interests of trade and commerce. The 1920 Stuttgart show changed this, opening up the culture to the new realist ideals of the New Objectivity photographers (Albert Renger-Patzsch, August Sander, Karl Blossfeldt). This development was consolidated in the 'Deutsche Fotografische Austellung' in Frankfurt in 1926, an exhibition unprecedented in its ambition. It took into account not only the demands of trade and industry, but also amateur photography, scientific photography (highlighted in this section was aerial photography), 'art' photography and 'documentary', which had come into use in Germany around this time as a distinct conceptual category. The exhibition, in fact, was

the first public assessment of reportorial practices since the First World War. The new industrial categories of the everyday valorised by Soviet photography (the city, labour, machinery) were accredited as having produced a new urban 'realism'. By the late 1920s this expansion of the categories of reportage became the *raison d'être* of a number of shows and publications which made overt connection between this new urban content and the new photographic technologies (portable cameras, better film stock). Technological change was linked in a positivistic fashion to the new realism or New Objectivity. Furthermore, as the Weimar Republic underwent a cultural renaissance, this was linked to the construction of a new democratic public sphere in which photography was held to be in a privileged position to reflect back the conditions of European modernity.

It is worth noting the extent of this technological change. The first camera to break with the traditional box camera was the *Ermanox* made by Ernamann in Dresden in 1924. It had a direct finder and a shutter that permitted $^1/_{20}$ to $^1/_{1000}$ speed range. The *Leica*, designed by the Leitz company engineer Oskar Barnack, appeared in 1925. It used 35mm film which allowed up to fifty exposures and had precise anastigmatic lenses. Those who favoured the *Ermanox* soon changed to the *Leica*. In 1931 Osram also produced the first flash bulbs lit by a portable electric battery.

These changes led to a profound transformation in the institution of photojournalism and the cognitive possibilities of the reportorial, as street photography and the 'close-up' became easier options and significant sources of visual experience in their own right. With this the new technology's extended powers of observance provided a renewed sense of the categories of the everyday as *lost to vision*. The contingent world of everyday objects and events was opened up in all its finely gradated and unexpected detail. However, this is not to argue that the new technology somehow *caused* the New Objectivity. The new cameras and film stock only came into common use in the early 1930s. Most photographers were still using large or medium cameras on tripods. What the new technology established was a continuing sense of the cognitive possibilities of photography which had been accumulating since the weakening of the influence of pictorialism at the beginning of the century. Thus when Carl Georg Heise declared in 1928 in his preface to Renger-Patzsch's *Die Welt ist Schön* that 'a revolution in aesthetic perception'[2] has occured, 'the camera is capable of perceiving certain natural objects more clearly than the eye',[3] he was not referring to the influence of the *Leica* but to the modern legacy of camera technology as such.

These three themes – revolution in perception, increased realism, new conceptions of the everyday – were all, of course, no strangers to Soviet photography. In New Objectivity, however, they were allied to a concept of aesthetic transformation that was still very much rooted in traditional naturalistic observances. The new photography's extension of the categories of the everyday allowed photography to draw the *whole of the visual world* into the orbit of aesthetic value without loss of vividness on the part of the photography – in short, nothing was too mundane, undistinguished or unpleasurable for aesthetic appropriation. 'Industrial photographs clearly show that it is possible to regard a machine or an industrialised plant as no less beautiful than nature or a work of art.'[4] Heise, here, may have been driven by a desire to capture photography for some Hegelian world 'aesthetic spirit', but his views were fairly widespread amongst the left and liberals during this period. Shows such as 'Neue Wege de Fotografie' organised by Walter Dexel (Jena 1928), the 'Film und Foto' show (Stuttgart 1929), and the 1930

Fig 7 *Flatirons for Shoe Manufacturer*, Albert Renger-Patzsch, *c.*1928 (Collection of the J. Paul Getty Museum, Los Angeles, California)

'Deutsche Fotografische Austellung' in Frankfurt, all formulated the claims of the new aesthetic positivism. A similar perspective was evident in the new photographic literature: Werner Graff's *Er Kommt der neue Fotograf!* (1929), Karl Blossfeldt's *Urformen der Kunst* (1928) (though Blossfeldt's work is somewhat anomalous given that it dates back to 1900; the New Objectivity simply took him under its wings), and of course Renger-Patzsch's *Die Welt ist Schön*. These books and shows set out to establish a new truth-relation between the new photographic technology and the everyday that exceeded both 'art' photography and previous reportorial work. Photography's extended powers of realism were held to have inscribed themselves in the very texture of things, hence the repeated call to photographers to direct their attentions to the intricacies and secrets of nature. Indeed advances in technology were seen to confirm photography as a branch of the empirical sciences. To scrutinise the surface patterning of the social world became equivalent to the study of nature. The sense that models of naturalism could provide photography with a 'scientific' status was clearly what compelled Benjamin to align himself with Soviet productivism. For Benjamin what was progressive about productivism was that the naturalistic moment of the photograph was made subordinate not to the 'truth' of the indexical but to the demands of critical intervention.

Renger-Patzsch, August Sander and the photography writer Hugo Sieter all looked to the new aesthetic positivism to remove the dead wood of 'artistic spirituality' in photography. All embraced the New Objectivity as finally negating the subservience of photography to the hierarchies of art history. Photography was no longer treated as being in debt to painting. As Renger-Patzsch argued in *Das Deutsche Lichtbild* in 1927, the new photography 'offers the opportunity to capture the magic of material things'.[5] This

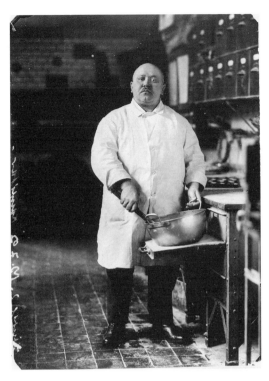

Fig 8 *The Master-Baker Franz Bremer, of Cologne*, August Sander, 1928 (Courtesy of Museum Folkwang, Essen)

anti-illusionism was also endorsed by Sander in his 'Remarks on My Exhibition at the Cologne Art Union' (November 1927): 'Nothing seems better suited than photography to give an absolute faithful historical picture of our time',[6] and in Sieter's 'Absolute Realism: On the Photographs of Albert Renger-Patzsch', photography supplies 'the most precise and objective record of thoroughly familiar things'.[7] This aesthetic positivism largely swept all before it, subsuming much leftist reportage and workers' photography as well, although a minority position did develop around Paul Renner and Walter Peterhans who asserted the need to recognise the 'formal laws' and artistic truths of photography.[8] Significant revision or extension of this model – in the photographic journals and magazines – was confined to the debate on montage, which I have dealt with in Chapter 1. In this chapter I want to concentrate on the dominant positivism via its wider claims on the culture and via its other critics such as Laszlo Moholy-Nagy, who was living and working in Germany in the 1920s, and Weimar women photographers such as Aenne Biermann.

In what has come to be known as the Moholy-Nagy/Renger-Patzsch debate, conducted in the pages of *Das Deutsche Lichtbild* in the late 1920s, Moholy-Nagy attempted to formulate a theory of photography that on the one hand accepted the new photography's novel claims on the 'real', but on the other refused to limit itself to these effects, that is, to photography's conventional pictorial powers. Renger-Patzsch, Sander and others, he said, do not take possession of the 'expressive potential' of photography's 'scientific' claims, they simply re-endorse photography as a *picture*-making exercise.[9]

Moholy-Nagy was to call this non-pictorial potential 'photoplastics', those non-representational resources that were available to photography through photograms,

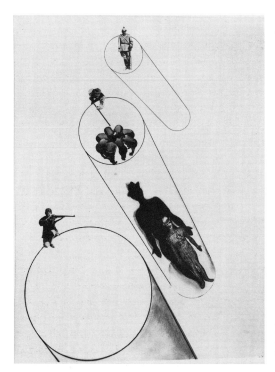

Fig 9 *The Eccentrics III / In the Name of the Law / Psychology of the Masses*, Laszlo Moholy-Nagy, 1927 (Collection of the J. Paul Getty Museum, Los Angeles, California)

microscopic photography, montage, over-exposure, solarisation, etc. Essentially, Moholy and his wife and collaborator Lucia introduced questions of the *performative* into the New Objectivity debate on realism and the everyday: it was the potential kinetic powers of the non-representational that stood to transform perceptions of the everyday, and not the dutiful recording of the contingent. The naturalistic extension of the categories of the 'everyday' was important, but the image was still locked into a realism of appearances. Yet, for Moholy-Nagy, this was not a debate about montage and its ideologically deconstructive powers, although the disruptive effects of montage played a part in his non-naturalistic model. Rather, what preoccupied him and Lucia were transformations of space as possible transformations in consciousness. The perceived dynamism of the non-objective – the subordination of meaning to formal relations in space – foregrounded the mathematical in the real and therefore the ontological relations between things *in* the everyday. To accept this was to acknowledge that the scientific moment of explication in art was not simply representational, but cognitive-practical; geometric or abstract form in photography was seen as articulating the spatial dynamics of industrial culture itself. The new spatial relations and light-conditions of the industrial everyday (seriality, linearity, repetition, artificial luminosity) were performed *in* the photograph.

This position has naturally become identified with the Bauhaus's reading of 'machine aesthetics'. However, although Moholy-Nagy and Lucia Moholy-Nagy worked at the Bauhaus from 1923–38 (in Berlin and Dessau) there was no photographic department at the institute until 1929, when Hannes Meyer took over as director. This had much to do with the fact that photographic education was valued as part of a general visual education and therefore did not warrant specialist teaching. The result was that there was

a great diversity of work produced at the institution (Paul Citreon, Florence Henri, T. Lux Feininger, Herbert Bayer, Hilde Hubbuch, Umbo).[10] Moholy-Nagy and Lucia may have defended a particular non-objective ethos but in no sense did this emerge as a Bauhaus school. In fact the non-institutionalisation of photography at the Bauhaus should be seen as a contribution to the notion of avant-garde photography as a set of research programmes into all aspects of photographic practice. This is certainly something Moholy-Nagy was prepared to endorse in the late 1920s, despite his differences with the New Objectivity. Thus he was quick to *defend* the New Objectivity when its progressive qualities came under attack by conservatives.

In 1929 in response to Hans Windisch's criticism of the New Objectivity as 'optical vivisection'[11] and aesthetically relativistic, he argued for the potentially scientific character of both pictorial and non-pictorial photography. Both sets of practices move our understanding of the visual forward, he claimed, because they disclose the fundamental asymmetry between the photographic camera and the human eye. This is very revealing, because it shows how much the aesthetic positivism of the New Objectivity and Moholy-Nagy's 'photoplastics' actually participated in a shared culture of the cognitive transformation of the everyday. A machine aesthetic offered a place for both the objective and non-objective as long as they claimed to be de-naturalising the connection between human perception and photography. For Moholy-Nagy the close-ups, strange angles and unfamiliar subjects of the New Objectivity did not so much reveal the transparent truth of things but how the truth of the photograph was a constructed process. What was demonstrated in New Objectivity was the very gap between naturalistic perception and the naturalism of the photograph. The powers of definition of the new photography were not a certification of the realism of photography but a means of revealing its artificiality. Yet this was not something most of the practitioners and defenders of aesthetic positivism dwelt on, contributing to that received view – principally through Benjamin – of the New Objectivists as naive realists.

By the mid to late 1930s, after the closure of the Bauhaus by the Nazis and their destruction of independent photographic culture, Moholy-Nagy began like many photographers and writers to distance himself from the scientism of a 'machine aesthetic'. As the Nazis' vast industrial programme put Germany on a war footing, the 'machine aesthetic' was now increasingly perceived as oppressive. Technology as social technique and critique had mutated into a technocracy of fascist propaganda. Living in Amsterdam in 1934 he started talking about photography as *art* again. In a letter written in 1934 to Fra. Kalivoda (published in *Telehor* in 1936), he says:

> We have now reached the stage when it should be possible to discard brush and pigment and to 'paint' by means of light itself. We are ready to replace the old two-dimensional colour patterns by a monumental architecture of light.[12]

By the late 1930s, after accepting the directorship of the New Bauhaus in Chicago, this was developed into an integrated photographic model in which 'art' and technology are fused. Photography no longer provides a cognitive bridge to a new industrial culture but becomes part of a systematic approach to the idea of art/technology as a creative transformation *of* reality. Key to this is his *Vision in Motion* (1947) published a year after his death.[13] In this he extends his earlier critique of representation. In the modern period, he asserts, the construction of the everyday has been constituted through 'fixed' representational perspectives. What is required if art is truly to transform social relations

is the need to embrace a 'new dynamism and kinetic existence freed from the static, fixed frameworks of the past'.[14] Art, science and technology were to be combined in plural ways in non-elitist communities of specialists and non-specialists. By now displaced from the radical culture of the 1920s that produced these aspirations, Moholy-Nagy grounds this 'future world' in a technologically determinist view of history. 'New tools and technologies cause social change.'[15] It is hard to believe in him saying this in the 1920s. As such, we can best describe his later model as the product of a defeated utopianism, and one of the last photography-based models of cultural transformation to be produced out of the ferment of the 1920s and 1930s.

Clearly, Moholy-Nagy's position owes a large debt to productivist and constructivist ideals, albeit de-proletarianised. The self-emancipation of the working class is exchanged for a vanguard of cultural and scientific workers and 'world government'. Nevertheless, his final work represents the point where the positivism of much European photographic culture operating in the wake of, or on the margins of, Russian revolutionary models, is left behind in a grand synthetic gesture. Attacking both orthodox humanist and Stalinised accounts of art and the everyday (one deeply anti-technological, the other crudely instrumental), he sees social emancipation as intimately connected to the power of technology to subvert the specialist division of labour in traditional approaches to art. 'It could translate Utopia into action.'[16] Of course it could not – outside socialist transformation – but it reveals how an expanded conception of art and the everyday continued to exert its imaginative pull even on artists who had left class politics behind. Richard Kostelanetz puts it very well:

> Moholy broke with the orthodox Marxists, on the one hand, over the resistance to both individual artistic integrity and non-representational modern art and with the artistic 'humanists', on the other, over their resistance to technology. As a more organic revolutionary, Moholy favoured radical changes in *both* art and life, and both technology *and* psychology, regarding transformations in each as feeding into the others, so that true political purpose for the artist lay not in portraying social injustice but in creating 'powerful new relationships'.[17]

However, it was the representation of 'social injustice' and a photographic 'sociology of the everyday' that continued to (necessarily) dominate German photography in the 1920s and 1930s. The rise of the Nazis made the prefigurative ideals of Moholy-Nagy something of a luxury. The Nazis' rise to power in fact politicised the reception of the New Objectivity. What had appeared to many, especially Benjamin, as a form of aesthetic relativism, became a source of anti-Nazi sentiment and social non-reconciliation. It was August Sander's work which the Nazis first attacked and destroyed. Admittedly, Benjamin noted the subversive nature of Sander's naturalism;[18] yet what Benjamin did not note in 'The Author as Producer' was how the New Objectivity had passed, under the glare of Nazi national culture, into the world of the disenchanted. New Objectivity's investment in scientific positivism took on the role of the defender of modernity. This is not to overestimate the political effects of the work, or to deny that many of the New Objectivists failed to understand how compatible the aestheticisation of everyday objects is with the demands of commodity culture, but that the would-be relativism of the work was a direct embarrassment to the Nazis' faith in hierarchical and authoritarian cultural values.

It is not easy, therefore, to sideline the New Objectivity into the realms of the conservative, as Moholy-Nagy acknowledged. In many ways its commitment to social and aesthetic inclusiveness provided a bridge in Weimar Germany to a set of democratic Modernist values that the Nazis were intent on destroying. Consequently, for all the New Objectivity's limited conception of the everyday as a contested category or set of categories – its weak sense of the social agency of the photograph – it is important to remember that it participated in a shared, modern, secular photographic culture with its avant-garde and proletarian critics.

During the period of the Weimar Republic Germany had one of the most powerful labour movements in the world. The SPD (Social Democratic Party) in the early 1920s was an openly socialist party, even if by the late 1920s it had purged its ranks of many radicals and made its peace with the German state. The German Communist Party was also one of the strongest in the industrialised West. The conditions, then, were highly conducive to the development of a combative proletarian culture: namely a relatively high level of class-consciousness and organisational strength on the part of the working class and a technically advanced industrial base which had grown steadily since the First World War. After a period of slow industrial growth in the 1830s, in the last quarter of the century (after the New German Reich of 1870) Germany experienced a huge upsurge in economic development, transforming what was largely an artisanal economy into a heavy industrial one. The First World War and the Depression in the 1920s may have weakened the confidence of the labour movement and Germany's industrial competitiveness, but nevertheless the country remained a centre of technical and scientific excellence, particularly in the area of light engineering and the new electrical divisions. For instance, from 1918 Germany had one of the most advanced communication industries in the world. At the end of the 1920s the German film industry produced more films than all other European countries put together. In 1918 there were 2,300 cinemas in Germany, with 800,000 seats, in 1930 there were 5,000 with 2 million seats. By October 1930 900 cinemas (with 600,000 seats) were adapted for sound films. Similarly a national radio network was in place by 1924. By April 1931 radio had an average of 3.7 million listeners.[19]

These details show the development of German photographic culture to be part of a wider process of modernisation. The richness of German reportorial photography and avant-garde culture generally, however, cannot be ascribed solely to advanced conditions of technical excellence. Along with the crisis of the older academic cultures it was the proximity of social revolution – in short the Russian Revolution – that underpinned the development of German photography.[20] Soviet models and perceived Soviet dynamism became the motor and measure of so much visual work during this period. In this way, New Objectivity fed into a whole range of expectations about what the new technology might do as part of the social reconstruction of reality. As in the Soviet Union a cult of the 'factual' grew up around photographic practices as the basis for the *de-academicisation* of the everyday.

The function of the 'factual' as a set of anti-aesthetic tropes is a constitutive component of the modern and Modernist experience. From Manet onwards the anti-aesthetic (the awkward, the ungainly, the ugly, the unassimilable) has been appropriated as a means of testing the ideological boundaries of the real and the establishment of non-academic, avant-garde taste. This taste of necessity has defined itself as anti-bourgeois. Sometimes, however, it is able to define itself not just in the negative, but in the positive,

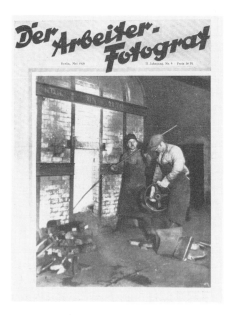

Fig 10 *Der Arbeiter-Fotograf* (cover), May 1928
(Courtesy of Terry Dennett)

as pro-working class. This invariably happens in periods of revolution or mass social change, when the balance of class forces changes to threaten the hegemony of the bourgeoisie, pulling aesthetic questions directly behind social ones. German culture in the 1920s experienced something similar to this as social instability and working-class combatancy met the rise of the new technology and the demands for democracy to produce a widespread desire for images of the diurnal and ordinary.

This de-academicisation of the everyday was at its most class-conscious in the workers' photography movement. In Weimar *Der Arbeiter Fotograf* was one of the main sources of promotion of this.[21] Changing the everyday as a revolutionary experience meant more than the use of strange perspectives and unusual angles, it also meant a radical change in who was behind the camera. The theory and practice of working-class self-authorship asserted the de-academicisation of the everyday in terms of the proletarian reordering or rewriting of the categories of the real. Worker photographers became the authentic bearers of the objective class interests inscribed in the everyday. As Edwin Hoernle argues in 1930 in *Der Arbeiter Fotograf*:

> If the bourgeoisie depicts proletarians and their world of suffering, it is only to provide a contrast, a dark background to set off the glories of bourgeois 'culture', 'humanity', 'arts and science' and so forth, so that sensitive folk can enjoy a feeling of sympathy and 'compassion' or else take pride in the consciousness of their own superiority. Our photographers must tear down this facade. We must proclaim proletarian reality in all its disgusting ugliness, with the indictment of society and its demand for revenge. We will have no veils, no retouching, no aestheticism; we must present things as they are, in a hard merciless light.[22]

This paradigmatic quotation speaks for a whole section of leftist, Proletkult-influenced reportorial work in Europe at the time. Confident in its positivism, strong in its belief in

documentary's powers of consciousness-raising, it proclaims the direct connection between photography and truth-telling.

The New Objectivity and workers' photography clearly shared a common set of epistemological presumptions; where they differed was on what constituted the basis of photography's truth-telling powers. As the Hoernle quotation implies, the New Objectivity was unable to move beyond the spectacle of class relations given its separation of truth from any explicit identification with proletarian consciousness. The confidence of this critique, and the political confidence that underlay workers' photographic culture generally in the late 1920s owes a great deal to the success of the cultural policies of the Comintern (Communist International) during its 'left-turn' from 1928 to 1935. This is the period which saw the development of various experiments in working-class culture carried out by various national Communist Parties and Communist-linked organisations under the Comintern's 'class against class' directive.[23] Along with the formation of *AIZ* and workers' photography groups in Japan, France and Britain, a broad-based documentary culture of the left emerged that looked to the Soviet labour photography of the 1920s as the foundation for a pro-working class aesthetic. In Trotsky's memorable phrase about the Bolshevik Party, workers' photography and the new leftist documentary staked its difference from the New Objectivity on the grounds that it was the *memory of the class*. The memorial capacity of photography is also something that Benjamin aligned himself with politically. Photography's intervention into the everyday lay in its ability to construct an alternative class experience of historical events. As the *Manifesto for the British Workers' Film and Photo League* put it in 1934, albeit in more prosaic language than Hoernle:

> Above all the bourgeoisie have used photography ... to make us forget our lives ... there is more real heroism and real drama in the daily lives of our class – in the class which is making history – than in anything the capitalist class can show us.[24]

This, of course, was a short-lived period of proletarian photographic activity. The formation of the Popular Front (1934–38), with its move away from 'class on class' rhetoric, and the dissolution of the Comintern by Stalin in 1943, brought to a close the links between photography, working-class culture and political intervention. By the time the American workers' photography group, the Photo League, had been put on the Attorney General's list of subversive organisations in 1947, the ideals of workers' photography, as the last outpost of the egalitarian ideals of Soviet culture, had been superseded by general notions of documentation.

Despite the ideological differences between the New Objectivity and workers' photography, the concept of 'documentary' was not something which was fought over in any specific sense in Weimar. Notions of 'documentary' were used casually as part of a general culture of photographic 'reason' and 'truth', but it was not constructed into a separate category that was then contested and shaped ideologically – something we are familiar with in the post-war world. Because of the relatively unstable political situation in Weimar, and the sharp class conflict over the uses of the new reproductive technologies, the category 'documentary' could not settle into a model of 'good practice'. It had to wait for its transmission to the more 'stable' democracies such as Britain and the USA for this to occur. The elaboration of documentary photography as a form of petitioning on behalf of the 'other' developed in these countries as the result of the

dominant reformist aspirations of the labour movement there, and the increasing historical and practical distance from Soviet avant-garde models. Here the proletarian reclamation of the everyday was realigned with social democratic populism, fuelled increasingly in the late 1930s by Popular Front politics. The effect was the incipient professionalisation of documentary photography and its incorporation into early Modernist protocols about the aesthetics of picture-taking. The result was the growth of a culture of the *auteur* which radically transformed the social function of 'factographic' photography.

The shift from an interventionist culture of the everyday to a reflective and reformist one is now a standard form of historicisation. In broad outline there is little to contest. The dissolution of avant-garde culture and the independent workers' movement by the combined forces of fascism and Stalinism, and the intense development of the mass media and corporate culture after the Second World War, reaffirmed aesthetic positivism as the admired norm. But in defending the political realities of this transformation – that is, acknowledging how much of early avant-garde photographic culture was grounded in the ideals of an independent workers' movement – the history of Weimar photography can be suspended too easily between different versions of industrial photography. During the Weimar period there existed practices – mainly by women – that cannot be fitted so easily into the binary logic of 'good' avant-garde class-consciousness and 'bad' aesthetic positivism. This is because these practices tended to subordinate public notions of the everyday (class action, collective identity, industrialisation) to the private and the domestic. In short the 'everyday' was extended and refigured in the interests of gender and the representation of the feminine. Much of this work was produced and shown outside any critical context that might have articulated its concerns. The work may have been seen but it had no wider discursive life that could shift critical perceptions or establish new aesthetic allegiances. Nevertheless it reveals the presence of fissures and aporias in the way the New Objectivists and their workerist and avant-garde critics constructed notions of the everyday.

Within European photography of the period the achievements of Hannah Höch, Florence Henri and Aenne Biermann have recently been much commented on, particularly within the new feminist photographic histories and the revisionist histories of the avant-garde. Their contribution to a politics of the everyday has received less attention; however, the work of Maud Lavin on Höch stands out as an exception.[25] German, French (though working in Berlin) and German respectively, they reveal Weimar photographic culture to be a major site of critical revision in the representation of women's experience in the 1930s.

In the Soviet Union, and under Soviet revolutionary models, the representation of women was subordinate to the realities of industrial life and to a universal – that is gender 'free' – conception of class. To be represented as an emancipated woman was to be represented as an industrial worker. This was undoubtedly liberating under a regime that had actually improved the material conditions of a large number of women's lives (the Bolshevik government was the first to provide abortion on demand and nursery care for factory workers). To be seen as a worker was to be seen as part of a community that did not associate women with idealised notions of the feminine. This may in itself be an idealised view of the actual relations between men and women during the early years of the revolution, but even so the representation of women outside of the home as workers on an equal footing with men can be judged as being progressive.

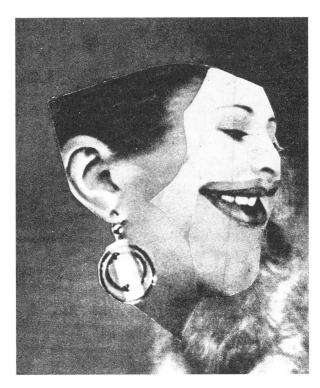

Fig 11 *Fröliche Dame*, Hannah
Höch, 1923 (© DACS 1996)

The eventual codification of women and men simply as workers, as the embodiment
of abstract labour and industrialisation, is another matter altogether. The point where
'progressive symbol' became 'inert stereotype' in the early 1930s reveals how the
'machine aesthetic', once it became symbolically identifiable with Stalinist
industrialisation, marshalled the bodies of men and women into a workers' army. Yet
Stalinism is not the progenitor of a de-feminised 'machine aesthetic'. As recent literature
on the period has argued,[26] the very notion of the body as machine was instrumental in
subordinating the division of labour between the sexes to a gender-neutral conception of
industrial and technological change. This is why the extension of the categories of the
everyday in the New Objectivity and in the Soviet avant-garde was so dominated by a
technocratic view of social change, because the rational control over nature and the social
world through new technologies and new industries was perceived as the bearer of a
gender-free egalitarianism. The result was the suppression of the feminine as a site of
social contradiction, and the association between the feminine and the non-functional.

In Weimar culture, though, these associations came under increasing scrutiny as the
discourse of the New Woman opened out a space for the discussion of the feminine as an
active and positive cultural identity.[27] The New Woman was at one level a middle-class
fiction, but at another, it showed how the Weimar Republic had brought about a change
in the expectations of women outside the home, and how these expectations might be
organised and represented. The New Woman was neither a wife nor a worker, but both.
Moreover, the New Woman was a consumer with her own tastes, her own lifestyle. To
say women photographers in Weimar took on the New Woman as a given subject is to
mistake what is resonant for what is discursively available. There was no public discourse

on photography and the representation of women's everyday experience that could define a community of practitioners. Nevertheless, what the New Woman adumbrated was a general sense of disappointment about how photography always seemed to *mislay* the feminine. This is why it is possible to read Hannah Höch's work now not as a failed response to the public demands of photomontage but as a diaristic rejection of the public masculinisation of women within political culture. Here is a montage of the everyday which deals with what it is like to be and to be seen as a woman.

Similarly, Aenne Biermann opened up dominant masculinised conceptions of the everyday by pointing her camera at the 'soft spaces' of the domestic. 'Soft spaces' because under the technocratic logic of the 'machine aesthetic' in all its forms, they fulfilled no observable function in reordering public perceptions of the everyday: the *hard* task of politics. Her family snapshots taken in the 1920s clearly open up a space for the representation of the everyday outside the public sphere.[28] But if these images invoke the domestic as a determinate absence in the rules of 'proper' engagement with the everyday, they do not stand as a proto-feminist critique of the 'scientism' of the New Objectivity. On the contrary, they are the very product of the New Objectivity and as such establish a vivid dialectic with the functionalism of the time.

Biermann produced the majority of her photographs between 1925 and 1933, the year she died. These were done under the influence and critical patronage of the New Objectivity and with financial support from her rich businessman husband. In the late 1920s and early 1930s her work was represented in all the big international shows of German photography. In 1930 Franz Roh wrote a short monograph on her.[29] Most of her studies were still lives or urban scenes, and more or less conventional for the period. However, from the early 1920s she began taking photographs of her young children in domestic settings. These are unusual for the time given that photographs of children were invariably taken in professional studios. It was only after the Second World War with the increasing production and purchase of the hand-held camera and the increasing commodification of domestic life (through women as the major purchaser of commodities in the family) that the snapshot took over from the professional studio portrait. As Ute Eskildsen says in her essay on Biermann, 'An Insight into Everyday Life', 'the intimacy with objects, the attempt to achieve a closer understanding of everyday situations and objects by means of the camera, was the starting point of Biermann's photographic work'.[30]

Notions of the spontaneous and contingent are of course central to the New Objectivity and the new photography generally. But they were invariably identified as public concepts. Thus when the New Objectivity embraced the notion of chance as constitutive of photography's 'realism', it was directed principally at how the world looked outside the home, where chance encounters obviously defined the subject's relations with the everyday. To say Biermann broke with this is not to say she took it on herself to break with public conceptions of the document. Rather, she developed her photography by taking what was at hand: that is, her experience as a mother, largely isolated and confined to her home. The representation of the everyday was dictated by what she could comfortably control, an experience that is also reflected in Höch's work and much other work by women artists and photographers during this period. Yet it would be disingenuous to assume that the decisions she did make about her resources as a Weimar photographer were not part of a wider set of reflections on photography. The de-academicisation of the everyday dominated Weimar culture. To be modern was to

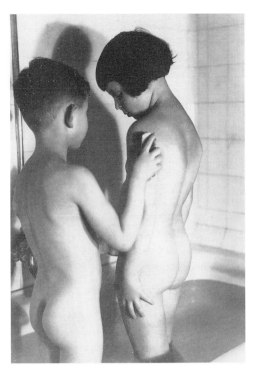

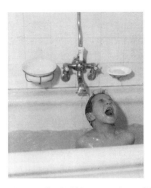

Fig 13 *The Cold Surprise*, Aenne Biermann, *c.*1929 (Courtesy of Museum Folkwang, Essen)

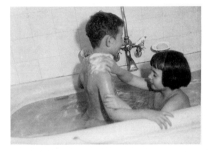

Fig 12 *Helga and Gerd*, Aenne Biermann, *c.*1929 (Courtesy of Museum Folkwang, Essen)

Fig 14 *The Big Wash*, Aenne Biermann, *c.*1929 (Courtesy of Museum Folkwang, Essen)

judge the commonplace as the site of the democratic. Prosaicness, the ordinary, brevity and the anti-metaphysical became synonymous with the pursuit of truth and a certain moral strenuousness, not only in photography and film but in poetry, the novel and theatre. Biermann's snapshots of her children are no different in this respect. Moreover, their informality and conscious distance from technological and industrial categories of the everyday touch on the issue of the functional status of the photograph, which was to set the New Objectivity off from so many of its avant-garde and proletarian critics.

In Weimar the pro-Soviet fascination with the functional united much of the left critique of New Objectivity, putting in place Germany's own version of the debate on the dialogic and the everyday. Some of the most significant ideas were developed in the area of poetry. Erich Kästner, Kurt Tucholsky and Brecht all saw the functional or pedagogic text as offering a more open dialogue between the work, the reader and the world. *Gebrauchslyrik* (functional poetry) was a poetry which offered the reader a piece of practical advice or a proscription, for example Brecht's *Aus einem Lesebuch für Stadtebewohner* (From a Reader for City-Dwellers)[31] and Kästner's *Ein Mann gibt Auskunft* (A Man gives Information).[32] The advice offered, however, was not to be taken literally but figuratively. Instead of the reader actually carrying out the poem's advice, the reader is placed in a situation where he or she reads about what he or she should do. The implication is that the poem acts as a kind of 'therapeutic jolt', something that pulls the reader up short and not an exercise to be followed to the letter.[33]

The categorisation of the everyday through the functional needs to be treated with discrimination and circumspection. Functional poetry or art, or to use Brecht's term

Lesebuch aesthetics, were concerned with raising the critical consciousness of the reader or spectator, in a way that the New Objectivity was not. In this there is a sense that the *radical* functionalists such as Brecht (and we might include the productivist Benjamin of 1934–38 in this) wanted to transform the categories of art and literature in the interests of the non-specialist forms of attention and competence of popular culture. What is it? How might I use it? By recasting everyday forms such as autodidactic manuals, cabaret songs, and ballads from a critical perspective, the literary functionalists sought to put in place a process of cross-fertilisation between popular pleasures and political education – in short, what Arvatov, Tretyakov and Benjamin called a 'melting-down process'. Benjamin's concern with the relationship between image and text in the interests of political literacy was an attempt to extend the functionalist ethos to visual culture as a whole. New Objectivity, on the other hand, alighted on the prosaic as a source of the sublime or beautiful, and as such opened up the spaces and forms of the industrial to the pleasures of aesthetic contemplation.

Although Biermann's domestic snapshots are grounded in the aesthetics of the New Objectivity, they also have something of the functional exercise about them, insofar as her aesthetic interests seem to be determined by her intersubjective needs as a mother. I hold that the photographs of her children at play and in the bath testify to the need at the time to break with the sentimentality and artificiality of dominant studio representations of children. In this there are echoes of the whole debate on the representation of children, of the desire to respect the authenticity of childhood, inherited from the nineteenth century, and which pass into the New Woman discourse on enlightened childcare. Respect for the autonomy of children is of course also the 'founding' moment of Freudian psychoanalysis. In the 1920s the European intelligentsia was learning to see the psychic continuities between childhood and adult experiences of the everyday. Biermann's photographs participate in this conjunction of forces, candidly showing her children in natural postures as if to suggest *her* childcare was free of cant and overprotectiveness. Yet these images were not produced for a public audience. They were produced sporadically for herself, her family, friends and occasional professional acquaintances. They therefore did not perform any public functional role as part of the New Woman discourse on childcare. Yet even so, it is not hard to see a pedagogic function being performed here. It is as if she is giving herself and her close friends and admirers a lesson in femininity and representation. These small and seemingly insignificant images of her children (she rarely enlarged the prints) stress the importance of the use of the camera at home in response to women's experience of the everyday. For all their hesitancy and 'invisibility' they provide a model of the everyday in photography which does not stop at the front door. Indirectly, then, they question the very separation of the public and private which the aesthetic positivism of the New Objectivity elevated as a matter of critical principle.

This undermining of 'pure' objectivism can be seen in the work of a number of other women photographers in Weimar, as they negotiated their place in photography's public culture; in particular Tina Modotti's staged images and Florence Henri's interiors with mirrors. Modotti worked for *Der Arbeiter Fotograf* and *AIZ* and spent considerable amounts of time in Berlin as a representative for the Comintern. Stalinist, ex-model and actress, she participated in an an extensive way in the debates on photography, the avant-garde and politics in the 1920s and 1930s. Her background and commitments, then, were very different from Biermann's. Deeply immersed in the proletarian critique of the

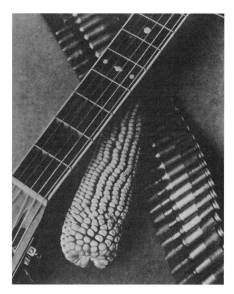

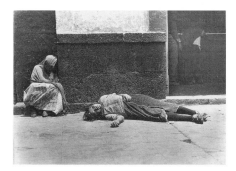

Fig 15 *Misery*, Tina Modotti, 1928 (Courtesy of Museum Folkwang, Essen)

Fig 16 *Bandolier, Corn, Guitar*, Tina Modotti, 1927 (Courtesy of Throckmorton Fine Art, Inc., New York)

New Objectivity and engaged in actual political activity, she was a public photographer in the way Biermann was not. Yet it is possible to see shared concerns. As Laura Mulvey and Peter Wollen argue in their essay on Modotti, 'Modotti's work as a photographer can only be understood in the context of her private life and position as a woman'.[34] In one sense this is a truism, but it makes clear that Modotti's adoption of Eisenstein's practice of *typage* – intellectual montage – in a range of pictures was a choice determined by more than Hegelian observances of dialectical balance. On the contrary, her turn to staged images recognises the absence of the process of subjective identification in the representation of the revolutionary subject. Thus in her photographs *Bandolier, Cob, Sickle* (1928) and *Bandolier, Corn, Guitar* (1927), the Mexican revolution is made to speak through the connotative manipulation of everyday objects as a means of locating the subjective moment (the moment of emotional identification) in political struggle. This is an image of the construction of political commitment. There is of course nothing gender-specific about this. But nevertheless for Modotti as a woman to see this as a viable issue at this time certainly is gender-specific, insofar as second-order images of political commitment were not a concern of proletarian photography. Without wanting to stretch the point too far, this is an image of *her* commitment to the class struggle and therefore an image that metonymically stages her own life story.

In a similar way Florence Henri's *Self-Portrait* (1928), a portrait of herself looking into a mirror, stages a moment of loss and absence to which the positivism of New Objectivity and workers' photography is unable to give a critical identity. These images of mirrors do not so much extend the everyday as a gendered space as embrace narcissism as a recoil from the everyday. After studying at the Bauhaus Henri returned to Paris in 1929 and took up portrait photography and fashion work.

To note these 'moments' briefly here is not to construct a nascent tradition of counter-images of the industrial everyday during this period, or to lay claim to some incipient feminist fraternity. Rather it is to show, albeit fitfully, how the dominant positivism of the

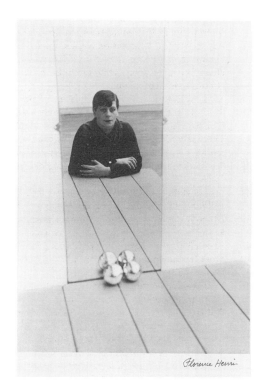

Fig 17 *Self-Portrait*, Florence Henri, 1928
(Collection of the J. Paul Getty Museum, Los
Angeles, California)

time was negotiated by those who were unable to invest fully in its categories. The
extension of the categories of the everyday under the New Objectivity and workers'
photography was shadowed by the work of women whose own commitment to the de-
academicisation of the everyday from within the space of positivism took on very
different kinds of agency and patterns of influence. These kinds of agency and patterns
of influence, though, do little to alter the wider picture of the power of the dominant
positivism. The legacy of the proletarian and New Objectivity positivism is formidable,
and it is out of this forbidding reality that the orthodoxies and dilemmas of documentary
photography have been constructed. It is this process I now want to look at in the work
done in Britain and the USA in the 1920s and 1930s, where the term 'documentary' as
the embodiment of the post-revolutionary democratic ideals of reportage and the
factographic was principally developed.

Notes

1 See Ute Eskildsen, 'Fotokunst stabt Kunstphotographie: Die Durchsetzung des fotografischen
 Mediums in Deutschland 1920–1935', in *Film und Foto: der zwanziger Jahre*,
 Wurttenbergisher Kunstverein 1979.
2 Carl Georg Heise, preface to *Die Welt ist Schön*, reprinted in David Mellor (ed.), *Germany:
 The New Photography 1927–33: Documents and Essays*, Arts Council of Great Britain
 1978, p. 9.
3 *Ibid.*,
4 *Ibid.*, p. 12.
5 Albert Renger-Patzsch, *Das Deutsche Lichtbild* (1927), reprinted in Christopher Phillips

(ed.), *Photography in the Modern Era: Documents and Critical Writings, 1913–1940*, The Metropolitan Museum of Art/Aperture 1989, p. 105.

6 August Sander, 'Remarks on My Exhibition at the Cologne Art Union' (1927), reprinted in Phillips (ed.), *Photography in the Modern Era*, p. 106.

7 Hugo Sieter, 'Absolute Realism: On the Photographs of Albert Renger-Patzsch', *Der Kreis* (1928), reprinted in Phillips (ed.), *Photography in the Modern Era*, p. 112.

8 See Paul Renner, 'The Photograph', *Die Form* (1930), and Walter Peterhans, 'On the Present State of Photography', *ReD* (1930), both reprinted in Phillips (ed.), *Photography in the Modern Era*, pp. 168 and 171.

9 See Laszlo Moholy-Nagy, 'Unprecedented Photography', *Das Deutsche Lichtbild* (1927), reprinted in Phillips (ed.), *Photography in the Modern Era*, p. 85.

10 See *Bauhausotografie: Eine Ausstellung des Instituts fur Auslandsbeziehungen*, Stuttgart 1984.

11 Laszlo Moholy-Nagy, 'Sharp or Unsharp? A Reply to Hans Windisch' (1929), reprinted in Phillips (ed.), *Photography in the Modern Era*, p. 133.

12 Laszlo Moholy-Nagy, 'Letter to Fra. Kalivoda', *Telehor* (1936), reprinted in Richard Kostelanetz (ed.), *Moholy-Nagy*, Allen Lane 1971.

13 Laszlo Moholy-Nagy, *Vision in Motion*, Paul Theobald 1947.

14 Moholy-Nagy quoted in Kostelanetz, *Moholy-Nagy*, p. 209.

15 *Ibid.*, p. 210.

16 Moholy-Nagy, *Vision in Motion*, p. 361.

17 Kostelanetz, *Moholy-Nagy*, p. 211.

18 Walter Benjamin, 'The Author as Producer', in Victor Burgin (ed.), *Thinking Photography*, Macmillan 1982.

19 See Eberhard Kolb, *Die Weimarer Republik*, R. Oldenbourg Munchen 1984.

20 See Perry Anderson, 'Modernity and Revolution', *New Left Review* 144 (1984).

21 See Richard Weber *et al.* (eds), *Der Arbeiter-Fotograf, Dokumente und Beiträge zur Arbeiterfotografie 1926–1932*, Prometheus 1977.

22 Edwin Hoernle, 'The Working Man's Eye', *Der Arbeiter-Fotograf* (1930), reprinted in Mellor (ed.), *Germany*, p. 49.

23 See Terry Dennett, 'England: The (Workers') Film and Photo League', in Terry Dennett, David Evans, Sylvia Gohl and Jo Spence (eds), *Photography/Politics: One*, Photography Workshop 1979.

24 *The Manifesto of the Workers' Film and Photo League*, quoted in *ibid.*, p. 103.

25 Maud Lavin, *Cut with the Kitchen Knife: The Weimar Photomontages of Hannah Höch*, Yale 1992.

26 Peter Wollen, *Raiding the Icebox: Reflections on Twentieth-Century Culture*, Verso 1993.

27 See Patrice Petro, *Joyless Streets: Woman and Melodramatic Representation in Weimar Germany*, Princeton University Press 1989.

28 See *Aenne Biermann: Photographs 1925–33*, Nishen 1988.

29 Franz Roh, *Aenne Biermann: 60 Fotos*, Berlin 1930.

30 Ute Eskilden, 'An Insight into Everyday Life', *Aenne Biermann: Photographs*, p. 12.

31 Bertolt Brecht, *Poems 1913–56*, ed. John Willett and Ralph Manheim, Methuen 1976.

32 Erich Kästner, *Gesammelte Schritfen, Volume 1: Gedichte*, Zurich 1959.

33 See J. J. White, 'The Cult of "Functional Poetry" During the Weimar Period', in Alan Bance (ed.), *Weimar Germany: Writers and Politics*, Scottish Academic Press 1982.

34 Laura Mulvey and Peter Wollen, 'Frida Kahlo and Tina Modotti', in Laura Mulvey (ed.), *Visual and Other Pleasures*, Indiana University Press 1989, p. 86.

3

The making of documentary: documentary after factography

If the term 'documentary' was barely used in Germany in the 1920s – or used simply as one academic category amongst many – in Britain and the USA in the late 1920s and 1930s it took on a generalised identity. This had much to do with how the term came to be used to mediate the 'factographic' culture of the Soviet Union separately from its revolutionary politics. However, this is not to say that the political influence of Bolshevik culture was completely absent from the 'documentary' movement in Britain and the USA, or that certain documentary practitioners were not revolutionaries or fellow travellers of the Communist Party. Anglo-American documentary culture was steeped in Communist and socialist sympathies. But we need to recognise that the reception and development of Soviet and German models were always undertheorised as sources of 'cognitive transformation'. In Britain the absence of a Modernist avant-garde in any coherent sense had a large part to play in this, as did the cultural positivism of the labour movement, which was more entrenched than in Germany. In the USA things were somewhat different. There was a relatively strong avant-garde (albeit centred on a tiny circle of practitioners and admirers in New York) and a technologically more sophisticated culture. Nevertheless, both 'documentary' movements came to be grounded in a powerful culture of social democratic paternalism. It is as if, particularly in Britain, Soviet models were considered alien to a certain Anglo-American gradualism and 'good sense'.

John Grierson gives an indication of this in his writing from the late 1920s. 'Can we heroicize our men when we know them to be exploited? Can we romanticize our individual scene when we know that our men work brutally and starve ignobly in it?'[1] The logic may be a bit strange here, but it provides clear testament to the situation in which early British and American documentary film-makers and photographers found themselves: a culture in which the labour movement, technological change and revolutionary cultural transformation were at odds.

Grierson's early films and writing were one of the key points of transmission of Soviet and German culture in the 1920s. Grouping around him young intellectuals, writers and film-makers (or people who were training to be film-makers), he established a nucleus of

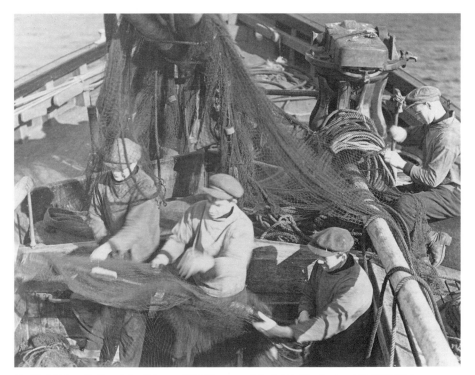

Fig 18 Still from *Drifters*, John Grierson, 1929 (Courtesy of the British Film Institute) (© 1996 COI)

individuals who wanted to create a 'culture of the everyday'. As with Vertov, who was a formative influence on Grierson, Grierson's initial target was the studio film and theatricalism. 'The studio films largely [deny the] possibility of opening up the screen on the real world.'[2] A crucial term at the time in connection with this is what Grierson calls the 'actual'. British commercial cinema is divorced from common experience and therefore what is needed is to substitute theatricality for actuality. Yet Grierson was not interested in a Vertovian 'mechanisation' of aesthetics; the abstract 'symphonisation' of the everyday in Walter Ruttman's highly influential *Berlin: Symphony of a City* (1927) had little to say to him about the men and women who actually operated the machines.

From early on Grierson was working up a filmic notion of the everyday that would avoid the confrontational cognitive disruptions of his much admired Bolshevik cinema. In short, what Grierson wanted was to tell stories of the 'everyday' in epic, pastoral form. In this he was concerned to keep his distance from the radical functionalism of Soviet and German culture, at the same time as embracing its celebration of the ordinary. It is no surprise, therefore, that by the early to mid 1930s Grierson's own notion of the de-academicisation of the real had become declassed, or had shifted its class content from worker to citizen, from working-class interests to the general human good. It is at this point that documentary began to be constructed as a category separate from the reportorial, that is, as a social reform movement within the constitutional bounds of liberal social democracy. Impressed by the Farm Security Administration experiment in the USA in the mid-1930s and in particular the film *March of Time* (1937), Grierson became increasingly preoccupied with documentary as a proactive defence of 'good

citizenship'. Film-making, he contended, is not about the generation of propaganda or the pedagogic, but the creation of a socially inclusive critical humanism. The influence of Popular Front aesthetics here is striking. The representation of the 'everyday' – the experiences and daily affairs of the working class – stand in for an ideal community in which the working class and a progressive section of the bourgeoisie work together against anti-democratic forces (fascism, big business and the aristocracy). Film-making is sustained by the 'quiet light of ordinary humanism'[3] in which the documentarist's 'good reason' will communicate to others the necessity for the social democratic ideal. As Grierson says in 'Education and the New Order': 'That is why documentary film has achieved unique importance in the new world of education. It does not teach the new world by analyzing it. Uniquely and for the first time it *communicates* the new world by showing it in its corporate and living nature.'[4]

By the late 1930s, then, but emphatically so after the war, when this was written, documentary for Grierson was the communication of the 'everyday' as a source of fraternity with others. In fact Vertov's concept of film as intersubjective class experience was exchanged for film as an intersubjective human experience. The institutional pressures on Grierson's aims were inevitably extensive. For films to be funded individuals and groups had to be approached that were openly opposed to any left agenda. Grierson was constantly covering up or watering down the radicalism of many of his co-workers, in order to sweeten the message. When the majority of the institutions of the left were not interested in financing such work for lack of money and reasons of pragmatism, it was understandable such a route was taken. Yet Grierson's intellectual development represents in an unambiguous way the structural formation of documentary in a post-Bolshevik world as an adaptive, liberal project of education from above.

That this has proved to be hegemonic in the post-war world does not mean that the term 'documentary' was not contested in Britain during the 1920s and 1930s. Grierson's work was, as was New Objectivity in Germany, part of a wider intersection between the working-class movement and independent cultural practitioners. Grierson may have chosen to distance his film-making from class struggle, but nevertheless his work participated in a particular resilient working-class culture of the 1920s and 1930s. As Stephen G. Jones has argued in his book on workers' film culture of this period, there was a 'thriving socialist cultural formation which challenged some of the mores and conventions of the dominant culture'.[5] In fact it was the residual strength of this culture that provided the conditions for the development of British documentary forms. Mass-Observation, Workers' Film and Photo League, Workers' Theatre, the new social issues film and the new documentary literature (George Orwell) would be inconceivable without an active proletarian culture. Britain may not have produced a theoretically acute avant-garde, but it had an extensive network of socialist film-makers, artists, photographers and intellectuals who provided, along with workers' organisations, an alternative culture to the one residing in Bloomsbury and the major artistic institutions.

However, this is not to argue that this culture was *oppositional* in any Proletkult sense, although certain groups were affiliated to, or were sympathetic to, the British Communist Party and modelled themselves on a proletarian aesthetic, as with the Workers' Film and Photo League. On the whole this culture, radical proletarian and social democratic alike, saw itself as an *independent* culture, basing itself on a strong sense that the pleasures and constraints of everyday working-class life were underrepresented in bourgeois culture. The inter-war culture of Britain, then, saw the

growth of an extensive informal proletarian resistance, as the working class sought to redefine itself culturally in response to the new technologies in the workplace and in the area of public entertainments. As in Germany, the cinema in Britain was in the process of developing into a major part of working-class entertainment. In 1923 there were 3,910 cinemas in Britain, in 1934 4,305 (containing 3,892,000 seats). These cinemas were inevitably dominated by the new Hollywood films. By 1926 the screen time devoted to British films was only 5 per cent (33 out of 749 films). However, between 1928 and 1939 England produced around 300 documentary films, many of which, along with British feature films, were shown on British screens.[6] Thus even if there was considerable opposition in Wardour Street and Bloomsbury to the new documentary movement, for a period of around ten years it created a small audience for itself within the working class.

In January 1930 the Empire Marketing Board (EMB) Film Unit was set up by Grierson, which lasted until 1933. In 1973 the film-maker and collaborator with Grierson, Paul Rotha, could say in his *Documentary Diary* that it 'was the only experimental workshop for film-making in the world'.[7] In 1933 the General Post Office (GPO) Film Unit was set up by Grierson, which continued until 1937. In this year, though, the film-maker Basil Wright left the group to set up the Realist Film Unit, following in the footsteps of another breakaway group, Strand Films. At the same time the oil company Shell was persuaded to fund a documentary film unit. By 1937 there were four documentary production units in operation, providing a bridge of sorts between the funding bodies of bourgeois culture and a working-class audience. Documentary was beginning to have an accumulative impact. In fact, it began to focus a wider debate in the culture about the moral effects of the new leisure industries on the working class. In distinguishing itself from the tardy theatricalism of the commercial cinema, documentary film sought to place itself in the service of an educative community ideal. Documentary's potential defence of 'everyday community' and 'good citizenship' provided an uplifting defence against the demoralising effects of a cinema and art of theatrical illusion. The idea of documentary as a 'voice of reason', then, was very much part of a general cross-class response to the commercialisation of culture that took place in Britain from the 1880s, in which the pleasures of the working class were figured as a problem. What kind of culture is in the best interests of the working class, asked socialist, liberal and conservative?

Commercial film was beginning to reorganise the pleasures of the working class, producing narratives of fantasy and fancy on a mass scale (although in no sense could it be said to *incorporate* the class through these processes of identification into a bourgeois view of culture). The response from the left and the right was to attack the new cinema: in the case of the left, as a distraction, and in the case of the right, as morally undermining. The effect was to link commercial cinema with various kinds of moral dissolution.[8] Furthermore, film and photography were seen by many left and right guardians of 'high culture' as vulgarly levelling *as such*. This was concentrated not just in Bloomsbury but in the Labour Party and the workers' movement generally, where defences of high culture as moral education were widespread. The effects of popular anti-Modernism on inter-war British culture, then, were somewhat different from their effects in Weimar. Much of the debate on documentary was mixed up with defining its values against popular commercial culture, whereas in Germany it was seen in dialectical tension. Of course in Weimar there were defenders of culture on both the left and right, who saw in the new technology a threat to aesthetic autonomy, but the popular anti-

Modernist argument never dominated discussion on the left. It never in fact was a real option for the Nazis although they railed against Bolshevik culture in the name of the *Volk* and the *Volkgemeinschaft*. The Nazi's popular anti-Modernism was largely a veneer, designed to woo and win the increasing anti-Modernism within the petit bourgeoisie. In power the Nazis embraced technological modernity as an indispensable part of rearmament and a modern media-based culture. 'An increased flow of verbiage and a heightened anti-Semitic campaign served to obscure the fact that the new National-Socialist party intended to consistently neglect the interests of its staunchest supporters.'[9] Thus there is a powerful sense in which the Nazis' smashing of independent photographic and film culture was not done in the name of anti-Modernism, but in the interests of cultural control, despite Hitler's own aesthetic nostalgia. It is possible to argue, therefore, that debates on technology in Germany in the 1920s and 1930s on both right and left involved a strong sense of the possibilities of its cultural integration – that is, the relationship between technology and the masses was not perceived as a moral threat. In Britain, however, in many quarters it was so perceived, locking the defenders of documentary into a debate with the anti-Modernists about the moral effects of technology. A defence of the 'everyday' in these circumstances, then, did not necessarily mean for those on the left a commonsense view of what was not bourgeois. Hence, it is possible, for example, to see the distance Grierson took from Bolshevik/Weimar 'radical functionalism' in his embracing of documentary as a poetic act, as a means of raising the aesthetic status of the 'everyday' in the eyes of his potential financial backers, traditional left intellectuals and sections of the labour movement keen to promote Folkist, Romantic sentiments. In an intellectual climate that associated technology with de-spiritualisation and anti-aestheticism, even work that attacked popular commercial culture in the name of an 'authentic' use of film and photography was subject to the taint of decadent Modernism. As a consequence, Grierson was keen to separate the spiritual and organic values of documentary from commercial film.

A similar set of problems are evident in the formation of Mass-Observation. Founded in 1937 by Charles Madge and Tom Harrisson as a mass literary and photographic archive of British society, Mass-Observation was actually deeply anti-populist in its commitments to the representation of the 'everyday'. As with much documentary activity outside small groups of worker photographers, Mass-Observation was conceived by middle-class intellectuals and activists as an anthropological survey of working-class life. That it involved *some* workers in this process does not alter this perspective. The result was a moral dissection of working-class mores and the new commercial pleasures in the name of 'reason', despite the unprecedented socialist ambitions of the project. Harrisson believed that modern culture was an adaptation of old superstitions to new conditions. The effects of the new leisure industries encouraged a 'tribal' view of class experience.[10] Yet if Harrisson stated that he did not want to pass judgement on such activities, his desire to inform the people about their superstitions established a theoretical disjunction in the organisation between an ideal sense of the everyday and the realities of industrial-urban culture. The covert pastoralism of Mass-Observation's anthropology (its sense of moving amongst the low and fallen) inevitably committed the organisation to a certain puritanism and elitism. As Julian Symons says: 'In course of time, and it was not a very long time, Mass-Observation became much less an instrument for the scientific examination of human behaviour and much more a tool of consumer research.'[11] This theme is developed in Gary Cross's work on Mass-Observation's literary archive

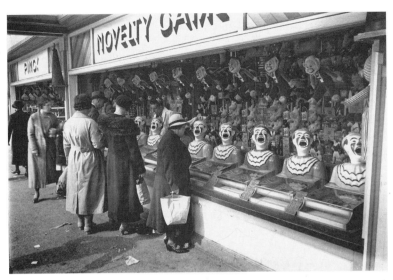

Fig 19 *Novelty Stall, Blackpool*, Humphrey Spender, *c.*1937 (Courtesy of Bolton Museum and Art Gallery)

'Worktowners at Blackpool', which was conducted over two holiday seasons in Blackpool in 1937–38. Cross argues:

> The dichotomy between the communion with nature and the commercial fleshpots ran through the Worktown surveys of holiday dreams and coloured observers' responses to Blackpool culture. For all their vaunted objectivity, Worktowner investigators were often repulsed by what they saw as the tacky commercialism of Blackpool. For them, Blackpool was a symbol of the modernized primitivism of the passive working class.[12]

The separation of 'everyday' experience into authentic community and modernised primitivism identifies the contradictions at the heart of the construction of the documentary movement in Britain during this period. Working-class identity and community needed to be defended against the divisive and amoral effects of commercialised leisure. The consequence of this, particularly in the case of Mass-Observation, was to treat the working class as a homogeneous mass and as a 'social problem'. It is at this point that documentary film and photography began to privilege certain images of the working class in *expectation* and *confirmation* of the loss of class cohesion and the 'modern primitive'.

Thus, the experience of unemployment and poverty in the 1930s during the Depression became a decisive factor in this symbolic process. For the experience of unemployment and poverty was seen as part of a continuing attack on the integrity of working-class community under industrial capitalism. The ravages of unemployment and poverty as injuries against community tended, therefore, to dominate how the new documentary depicted the social crisis of the 1930s. Across Humphrey Spender's photographs of Bolton and Blackpool for Mass-Observation, and the photospreads in *Picture Post* and *Weekly Illustrated*, the economic crisis was reported as a loss or diminishment of working-class community.[13] There were many images that abjured such symbolisations, images that show the working class on the move so to speak – Edith

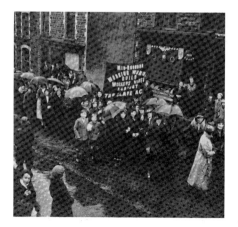

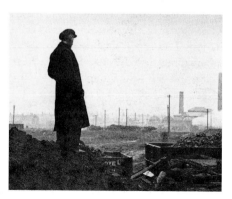

Fig 20 *Working Women's Guild of Mid-Rhondda: Working Wives against the Slave Act*, Edith Tudor-Hart, *c.*1935 (Courtesy of the Democratic Left Picture Library)

Fig 21 *UNEMPLOYED! ... February 1939* (*Picture Post* 86, 2: 6, 11 February 1939. (© Hulton Getty Picture Collection)

Tudor-Hart's unemployment march photographs for the Workers' Film and Photo League, for example[14] – but they were never in a position to define a new or emergent sense of community. What Mass-Observation and the illustrated magazines wanted were not oppositional images, but images that invoked absence of continuity or showed people 'getting by'. This is why so much of the 'poor' photography of the period concentrated on the North of England, where the effects of the economic crisis were at their greatest, and where the symbolic identifications of industrial life were at their sharpest. Photographing disused factories with forlorn figures, empty streets, children playing in rubbish, houses in severe disrepair, dreary vistas, the crisis of capitalism was rendered as the demise of shared values. One of the period's most well known images from *Picture Post* in 1939 shows a solitary unemployed miner standing in front of a deserted melancholic landscape – not just a symbol of unemployment, but a metaphor of the loss of communal stability.

Nevertheless, this is not to argue that such images did not have radicalising political effects. Such images wherever they were seen stood in a position to confirm the attack on working-class community as evidence of continuing class exploitation. But these effects were continually circumscribed by the anthropological construction of documentary as a 'melancholic art' of class observation. To represent the Depression principally in terms of images of class antagonism would betray the emotional truth of the working class's economic subjugation. For Mass-Observation, documentary's job was not, to echo Grierson, a forthright art of instruction, but the gentle art of human identification. It can be argued, therefore, that British documentary of the 1930s was dominated by a valedictory construction of the 'everyday' (as to a large extent it was in the USA). Photography turned to the experience of the working class as an identification with the authenticity of working-class life rather than with expressions of class-*consciousness*. This was obviously very different from the Soviet Union, where the 'factual' and reportorial may be constructed as anthropological data, but as a shared experience of working-class *power*.

This sense of valediction can be linked to Britain's imperialist legacy. The Depression of the 1930s for Britain was a crisis of its imperialist markets as world trade fell

dramatically. The effect was the collapse of British exports, thereby crippling the North and West of Britain where heavy industry was situated. The northern British working class, after a period of relative growth in its living standards, found itself pauperised, a far cry from Britain's self-image as a great imperial and industrial nation. Documentary photography in the 1930s fed into this imperialist crisis. In photographing the Depression as breakdown of community, Mass-Observation and the illustrated magazines revealed, or identified with, a national nostalgia at the time for Edwardian images of cross-class stability. Thus it can be argued that Mass-Observation constructed its ideals in response to what was perceived as having been lost in recent memory, a use of reportage that restricted the non-bourgeois extension of the everyday to the melancholic.

In this respect we need to take into account how the moral categories of social reformism dovetail with the middle-class backgrounds of many of the journalists and photographers who developed documentary in Britain. As Steve Edwards says in his essay on 1930s documentary, the documentarists 'came predominantly from the families of those involved in "British" home or Colonial administration, and in most cases were themselves trained to take up similar positions, only turning to the alternative professions of photography or journalism when the Depression precluded entry into those expected posts.'[15] Many of the journalists and photographers came from backgrounds in which to serve others (i.e. the people) was an expected duty. To acknowledge this is not to reduce British documentary to an epiphenomenon of middle-class paternalism, but a recognition that irrespective of many documentarists' actual *anti*-imperialist beliefs, they were part of, and contributed to, a culture of public service in which the memory of national images of class-cohesion figured strongly as a shared middle-class culture through which the democratic ideals of the new documentary were received. When we look at the backgrounds of leading photographers working in Germany during the 1920s, for example, we see a greater mix in class background and social experience (many were immigrants) and an intellectual culture that is predominantly free of the paternalism of public service.

One of the key texts of the new documentary during this period, of course, is George Orwell's *The Road to Wigan Pier* (1937),[16] which actually first appeared in its Left Book Club imprint with photographs, although the majority of the photographs were not of the North but of the South of England. Orwell's book has usually been categorised as belonging to the documentary-as-social anthropology school, providing further evidence of working-class passivity and status as a 'race apart'. Characteristic of this position is Raymond Williams's evaluation of Orwell in *Politics and Letters* (1979):

> the mode of an extreme distaste for humanity of every kind, especially concentrated in figures of the working-class, goes back after all to the early Eliot – it was a mode of probably two successive generations and it has not yet exhausted itself. You can see it in Orwell's choice of the sort of working-class areas he went to, the deliberate neglect of the families who were coping – although he acknowledged their existence in the abstract – in favour of the characteristic imagery of squalor: people poking at drains with sticks. His imagination always and submissively goes to that.[17]

For Williams, *The Road to Wigan Pier's* reportorial plainness is a mere objectivist convention in the manner of Mass-Observation, a 'decent' observer's pose. There is some truth in this, insofar as Orwell engages in a standard journalistic distancing from the

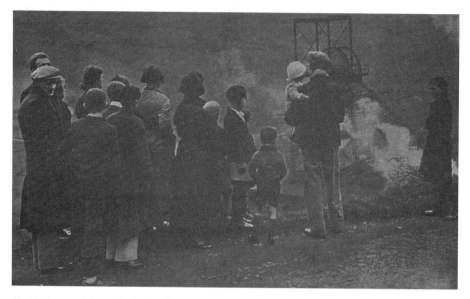

Fig 22 Photograph from *The Road to Wigan Pier: Nine Mile Point Colliery, Newport*, Anon, *c*.1937
(© Anon)

social relations he is observing. However, what also has to be taken into account, as it has hardly been at all, is that the report on Wigan is a *satire*, a satire in fact at the expense of the portentious claims of the new social anthropology and the middle-class documentary movement as a whole. The title itself is ironic, echoing fantasy literature. He declares outright his dislike of 'high-minded Socialist slum-visitor[s]'.[18] 'The truth is that, to many people calling themselves socialists, revolution does not mean a movement of the masses with which they hope to associate themselves; it means a set of reforms which "we" the clever ones are going to impose upon "them", the lower orders.'[19] It is of course common practice to condemn something, and then do exactly what you are condemning without noticing it. Williams no doubt would judge Orwell to be indulging in such double standards. Yet, however we might want to judge Orwell's treatment of his material, the book is largely a passionate critique of the *idealisation* of the working class and the cult of working-class authenticity which Orwell sees as being so pervasive within the new documentary. This romanticism for Orwell is rooted in the fetishistic identification of manual labour with working-class experience, the idea that the 'only proletarians are manual labourers'.[20] The clerk, the engineer, the village grocer, the lower-grade civil servant are also proletarians, he argues. This counters, strongly, the idea that Orwell was out to aestheticise the northern British working class in their misery. On the contrary, what concerned him was the way certain stereotypes of the working class, inflated by the new documentary, continually stood in for the heterogeneity of working-class experience.

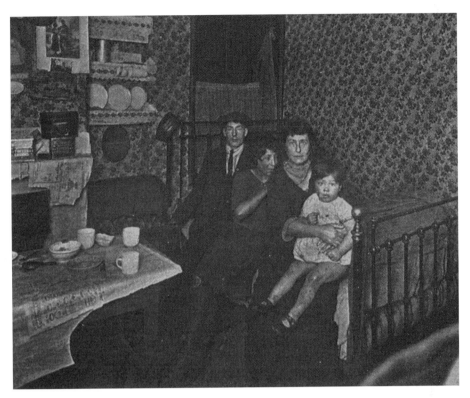

Fig 23 Photograph from *The Road to Wigan Pier: Bethnal Green*, Anon, *c*.1937 (© Anon)

I think these points about Orwell's anti-romanticism are important, because they suggest that by the late 1930s aspects of the new documentary had become habitual. This is why it is more profitable to read *The Road to Wigan Pier* as a criticism of the lack of self-consciousness in prevailing documentary modes. It also suggests why it was so widely attacked on the left.[21] Orwell's sideswipes from the sidelines, though, did little to disrupt the construction of a documentary culture devoted to idealised or pastoral images of the working class. As in Germany, both documentary and its proletarian critics were grounded intellectually in the dominant positivism. But unlike Germany, given the weakness of avant-garde culture generally, there was no disruption of this hegemony in response to debates on montage or a 'machine aesthetic'. (What debate on geometric and abstract form there was, was in the area of painting and sculpture.) Avant-garde opposition to the new documentary was largely invisible.

The presence of workers' photography was also faint. Workers' photography in Britain began with the formation of *Workers' Illustrated News* (*WIN*) in 1929, a British counterpart to *AIZ*, formed like *AIZ* under the aegis of the Comintern. Lasting for three issues, it claimed in its first issue to 'translate the politics of revolutionary class struggle into pictures'.[22] *Workers' International Pictorial* preceded *WIN* in 1924–25, but this was primarily a magazine devoted to images of Soviet achievement and international comradeship. *WIN* was the first magazine in Britain to encourage worker-photographer correspondents and included positive images of class combatancy and pastoral images of class community. The example of *WIN* fed into the Workers' Camera Club which was

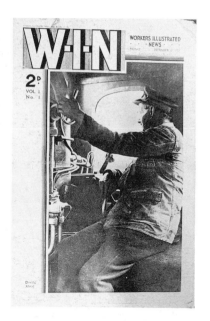

Fig 24 *WIN* (*Workers' Illustrated News*) (cover), 1:1, 13
December 1929 (Courtesy of Terry Dennett)

formed in the early 1930s in the East End of London, basing itself it seems on the
American worker photography groups. In 1934 the Club agreed to merge with the Film
and Photo League which was formed in 1933 in London in response to the interventionist
cultural directives of the International Workers' Theatre Olympiad in Moscow in May of
that year.[23] The outcome was the Workers' Film and Photo League. In the brief period of
Comintern influence (1934–35) the organisation asserted the need for a combative
proletarian documentary culture. As it argues in its first *Manifesto*:

> Workers' Film and Photo League thinks the time has come for workers to
> produce films and photos of their own. Films and photos showing their own
> lives, their own problems, their own organized efforts to solve these problems
> ... The League will produce its own films giving a true picture of life today,
> recording the industrial and living conditions of the British workers.[24]

It is not clear whether Orwell's distaste for middle-class social anthropology was at the
same time an endorsement of this kind of thinking. However, whatever his sympathies,
by the time he was writing *The Road to Wigan Pier* this combative proletarian culture
was on the wane, being subsumed via the turn to the Popular Front into the new
documentary culture generally. The second *Workers' Film and Photo League Manifesto*
was shorn of the earlier proletarianism. As Terry Dennett says:

> The 'Popular Front' tactic demanded a complete reorientation not only of
> policy but also of organizational structure. This involved the deliberate closure
> of several successful organizations ... and the running down of many national
> organizations with 'class against class' policies, especially those whose
> 'agitprop' structures were not amenable to multi-class propaganda.[25]

By 1936–37 a certain ideological convergence occurred between the new documentary
and its proletarian critics. For new documentarist and worker photographer alike, images
of working-class community or loss of community and of the dignity of labour defined

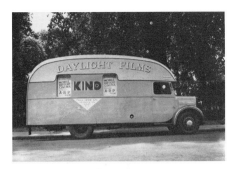

Fig 25 Workers' Film and Photo League, *Daylight Kino Van*, John Maltby, 1935 (Courtesy of Terry Dennett)

Fig 26 Workers' Film and Photo League, *Cambridge Bus Strike*, John Maltby, *c.*1935 (Courtesy of Terry Dennett)

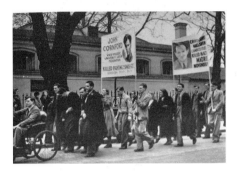

Fig 27 Workers' Film and Photo League, *Spanish Civil War March, Cambridge*, John Maltby, 1937 (Courtesy of Terry Dennett)

what was acceptable and popular. The result was an alignment with the idealised communalism of post-1930s Soviet socialist realism. Thus although British documentary was constructed from very different ideological materials (loss of community, economic depression, English pastoralism), it nevertheless, like Soviet labour photography of the time, produced a certain ideological closure around the representation of the everyday. 'The representations of 30s documentary ... ended by closing down the very visibility of difference which the observers had set out to raise.'[26] The 'everyday' in Orwell's 'bad imaginary' became located solely in a narrow range of images of class identity (whether sentimental or melancholic) producing codes of accessibility and the political which formed the basis of reform documentary practice.

One of the familiar themes in criticism of photography and art in Britain during the period 1925–39 is the absence of a sophisticated theoretical culture along European lines. The Marxism on offer, through the Communist Party, the Labour Party, the Independent Labour Party and the independent left, was, commentators argue, extraordinarily homogeneous: a stodgy mix of crude ideology-critique, proletarian expressionism and positivism. For these theorists and activists the cultural struggle was self-evident: there was a thing called bourgeois culture which reflected the dominant ideology, and a thing called working-class culture which represented progressive proletarian values. As Stephen G. Jones says, such thinking reflected 'the immaturity of British Marxism in the inter-war years'.[27] Positivism and proletarian expressionism were of course no strangers to Soviet and German culture – this was how a great deal of photographic theory sought to distinguish its interests from what was perceived as the anti-scientism of bourgeois culture. Yet even so, this severe judgement is difficult to disagree with. By the time of the

Popular Front, and in the absence of any real knowledge of the intense debates within the early avant-garde, a defence of an 'art of the everyday' had fallen under the sludge of a Stalinised positivism. The reviews, journals and newspapers of the left at the time all followed this model. The *Left Review*, dominated mainly by Stalinists and fellow travellers (although it gave space to Herbert Read to defend surrealism and geometric art), is a good example of this. Here is F. D. Klingender in his essay 'Revolutionary Art Criticism' published in October 1935: 'Art can face the facts of social reality, and point towards a method of their solution, or it can hide them and provide an escape from them'.[28] Klingender was the translator of Moholy-Nagy, and could be said to be one of the best Marxist intellectuals of his generation, yet he produced no extended engagement with photography. In fact what is striking is the absence of discussion of photography in the *Left Review* and elsewhere; at the same as it dominated the national culture the new documentary was theoretically barely visible; the full weight of a Stalinised positivism was applied to painting and literature.

That British intellectual life on the left in the late 1920s and 1930s did not produce a Benjamin or an Adorno, or even a Meyer Shapiro or Moholy-Nagy, is not just to reveal the ideological strength of a provincial Stalinist culture, but to show how middle-class intellectual production generated an actual *fear* of theoretical engagement with everyday culture. There is an almost risible indication of this in Maurice Richardson's 1937 article on Mass-Observation in the *Left Review*. 'It is interesting to note that working-class observers are far more objective in their attitude than the intellectuals.'[29] Sentimentalism and anti-intellectualism posing as class solidarity – everything that Orwell rightly hated.

There was very little space in or around the British Communist Party, therefore, for a sophisticated discussion of photography and film. As with the Labour Party, the Communist Party wanted a 'documentary' of the everyday that served the immediate needs of the working class. Yet, even at this level, it was largely uninterested in funding institutions on the ground. This is why pre-Popular Front the relationship between the Communist Party and photographers and film-makers is a history of underfunding, ideological indifference and fluffed opportunities. The same could be said of the Labour Party, which wanted a workers' film and photography culture in theory, but in practice did not want to do much about it for fear of antagonising its right wing.

In the light of this the Workers' Film and Photo League was a missed opportunity for independent photography and film – a point where realignments could have been made. However, this is not to indulge in national nostalgia. Rather it allows us to point to how historical contingencies – in this instance the powerful suasions of the Popular Front – can block certain avenues of development. Although it would be foolish to say that the League was in an unassailable position to develop an independent critical existence from a Stalinised Communist Party, in the course of its activities it could have played a considerable role in opening out a theoretical culture of the everyday in ways that avoided the adaptive pitfalls of Grierson and Mass-Observation and the idealisations of the Stalinists. It could, therefore, have turned around the provincialism of much British cultural work at the time by becoming a pole of attraction for documentarists and the avant-garde. There is a sense of this in Paul Rotha's rather melancholic *Documentary Diary*. Rotha's marginalisation in the late 1930s, his impending sense before the war that the documentary *movement* was over, is touched by the feeling that a radical culture of the everyday was lost in Britain during this period through ideological confusion and aesthetic indifference.

By 1939 documentary in Britain was consumed by the categories of Popular Frontism. After the war, with the arrival of the big circulation illustrated magazines and the development of the commercial cinema, documentary became *professionalised* as journalism, and started its short road to successful incorporation into the dominant centres of bourgeois power, radically restructuring the relationship between photographic culture and its audience in the post-war world. It is this intensification of the debate over documentary, the everyday and professionalisation that I now want to look at in the USA from the 1920s onwards: that is, the way that theories of authorship in photography fed into documentary practice and the crisis of the everyday, to produce photographic Modernism.

Notes

1 John Grierson, 'Flaherty', in Forsyth Hardy (ed.), *Grierson on Documentary*, Faber and Faber 1979, p. 30.
2 John Grierson, 'First Principles of Documentary', in Hardy (ed.), *Grierson*, p. 36.
3 John Grierson, 'Searchlight on Democracy', in Hardy (ed.), *Grierson*, p. 100.
4 John Grierson, 'Education and the New Order', in Hardy (ed.), *Grierson*, p. 129.
5 Stephen G. Jones, *The British Labour Movement and Film 1918–1939*, Routledge 1987, p. 38.
6 *Ibid.*
7 Paul Rotha, *Documentary Diary: An Informal History of the British Documentary Film, 1928–1939*, Secker & Warburg 1973, p. 33.
8 See Jones, *British Labour Movement*.
9 Shulamit Volkov, *The Rise of Popular Antimodernism in Germany: The Urban Master Artisans, 1873–1896*, Princeton University Press 1978, p. 351.
10 Charles Madge and Tom Harrisson, *Mass-Observation*, pamphlet, London 1937.
11 Julian Symons, *The 30s*, Cresset 1960, p. 113.
12 Gary Cross, 'Introduction: Mass Observation and Worktowners at Play', in Gary Cross (ed.), *Worktowners at Blackpool: Mass-Observation and popular leisure in the 1930s*, Routledge 1990, pp. 9–10.
13 See *Camerawork* 11 (1978), in particular Derek Smith and Tom Picton, interview with Humphrey Spender, 'Humphrey Spender: M.O. Photographer'.
14 See *Camerawork* 19 (1980).
15 Steve Edwards, 'Disastrous Documents', *Ten: 8* 15 (1984), p. 17.
16 George Orwell, *The Road to Wigan Pier*, Victor Gollancz 1937.
17 Raymond Williams, *Politics and Letters: Interviews with New Left Review*, NLB 1979, p. 391.
18 Orwell, *The Road to Wigan Pier*, p. 157.
19 *Ibid.*
20 *Ibid.*, p. 200.
21 For a discussion of this see John Taylor, 'Picturing the Past: Documentary realism in the 30s', *Ten:8* 11 (1982).
22 *Workers Illustrated News* 1:1 (1929), p. 2.
23 See Terry Dennett, 'England: The (Workers') Film and Photo League', in Terry Dennett, David Evans, Sylvia Gohl and Jo Spence (eds), *Photography/Politics: One*, Photography Workshop 1979.
24 *Ibid.*, f.n. p. 103.
25 *Ibid.*, f.n. p. 114.
26 Edwards, 'Disastrous Documents', p. 22.
27 Jones, *British Labour Movement*, p. 54.
28 F. D. Klingender, 'Revolutionary Art Criticism', *Left Review* (October 1935), p. 39.
29 Maurice Richardson, 'Mass Observation Day Survey', *Left Review* (Nov. 1937), p. 625.

4

The state, the everyday and the archive

Documentary in the USA in the late 1920s and early 1930s developed under very different conditions from that of Britain, although the impact of Popular Front politics exerted a similar impact on artists and photographers in the mid-1930s. What distinguished the 'factographic' culture of the late 1920s in the USA from Britain was that it could call on particular photographic precedents, establishing a certain continuity between industrial culture and the photographic document. Admittedly, much of this early photographic culture was reclaimed in the 1930s during the Depression, but nevertheless, there was a recoverable space (or spaces) within the national tradition that the new photography could call on as strong points of identification. This is why early American Modernism with its valorisation of the machine, and American industrial and technological culture generally, had such a huge impact on Soviet and German photography in the 1920s. America's evident disregard for European classical precedents, its incorporation of photography into debates on art within an urban context, seemed to presage an art 'beyond' the confines of traditional art history, offering very different kinds of cognitive spaces and imaginative identifications for the modern metropolitan artist. American vernacularism was thus seen to be extraordinarily liberating. All the leading Soviet photographers and film-makers in the 1920s acknowledged this at some level.

Even Alfred Stieglitz's and Alfred Langdon Coburn's romantic urbanism appeared to offer the possibilities of a post-artisanal aesthetic. Stieglitz may have wanted to re-aestheticise photography, but he wanted to do it without the trappings of spirituality in a modern, industrial culture. Thus, by the time Lewis Hine was working for *Survey* in 1910, the American industrial and urban scene had become associated with a radical contemporaneity. Of course, Hine was ill-disposed towards Stieglitz's and Coburn's incipicient Modernism, but all looked to the industrial landscape to de-academicise photographic practice. The 'American everyday' became the *raison d'être* of US cultural identity. Hine, naturally, was not involved in the production of photographic *art*, but his work, no less than Stieglitz's and Coburn's, participated in the formation of a national,

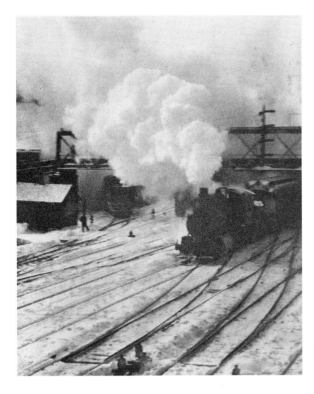

Fig 28 *In the New York Central Yards*, Alfred Stieglitz, 1903 (© Library of Congress)

Fig 29 *Pit Boy*, Lewis Hine, *c.*1905 (© NMPFT / Science and Society Picture Library)

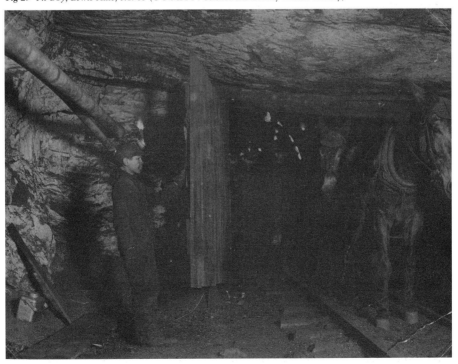

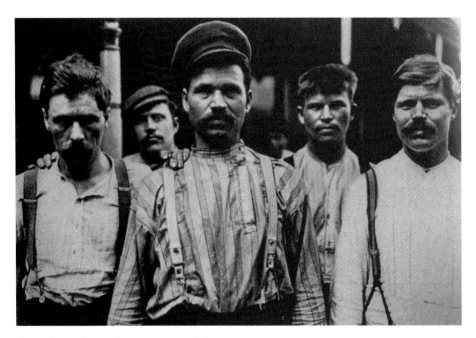

Fig 30 *Slavic Labourers*, Lewis Hine, 1907 (© Anon)

industrial cultural identity. Thus we need to recognise that Hine's early work was more than simply the *product* of the American reform movement, rather it was a self-confident expression of the meeting between the new photographic technology, the industrial base of US capitalism, and American liberalism. Here was a photography that showed the advance of American liberalism through the social uses of photography, *and* how powerful US capitalism was becoming on a world stage. In this respect Hine's commitment to working-class struggle was no less a participant in the 'glamour' of machine culture than Coburn's and Stieglitz's urban pastoralism. It is no accident, then, that Americanised notions of the everyday in this period find such a receptive audience in the Soviet Union and Germany. American culture did seem to offer up images of modernity that embraced the terror and sublimity of the new capitalism.

By 1908–9 Hine was forging a photography of the 'everyday' that was far in advance of anything being produced in Europe. In his 1909 speech on 'Social Photography' to the National Conference of Charities and Corrections, he declared: 'Whether it be a painting or a photograph the picture is a symbol that brings one immediately into close touch with reality.'[1] What takes this far beyond Coburn and Stieglitz is that the 'real' or the 'everyday' is associated with the representation of *social and productive relations*. Hine wanted to bring his audience – which was predominantly middle-class liberals as well as trade unionists and social workers – into close proximity to the manufacturing process. On the one hand, this was to show what the real cost of the manufacturing process was on the working class, and on the other, to show that labour is the basis of the industrial modernity that the Modernists were celebrating. This is why it behoves us to recognise how important the frontality of the subject in Hine's photography is for his notion of realism. By the 1870s severe frontality in painting (borrowed itself from the emergent photography) was reconstituting concepts of the 'natural' and the 'real' in French

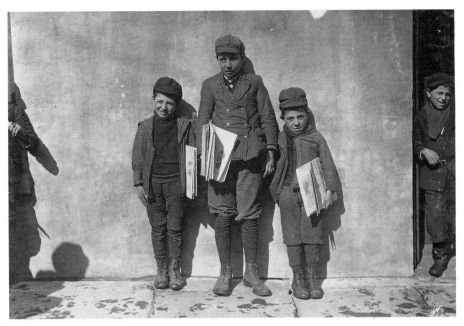

Fig 31 *Hartford, Conn., Newsboys*, Lewis Hine, 1909 (© Library of Congress)

painting, the chief example being Manet's work. Frontality signified that *nothing was hidden*, in the sense that a sitter for a photographic portrait was by looking direct to the camera exposing himself or herself to an 'objective' perceptual process. To the spectator of a painting, frontality of posture and eye-to-eye contact signified a similar 'honesty' (or brutality according to the depth of your aesthetic investments in the pleasures of beholding a scene in which the participants are unaware of the spectator). This frontality in early Modernist painting establishes a dialogic extension of the tension between theatricality (the acknowledgement of the spectator) and absorption[2] (the denial of the spectator) found in eighteenth-century history painting.

In Hine's photography the same principle applies: frontality is embraced essentially as a democratic convention, insofar as its intersubjective address stands as a metaphor for the beginning of a conversation. For Hine, though, this relation is a class-conscious act. For the child labourer or male or female worker to stare out of the photograph with a certain pride and autonomy is to transform the object of the capitalist labour process into the subject of that process. This was profoundly radical and must have been profoundly disturbing for those used to seeing the poor and workers as the passive object of their gaze. In fact, Hine was constantly worried that the seeming autonomy of his subjects actually undermined his case for labour reform. As a consequence, he sought a median position for his subjects between abjection and self-assertion, taking care to find subjects that did not look completely beaten down by their work and environment or subjects that looked at ease in their circumstances. This balancing act was difficult; the signs were always being misread; subject collapsed into object and object into subject according to who was looking and judging. This problem of course goes to the very heart of the photographic act itself, and prefigures all the major assessments of photography as a documentary enterprise from Benjamin onwards: the essential instability of the

subject – object relation in photography.

In her essay on Hine's work for the Red Cross in Europe in 1918, Daile Kaplan stresses that Hine's frontality-as-dialogism has its origins in pre-industrial traditions of co-operation 'rooted in the moral landscapes of nineteenth-century New England and the West, where mutual concern for the functional uses of art gave rise to new forms of expression at once individualistic and democratic'.[3] This vernacular tradition, exemplified by the writing of Ralph Waldo Emerson, was concerned with comprehending a diversity of places and people in specific, 'factual' terms. 'I sit at the feet of the familiar', Emerson said.[4] In literature this functionalism finds one of its major expressions in the transcendental naturalism of Walt Whitman. In Whitman's *Leaves of Grass*, published in 1855, the author identifies himself with the everyday experiences of 'everyman' and 'everywoman'.[5] As Kaplan says: 'Whitman's audacity lay in proposing an alternative model of the American hero. Like the central character in Hine's street photographs, the new man inhabiting the New World was urban and common.'[6] Communality was a pervasive concern within the early liberal tradition, particularly in rural areas where the pre-industrial ideal of a commonwealth of producers (inherited from the radical protestantism of the New England founders) remained strong. These tributaries flowed together in the 1880s with the development of the Populist Movement, a self-help organisation of farmers and rural workers formed initially on the edge of the Great Plains. The political organisation that provided the basis for the movement was the National Farmers' Alliance and Industrial Union. Although it was established in the South, by 1892 the National Alliance had reached into forty-three states, recruiting impoverished farmers and rural workers who were to constitute the mass base for the future party of the movement, the People's Party. The aim of the movement was no less than the structural reform of capitalist agriculture.[7] For a long period the dominant influence in agrarian regions was entrepreneurial capital. Consequently the movement sought to overcome the power of the Eastern merchant banks and their aggressive attempt after the Civil War to accelerate the process of land centralisation. Key to this process was 'crop lien'. Whether farmers owned their land or not, they had to find a way of obtaining food and clothing during the long period when their crop was growing. Particularly in the South, they got their supplies by mortgaging their crop to the bank, which then lent the farmer money at an extraordinarily high interest rate. This system naturally created mass immiseration as the farmer was rarely able to 'pay up'. By 1940 most 'landowners' were locked into permanent indebtedness.

What the National Alliance demanded was an end to this peonage. The result was a powerful mass movement of the landless and poor, at the core of which, to quote Lawrence Goodwyn, was a 'dream of [a] cooperative commonwealth'.[8] Although the movement was not expressly anti-capitalist, it nevertheless furnished a 'mass culture of hope and self-respect among the voiceless'.[9] 'A certain democratic ethos emerged.'[10] However, by the turn of the century the movement as a political organisation had disintegrated through internal conflict and a disappointing performance at the polls. Yet this dissenting agrarian tradition and democratic ethos did not disappear completely, but fed into the non-deferential aspects of the liberal tradition and American popular culture generally. Hine was very much heir to this, particularly through the liberal communalism of John Dewey, who was first an influence on Hine when Hine was studying education in the early part of the century.

Dewey's process-orientated education theory stressed the need for the teacher to

develop in his or her pupil the art of social seeing, that is, the ability to find the common in the everyday as a shared experience. In 1934 Dewey published a book on art, the largely forgotten *Art as Experience*, which summarised his position on culture and pedagogy.[11] Although there is a certain conservatism in his views on art derived in part from his response to European avant-gardism, it is nevertheless revealing how much of what he argues for overlaps with the demotic factographic culture of the period. Dewey asserts that the experience of the artwork should not be confined to its physical state (what is given in perception), but understood as a process (as something which establishes social relations between human beings). The value or strength of an artwork therefore depends upon how it encourages these dialogic powers. The successful artwork produces a heightened form of everyday experience.[12]

This is not far removed from Soviet productivism or Benjamin's dialogic reading of it, or Weimar functionalism. George Herbert Mead, a pupil of Dewey's, extends this principle by arguing that successful art does not create social consciousness in the abstract, but through a process of empathy with the 'other'.[13] The very act of engaging with a work of art creates sociality. Again we are in the realm of the intersubjective: the human subject of the vivid artwork should act as a call to the humanity of the spectator. For Hine, though, this call was not simply an inducement to the spectator to feel concern, but a means of placing the experience of his subjects in imagined conversation with the spectator as rational critic of the world. The ensuing dialogue, then, is necessarily split across class lines. For the worker-spectator or trade unionist the dialogue is a confirmation of shared interests and class interests. For the middle-class spectator the dialogue disrupts the limited concept of bourgeois autonomy to assert that both worker and non-worker coinhabit a shared industrial world, in which some, the majority, suffer at the hands of this system more than others. This conversation is obviously the one that preoccupies Hine and his reform patrons. In Deweyian terms there can be no real communality until those with power see that their humanity is constantly disfigured by the very existence of those who have no power.

The consequence of this is that Hine's dialogism is bifurcated by a powerful ideological tension between Deweyian communalism and the realities of a class system that cannot be healed through intersubjective empathy. Hine's work may have deep roots within the liberal communal tradition, but it also recognises the material interests that prevent human community. As such, to overemphasise the image of imagined community in his work is to deny the violence of disconnectedness that is also there. Hine's factory workers may appear to be engaging in everyday conversation with us, but they are also not of 'our' world. They are forced to exist in a world of alienation and disconnectedness. And this is what makes the early photographs so compelling: the essential object–subject ambiguity of the human presence in photography becomes a metaphor for the very experience of the working class itself.

Hine's work forms a significant contribution to the development of a class-conscious reportorial culture in the USA, drawing on an indigenous liberal communalism as a source of cultural resistance to the new capitalism. In this respect Hine was perhaps the first photographer of industrial subjects to see photography as a means of identifying and producing a class-based community of interests. However, whatever success his work had through the reform agencies in the early part of the century, this did not mean that Hine was in a position to transform the emergent photography in his own image. Hine's work was largely perceived at the time as an extension of social work. In the 1920s during the

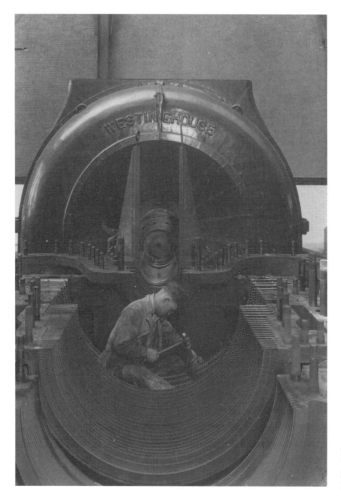

Fig 32 *In the Heart of a Turbine*, Lewis Hine, 1932 (© NMPFT / Science and Society Picture Library)

boom there was no ideologically confident reportorial culture that was in a position to support and extend Hine's interventions. In fact, talk of a continuity in American reportorial photography in the first three decades of the century is a myth. Hine's work became 'lost to view' in the 1920s and had to be *rediscovered* in the 1930s by a new generation of photographers. Despite the powerful precedents of Hine's work at the beginning of the century, his photography was not received with much enthusiasm in wider cultural circles. Photography itself was still very much on the defensive in the 1920s, particularly photography that based its aesthetic effects on forms of social interaction with its subjects. Coburn and Stieglitz had managed to move photography more centre stage, but at the very expense of what Hine was arguing for. As Allan Sekula and others have pointed out, Stieglitz's recourse to an assertive aestheticised model of photography sought to carve out a respectable institutional space for the photographer as author.[14] Reworking pictorialist debates about the *craft* of photography, the social function of photography, and therefore its scope for communal dialogue, was subordinated to the sensitive, aesthetic disposition of the photographer. This obviously had great appeal to those cultural institutions who were continually worried about

photography's creative status, and the fact that too much of the world spoke back through photography, ridding the 'everyday' of the pleasures of poetic distance. Stieglitz offered them a photography with the 'everyday' suitably aestheticised.

The institutional success of Stieglitz's Modernism in the 1930s, then, was forged out of a rejection of the liberal communal tradition, at the same time as it shared in that tradition's national/populist symbolisation of the American industrial 'everyday'. It is ironic, therefore, that those who set out to reclaim Hine's reputation in the 1930s did it from within an emergent Modernist framework. In 1939, the year of the hundredth anniversary of the invention of photography, Hine was given a retrospective at the Riverside Museum in New York. This was co-arranged by an alliance of young critics, the old left and socially engaged photographers. Lifting his images from the pages of magazines and onto the gallery wall, the show endorsed his singular contribution to the American photographic scene. As Alan Trachtenberg puts it: 'The event confirmed Hine's incorporation into the canon of the medium then being shaped, as the exemplary "documentary" photographer.'[15]

This was a significant moment for conceptions of the everyday in American photography in the 1930s. Under the impact of the Depression and the influence of European factographic culture, the social function of photography in the USA moved into a position of public and confident opposition to the Modernists. And, overwhelmingly, the 'primary scene' of this conflict was the work of the Farm Security Administration (1935–39) in which the liberal communal legacy of Hine and the new European factography steered photography back into an archival role. In conditions of social crisis the aestheticised and selective appropriation of the 'everyday' made no sense; in fact it was perceived as a form of cultural violence against the real. What was required was an extensive accumulation of social detail. In this the FSA's use of photographers such as Walker Evans, Dorothea Lange and Ben Shahn to record the lives of the rural poor in the South provides the first conscious evidence within American photography that the category 'documentary' carried with it a particular political inflection, separate from mere notions of reportage. That is, the FSA photographers enjoined American photography, via the legacy of Hine, to that earlier reformist and functionalist account of the photographic enterprise as a continuous, unfolding social archive. Consequently the FSA represents the point where notions of reportage in American photography became codified as documentary. Documentary was used to distinguish itself from Modernism on the grounds of its 'systematic' exposure of the social world. Like Mass-Observation the FSA embraced the categories of social anthropology as a means of separating itself from photography as an occasional activity.

However, the FSA established a very different kind of social intervention for photography than Mass-Observation, even if they both endorsed documentary as an archival practice. The FSA was first and foremost a response by the US state to the economic and social crisis of the mid-1930s. The effect of the Depression on the rural South and South West was so great that hundreds of thousands of farmers and rural workers were displaced. The FSA was a rural rehabilitation agency set up under Roosevelt's New Deal to provide help to those who were destitute or on the verge of destitution. To facilitate this and provide evidence of what was happening in the South, the agency set up a Historical Section to employ photographers. The result was an extensive record of one of the worst affected areas of the Depression. By 1935 almost half the people working the land in the South were reduced to tenancy; most of the remaining

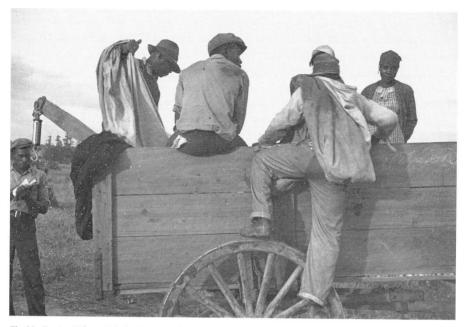

Fig 33 *Cotton Pickers, Pulaski County, Arkansas*, Ben Shahn, 1935 (© Library of Congress)

'landowners' were in debt. The average income of a sharecropper was $312 per annum and itinerant farm labourers might earn around $300.[16] In fact Roosevelt's Agricultural Adjustment Administration did little for the poorest. By advising farmers to plant less it simply exacerbated the worst effects of crop lien, in many cases forcing sharecroppers and tenants to leave the land.

Mass-Observation archival work was never structurally attached to the state in this way. The research findings of Mass-Observation were undoubtably used by state departments to monitor working-class life, but at no point did the organisation operate for the state. In contrast the FSA was a state-funded information agency, established in the interests of producing a positivistic science of the 'everyday' that might both help the reorganisation of agriculture and provide the public with images that showed the government was 'on the case'. It was the latter of course that was eventually to dominate the running of the agency, as images of the South came to define how the Depression was portrayed to the American people, in much the same way that images of the industrialised North of England defined the Depression for Britons during this period. The agency, then, was increasingly called upon as a national publicity outlet. The result was that the FSA became more than an archive *for* images, a 'non-prejudicial' gathering of sociological data. On the contrary, as its images were subject to subtle and not so subtle editorial manipulation in the outside world, the organisation became a contentious site for the competing claims of the social function of photography and new documentary. Under pressure from central government for the agency to play down the 'leftism', and in the face of the populist demands of magazines eager for affecting images of the tragic, the FSA photographers had continually to negotiate their autonomy as committed photographers.

The bourgeoisie cannot rule through coercion alone; civil society is a contested space in which the integration of the working class into bourgeois society is effected through

an ongoing process of negotiated settlement between the bourgeoisie and the bureaucratic leadership of the working class (trade unions, social democratic parties). In times of social stability the balance of class forces is in the favour of the bourgeoisie, hence the effective marginalisation of the popular influence of the left. In times of economic or social crisis, though, the possibility of the loss of working-class confidence in bourgeois rule becomes a reality, creating a potential or actual shift in the balance of class forces towards the working class. In such periods governments are desperate to make concessions to the left – if outright repression is not an option – or are prepared to put on a 'left face' themselves. For what is of paramount importance is the *management* of the crisis. This is what occured under Roosevelt's New Deal government of the 1930s. The economic and social crisis of the early 1930s was so deep – in 1933 industrial production was down by 50 per cent and around 15 million people were unemployed – that it was necessary for Roosevelt to make concessions to the left and to non-market forces. The huge public works programmes (road building, inner city reconstruction) and democratic cultural initiatives involving workers and artists (such as the Works Programme Administration) were an attempt to get millions off the dole and re-establish US economic confidence. The development of a populist leftism within the working class, which owed something to both socialism currents and liberal communalism, transformed American public culture in non-deferential and self-activist directions to which the government was happy to pay lip service but in reality considered a threat. As Howard Zinn has argued, Roosevelt's reforms had to confront two pressing needs: 'to reorganize capitalism in such a way as to overcome the crisis and stabilize the system; also, to head off the alarming growth of spontaneous rebellion in the early years of the Roosevelt administration – organization of tenants and the unemployed, movements of self-help, general strikes in several cities'.[17] To do this the government obviously had to establish its influence within, and hopefully direct, this groundswell of popular radicalisation.

The FSA, then, had a very different role to play in the construction of a national populist imagery of community and nation from that of Mass-Observation. Photographs from the FSA archive were published in mass-circulation magazines that were edited by staff who saw their role as intervening in the public domain on behalf of the government and the national interest. There are obvious connections with the public dissemination of documentary as the voice of national conscience in Britain. In the USA, though, this was state-sponsored in highly conscious ways. It is this aspect of the FSA programme that has naturally received a great deal of critical attention. What the FSA embodies, according to this writing, is the unprecedented use of the photographic archive by the state to produce forms of ideological consensus. The history of photography is unambiguously a history of its ideological use by the state, but in this instance the public use of photography stands as the modern precursor of the *structured consensus building* of a post-war media-saturated culture. In short, the FSA is on the cusp of the society of the spectacle, and the increasing awareness of governments about the ideological significance of mass communications. The social and economic crisis of the Depression had to be represented, and it had to be represented from a position of sympathy with the poor and dispossessed, but these forms of representation had to be controlled: that is, guided into the safe waters of human tragedy and national populism, rather than the murky waters of class struggle. Thus in the opinion of John Tagg, whose writing on the FSA has been most associated with this position, the FSA was the point where documentary photographic practice became incorporated into the state machinery of social democratic reformism.[18]

Photography records the misfortunes of 'others' in order to petition the 'people' for the need for social change, the desired effect being that the 'people' will view things as so bad as to bring pressure to bear on their elected democratic representatives to change things. To do this photographically it is necessary to construct forms of cross-class identification that can divest the crisis of its class realities. As with Hine's dialogue between the worker and the middle-class spectator, and much of the photography produced by Mass-Observation and others in Britain in the 1930s, this was predicated on dominant populist notions of 'lost community' and damaged national identity. In this the legacy of liberal communalism served the government well, insofar as it provided both a popular non-conformist and traditional patriotic framework in which the crisis could be represented. The Dust Bowl farmers and rural workers became a part of a 'lost community' of American citizens, and yet in their adversity remained part of a wider mythologised imaginary community of 'true' or 'typical' Americans: the original pioneers and homesteaders. As the FSA's images filtered out into American life, they were used to provide discursive evidence for this American Tragedy. The Depression was seen as the result not of conscious economic processes, but of unforeseen and controllable forces that were exceptional and therefore in need of patient remedy and not radical transformation. However, to judge the FSA as participating in the work of ideological state management is not to view this process conspiratorially as if Roy Stryker (the FSA administrator) and his superiors had an ideological blueprint worked out. Rather, it reveals in fairly graphic terms how the negotiated space of civil society subjects the individual to certain ideological and material constraints of bourgeois rule beyond the will of that individual. Representation of the everyday through the main channels of communication in bourgeois society (mass circulation magazines, TV, film) is anchored under ideologically weak collectivities such as 'humanity' or 'the nation'. The specificities of class are allowed into these collectivities on the grounds of their contribution to rich and expanded notion of human identity.

Thus what is significant about the experiences of the FSA is the profound lesson it offered photographers in the late 1930s about the realities of the contemporary capitalist state. The theorisation of the new reportorial photography in the late 1920s and the early 1930s on the back of a relatively confident labour movement had been part of a wider sense that the new technologies provided the means for the hegemonic advancement of working-class interests. Benjamin's 'The Work of Art in the Age of Mechanical Reproduction' is a familiar example of this. The new photography was concerned not just with winning back the 'everyday' for the working class but with reconstructing it in its interests. The experience of the FSA showed to the first generation of post-Bolshevik and post-Weimar radical photographers how difficult such ideals actually were. Radical photographers may organise themselves into autonomous groups, they may show their work to working-class audiences, but how the images signify within the culture, how they are received and used, was largely determined by the main centres and agencies of the capitalist communications industry. The early hopes of the FSA photographers (in particular Dorothea Lange and Ben Shahn) are no different from those of British documentary photographers of the same period. Yet although a certain public space was conceded to documentary with the shift in the balance of class forces, the FSA had to deal with a powerfully entrenched mass communications industry that openly despised Roosevelt's New Deal policies. Indeed, it is one of the distinguishing characteristics of the construction of the category 'documentary' in the USA that progressive notions of the

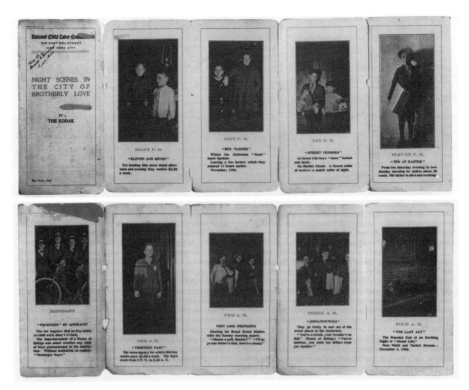

Fig 34 *Night Scenes in the City of Brotherly Love* (leaflet), Lewis Hine, 1907 (© National Child Labour Committee Archive)

'everyday' were contrasted ideologically with advertising and corporate cultural values generally. There are significant overlaps here with the development of British documentary. But in this instance it was not popular entertainment that was seen as the destroyer of communal working-class identities, but a newly voracious world of advertising, intent on replacing collective values with competitive individualist and cloyingly familial ones. Advertising was the highly visible mediator of the American Dream. Even Lewis Hine in the early part of the century had begun to incorporate a critique of the power of the new advertising into his work. In his early anti-child-labour text and image montages and his quasi-filmic text and image sequence of night-time boy paper sellers (*Night Scenes in the City of Brotherly Love*) published in 1907, he was producing essentially anti-advertisements.[19] The relationship between photography and advertising this century is a complex and dialectical one, in which both advertising image and photographic image have fed off each other. The manipulative presence of advertising haunts photography's self-identity. Heartfield opposed the Nazis' self-advertisements at the same time as appropriating the rhetorics of advertising. Yet for the FSA the world of advertising was the overwhelming 'other' of what documentary as an art of the everyday might stand for. This is due, I believe, to the fact that advertising and its corporate values had even by 1935 a long history of domination in the USA and on public visual forms, increasingly threatening the independent identity of the photographer and artist. American Modernist photography largely constructed its own defence of the everyday as poeticised reverie in response to this environment; just as American Modernist painting was to do in Clement Greenberg's identification between

value and anti-populism in 'Avant-Garde and Kitsch' in 1939.

The world of capitalism's self-visualisation needs to enter the reckoning in our analysis of how the 'everyday' is constructed and mobilised during this period. Advertising – though this was of course to change – was seen by many FSA photographers as *un*-American. Its idealised view of America's 'greatness' was in palpable contrast to the realities of most working-class Americans' lives, and thus an affront to their dignity. In this respect it is interesting to note how a number of FSA photographers actually began to take photographs of advertising hoardings for ironic effect (Dorothea Lange, John Vachon, Russell Lee and Edwin Locke amongst others). More generally, though, the leading defenders of the FSA's interventionism, such as Ben Shahn and Russell Lee, saw documentary photography's powers of historical recall and remembrance as providing access to an America that an advancing corporate culture was seeking to overwhelm and that the Depression was brutally vanquishing. As James Guimond says in *American Photography and the American Dream* (1991), drawing on the importance of the liberal communal legacy for the FSA, the FSA had an:

> affinity for what might be described as American *ways* of living that were different from the bland, homogenized American Way celebrated on billboards. Their positive pictures usually contained images of regional cultures or eccentric, individual behaviour; they usually celebrated work, not consumption.[20]

Thus at the same time as documenting what had been done to rural communities in the name of economic reason, a number of FSA photographers were producing images of 'ways of living' that were not governed by the laws of the market. The effect of this was that the FSA's appeal to notions of 'lost community' was marked by a strong sense of continuity with non-urban democratic ideals, establishing the 'everyday' for documentary outside its dominant urban categories. These images, then, for example Arthur Rothstein's *Mr and Mrs Andy Bahain, FSA Borrowers, on their Farm* (1939), provided more than an idealised vision of social cohesion in 'troubled times', or in John Tagg's terms, evidence of state paternalism. On the contrary, the work of Rothstein and Lee, in particular, set out to show the complexities of such communities. These images were meant to be read as critiques of the market and what was perceived as the one-dimensionality of much urban living. This was feasible *because* of the legacy of communalism. The implied social cohesion of such images offered a kind of utopian distance from the alienations of corporatism. In effect, what the FSA produced in contradistinction to its official 'positivistic aims' was an extending and deepening of the non-deferential aspects of the liberal communal legacy and the new factographic culture, that until the Second World War were highly disruptive of dominant American culture. It is this local disruptiveness under the shift in the balance of class forces that Tagg fails to address fully. As with the growth of documentary modes in Britain, the FSA participated in an extensive working-class culture that brought workers into the audience for art and photography for the first time. Thus if we should be wary of exaggerating the political effects of this shift, we should at least acknowledge the complexity and diversity of the period's counter-hegemony. There were many other archive projects during this period. Many of these had a specific political agenda: reporting on the condition of blacks, the anti-war movement, the urban working class and youth.[21] A number of the photographers who worked for the FSA worked on these. Moreover, as Andrea Fisher

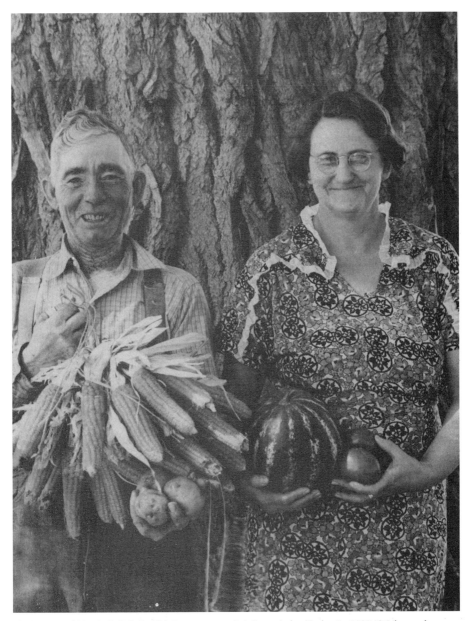

Fig 35 *Mr and Mrs Andy Bahain, FSA Borrowers, on their Farm*, Arthur Rothstein, 1939 (© Library of Congress)

has shown, the FSA employed a number of women photographers who in the late 1930s and 1940s produced a range of images that broke with dominant maternal images of the feminine. In *Let Us Now Praise Famous Women* (1987)[22] Fisher argues that one of the principal ideological props of the way FSA photographs were used to construct an American community under threat was the image of the maternal. She cites Dorothea Lange's *Migrant Mother* (1937) as a primary example of this, one of the most reproduced photographs of the period, so much in fact that it could be said to stand in iconically *for*

the Depression. For Fisher the way this image was cropped and contextualised reveals how much the image of damaged femininity came to symbolise the crisis of community for the American public. Anxious and in obvious poverty, the woman holds on to her two children, suggesting the power of maternal values to overcome the most dire of circumstances. Here is a woman who has lost everything, yet heroically, stoically keeps here family together. Here in essence was what the magazine editors were waiting for: an image of tragedy *and* resistance. That this image became so successful reflects how great a part gender played in the symbolic management of the Depression. The image of the damaged mother doubled as an image of damaged wholeness, effectively identifying the health of the nation with the health of the family. Such familial ideology has always played a prominent part in the construction of bourgeois formats of representation. It was relatively absent, though, from the documentary culture of the 1930s. The construction of the 'truths' of documentary in the 1920s and 1930s was largely based on the exclusion of the feminine. Images of damaged femininity as metonyms of social crisis were rare. Images of damaged masculinity invariably did this kind of symbolic work. Lange's image, therefore, is somewhat anomalous in terms of what was judged to be proper to documentary practice, even if it had a ready reception in the mass-circulation magazines and newspapers. Lange in fact produced a wide range of images of impoverished rural women that create a very different kind of rhetorical effect. In her *Daughter of a Migrant Tennessee Coal Miner Living in American River Camp, Sacramento, California (Vicinity), November 1936*, the woman as in Hine's work is pictured as an active subject. As Fisher says: 'she is not collapsed in dereliction; neither has she that hard bitten strength of years "leaning against the wind" ... here is a sense that, in Lange's appreciation of that other presence, Lange approached her not entirely as the knowing Mother, but also as a woman of equal complexity'.[23] Of course, the magazines did not want images of working-class women of 'equal complexity', just as they did not want images of black people organising amongst themselves from the other archives. Similarly there was no place in the culture for an extraordinary range of images of women by Esther Bubley, Marjory Collins and Ann Rosener taken in the late 1930s and early 1940s. As with Aenne Biermann in Weimar, Bubley, Collins and Rosener undermine the dominant positivism from within by naming what documentary finds impossible to name: the feminine. In these images of young women in various urban settings, the growing independence and *desire* of women (many of the women are pictured in distracted states or states of reverie) show the 'everyday' as the place where the material world and the psychic intersect. This seems to me to be unprecedented in this period, revealing the extent to which new commercialised forms of fantasy were entering working-class life. These are images that establish the feminine outside of the maternal and familial. Needless to say these photographs remained invisible in the culture. They failed to signify for both the dominant documentary and the commercial magazines.

In analysing the FSA's and other photographers' part in the representation of the Depression, we should be clear therefore about how unstable the term 'documentary' actually was. The FSA's dominant position through the state – and the dominance of certain photographers within the organisation because of this – was one expression of a complex interaction of forces and interests around the construction of the 'everyday'. Although the term 'documentary' became identifiable in the middle-class public's imagination with a few generic images (the impoverished mother, the poor but sturdy family, the forlorn unemployed man looking for work), the culture of documentary was

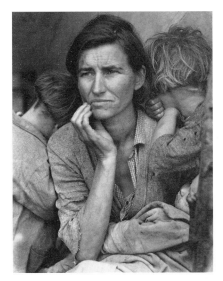

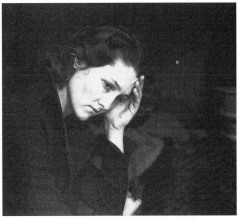

Fig 37 *Daughter of a Migrant Tennessee Coal Miner Living in American River Camp, Sacramento, California (Vicinity), November 1936*, Dorothea Lange, 1936 (© Library of Congress)

Fig 36 *Destitute Pea Pickers in California, a 32 year old Mother of Seven Children, February 1936* (Migrant Mother), Dorothea Lange, 1936 (© Library of Congress)

far richer and more heterogeneous than that. Under the imperative to represent the Depression, American photography came to effect a massive readjustment in what was taken to be significant in American corporate culture. In the process, for a short period of time, it produced a counter-hegemonic bulwark against an emergent state Modernism.

The term 'documentary' itself did not come into common use in the USA until the mid to late 1930s. Paul Rotha argues that it was not until the dissemination of British documentary film and critical writing in the USA that the term was taken up. As he says, 'until the introduction of our films in 1937–38, the influence of Grierson's writings circulating in the U.S. and perhaps the reaction to my own *Documentary Film* book, the use of the documentary label was unknown there'.[24] If there is hurt pride and exaggeration here – the term was in institutional circulation by the mid-1930s as other aspects of US culture came under the sway of 'factography', such as the Federal Theater Project's *The Living Newspaper* – the influence of early British documentary film has certainly been underacknowledged in the development of US documentary in the 1930s. Indeed, contrary to the idea of two separate cultures developing autonomously, there was an exchange of ideas and skills through a shared language. Paul Rotha spent a lot of time in the USA. Paul Strand even managed to visit the GPO Film Unit in Soho Square in 1935 on his return from Moscow, even if there was not much sympathy for his photographs of Mexican adobe huts.[25] By 1937 both Grierson and Rotha were hoping for an integration of American and British documentary as part of a 'common policy for the future'.[26] This of course was never to be as the war intervened for Britain in 1939 and then for the USA in 1941, and internal political division within the British documentary film movement in particular, and individual ambition, made the aim of an Anglo-American documentary movement increasingly unreal. Furthermore the very political success of the New Deal precipitated entrenched divisions in US documentary culture. As the New Deal funding put in place a huge cultural revival from below, it also speeded up

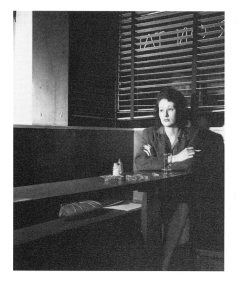

Fig 38 *Girl Sitting Alone in the Sea Grill, Washington*, Esther Bubley, 1943 (© Library of Congress)

Fig 39 *Sleeping in a Car*, Marjory Collins, 1942 (© Library of Congress)

a recognition of the critical oppositions between reform documentary and its proletarian avant-garde critics. More importantly, though, by 1942 the political situation in the USA had changed dramatically. The anti-fascist drive of the late 1930s was subjugated to national populist propaganda as part of the war drive. The New Deal critique of American culture and corporatism was now frowned on, and in fact vigorously opposed by the government; the left consequently found itself on the defensive. This affected the FSA and other cultural agencies directly, as photographers and film-makers were asked to produce 'reassuring propaganda'. Passing on a directive from his superiors, Roy Stryker was explicit about what was now needed:

> We particularly need young men and women who work in factories, the young men who build our bridges, roads, dams and large factories ... More contented-looking old couples – woman sewing, man reading ... coming from church, at picnics, at meetings.[27]

In short, pictures of migrant workers, Dust Bowl farmers, impoverished mothers, eroded land and the ravages of industrial life were just too depressing. The economy was picking up and all classes should support the national war effort. Stryker's direct injunction to idealise and sentimentalise could have come straight out of a socialist realist manual, pointing to how the fragile attempt by the FSA to open up the dominant categories of the 'everyday' was over. By 1941 this change of mood was already in place. In that year the FSA exhibited work at the Rockefeller Centre entitled *The Way of the People*. The exhibition was full of optimistic images, showing how strong, prosperous and healthy the USA was, how the depredations of the 1930s were now behind the American people.[28] Effectively from this moment on the link between photography, 1930s documentary ideals and a critical reading of the 'everyday' were disconnected in American culture. As a result photographic culture underwent a profound change in the conditions of its reception. At the end of the war and the start of the Cold War as the Soviet Union became

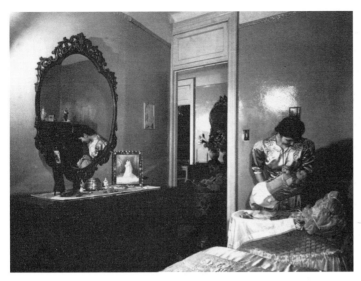

Fig 40 *Mrs Frank Romano Putting her Baby to Bed*, Marjory Collins, *c.*1943
(© Library of Congress)

the main enemy of American global interests, the non-deferential photographic culture of the 1930s was identified with un-American sympathies. Social critique was now associated openly with communist infiltration. The consequence was a *massive reversal* of the diversity of 1930s culture, as the new right and Republican/Democrat anti-communist alliance sought to expunge the liberal communal legacy of the New Deal from public life. One of the first victims of this was the Photo League which was still considered subversive enough in 1947 to be banned.

The history of the Photo League from the 1930s is, in fact, particularly revealing of the development of the documentary ideal in the USA, insofar as its own development reflects the political changes and tensions that interventionist photographic culture underwent in the 1930s and 1940s. The Photo League developed out of the Workers' Film and Photo League founded in 1930 (after 1933 it became known as the Film and Photo League). Like its British counterpart, the organisation was set up under the aegis of the Comintern to provide images of workers' struggles. The goals of the newly formed Workers' Film and Photo League were: (1) to struggle against and defeat reactionary film; (2) to produce documentary films reflecting the lives and struggles of the American worker; and (3) to spread and popularise the great artistic achievements of Soviet film and photography.[29]

In 1934 a dispute occured in the film section of the organisation. Should the League follow the daily struggles of workers through the use of newsreels and short documentaries (in the manner of Vertov) or should it produce large-scale campaigning films with actors? In that year defenders of the latter position decided to form a sub-group called Nykino. This discussion group wanted a more open approach to documentary practice, arguing for a more dramatic engagement with social analysis in film, and asserting the need for a greater theoretical assessment of documentary form itself. Loosely framed, this was the avant-garde wing; the other group stood by a Soviet-style Proletkultism and considered Nykino reactionary. In 1936 under the weight of this

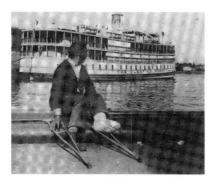

Fig 41 *'Floating Hospital', East River Dock, New York City, 1932*, Leo Seltzer, 1932 (Courtesy of Terry Dennett)

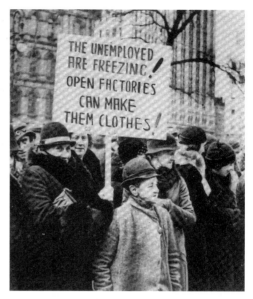

Fig 42 *Unemployed Women Demonstrate at City Hall, New York City, 1932*, Leo Seltzer, 1932 (Courtesy of Terry Dennett)

opposition the League split. The photographers – who had never had much power in the organisation – formed the Photo League without the Proletkultists, and Nykino regrouped to form Frontier Films. Frontier Films included Paul Strand as a member, who was to exert a considerable influence on the group. As Anne Tucker says: 'The members of Frontier Films and of the Photo League showed a commitment to documentary photography and its potential as an art form, not just a tool for mass communication or "art as a weapon".'[30] The Photo League had an open membership and an average of six exhibitions were held each year. Six issues of the group's newsletter *Photo Notes* were published annually between 1938 and 1948. Broadly, the group set out to produce, to quote from a *Photo Notes* editorial, an 'honest'[31] American photography. By the time of the split in 1936, though, this notion of 'honesty' had to a large extent become divorced from any explicit political programme. In 1933 the Workers' Film and Photo League had already expanded its range of urban proletarian subjects in order to respond to the New Deal. Subjects that were covered in this period were rural unemployment, the housing crisis, militarism and child misery. After the split this shift was reinforced under the impact of the new cross-class politics with their emphasis on social inclusiveness. As the San Francisco Photo League group argued in 1935: 'We want to seek subjects that are powerful and representative factors in the present struggle of social forces. We want bankers, workers, farmers (rich and poor).'[32] In 1942 after America's entry into the war this became an explicit form of cross-class anti-fascist populism. 'The first job is to make photographs for the defense project which the League is working on. To make photographs of the people of America as they organize themselves to defeat fascism.'[33]

By the late 1930s, then, the proletarian legacy of the early Workers' Film and Photo League was on the wane, as the group reorientated itself to the reform ideals of the FSA 'mainstream' and liberal accounts of documentary. However, this is not to say that there were not members who continued to identify with this legacy, and contribute material to

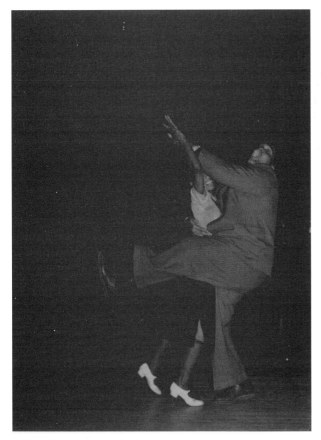

Fig 43 *Savoy Dancers* (from *Harlem Document*), Aaron Siskind, 1940
(© Aaron Siskind)

the *New Masses* and *Daily Worker*, but the organisation no longer saw itself aligned directly to the labour movement. Under the influence of Popular Frontism 'honesty' now came to signify the representation of an upbeat everyday American scene. In the *Photo Notes* editorial referred to directly above, Edward Steichen is quoted approvingly: 'Your portrait of America today is in the faces of the people.'[34] As I mentioned earlier, something similar happened in the British section of the Workers' Film and Photo League. In its first incarnation it was constituted as a self-conscious proletarian vanguard, by 1937 it had redrafted its manifesto into 'a much blander statement of intent'.[35] In the case of the American Photo League, however, this transformation saw the conscious emergence of a professionalised documentary directed at a middle-class audience through the new illustrated magazines and emerging gallery-based photographic culture. This transformation was exemplified by the activities of a group of photographers in the League who also acted independently of the League – the 'Feature Group' run by Aaron Siskind. In 1936 Siskind gathered around him a group of young collaborators to produce various archival documentary projects. One of the most ambitious of these was the *Harlem Document*, begun in 1938 and completed in 1940.[36] Although Siskind offered editorial guidance, what is interesting about the Harlem Project and other projects is their collaborative and self-critical nature, in which the very conventions and codes of

Fig 44 *Lunch Wagon* (detail from *American Photographs*, no. 9), Walker Evans, 1931 (Collection of the J. Paul Getty Museum, Los Angeles, California)

Fig 45 *Houses and Billboards in Atlanta* (from *American Photographs*, no. 47), Walker Evans, 1936 (The Museum of Modern Art, New York. Purchase. (© 1996 The Museum of Modern Art, New York)

documentary practice were being tested. As with the aims of the Nykino majority, the 'Feature Group' recognised documentary as a constructed mode of representation. Careful shooting scripts were planned as a means of linking picture-making to specific ideological issues. The 'everyday' was broken down into component parts as a means of drawing out the complexities of social relations. Thus in the Harlem Project the outline for the section on religion reads:

> 1) Religion most important single controlling factor in life of community.
> Greater percentage of active church members here than in similar
> communities.
> a. historical role of church
> b. its social and political accomplishments
> c. expression of the import seen in tremendous expenditure for the church
> d. religion not inseparable from physical structures.[37]

The FSA employed working scripts, but nothing as complex as this. This is a long way away, therefore, from the hit and run tactics of the proletarian realists in the older League, such as Leo Seltzer. 'There was no formal directing because you couldn't control your subject matter. Documentary coverage depended on where you were, how long your shot was and how you moved your camera.'[38] The Feature Group had more in common with Tretyakov's and Rodchenko's debates on the multiperspectival and sequential notions of montage. As Siskind declared in 1940 in *Photo Notes*:

> we came to see that the *literal representation* of a *fact* (or idea) can signify less
> than the fact or idea itself (is altogether dull), that a picture or a series of
> pictures must be informed with such things as order, rhythm, emphasis, etc, etc
> – qualities which result from the perception of the photographer, and are not
> necessarily (or apparently) the property of the subject.[39]

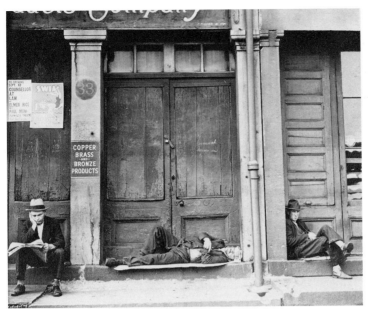

Fig 46 *South Street, New York* (from *American Photographs*, no. 48), Walker Evans, 1932 (The Museum of Modern Art, New York. Gift of the Farm Security Administration. (© 1996 The Museum of Modern Art, New York)

Like Hine's incorporation into the canon, this was a significant moment in the development of US photographic culture. As the USA entered the war and the radical legacy of the 1930s was foreclosed on, questions of auteurship and a reassessment of the 'truth claims' of photography asserted themselves. Now, in a situation where 'class on class' photography was impossible, and where reform documentary was becoming associated with communist infiltration, it was inevitable that such a situation would produce ideological compromises and repositionings. However, unlike Photo League photographers in Britain, in the USA the crisis of documentary photography on the eve of the USA's entry into the war produced a critical reassessment of the claims of the whole tradition. As documentary was being constructed as a way out of the crisis of American culture, it was being deconstructed at the same time. The effect was a provincial rerun of Soviet and European debates over the 'factual' and the 'cognitive'. One would not want to exaggerate this, but we can see a repositioning going on not just in the Feature Group but in Walker Evans's work. Evans had been released from the FSA in 1937, for not fulfilling his brief. In 1938 he had a one-person show at the Museum of Modern Art, New York (MOMA), entitled *American Photographs*, with an accompanying book. The book contained 87 images from the 100 that were shown at MOMA.[40] What is revealing about the book is that although the majority of the photographs were produced under the auspices of the FSA, their presentation offers no evidence of this. There are no words to link or anchor the pictures; there is no concern with conventional unities of time and place. What is obviously the result of archival production is arranged in a consciously anti-archival way. In this sense the book disrupts and actually renders opaque the idea that such photographs establish a transparent relationship to the 'truth' of the everyday. The 'everyday' of the documentary ideal is made to appear oblique, discontinuous, slippery. As Alan Trachtenberg suggests: 'The very openness of *American Photographs*

implies scepticism toward closed forms and fixed meanings. The book invites its readers to discover meanings for themselves, to puzzle over the arrangement of pictures and figure out how and why they appear as they do.'[41]

Breaking down habitual, positivistic forms of viewing, the spectator is prevented from seeing the pictures as a narrative *about* the Depression. In these terms Trachtenberg establishes a connection between Evans's and Eisenstein's theories of montage (Eisenstein's 'word-complexes'). As in the case of Eisenstein, Evans endorses sequential montage as generating an active form of engagement with the work. The reading of the photographs becomes a continuous unfolding event, in which the construction of meanings is identifiable with revision and readjustment. Meaning functions relationally. The result is a collection of images which engage with the *rhetorics* of realism and documentary, as if Evans were discharging himself from the ideals of the 1930s. Yet this move is not a return to Stieglitz's *indeterminancy* of the 'everyday'. Rather the work attacks the instrumentalism involved in the FSA's relationship to the state and the new illustrated magazines' reliance on big business. Whatever the politics of the photographer, for Evans the demands of social reform or the market turned the photograph into an illustration of a concept or a point of view. There are certainly affinities with Modernism here, but what distinguishes Evans from the Modernists is his continuing commitment to photography as a social practice. The taking-up of avant-garde strategies of interruption (which in fact owe as much to image-text experiments in surrealism as to Eisenstein) is pursued within the purview of documentary, but a documentary without illusions of radical influence. This also distinguishes his work from Bill Brandt's, who interestingly was making similar kinds of moves against reform positivism in Britain in 1936. His *The English at Home*[42] fulfils a comparable role to Evans's *American Photographs*. Critical of the iconic status of the image in reform documentary, he produced a collection of photographs of English life across classes that subordinate historical detail to conceptual relations between images. As John Taylor says: 'Brandt was able to embed people in larger social contexts – to draw attention to institutions and ideological structures.'[43] As such, the audience 'were expected to see the *relationships* and *differences* that built up page after page'.[44] Brandt, though, was not working *out of* the documentary tradition; his anti-bureaucratic stance seems as a result to be an intellectual exercise, not a matter of necessity, which is reflected, it can be argued, in his subsequent career as an 'art' photographer. Evans, on the other hand, I contend, employed sequential montage as a means of extending photography as a social practice.

To say, then, that Evans's show at MOMA represented the official point at which 'documentary' became an *auteur*-led museum practice is only half-true. The 1938 exhibition did in fact signal a shift in the balance of force away from the New Deal culture that sustained much of the photographic activity of the 1930s. However, like Siskind's 'Feature Group', Evans tried to reclaim a degree of critical autonomy for photography in conditions where the state and market were dictating *how* photographs were to be produced and used. The bid for autonomy was naturally a limited one, reflected in the fact that even confined to the 'pure' space of the museum a photography of the 'everyday' was still adversely affected by the anti-communist and anti-left hysteria of the late 1940s and 1950s. Evans did not produce work of a similar nature until his *People and Places* portfolio in 1961.

In summary we might say that Evans and Siskind had to discover or rediscover a certain ambiguity in the 'everyday' if a photography *of* the 'everyday' was to survive. This

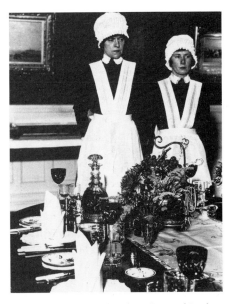

Fig 47 *Miners Returning to Daylight, South Wales* (from *The English at Home*), Bill Brandt, 1936 (© J.-P. Kernot)

Fig 48 *Parlourmaid and Underparlourmaid Ready to Serve Dinner* (from *The English at Home*), Bill Brandt, 1936 (© J.-P. Kernot)

makes the idea of the Photo League as subversive, proletarian organisation in 1947 deeply ironic. During the war the League tried to outdo the FSA in the national-populist stakes: 'The all inclusive task before the members of the Photo League today, is to use the photographs it makes as a means of mobilizing the people to a greater participation in the war effort.'[45] Thus, when a special meeting of the League met on 14 December 1947 to discuss the Attorney General's action, there was some confusion over where the organisation actually stood. This is not surprising for by 1947 a good deal of critical disavowal and pussy-footing was going on about the 1930s. Messages of support sent to the meeting make interesting reading:

> I always understood that the League was a non-political professional group dedicated to the advancement of creative photography, and I have never observed anything to the contrary in its activities.
>
> Henry M. Lester[46]
>
> The Photo League is a photographic and not a political organization.
>
> Walter Rosenblum (President)[47]
>
> From my experience the Photo League has done invaluable and important work in the Field of Creative Photography, and I hope that this work will continue and grow.
>
> Dorothea Lange[48]

Of course, in one sense they were all correct. By 1947 the League *was* predomiantly a non-political organisation. Yet all these contributors failed to address why this was so, and therefore the nature of the history of the organisation. It was left to Paul Strand, still sympathetic to the communist movement, to defend what the real history of the League was, and the realities facing critical photographic practices at that moment:

We are all shocked at the listing of the Photo League as a disloyal organization by Attorney General Tom Clark. But I don't think we should have been too much surprised. Nor should we feel isolated. We are the co-creation of something happening in the country today that is widespread and which threatens every American ... That is why we here tonight have to stand up to this thing. No use in trying to run away and be afraid and say 'Please, I am a good boy'. It won't do any good. We have been picked out because we are articulate people ... There is an old quotation from Nazi ideology: 'When I hear the word "Culture" I reach for my gun' ... Well, the time has come for us in the Photo League to realize that something like that is happening in America. The reactionaries are reaching for their guns.[49]

It was a brilliant speech, turning the recent struggle against fascism abroad to a struggle against 'fascism' at home. But for the organisation as a viable and active entity it was too late. Although the League lasted until 1951, the culture had shifted to such an extent that it was impossible for the group to operate freely, even on its own by then highly restricted political terms. Soon after, Paul Strand left for Paris, returning to America only once to attend his retrospective at MOMA. The radical culture of the 1930s was over. America had to wait twenty years before space was again opened up for an interventionist photography of the 'everyday'. Those twenty years imposed a heavy ideological burden. The 1920s and 1930s were not just lost to view, but buried under an onslaught of Modernist aestheticism. By the late 1930s the more prescient of the photographers and film-makers could see this coming. What they could not see was the institutionalised auteurism of the post-war years and the dissolution of photography's organised links to the labour movement.

Notes

1 Lewis Hine, 'Social Photography: How the Camera May Help in the General Uplift', in the *Proceedings of the National Conference of Charities and Corrections, Thirty-Sixth Annual Session*, Fort Wayne Printing Co. 1909, p. 356, quoted in James Guimond, *American Photography and the American Dream*, University of North Carolina Press 1991, p. 81.

2 For a discussion of absorption and theatricality see Michael Fried, *Absorption and Theatricality: Painting and Beholder in the Age of Diderot*, University of California Press 1980.

3 Daile Kaplan, *Lewis Hine in Europe: The Lost Photographs*, Abbeville 1988, p. 25.

4 Ralph Waldo Emerson, *Addresses and Lectures*, Riverside Press and Houghton Co. 1837.

5 Walt Whitman, *Leaves of Grass*, Eakins 1966.

6 Kaplan, *Lewis Hine*, p. 26.

7 See Lawrence Goodwyn, 'The Cooperative Commonwealth and Other Abstractions: In Search of a Democratic Premise', *Marxist Perspectives* (Summer 1980).

8 Lawrence Goodwyn, *The Populism Moment*, Oxford University Press 1978, p. xx.

9 *Ibid.*, p. xxii.

10 *Ibid.*, p. xii.

11 John Dewey, *Art as Experience*, Putnam 1958.

12 *Ibid.*

13 See Charles W. Morris (ed.), *Works of George Herbert Mead, Volume 3: The Philosophy of the Act*, Chicago 1938.

14 See Allan Sekula, 'On the Invention of Photographic Meaning', in *Against the Grain*, Nova Scotia Press 1984.

15 Alan Trachtenberg, *Reading American Photographs: Images as History, Mathew Brady to Walker Evans*, Hill & Wang 1989, p. 169.

16 See Howard Zinn, *A People's History of the United States*, Longman 1980.

17 *Ibid.*, p. 383.

18 John Tagg, 'The Currency of the Photograph: New Deal Reformism and Documentary Rhetoric', in *The Burden of Representation: Essays on Photographies and Histories*, Macmillan 1988.

19 See Kaplan, *Lewis Hine*.

20 Guimond, *American Photography*. p. 127.

21 For example photographs taken for the National Youth Administration and Civilian Conservation Corps. See Pete Daniel, Merry A. Foresta, Maren Stange and Sally Stein, *Official Images: New Deal Photography*, Smithsonian Institute 1987.

22 Andrea Fisher, *Let Us Now Praise Famous Women: Women Photographers for the US Government 1935 to 1944*, Pandora 1987.

23 *Ibid.*, p. 153.

24 Paul Rotha, *Documentary Diary: An Informal History of the British Documentary Film, 1928–1939*, Secker & Warburg 1973, p. 184.

25 *Ibid.*, p. 162.

26 John Grierson, letter to Paul Rotha, 28 January 1938, quoted in Rotha, *Documentary Diary*, p. 206.

27 Roy Stryker, memorandum, 19 February 1942, quoted in Guimond, *American Photography*, p. 138.

28 For a discussion of the exhibition see Matthew Teitelbaum (ed.), *Montage and Modern Life 1919–1942*, MIT/ICA 1992.

29 See Anne Tucker, 'Photographic Crossroads: The Photo League', *Afterimage* 25 (1978), p. 3.

30 *Ibid.*, p. 4.

31 *Photo Notes* (August 1938), p. 1.

32 *Filmfront* 2 (1939), p. 13.

33 *Photo Notes* (April 1942), p. 1.

34 Edward Steichen, *Photo Notes* (April 1942), p. 1.

35 Terry Dennett, 'England: The (Workers') Film and Photo League', in Terry Dennett, David Evans, Sylvia Gohl and Jo Spence (eds), *Photography/Politics: One*, Photography Workshop 1979, p. 104.

36 Aaron Siskind, *Harlem Document: Photographs, 1932–1940*, ed. Charles Traub, Matrix Publications 1982. See also Anne Tucker, 'Aaron Siskind and the Photo League: A Partial History', *Afterimage* (May 1982).

37 See Tucker, 'Aaron Siskind', p. 4.

38 Russell Campbell, 'Interview with Leo Seltzer: "A Total and Realistic Experience"', *Jump Cut* 14 (1977), p. 26. See also Russell Campbell, 'America: The (Workers') Film and Photo League', in Dennett *et al.* (eds), *Photography/Politics: One*.

39 Aaron Siskind, 'The Feature Group', *Photo Notes* (June–July 1940), p. 6.

40 Walker Evans, *American Photographs*, with an essay by Lincoln Kirstein, Museum of Modern Art New York 1938.

41 Trachtenberg, *Reading American Photographs*, p. 258.

42 Bill Brandt, *The English at Home*, Batsford 1936.

43 John Taylor, 'Picturing the Past: Documentary Realism in the 30s', *Ten:8* 11 (1982), p. 30.

44 *Ibid.*, p. 29.

45 *Photo Notes* (April 1942), p. 1.

46 Henry M. Lester, *Photo Notes* (January 1948), p. 4.

47 Walter Rosenblum, *ibid.*, p. 8.

48 Dorothea Lange, *ibid.*, p. 4.

49 Paul Strand, *ibid.*, pp. 2 and 3.

5

Surrealism, photography and the everyday

In *The Critique of Everyday Life* Henri Lefebvre attacks surrealism for its retreat from the 'everyday'. The surrealists 'belittle the real in favour of the magical and the marvellous'.[1] For Lefebvre surrealism was not dialectical enough; it impoverished the everyday by condemning all things bourgeois. As a result the group existed in a world of 'pure spirit'. Surrealism's 'only remaining interest is that it was a symptom. At one and the same time surrealism marked the absurd paroxysm and the end of the methodical disparagement of real life and the stubborn attack on it which had been initiated by nineteenth-century literature'[2] (that is, Baudelaire, Flaubert and Rimbaud, according to Lefebvre). The basis of this condemnation is that surrealism's attempted reclamation of the 'marvellous' from the 'everyday' is a process torn from any real sense of community. In pre-capitalist civilisation the mysterious, the ineffable and sacred were part of living social relations, 'affective and passionate forces'.[3] With the surrealists the 'marvellous' falls to the level of the cheap shock, the adventitiously weird and bizarre. It cannot renew or replenish human community, it can only reinforce the prevailing fetishism of things. Lefebvre admits that surrealism at times does provide a 'certain criticism of everyday life', but it is invariably 'clumsy' and 'thoroughly negative'.[4] For Lefebvre what counts as a purposeful engagement with everyday life is work that extends our critical knowledge of daily human relations. Metaphysics and the 'innerlife' must be left behind in order to discern the 'inner, human wealth that the humblest facts of everyday life contain'.[5]

This is a strange and harsh verdict, but perhaps we should not be too surprised, for it chimes with many of the commonplace opinions about surrealism on the left in the 1930s. With the exception of an Evans or Brandt, surrealism was considered antithetical to debates on photography and realism. Surrealism, it was argued, glorified in the trivial and arbitrary, its anti-bourgeois rhetoric merely provocative. It was incomprehensible to workers; it was opportunist; moreover, it was actually hypocritical – what political faith could be invested in a movement when one of its leading film-makers, Luis Buñuel, produced an 'acceptable' edited version of *L'Age d'or* (1930) for manual workers? Lefebvre's prejudices clearly owe a debt to the 'common sense' positivism of 1930s

factographic culture; hard material *facts* are what art requires. If this is difficult to square with Lefebvre's dialectics of the everyday, it makes more sense when we realise that the documentary ideal largely bypassed photography in France in the 1930s; surrealism was hegemonic on the left. When Lefebvre was writing in the 1940s and 1950s there was a feeling, therefore, that certain questions were still waiting to be addressed.

Surrealism does not need to be defended from such an attack. However, what does need to be analysed with some care is the way in which surrealism participated in, and challenged, received debates on realism and the everyday in the 1920s and 1930s. Surrealism's relationship with photography has been subject recently to an extensive amount of analysis; what was originally considered to be marginal to the group is now embraced as of equal importance to the poetry, novels, objects and paintings. In fact photography has now taken on a centrally defining role in discussions of the 'marvellous', convulsive beauty, and the revolutionary transformation of everyday life. For Rosalind Krauss[6] and Hal Foster[7] it is the imaginary landscape of the photography that now is identifiable with the surrealist project. This of course has much to do with the revision of Modernism through gender studies and critical theory in the 1980s, and the foregrounding of photography within avant-garde practice, but it is also the result of an increasing recognition that it is impossible to separate out the different activities of the surrealists in the name of a surrealist 'authenticity'. There is no *essential* kind of surrealist practice; in this space photography has come to reassert itself.

Surrealism emerged out of a mixture of Dadaism, anti-positivism and anarchism. It was anti-clerical, anti-Western science, pro-Eastern culture (particularly Buddhism), pro-pornography, pro-drugs and anti-nationalist. A heady list of anti-bourgeois *gestes*. In a phrase that he lived to regret, Louis Aragon even referred to the Russian Revolution as a 'vague ministerial crisis'.[8] Under the influence of Breton, though, by 1925–26 the group had made a clear commitment to Marxism. Influenced by the young Marxists at *Clarté*, Breton began to think strategically about the aesthetic and political claims of the movement; fearing avant-garde burn-out he wanted to avoid all the rhetorical pitfalls that had destroyed Dada and that were looming up through the group's anti-bourgeois gesturalism. In 1925 the group published a declaration in *L'Humanité*, the French Communist Party (PCF) newspaper. 'There was never a Surrealist theory of Revolution. We want the Revolution; however, we want revolutionary means.'[9] For *Clarté* and the surrealists, then, the task was the systematic demoralisation of thought (of bourgeois categories of the everyday) in the interests of the working class. The problem for Breton, though, was to find a space of compatibility between what he conceived of as the relative autonomy of art and revolutionary politics. As Breton argued in *Clarté* in 1925, 'there is no true work of the mind that is not shaped by the desire for the *real* amelioration of the conditions of the existence of the whole world'.[10] In 1926 Pierre Naville took over the editorship of *Clarté* and under pressure from *L'Humanité* stopped publishing the surrealists. This was the point at which Breton began to concretise his revolutionary aesthetics of the 'everyday' against the cultural policy of the PCF, attacking the party for its positivism and arguing that surrealism was the real and legitimate heir of communist culture (although, strangely, none of the debates on Soviet revolutionary culture came up as part of Breton's defence).

Yet, despite the widening gap between the surrealists and the PCF, Benjamin Peret, Louis Aragon, Paul Eluard, Breton and Pierre Unik all joined the party in 1927. It was as if the group had decided upon an entryist cultural position in order to win the party

from its proletarian positivism. Inevitably this move was to be a source of grievous acrimony, both in the group's relationship to the party and in terms of relations within the group itself. Hauled before the PCF's Central Committee to justify his continued assertions of surrealist independence, and attacked mercilessly in the communist press, Breton also had to deal with Aragon's infamous conversion to socialist realism in 1932 after Aragon's visit to the USSR. Breton saw this effectively as a betrayal of the growing links between the party and avant-garde culture. Aragon, in response, wasted no time in denouncing surrealism for the party. As he declared in 1935 in *Pour un réalisme Socialiste*, 'let us have done with hallucinations, the unconscious, sex, dreams, etc. Enough of fantasy! I hereby proclaim the return to reality.'[11]

What is compelling about such exchanges in the late 1920s and early 1930s in France is that surrealism is the one significant avant-garde group in Europe which had organic connections with the Communist Party. In these terms it confronted head-on the relationship between aesthetics and politics, the 'everyday' and art, photography and class-consciousness, that other groups dealt with partially or fitfully in their links with the organised left and the labour movement. The surrealists, in effect, tried to keep open a non-instrumentalised space for a cognitive model of an aesthetics of the everyday in conditions where Stalinised socialist realism, Popular Frontism, and a bland communalism were by the mid to late 1930s sweeping all before them. When Walker Evans produced his *American Photographs* in 1938, he was effectively making an alliance with this kind of intervention even though he may not have been an artist *of* the left. Like Breton he recognised that the crisis of capitalism and the rise of Stalinism had brought about an unconscious collusion between right and left in the instrumentalisation of culture for pragmatic political gains.

To read surrealist literature from the 1930s is to see an organisation desperately trying to keep open a space for an aesthetics of the everyday beyond a mere formal attachment to the world of daily events and affairs. Breton wanted an aesthetics of the everyday that discharged the hidden intensities of everyday objects and experiences. During the First World War Breton had read Freud and realised that psychoanalysis had important implications beyond the clinical and medical. Freud had produced not just a new diagnostics, but a new hermeneutics of the everyday. The possible truth of things and events lay beyond the initial moment of empirical verification in their unconscious significance. As a consequence, everyday life became filled with motives and intentions whose meaning lay beyond the consciousness of their agents. For Freud, this 'forgetting' represented the effects of social repression, but at no point did he ever assume psychoanalysis was an antidote to bourgeois ideology or engaged in some long-term exposure of it. Freud was not a revolutionary. Breton, though, transformed Freud's hermeneutics of repression into an explicit anti-bourgeois model by applying the subjects and categories of psychoanalysis (desire, memory, dreams, involuntary action, psychic disorder) to an interventionist account of art. Under the categories of psychoanalysis art was able to disorganise the imperturbable surfaces of bourgeois order. Hence for Breton the importance of psychoanalysis as a dialectical method: its pursuit of truth as a bringing forth from the collision of opposites, or from the recurrence of the seemingly insignificant. What gave art an affinity with such a method is that it made its processes startlingly palpable. Thus in Breton's eyes psychoanalysis re-established the poetic relations between art and politics, insofar as it extended the categories of the everyday beyond proletarian positivism and the representation of *the struggle*.

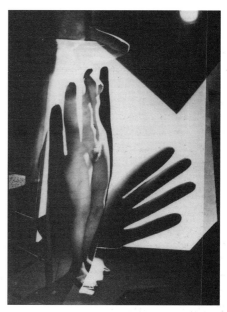

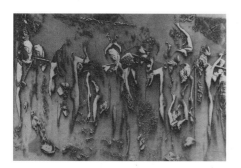

Fig 49 *The Battle of the Amazons (Group III)*, Raoul Ubac, 1939 (© ADAGP, Paris and DACS, London 1996)

Fig 50 *Untitled*, Maurice Tabard, 1929 (Courtesy of Robert Shapazian, Fresno, California)

Yet Breton was determined to ground his aesthetic categories in political realities (the struggle for working-class self-emancipation) and not in academic circles or the artworld. The only plausible means, for him, of doing this was through an involvement with the Communist Party, in 1927 still the legitimate vanguard of the working class. To acknowledge this is to acknowledge what the aesthetic/political programme of surrealism also inherited from the ideals of the Russian Revolution and the early Soviet avant-garde, and what fired Breton until he died in 1966 still committed to Marx's critique of capitalism and still a principled anti-imperialist. Breton's disorganisation and transfiguration of the everyday, therefore, cannot be distinguished from the group's general commitment to the revolutionary overthrow of wage-labour relations and the disruption of the commodification of everyday life.

The Bretonian view of surrealism, though, has come in for a certain amount of criticism recently in the new literature, restoring those idealist aspects of the surrealist programme to centre stage. The Bretonian politics, in a sense, do not fit the bill at the moment; they appear too rhetorical, too utopian, too tired, against the petrel-like flights of transgressive imagination of a Georges Bataille.

It is Bataille's writing that has underpinned much of the new work on photography, in particular Krauss's and Jane Livingston's co-authorship of the surrealist photography catalogue *L'Amour Fou* (1986), which set the revisionist ball rolling. Krauss uses Bataille's concept of the *informe* – the unformed – to define those photographers who worked around Bataille at *Documents* (Jacques-André Boiffard), the would-be alternative surrealist art review set up by Bataille and other dissident surrealists in 1929, and formally experimental photographers such as Raoul Ubac and Maurice Tabard. For Krauss the dissolution or distortion of bodily form in these images – the unformed body – holds the key to surrealist photography and what she sees as the essential anti-realism

of the surrealist enterprise. Employing Bataille's notion of the *informe* as a concept of liminal identity, she treats the formal ambiguity of the body in these photographs as evidence of a desired dissolution between reason and unreason. There are two related concerns here: to prioritise the effects of these images over the indexical function of the photograph, and to prioritise these kinds of images against those iconic photographs of the urban and the city in the surrealist literature that obviously establish a very different, *un-informel* relationship to the world. The favouring of these photographs, and the favouring of a particular *reading* of Bataille, is detectable as a move against representation and the 'everyday'. This is not to confuse the issue. Breton's surrealism *was* an attack on representation and the idea of the transparency of meaning in the image. Breton's theory of 'convulsive beauty' – his semiological categories of *erotique-voilée* (inorganic matter taking on the look of other things, such as mandrake roots), *explosante-fixé* (an object detached from the flow of events, for example his famous image of the locomotive stranded in a jungle) and *magique-circumstancielle* (the found object as an object of the finder's desire) – interprets reality as the work of signification. That is, Breton opens up the categories of the everyday to the divided desires of the subject; the object, as Breton was to say in *L'Amour Fou* (1937), in becoming something other to itself, becomes a *catalyst* for our subjectivities.[12] As David Macey says, 'Surrealism is, among other things, an exploration of and meditation upon the production of signification.'[13] However, in Krauss's writing surrealism and surrealist photography are assumed to be concerned *principally* with this, as if the photographers set out to fulfil a specific research programme on representation. The result is the academicisation of the surrealist project as a discourse on the signification of signification. The operations of meaning formation are contained *at* the level of the image, doing violence to both the political programme of surrealism and the fact that it is the debate over realism and the everyday that actually sustains the debate on representation.

A singular kind of closure is taking place here, in which surrealism is being primed for prefigurative post-structuralist status as a discourse on fragmented identity and the dissolution of politics into textuality. These issues are important to our narrative, because such ideas weaken the place of surrealist photography's dialogue *with* factography. By focusing on surrealism as a critique of all things naturalistic, the revolutionary culture of the period, the impact of the new documentary and Breton's anti-Stalinism are either screened out or made to seem incidental. However, Breton's semiological categories of *erotique-voilée*, *explosante-fixé* and *magique-circumstancielle* were not simply textual ascriptions of reality, but active forms of social intervention in which the world of things is sensitised to the power of human imagination and therefore to what *passes* for the everyday and the real. To defend this is not to reinvest in the avant-garde's political over-valorisation of art: where a change in consciousness occurs action follows; something to which Krauss is rightly unsympathetic. On the contrary, it is to reinstate the fundamental sociality of surrealism's development of psychoanalytic subjects, techniques and categories for art. To see the everyday world of things and events as catalysts of desire *for* the subject, is to view textual interpretation as a socially interruptive act, as something that carries within it the hope or possibility of social transformation. Distinct from Krauss's reading of Bataille, surrealism's recognition of the liminal or ambiguous status of the sign is not an attack on reference as such. Surrealism's use of photography was concerned in a profound way with the referring powers of images, how images of

the unprepossessing, marginal or banal can under the 'control' of human desire allegorise capitalism as a world of unreason. That these kinds of images were invariably outside the more conspicuous debate on representation of female sexuality, and are closer to documentary archive practice, make them out of step with the attempt to see surrealism as a thoroughgoing critique of realist models. Moreover, the fact that Breton rarely wrote on photography and at times collapsed surrealism into expressionism in his work on automatism (which he was never very happy with) has allowed Bataille's more overt textual sensitivity to the image to prevail. So, forget Breton who was at heart an expressionist and utopianist who believed art could bestow the possibility of change on the world, and embrace Bataille, whose 'black'[14] surrealism, focus on photography as a textual act, and advocacy of sexual transgression, allow us to harness surrealism to a 'politics of identity'. The rediscovery of the photographer Claude Cahun in the late 1980s is very much within this brief.[15] Both interpretations, though, are profoundly flawed, separating where they should connect, and exaggerating where they should discriminate. Breton and Bataille shared more than what divided them; Bataille's work on photography was not shaped by 'formal experiment' but by the debate on realism.

What attracted Bataille to photography in the late 1920s was its indexicality and therefore its potential anti-aesthetic qualities. For Bataille it is photography's gruesome powers of resemblance that is anti-bourgeois. Hence the presentational importance of the photograph as 'base evidence' in the elaboration of his theory of base materialism, and the significance of photographs generally in the journals he was involved with, such as *Documents* and *Minotaure*. Base materialism was a theory of the revolutionary power of the abject, or ignoble: all those forms of transgression or low behaviour that unsettle prevailing hierarchies and systems.[16] It borrowed from Marx's theory of proletarian revolution but extended it to the realm of the symbolic. Cojoining Marxism with a Romanticism of the 'other', Bataille produces a kind of Marxist-primitivism in which the lowly, humble and abject stand to disrupt the repressive functions of social power. In these terms photography's strength lies in its ignoble appeal, the fact that its powers of resemblance are in a privileged position to bear witness to the 'lowest of the low' and the abjectness of the world. That Bataille selects Boiffard's close-up of a big toe for his essay 'The Big Toe' in *Documents* in 1929 is in keeping with this.[17] The toe functions as a metonym for social eruption from below.

In this there are strong overlaps with Mikhail Bakhtin's Romantic-primitivist writing on the grotesque body in the 1930s.[18] Like Bataille, Bakhtin adopts an anti-positivist notion of realism to attack both Stalinist and bourgeois culture, although for obvious reasons Bakhtin's anti-Stalinism is never made explicit. For Bakhtin the grotesque body performs a similar eruptive function. Popular, celebratory, disordered, a body that disrupts the closed and classicising tendencies of dominant cultures, it becomes synonymous with the 'unofficial speech'[19] of those without power. 'The grotesque body ... is a body in the act of becoming. It is never finished, never completed; it is continually built, created, and builds and creates another body.'[20] Grotesqueness or base materialism, then, centres on the connectedness of the body to nature, in a world that continually instrumentalises or suppresses that relation. This is why both writers base their 'primitivism' on such strong images of animality. Both emphasise images of animality in the human (the gaping mouth for instance) as evidence of the bourgeoisie's fear of what is uncontrollable. In Bataille, though, this is attached to a socialised ethics, rather than a celebration of the 'primitive' or *informel* as such. To embrace the abject, ignoble and low

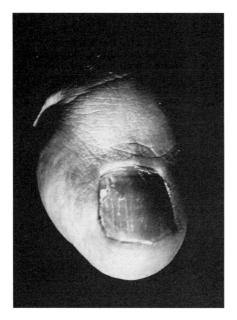

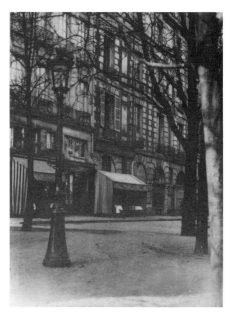

Fig 51 *Untitled* (Big Toe), Jacques-André Boiffard, 1929 (Courtesy of Madame Boiffard and the Musée Nationale d'Art Moderne, Paris)

Fig 53 *Street Scene* (from *Nadja*), Jacques-André Boiffard, 1928

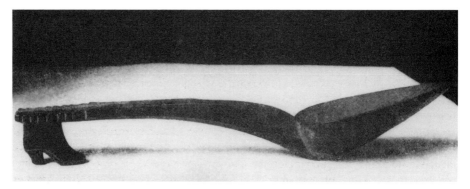

Fig 52 *Spoon* (from *L'Amour Fou*), Man Ray, 1937 (© Man Ray Trust / ADAGP, Paris and DACS, London 1996)

is to recognise that human beings have to pass through such states before they can achieve real freedom and autonomy. In effect, although base materialism's ideological sources are highly heterodox, it remains an allegory of class struggle. Consequently the value of certain photographs lies in their ability to seduce the spectator in a base manner – that is, the indexicality of the image connects the spectator to the messy materiality of the world.

Around the time Bataille was formulating his theory of base materialism and considering the function of photography, he was friendly with Boris Souvarine. Souvarine had been expelled from the PCF in 1926 for anti-Stalinist sympathies and had first-hand knowledge of Soviet avant-garde debates. Without saying there was any direct influence, it was during this period that Bataille saw himself as contributing to Marxist debates on

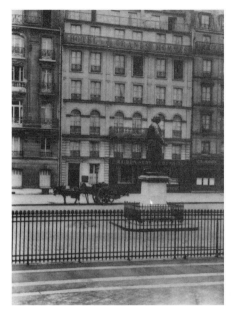

Fig 54 *Street Scene* (from *Nadja*), Jacques-André
Boiffard, 1928

Fig 55 *Street Scene* (from *Nadja*), Jacques-André
Boiffard, 1928

art and the everyday, culminating in his involvement in Contra-Attaque in 1935 with
Breton and Roger Caillois, an anti-Popular Front organisation. Even if Bataille moved
away from this politics during the war, embracing Nietzsche and esotericism, his position
is more complex than the one that would have him in opposition to Breton as the
defender of sexual transgression and the untempered passions. As he was to say later: 'It
is through [the] release of the passions that we enter into the instant, it is by the use of
reason that we dominate the future.'[21] Bataille remained sympathetic to a libertarian
socialism until his death. It is difficult, then, to construct an anti-Marxist Bataille against
Breton without doing serious damage to the many shared views and ideals of the two
men, despite their early and infamous falling out. In the 1940s, after a period of 'cooling
off' about the value of surrealism, Bataille was to say that surrealism remains
indispensable in '*terms of mankind's interrogation of itself*, there is surrealism and
nothing'.[22] Breton reciprocated in kind by refering to Bataille as one of the few people
worth getting to know.[23]

 Essentially you can't place Bataille's views on surrealism outside the wider debate on
realism and the document. Thus we need to acknowledge the actual symmetry between
Breton and Bataille on the function of photography: both took the photograph as
document to be important to the taxonomic concerns of surrealism, its re-categorisation
of the everyday. Breton may have never addressed himself specifically to this question,
but nevertheless his use of photographs in *Nadja* (1928)[24] and *L'Amour Fou* belie this. In
L'Amour Fou the relationship between photograph and text is not arbitrary or
metaphoric, but reportorial. The images of Man Ray, Brassai and Cartier-Bresson are
there to anchor the words. Similarly in *Nadja* the photographs by Boiffard of deserted
Paris streets and alleys function as a secret map of the city, particularly now we know
that each site photographed by Boiffard had a radical or revolutionary historical

significance.[25] Breton may have disliked the photographs but there was certainly a recognition here on Breton's part of the anthropological links between photography and flâneuring. This made photography the intimate ally of flâneuring. Suffice it to say the use of photography by the surrealists across different kinds of practices, reflects an uncertainty about the tenacious naturalism of photography. Surrealism wanted a photography that was critical of positivism, yet at the same time saw in the photograph's indexicality a 'new real' or new realm of the everyday, an everyday that connected the insignificant and ordinary to an increased social intensity of perception. As a theory of human interconnection with nature, Bataille's base materialism is also a critique of idealism and idealist aesthetics. Photography's indexicality comes to stand in as a critique of mythification and illusion. In other words Bataille sees photography as culturally democratising in its 'primitivism' – an argument that shorn of its allegorical context is not far away from contemporaneous debates on documentary, although he had no sympathy for Soviet productivism. In this respect what counted for Bataille was the potential 'poetry' of the document. Like Breton, Bataille never divorced his anti-aestheticism from the poetry of the insignificant and ordinary. Thus we might argue that Bataille's defence of photography's indexicality was a recognition of the poetic transference given the object in the act of photography. For Bataille poetry embodied in an affirmative way non-alienated relations between human beings; photography's privileged access to the poetry of the abject and the lowly heightened this. In short Bataille Romanticised the document as a source of anti-bourgeois sentiment.

It is conceivable to argue that Bataille supplied in a fragmentary way the missing discourse on surrealism as a *sur*-realism, a realism beyond positivism. By embracing the abject for the document, at the same time as emphasising how photography functions metonymically and synecdochically, he was able to locate photography and the everyday in a very different political and social space from that of the positivists. That is, he was able to locate photography in a very different *archival* space. This is perhaps not surprising once we remember that Bataille was by profession a librarian and archivist and had daily access to photographic archives.[26] The point, however, is that the notion of the archive and its *redefinition* was central to the surrealist project. To look at different photographic practices within surrealism is to see not just the work of different artists but the production of different kinds of archives: the archive of female sexuality, of the animalistic body, of the uncanny object, and perhaps most importantly, given that it acts as a meta-archive, the city as a screen for desire.

What unites Breton and Bataille, and other surrealists who took an interest in photography such as Salvador Dali, was the idea of the city as a machine of the surrealistic. Like a huge puzzle or conundrum its spaces and pleasures offered up a hidden archival knowledge of modernity. Thus if the modern artist is a seeker after critical or arcane knowledge, the metropolis, as a place where the body is brought to a pitch of intensification, is where it will be found. This of course is one of the dominant, masculine, heroic thematics of early Modernism (1860–1939): the artist caught up in the maelstrom of the industrialised city. Surrealism, though, turns the conflict between the modern individual and the modern metropolis into a stage for the projection of fantasy and memory in the spectator; the city is opened up to the spectator, and not confirmed as a place of moral dissolution. The urban photography the surrealists favoured, therefore, tended to be absent of bodies engaging in social interaction. What they were drawn to were those things that in a sense were made visible in objects and places once

they had been separated from the veil of human presence: power and desire, 'convulsive beauty' and the 'marvellous' are categories attached essentially to the suggestibility of the inanimate. It is no wonder, then, that Lefebvre's attack on surrealism is so vociferous, and the communist press considered them to be petit-bourgeois *poéts maudits*.

In the 1920s and 1930s the representation of the city underwent an extraordinarily vivid transformation through Bolshevik and post-Bolshevik factographic models. What characterised much of this photography is in fact something that is rarely commented on: the city's occupancy or domination by the organised working class. From the Russian Revolution onwards, we see the city represented as a space where the working class is either in power or contesting power. Rodchenko, Klutsis, Modotti, and in particular the Spanish Civil War photographer Agustí Centelles,[27] show us the city as a place where the masses are a source of affirmation and not of homogeneous alienation. This is very different from a great deal of Modernist literature and painting, where the symbolisation of the masses usually connotes threat or coercion. Surrealism's disruptive logics completely bypass these new forms of occupancy, turning in contrast to other forms of occupancy: the commodity and its secret history. Lefebvre's attack on surrealism's anti-realism is closely related to this 'absence of the crowd'. In a period of crisis for the left in the mid-1930s, why were the surrealists not providing the French left with 'politically convertible' images of the urban? The reasons the surrealists were not doing this was that for Breton the representation of revolutions was not identifiable with the representation of the revolutionary process, of the masses *in* action. For Breton there was a fundamental distinction between proletarian art and images of revolutionary or collective activity, on the one hand, and revolutionary art, on the other. This key avant-garde proposition of necessity opens up photography to other orders of social and political referentiality not containable by conventional categories of realism (recognisable people doing recognisable things in recognisable settings etc.). This is why, although Breton despised socialist realism and Popular Front communal aesthetics of all kinds, at no point does he denounce photographic naturalism as such. Rather, it comes to serve, as it does for Bataille, an allegorical function, in which the appearance of the seamlessness of reality in the photograph is opened up by the juxtaposition of one photograph with another, or through the recognition of some extraordinary or anomalous detail in the photograph itself. At the basis of Breton's aesthetic categories, therefore, was a commitment to montage as principle of interruption. What distinguishes it, though, from the productivist tradition is that the processes of montage as a revelation of the heterogeneity of reality were to be found extant in photographic images themselves. We might describe this as an internalist model of photographic montage. By implication, the surrealist collecting of found objects and images is extended to the internal details of the photograph itself.

This internalist model of montage is explored by Salvador Dali in his essay 'Psychologie Non Euclidienne d'une Photographie' in *Minotaure* in 1935.[28] In 1935 Breton and Dali were vehement opponents, yet there is much in Dali's essay that extends the Bretonian use of photography. Dali presents an anti-positivist reading of a photograph of two women and a man standing outside a Parisian shop, by locating the significant meaning of the photograph not with the centred image of these three figures but with a small bobbin in the lower left-hand corner. 'Direct your gaze away from the hypnotic centre of this photograph, and turn your eyes with careful expectancy towards the lower left hand corner, for there, just above the pavement, you will be able to observe with amazement a bobbin without any thread utterly naked, utterly pale, immensely

Fig 56 *Bobbin* (from Salvador Dali's essay
'Psychologie Non Euclidienne d'une Photographie',
Minotaure, 7, 1935), Anon, n.d. (DEMART PRO
ARTE BV / DACS 1996)

unconscious, clean, solitary, minuscule, cosmic and non-Euclidian.'[29] For Dali such an insignificant detail 'cries out to be interpreted'.[30] He does this by proposing an anti-Kantian view of representation. In Kant time and space are closed categories. The bobbin for Kant, therefore, could only be envisaged as being situated in space in an absolute fashion. It could be nothing other than something outside of ourselves. However, with the 'merciless expulsion'[31] of Kant's metaphysics in the theory of relativity, the separate categories of time and space are liquidated. The fixity of the object in time and space is broken. Thus for Dali the 'insignificance' of the bobbin represents something that escapes the fixed hierarchies of meaning of Kantian metaphysics or positivism. It in effect solicits us from beyond its place of invisibility. In this reordering of the bounds of visibility, what is lowly, in Bataille's language, proclaims its 'evident physical reality'.[32] Or psychical reality. 'It is precisely this empty bobbin, these deplorable insignificant objects, to which at this time, we the surrealists are devoting the greatest and best part of time.'[33] Crucially, Dali extends the referential function of the photograph, like Breton, into what Benjamin was to call an 'unconscious optics'.[34] There is a systematic attempt to treat the photograph as a unit of meaning that is not fixed by its manifest content or by its original conditions of production. Meaning is also elsewhere.

The realm of what constitutes 'truth' is thereby radically transformed. All surrealism's categories of displacement and interruption – *erotique-voileé*, doublement etc. – in effect *re-spatialise* photographic referentiality away from the phenomenal to the conceptual. The result of this, naturally, is to foreground the interpretative activity of the spectator. Now, of course, there was nothing new in avant-grade photography circles in the 1930s

about this. Soviet avant-garde photography had been clear about the proactive position of the spectator. But in surrealism something qualitatively different comes into play. In surrealist accounts of photography the spectator is loosened from their *un-differentiated* position within revolutionary discourse. Soviet avant-garde rhetoric sets out to create a unified revolutionary subject, surrealism sets out to create a revolutionary subject that was split by fantasy and desire. To construct a new realism, a *sur*-realism, out of any fixed proletarian symbols was to cancel out the subjectivity of the spectator and the reality of what lay outside immediate political demands. The undifferentiated revolutionary subject was quite literally a fantasy. This is why the surrealists never engaged with the activist or collectivist image, because it was too contaminated by social contingencies, by day-to-day forces that suppressed the utopian and non-identical.

To reconstruct the 'everyday' armed with psychoanalysis, anti-Kantianism and poetics, was to engage in a fundamental battle over where art/photography stood in relation to realism. For the majority of those who defended the documentary ideal in the 1930s, realism was identifiable with the contemporaneous. Photographic practice became historical practice in this sense, the continuous recording of the moment. However, what characterises surrealism's anti-positivism is an identification of the 'time of the artwork' as discontinuous. This is the reason Benjamin was so favourable – initially – to the group, because he could see that the psychoanalytic techniques and subjects were redemptive of the social world. The content of the photographic image was not contained by its phenomenal content, but could be written into other times and spaces, other histories. The past could be said to convulse the present, just as the present might convulse the past. This montage model of shock, discrepancy and non-correspondence is not compatible with a view of surrealism as blurring formal and logical categories to the point of dissolution. On the contrary, Breton remained committed to a dialectical grasp of the real, to a belief that contradictions exist *in* reality and art has a part to play in exposing their contents. The strategies of interruption and inversion were intended to deepen the foundations of the dialectical methods. 'How can one accept the fact that the dialectical method can only be validly applied to the solution of social problems? The entire aim of Surrealism is to supply it with practical possibilities in no way competitive in the most immediate realm of conciousness.'[35] As Aragon also argued in his early surrealist period in *Le Paysan de Paris* (1926): 'The marvellous is the eruption of contradiction within the real.'[36] The wider status of photography within surrealism, then, rests on how we read its strategies of interruption. If surrealist photography announces the world-as-sign, and art as form of textual play, on what terms are we to embrace this? Anti-realist or a new realism?

The spectre of conventional realism looms larger for Breton throughout the history of the organisation. The workerism and positivism of the PCF in the late 1920s and early 1930s created a stifling atmosphere on the left, no more so than after the 1934 Moscow Writers' Congress where the tenets of socialist realism were endorsed as Stalinism's 'house style'. By 1935 there was a 'united front' against surrealism within the PCF, finally forcing the group out of the party. It is no surprise that realism for Breton becomes associated with the death of art. However, at no point does Breton give up on the ideal of a critical engagement with the real. Rather, the terms under which the real might be described and symbolised had to change decisively. Effectively, the surrealists' re-spatialisation of the content of the artwork outside its phenomenal form breaks down the idea of realism as a mirroring of an external world, and therefore the dichotomy between

'inside' and 'outside' that underwrites conventional documentary accounts of realism. Psychical space – fear, anxiety, desire – was in a sense made real, that is externalised and given visual form. More importantly these processes were identified as dynamic social ones; the psychic was not a mere appendage of the social, some distant outpost, but was the very means by which we negotiate, reproduce and resist material reality. The introjection of the categories and techniques of psychoanalysis into the field of vision constitutes, therefore, a radical break with prevailing expressivist or externalist models of representation. Surrealism may have used the insights of psychoanalysis as sources of creative therapy or libidinal energy, but on the whole surrealism's advocacy of psychoanalysis was a textual and interpretative one. Surrealism was more concerned with *working out of* the symbolic spaces and thresholds that psychoanalysis advanced in its revision of the relationship between object and subject, its internalisation of the social world in the individual. Thus as a site of the unconscious, the city – Paris – exists as a place of confrontation between desire, loss and the social world, and not the background to psychoanalytic 'experiments' or therapeutic manifestations. The city is a place to be deciphered.[37] Hence, surrealism introduced a radical symmetry into the political reception of the image, undermining the idea that 'lived experience' and the 'everyday' were a source of transparent meaning that could be converted into immediate political capital. Meanings, they insisted, are not pre-given, but produced in the act of reception and re-reception. It can be argued with some confidence, therefore, that surrealism's attack on positivism and dogmatic historical optimism does not reduce to a critique of realism *tout court*. Breton always makes a distinction between realism as a set of proletarian (positivistic) codes, and realism as a critical project of the everyday. Without this distinction it is impossible to understand his alliance with Trotsky during the period of the Popular Front.[38]

Essentially, surrealism's non-positivistic use of urban photography inscribes the political and social relations of power into the very divisions of space itself. The surrealists were one of the first avant-garde groups to understand, in any coherent way, that physical space is also social space and that social space is also psychical space, a space for our imaginings and longings. It is one of the ironies, then, of Henri Lefebvre's attack on surrealism, that there are actually strong lines of connection between Lefebvre's own work on the production of social space in the 1960s and their notion of the 'unconscious city'. Furthermore, the connections are not just coincidental, but the product of an extraordinary continuity of concern with the social meanings of space in French culture this century and last. The spatial organisation of the city into areas of pleasure and threat – in particular Paris – has been a key thematic in the development of modern French culture from the Impressionists and Post-Impressionists. The surrealists' characterisation of themselves as flâneuring urban artists is a reminder that they saw themselves in the tradition of the modern artist as the marker out of symbolic boundaries. But as designators of the marginal, remaindered and shadowy, they brought to light those social spaces that an earlier Modernism had considered dreary or banal: back streets, cheap hotels, eccentric and antiquated shops, forgotten squares, a nether world of small lives, desperation, powerlessness and the detritus of commodity culture. To bring these spaces into view (as in Boiffard's photographs) is to produce another city, a Paris that is emptied of the *allure* of the bourgeoisie.

For Lefebvre the notion that space is an active concept, that it *produces* meanings, is inseparable from this legacy. He admits as much at the beginning of *The Production of*

Space (1974): 'The fact is that around 1910 a certain space was shattered.'[39] Objects, it was argued, did not just exist in space, they acted on each other to produce space; space was neither empty nor immobile. The point for Lefebvre is not simply that space embodies social relationships but that it does so in particular material ways. For Lefebvre this means locating the production of space in relation to the increasing centralising impulses of capitalist monopolisation. Imperialism, the homogeneity of commodity production, architectural rationalisation of all kinds – inner city high – rises as much as suburbanisation – all reflect the tendency towards what Lefebvre calls the abstraction of space. 'The dominant form of space, that of the centres of wealth and power, endeavours to mould the space it dominates (i.e. peripheral spaces), and it seeks, often by violent means, to reduce the obstacles and resistances it encounters there.'[40] Lefebvre was writing on these issues from the 1950s, borrowing from and influencing the Situationists, who were to acknowledge an intellectual if not an aesthetic debt to surrealism. Lefebvre's process of abstraction was well under way by the 1930s, to which we can clearly see the surrealists responding. Their 'peripheral spaces' stand in opposition to a public and official Paris of state spectacle and instrumental social control. To oppose such forms of abstraction is, for Lefebvre, in itself a form of class struggle. 'Today more than ever, the class struggle is inscribed in space.'[41] Concomitantly, to change the dominant uses of space is a class-conscious act. In fact it is *only* the class struggle which has the capacity to halt the abstract appropriation of space, and generate significant differences. Thus as allegories of difference or archives of base materiality, the Paris photographs of the surrealists sought to connect a photography of the city with a class-conscious negation of abstract space. That Lefebvre and others did not see this reveals how much surrealism has been persistently misread on the left. Demonised as anti-realist, anti-reason and fractiously poetic, its use of photography as a *counter*-archival activity is conveniently forgotten. This understanding is crucial, therefore, in developing a dialectical account of the impact of photography on the group; and why Krauss, like Lefebvre, suppresses or fails to recognise the significant impact of documentary photography on the surrealist project, despite her textualist position. Krauss in effect places the surrealist's textual use of photography outside the social demands of the archive, thereby making it impossible to see how Boiffard's urban photographs rewrite abstract bourgeois space in the name of a utopian social space. Although she talks about the importance of spacing in a number of surrealist photographs – 'spacing ... is the signifier of signification, the indication of a break in the simultaneous experience of the real'[42] – she does not pause to consider the kind of spaces and spacing involved in the urban photography. To do this would mean connecting the photograph's textuality to the contradictions and conflicts of the social world, a connection that obviously destabilises the idea that the surrealists were concerned *first and foremost* with sexuality and the disarticulation of identity through the *informel* or dream-space. Now this is not to deny the centrality of sexuality or questions of identity within the group, or to suppress the vertiginous sexism of the group's exposure of the feminine,[43] but to re-establish the significance of those ideals and concerns of reportorial culture on surrealism, ideals and concerns that run deep through all avant-garde photographic culture of the 1930s. Once we recognise the importance of the urban counter-archive within surrealism, we can see in fact that documentary practice did not bypass surrealism, but passed through it radically transforming its content in the process.

In this, surrealism released what had been suppressed in the dominant positivist

Fig 57 *Street Scene* (from *Nadja*), Jacques-André Boiffard, 1928

account of photography in the 1920s and 1930s, its profound connection to spaces other than those inscribed at the level of the photographic index. This use of photography presupposes a very different relation between the spectator and the political meaning of the work. The space of politics in the image is transformed from the representation of human agents acting on things (or being acted on by things), to the representation of the object or an environment as a 'trigger' for reverie, speculation and memory. The logic of Breton's 'convulsive beauty', then, is *meta*phenomenological. Walker Evans attempted to grapple with these problems as a way out of the bureaucratic impasse of state-archive work and the aesthetic crisis of the left. The surrealists believed that new forms of symbolic interpretation presaged a revolution at the base. Both invested in photography as a resistance to the abstractions of their epoch. That surrealism was overcome by abstraction itself, and incorporated into the general circulation of commodities, is of course part of that crisis of the avant-garde with which we are now so familiar, and to which Breton and others were so blind. Furthermore, the image of 'disordered reason' as an aesthetic experience is now the cultural orthodoxy of so much contemporary photographic practice. This work, though, embraces the critique of positivism from a vehemently anti-realist position, bringing the dynamics of intertextuality in line with its recent, and widespread, idealist postmodernist promoters. This, needless to say, was not surrealism. Hidden at the heart of surrealism's use of photography is a realist insistence on the power of photography to bring the contradictions of social reality into view. The document and archive are not incidental to 'convulsive beauty', but its dialectical partner.

Notes

1 Henri Lefebvre, *The Critique of Everyday Life*, Verso 1991, p. 110.
2 *Ibid.*, p. 113.
3 *Ibid.*, p. 117.
4 *Ibid.*, p. 119.

5 *Ibid.*, p. 132.
6 Rosalind Krauss and Jane Livingston (eds), *L'Amour Fou: Photography and Surrealism*, Arts Council of Great Britain 1986.
7 Hal Foster, *Compulsive Beauty*, MIT 1993.
8 Helena Lewis, *Dada Turns Red: The Politics of Surrealism*, Edinburgh University Press 1988, p. 27.
9 *Ibid.*, p. 47. For a discussion of Breton's relationship with the PCF, see Alan Rose, *Surrealism and Communism: The Early Years* (preface by Pierre Naville), Peter Lang 1991.
10 André Breton, quoted in ibid., p. 51.
11 Louis Aragon, *Pour un réalisme Socialiste*, Denoël et Steele 1935, p. 15.
12 André Breton, *L'Amour Fou*, Nouvelle Revue Française 1937; English translation, *Mad Love*, University of Nebraska Press 1987.
13 David Macey, *Lacan in Contexts*, Verso 1988, p. 53.
14 Patrick Waldberg, quoted in Michael Richardson, 'Introduction', Georges Bataille, *The Absence of Myth: Writings on Surrealism*, Verso 1994, p. 6.
15 See, for example, François Leperlier, *Claude Cahun: l'ecart et la métamorphose*, Jean Michel Place 1992, and *Claude Cahun Photographie*, Musée d'Art Moderne de la Ville de Paris, Jean Michel Place 1995.
16 Georges Bataille, *Visions of Excess: Selected Writings 1927–1939*, ed. Allan Stoekl, Manchester University Press 1985.
17 Georges Bataille, 'The Big Toe', in *ibid*.
18 Mikhail Bakhtin, *Rabelais and his World*, Indiana University Press 1984.
19 *Ibid.*, p. 319.
20 *Ibid.*, p. 317.
21 Georges Bataille, 'The Surrealist Religion', in *The Absence of Myth*, p. 88.
22 Georges Bataille, quoted in Michael Richardson, 'Introduction', *ibid.*, pp. 3–4.
23 *Ibid.*
24 André Breton, *Nadja*, Nouvelle Revue Française 1928; English translation, Grove Press 1960.
25 See Margaret Cohen, *Profane Illuminations: Walter Benjamin and the Paris of the Surrealist Revolution*, University of California Press 1993.
26 I would like to thank David Evans for discussions on this issue.
27 See *Agustí Centelles (1909–1985)*, Fotoperiodista, Fundacio Caixa de Catalunya 1988.
28 Salvador Dali, 'Psychologie Non Euclidienne d'une Photographie', *Minotaure* 7 (1935), reprinted in *Qui 2*, Denoël/Gorthier 1971.
29 Dali, *Qui 2*, ibid., p. 50.
30 *Ibid.*
31 *Ibid.*, p. 54.
32 *Ibid.*
33 *Ibid.*
34 Walter Benjamin, 'Surrealism. The Last Snapshot of the European Intelligentsia', in *One Way Street and Other Writings*, Verso 1985.
35 André Breton, 'Second Manifesto of Surrealism' (1930), in *Manifestos of Surrealism*, University of Michigan 1969, p.140.
36 Louis Aragon, *Le Paysan de Paris*, Gallimand 1926; English translation, *Paris Peasant* 1980. p. 217.
37 Paris was not the only French city favoured by the surrealists. Nantes was also a favourite of Breton's. See *Le rêve d'une ville: Nantes et le Surréalisme*, Musée des Beaux-Arts de Nantes, Bibliothèque municipale de Nantes, 1994.
38 André Breton and Leon Trotsky, 'Manifesto for an Independent Revolutionary Art', in Franklin Rosemount (ed.), *What is Surrealism? Selected Writings of André Breton*, Pluto 1974.
39 Henri Lefebvre, *The Production of Space*, Blackwell 1991, p. 25.
40 Ibid., p. 49.
41 Ibid., p. 55.
42 Krauss and Livingston (eds), *L'Amour Fou*, p. 35.
43 See José Pierre (ed.), *Investigating Sex: Surrealist Research 1928–1932*, Verso 1992.

6

Inside Modernism: American photography and post-war culture

By 1945 the great wave of avant-garde and factographic culture was over. What aspects of these cultures fascism and Stalinism had not managed to break or disperse, the post-revolutionary consensus in Europe consigned to another intellectual world. The social fabric and institutions in Europe were being rebuilt and representative democracy seemed to offer a realistic participatory role for parties of the working class; a culture and politics of confrontation, of class struggle and revolutionary transformation had no real objective sense of possibility. People were tired, brutalised. The story of how the revolutionary avant-garde became Modernism and factography documentary is now a familiar one, but it is no less important for that. The story of how art as social intervention became culture and a form of spectacle is the dominant explanatory framework out of which we continue to make sense of the past and present and possible futures.

This narrative of loss, though, is only of recent invention. It is only post-1968, and in particular post-1973, that the revolutionary implications of the great wave of avant-garde and factographic culture has been incorporated into a coherent, materialist perspective. These revolutionary implications were largely lost or domesticated in the 1950s and early 1960s in Europe and North America, as modern art found its way into the museums under the auspices of a high-cultural disdain for the demotic and political uses of the new technology in art. The aims and ideals of the 1920s and 1930s had to be reclaimed and written in the early 1970s, as a means of breaking with the increasingly acceptable idea that Modernism and documentary were somehow continuous with early avant-garde and factographic culture. The period 1945–73, however, established an enormous ideological bulwark against the recovery of these knowledges. It could be said that only with the end of the post-war boom (1947–73) did spaces open up in Western culture for these lineages to be developed. Naturally, this was not a simple process of acknowledgement and recovery, but a dialectical process of identification and critique in response to new political and cultural circumstances.

In the 1950s, predominantly in the USA, there was a concerted swing by the state and intellectuals against the political legacy of the 1930s; modern art was rewritten from an

avowedly revisionist, depoliticised position. The critiques of authorship and conventional forms of aesthetic attention were conveniently forgotten or misread in a return to individualist accounts of creativity and value. Generally, what was being attacked was the *collectivist character* of 1920s and 1930s avant-garde and factographic culture. The early Soviet avant-garde, the early reportorial proletarian photography and film, and surrealism, all embraced the new reproductive technologies in order to move artistic creativity out of the 'expressionist camp' into a dialogic and semiotic one. In the post-war world, with working-class culture being further reconstructed in the interests of consumerism, such models seemed bureaucratic and dull. In contrast, what became dominant across the arts in the post-war period was the celebration of the hero or anti-hero (invariably male) battling alone against social convention and the greyness and ennui of post-war realities. Abstract Expressionism (Jackson Pollock), European expressionism (Francis Bacon), the New British Cinema (Lindsay Anderson, Karel Reisz), the New German novel (Heinrich Böll, Gunter Grass), the New American novel (Jack Kerouac, Norman Mailer) and the New American photography (Robert Frank, Diane Arbus), all emphasise the qualitative experience of the individual against the quantitative and homogenous character of social reality. The social world is alien; the function of the artist, or the hero of fiction or film, is an ethical disaffirmation of the routine and normative. Much of this work, dealing as it does with the aftermath of the war and the rush to consensus, produces a strong ethos of redemption, in which the artist seeks to recover what is human in what is social.

One of the clearest indications of these processes is in post-war British realist cinema, which in turning to class as a focus of identity about where people see themselves as standing in relation to the new 'affluence', actually diffuses class as a social category. In 1950s and early 1960s New British Cinema (*Saturday Night and Sunday Morning, Room at the Top, The Loneliness of the Long Distance Runner*) working-class life is turned into a comfortable object of contemplation, in which social transformation is seen to result from personal attributes rather than collective action. The effect of this is to separate character from environment. As John Hill argues in *Sex, Class and Realism* (1986):

> While in *Saturday Night and Sunday Morning* there is a specific contrast between Arthur and those who have been 'ground down', there is little in the film itself which would provide an account of why they have been so reduced (e.g. predatory capitalism, alienating labour). The blame, instead, would seem to attach to the individuals themselves, either as willing victims or bearers of 'bad faith'. This tendency to reduce social relations to individual characteristics is more generally true of all the movies. Thus, in *Room at the Top*, class relations are converted into the personal tension between Joe Lampton and Brown.[1]

Thus although these films claim to deal with 'social problems' and the realities of working-class life, social issues are dealt with as a matter of individual resolution. Furthermore, in many cases the working-class male is represented as in actual, or in imagined, escape from his class and his past; individual assertion is seen to outweigh collective responsibility. In his work on the literature of the period, Ken Worpole argues that much of the British working-class picaresque fiction of the 1950s (Alan Sillitoe, Bill Naughton), protestant individualism and the 'tough-guy' mores of pre-war American detective fiction combined to produce a 'notion of "freedom" that is totally abstract,

talismanic'.[2] In fact it was the exciting images of masculine escape from the domestic and rebellion against authority in American popular culture that began to shape the social perceptions of a new generation of artists in Europe confronted by the steady growth in working-class wages and the expansion of consumerist culture generally. And this is particularly evident in the New Cinema: notions of personal freedom came to be defined through the working-class male's pursuit of unconstrained pleasure.

The impact of existentialism, out of pre-war Paris, is also a factor here. Although existentialism was not actually an anti-communal philosophy – 'I cannot make liberty my aim unless I make that of others equally my aim' (Sartre)[3] – its emphasis on the idea that humans make themselves promoted a powerful self-authenticating message. Existentialism was perhaps the most successful of individualist ideologies of the post-war period. The world had been brutalised by the rise of authoritarian systems of social control and was now in the grip of a Cold War, the only secure set of values seemed to be those that the individual might create out of their own sense of autonomy. It is easy to exaggerate here, but the *strong act* of existential choice – the affirmation of freedom as the value of that which is chosen – fed into a widespread return to Romantic themes in European and North American culture, strengthening the masculinisation of culture in the process. The strong artist was the artist who rejected the shallow comforts of the communal. The immediate effect of this was the reordering of the boundaries between advanced culture and working-class life and politics in the interests of what was exceptional and unshareable, what was beyond common taste. This was no more so than in the area of art and photography. There developed an increasing dissociation between art and photography and the actual or imagined links with the organised workers' movement. The avant-garde view of art and photography as social practices attached to collective action froze, as commercialised notions of audience through the development of the museum system and the celebration of the (male) artist as non-conformist finally broke the institutional connections between the avant-garde and working-class politics. This of course was not difficult in the anti-leftist climate and the fact that Stalinism in the West had absolutely no time and space for the remnants of the avant-garde; it was now securely, and without complication, the formalist enemy. As such the very rejection of cultural modernity by a large section of the labour movement actually promoted the turn away from collective images of belonging. Mutual and communitarian values, rather than acting as a barrier against conservative individualism, appeared stifling and oppressive.

These themes and identifications were also reinforced by the post-war development of bourgeois humanism into a cross-class liberal humanism, which placed the rights of the individual and humanity above those of 'narrow' social interests such as class. Liberal humanism had played a large part in diffusing the radicalness of 1930s culture, or deflecting it into safe social channels; in the post-war world it became a full-blown ideology, confidently defining itself as the new democratic voice of a 'post-collectivist' West. For Western governments the new affluence signalled the end of collectivist ideology – a delusion that certainly did not begin with postmodernism. Certain aspects of existentialism – its Nietzschian rejection of stable moral codes – may have been alien to this ideology, but nevertheless both existentialism and liberal humanism saw the individual as able to define his or her own destiny. The effect of this on art is obvious. Existentialism and liberal humanism allowed art to fashion the reconstruction of pre-avant-garde notions of the artist's 'specialness'.

The construction of photographic Modernism in the 1960s in the USA was very much built out of these ideological materials. With the demise of the Photo League, with the break-up of left photographic culture, and the rise of the new photojournalism and public relations industries, photographic theory and practice retreated to the museum in order to reinvent photographic aestheticism.

Beaumont Newhall, the first director of the Museum of Modern Art photography department, had cleared a path for this in the early 1930s,[4] but it was John Szarkowski who developed the commanding heights of this theory after he was appointed to the same position in 1962. To say that Szarkowski single-handedly reinvented photographic aestheticism for the American art market is to overstate the suasiveness of his model. It is also important to recognise the massive ideological shift in popular consciousness in the 1950s in the USA, which prepared the ground for American Modernism's liberal humanism. If in Britain in the 1950s social class became a focus for national self-examination, in the USA the vindictiveness of a state-directed anti-communist drive drove an irreconcilable wedge between art and social practice. Nevertheless, given his powerful position, Szarkowski had an enormous contributory influence throughout the 1960s and 1970s on the dehistoricising of photographic practice. Yet, it has to be said, Szarkowski was not a *High* Modernist in the manner of Stieglitz, although Stieglitz served as one of the cornerstones of his aestheticism. Rather, Szarkowski wanted to elide an American vernacular that somehow denied any claims to style, and a Modernism that feigned its own constructedness. Essentially, Szarkowski wanted a photography of the 'everyday' that combined an American vernacular with nineteenth-century European aestheticism. The value or the authenticity of the image – its quality of 'everydayness' – lay in its seeming spontaneous vocabulary of the fragmentary and the ephemeral. But at the same time such 'feigned naturalness' had to display, through its internal self-consciousness and formal logic, a historical connection to other practices. As Szarkowski was to argue in 1966, it should be possible to consider the history of photography in terms of the 'photographer's progressive awareness of characteristics and problems that have seemed inherent in the medium'.[5] The representation of the 'everyday', therefore, lies in its capacity to invoke powerful or significant precedents, through either imitation or negation. This of course is an orthodox account of Modernist formal development transposed to the field of photography. The production of meaning is inherited internally through a closely monitored canon of achievement. However, in the case of photography, rather than painting, a problem or paradox arises. The photograph's indexicality is a continuous reminder that the meaning of the image cannot be reduced to a horizontal axis of photographic precedents. Indexicality, emphatically, historically, connects the image to the world. This has always been a problem for the aesthetic rewriters of photography, as Allan Sekula admirably sets out in his essay 'On the Invention of Photographic Meaning', written in the same year as the Szarkowski passage above, and one of the first frontal attacks on the institutionalisation of Modernism.[6]

The solution sometimes has been to ignore the photographic index, or suppress it by devaluing its significance. In order to do this the photographer or writer has had to upgrade the perceptual and poetic powers of the photographer, as Stieglitz tended to do. Most ordinary photographs are simply that, ordinary. However, the 'great' photographer armed with an acutely poeticised understanding of the 'everyday' can extract a transcendental beauty from the fragmentary and ephemeral. This is Szarkowski's position, and like other modernists, it involves him in a reinvention of the photographer

as *auteur*. Evidence of a good photographer lies in his or her ability to significantly transform the canon by drawing attention to the 'everyday' in formally new ways. The New Objectivity photographers of the 1920s pursued a similar version of the transformation of the 'everyday'. But as defenders of positivism and a machine aesthetic they had no interest in any systematic inflation of the photographer as *auteur*. Moreover, as I have explained, their work was grounded in the dialogical aims of the avant-garde. Szarkowski's photography of the 'everyday' is a kind of etiolated and dehistoricised echo of this, in which the presence of the photographer as creator is suspended over and above the work's function as a source of social exchange. The photographer, then, is reinvented as a poetic transcriber of the 'everyday', the things we see in a photographer's pictures being ascribed to his or her sensitive and exceptional vision. The title of Szarkowski's 1966 exhibition at MOMA, 'The Photographer's Eye', is very revealing in this respect.

Under this kind of jurisdiction photography's relationship to the 'everyday' undergoes a substantive transformation. The photographer no longer petitions for what he or she records (as in Hine), or intervenes in order to declare a political identity with the referent (proletarian photography), or even recontextualises the image in the name of a greater conceptual veracity (as in surrealism), but creates an aura of anonymity and distance. If some photographers in the late 1930s critical of engaged photography's fetishisation of the document's 'now-time' took this on in order to provide some breathing space for themselves, in Szarkowski the refusal of 'now-time' is complete. However, this is not an adaptation of Benjamin. For Szarkowski photographic meaning can in *no* sense be confined to its historically specific moment. To do so would simply replicate the inert historical details of the image at the expense of its formal interest.

Many of these issues can be seen in Szarkowski's writing on Walker Evans, who by the late 1960s had been incorporated into Szarkowski's canon of poeticised American vernacular photography. His complete eradication of the ideological tensions that formed Evans's practice in the 1930s and 1940s is strikingly revealing of how historically unselfconscious American Modernism had become by the early 1970s. As Szarkowski declares in his introduction to Evans's retrospective at MOMA in 1971: 'He [Evans] thought of photography as a way of preserving segments of time itself, without regard for the conventional structures of picture-building. Nothing was to be imposed on experience; the truth was to be discovered, not constructed.'[7] Evans's photography, in short, is an unconscious and anonymous process. Avoiding what Szarkowski calls a 'personal style',[8] Evans sets himself the 'goal of an art that would seem reticent, understated, and impersonal'.[9] Consequently, 'Evans at his best convinces us that we are seeing the dry bones of fact, presented without comment.'[10]

This notion that photography is at its best when it is 'artless', unaffected, impersonal, derives from late nineteenth-century Modernist dictates about revealing the 'significant' in the commonplace. The 'significant detail' is 'intuitively sought and found',[11] never constructed. The 'everyday' is something that the photographer alights on spontaneously, drawing out what normative, unaesthetic vision bypasses – the argument being that through the *re*-visioning of the 'ordinary' the photographer momentarily speaks for us all, for our own basic, shared humanity. 'It is ourselves we see, ourselves lifted from a parochial setting.'[12] There is also something of Grierson's poeticisation of the ordinary in this, but Szarkowski has no sympathy for any kind of functional account of meaning. The significant photograph of the everyday is that which renews our humanity against the alienations of the social world, and not what connects us to conflicting material interests,

social division and ideological manipulation. In these terms it is easy to criticise Szarkowski's model: he enjoins photography to a formalist poetics in an attempt to construct an aesthetic identity for photography that it cannot possibly fulfil. The point, though, is could we expect anything else from a US state institution in the 1950s and 1960s, when the very idea of photography as social practice was identified with communist subversion? MOMA wanted American art and photography to be a powerful presence on the world stage, it did not want the promotion of any agenda that would undermine nationalist aspiration. Promoted as the guardian of American photography for the market, Szarkowski accordingly cut his ideological cloth to fit the times, justifying his moves, as the pace of anti-Modernism criticism hotted up in the late 1970s, under a cloak of 'quality' and 'value'.

When we look at the broad sweep of European culture from 1917 to 1945, Szarkowski's promotion of a photography of the 'everyday' can be seen as a highly tendentious negotiation with the factographic tradition. That is, his writing is a largely undeclared engagement with the legacy of realism, in the interests of diffusing its critical impact. In a period of sharp ideological opposition between the USA and the Soviet Union, between the pursuit of so-called individual free expression and collectivism, his defence of the *auteur* resolves the troubling referentiality of photography in the direction of aesthetic delectation. The result is a theory of photography that knows photographs are also pictures, but which has no or little interest in the photographer who looks and *knows*, and the spectator who looks and *knows*, subjects, in short, who are not bound by the ideological constraints of 'anonymity'. By defending creative authorship the critic defers to the authority of the artist, confining the dialogic to the private or subjective conversation between the image and the spectator, a relationship that Beaumont Newhall was keen to promote and that Szarkowski continued. In the 1940s there appeared to be some critical mileage in this, as part of a post-surrealist critique of positivism. By the early 1970s, though, it lacked all positionality, dehistoricising and depoliticising all it touched in the name of 'quality' and 'vision'. One of the low points of this period is Szarkowski's essay on Evans. Although Evans had little sympathy for the photographer as state archivist, he was nonetheless deeply affected by his experiences in the FSA. He thus is worth far more than this attempt by Szarkowski to write out the social ideals of the FSA from Evans's work altogether. The function of the FSA may have been political 'but to the photographers in the field it was an opportunity to make true photographs, away from the carping help of editors or clients.'[13]

To read Szarkowski's interpretation of Modernism and modern photography is to become increasingly aware of a deep ideological crisis in post-war American photographic culture. It is as if photography's relationship to the 'everyday' could be decided upon only as a matter of institutional taste, and not through the realities of post-war American life: American imperialism, racism and the struggle for civil rights. At the same time as American photographic Modernism was embracing the virtues of anonymity, the USA was undergoing a series of massive political convulsions (Korea, black struggle for democracy, Vietnam) that would eventually shatter the WASP conformities of the post-war boom. None of this is reflected in Szarkowski's understanding of the 'everyday'. The 'everyday' has nothing to do with reportage, but only with celebrating the communalities of ordinary life. The outcome of this was the theorisation of Modernism as separate from the demands of documentary, and effectively the marginalisation and suppression of whole areas of social life during the period. To

examine Szarkowski's tenure at MOMA is to see Modernism foreclosing on anything that disrupted the fiction of an ideological free subjectivity. A major case in point is the representation of black experience. The civil rights movement of the 1960s coincided with the growth in numbers of black photographers and the reassessment of early black photographic pioneers such as James VanDerZee. VanDerZee was one of the first black photographers to represent black people as other than a social problem for a white audience. Working mainly in Harlem like many of his peers, by the 1950s he had produced an extensive archive of the area. In 1969 Grove Press published a selection of these images, entitled *The World of James VanDerZee: A Visual Record of Black Americans*. In the 1950s and 1960s Gordon Parks and Roy DeCarava had also contributed extensively to the archival recording of Harlem. By the late 1960s, then, there was a long line of black photographic achievement in place. Yet, although DeCarava had been selected by Szarkowski for 'The Photographer's Eye' and had been included in 'The Family of Man', shows of black photographers were rare outside of Harlem. Szarkowski did nothing to alter this state of affairs, silently excising black (and women) photographers from the remaking of the canon. As A. D. Coleman, one of the few white photography critics to write consistently about black photography at the time, said in 1970:

> In a peculiarly American perversion, our society delights in taking credit for the success of artists who manage to overcome the endless obstacles we place in their path ... For black artists, needless to say, these problems are so compounded that superhuman efforts are required merely to retain enough sanity to go on.[14]

Szarkowski's Modernism could tolerate the black photographer but not the *black archive*. Similarly Szarkowski could give over space to the war photographer caught up in the 'intense heat of human agression', but not the photographer of Vietnam as the narrator of American imperialism. For Szarkowski all this ideological assertiveness was the proper domain of photojournalism, which, unlike Modernism, fed off the voyeuristic and prurient in order to satisfy the salacious tastes of a mass audience. This is why Szarkowski's notion of the 'everyday' is so driven by the discreet and ordinary, because photojournalism and mass culture enforce spectatorship rather than looking. Modernism's domain of the particular and peculiar defies mass culture's spectacularisation of the everyday. Thus it would be inadmissable to say Szarkowski's Modernism is completely antithetical to social critique. In fact Szarkowski's Modernism can be seen as a highly mediated response to America's post-1950s cultural crisis. Szarkowski was drawn to many of the new generation of photographers, such as Robert Frank and Diane Arbus, who tried to recover a viable critical tradition, seeing themselves in the process as the steadfast debunkers of the New America and the American Dream. Yet his support always dispersed their political effects, aligning their unease too easily with the existential idea of the alienated artistic visionary: the artist who sees through his or her pain to the 'truth of the matter'. The effect was to Romantically inflate the idea of the photographer as the powerless and itinerant observer of events, a figure whose only responsibility was to the 'good picture'.

We need to remember that Szarkowski was constructing his Modernism at a time when there was a great fear of, and opposition to, social negativity in American culture. Popular chauvinism, anti-communism and a buoyant economy turned social critics into

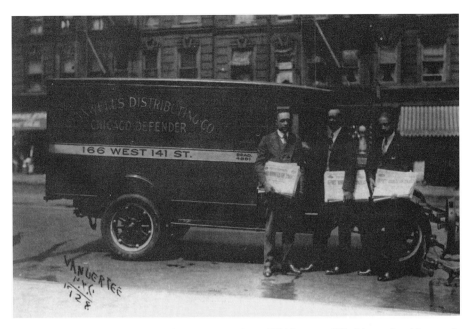

Fig 58 *Distributing the Chicago Defender*, James VanDerZee, 1928 (Courtesy of The Metropolitan Museum of Art, New York)

pariahs. In 1947 President Harry Truman had initiated a programme to search out any 'infiltration of disloyal persons' in the US government, beginning what we now know as the McCarthy purges. Between the launching of the security programme and December 1962 6.6 million people were investigated. Also, between 1948 and 1954 more than forty anti-communist films were made by Hollywood. It was in this atmosphere that the government could get mass support for a policy of rearmament. At the start of the Korean war in 1950 the US budget was about $40 billion, and the military component of this was approximately $12 billion. By 1955 the military part had risen to $40 billion out of a total budget of $62 billion.[15] Arguing in terms of a world-wide communist conspiracy, Truman mobilised liberal opinion behind the militarisation of the economy as part of a Republican/Democratic coalition on foreign and domestic affairs. Yet it was not just the perceived threat of Soviet expansionism that created this ideological climate. An extensive wave of anti-imperialist insurrections was rocking the world – some led by local communist parties, some led by middle-class nationalists. To defeat this, it was argued, would require an enormous effort on the part of the USA. The bipartisan position on the militarisation of the economy and the suppression of domestic opposition to foreign intervention was seen as a necessary step in an attempt to create a new populist consensus for the post-war years. The national populism of the war years had faded. It needed to be recreated, this time though with communism as the main enemy of American interests.

It is no surprise, therefore, that the spaces for cultural opposition and critique were severely narrowed; opposition went underground or allegorical in much the same way it did under Stalinism in the Soviet Union. As such, despite Szarkowski's very restrictive sense of what constitutes a photography of the 'everyday', his fetishisation of 'anonymity' and 'distance' betrays something more than insouciance. Out of the dry bones of his

empiricism, and his identification with the 'existentialism' of a Frank and an Arbus, is born a photography of 'homelessness'. Szarkowski never constructs it in these terms – that would have been too finite and literary an aesthetic programme – nevertheless his selection of favoured photographers in the 1950s and 1960s (Frank, Arbus, Evans, William Klein) reflects an *unambiguous* dislike for the corporate and imperialist values of the USA. They all chase and court anxiety, loneliness and desuetude. Under the covert term of American vernacular Szarkowski in fact constructed a melancholic tradition that took its values from the 'other side' of American corporate confidence and conservative, familial ideology. Thus, paradoxically, the MOMA photography department became one of the few public places in the culture where a sense of things 'not belonging' were given an identity. This is not to say that Szarkowski was conducting a hidden ideological battle against corporatism and imperialism. His public record on these issues endorsed much of the diffidence of the liberal orthodoxy of the time. But traditions and critical perspectives do not get constructed out of non-contradictory materials; the workings of ideology are subcutaneous and heterodox. Szarkowski was undoubtedly building a conservative photography of the 'everyday' *against* the left and the factographic/avant-garde legacy, and in the process doing the ideological work of an embattled US bourgeoisie. Yet at the same time, as a Modernist, as someone committed to the unfamiliar, he had to select those photographs that differentiated themselves from prevailing cultural values. It was inevitable, therefore, that his tradition of the 'everyday' would find it impossible to transcend the *accumulated realities* of the photographs he selected for formalist approval. The historical referent would always return to haunt and destroy the aura of anonymity. The general point, here, is that intentions betray unconsciously as much as they reveal manifestly, forcing the historian and critic to take the ideological pressures that bear on social agents as serious determinants of meaning.

Reading against the grain of received critical opinion on American photographic history is important, because so much of the cultural practice of the time was produced under inordinate political and social pressures. What we take to be a straightforward expression of social constraints turns out on inspection to be more complexly authored. This no more so than with the *Family of Man* exhibition at MOMA, which preceded Szarkowski's tenure at the photography department, and although critically distant from Szarkowski's aestheticism nonetheless has a comparable paradigmatic status within post-war American photography.

The Family of Man show has in recent years become the *bête noire* of the new photographic criticism and a staging post for the new cultural anti-humanism. Written about by Roland Barthes (1955),[16] Allan Sekula (1981)[17] and others, it has come to represent the worst aspects of the post-war liberal humanist settlement. Organised in 1955 by Edward Steichen, during his time as the head of photography at MOMA, the show has been described as a huge Cold War propaganda exercise on the part of the American government. Partly funded by Coca Cola, the exhibition of over 500 photographs from sixty-eight countries was seen in over twenty European and non-European countries. Embracing the idea of a 'world family', the show drew together photographs from different peoples and nations to create an image of a shared humanity. In this sense, in a period of strong ideological polarisation between East and West, 'The Family of Man' invoked an America-led version of humanist reconciliation. There is a clear sense, then, that the exhibition was part of a concerted effort on the government's behalf to connect the ordinary lives of Americans with a defence of American-type

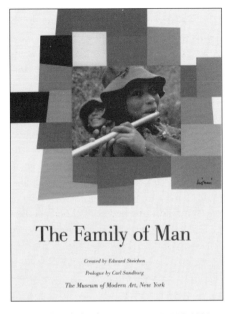

Fig 59 *The Family of Man* (cover), 1955 (© 1996 The Museum of Modern Art, New York)

Fig 60 Installation view of the exhibition *The Family of Man*, Museum of Modern Art, New York, 24 January–8 May 1955 (© 1996 The Museum of Modern Art, New York)

capitalist democracy on a world scale. Americans are shown to be 'decent folks' who do not really want to exclude anyone, even if they are communists. The communist system is simply wrong and one day, under the benign influence of American capitalism, the people of these countries will realise this. Under this banner of reconciliation ideological conflict is held to be transitory. The things that unite humanity are far stronger than what divides it. One section of the exhibition, on families, openly reflects this. In succession there are photographs of peasant families from Japan and the Soviet Union, and of a tribal family from Bechuanaland in Africa, and a rural working-class family from the USA. Of particular interest, though, is the large photograph opening the section of a smiling farmer and his wife and their child seated on a cart. The family are from Italy but they could easily be from the Soviet Union or any other Eastern European country given the socialist realist conventions of the picture. It is as if this obviously culturally locatable but ideologically ambiguous photograph speaks for a view of family life beyond ideology. This is reinforced by the accompanying quotation from a Sioux Indian: 'With all beings and all things, we shall be as relatives.' Or as Carl Sandburg puts it in his prologue to the book of the exhibition, here are 'the lonely and abandoned, the brutal and the compassionate – one big family hugging close to the ball of Earth for its life and being'.[18]

Barthes's criticisms of this humanism have become standard. 'We are at the outset directed to [the] ambiguous myth of the "human community".' 'Exoticism is insistently stressed ... the image of Babel is complacently projected over that of the world.' 'Everything here ... aims to suppress the determining weight of history.'[19] The show, in short, celebrates injustice and social division as 'difference'. When we read the apologetics for the exhibition, and begin to investigate who backed the show and on what terms, it is difficult to disagree with these comments. However, the problem with

Barthes's criticism, and to a lesser degree Sekula's more context-sensitive writing, is that there is a failure to examine in any depth the political conjuncture that gives ideological shape to the show. In looking at how Steichen's humanism comes to intercede on behalf of the photographs we need to judge what moves were institutionally feasible for photography in the early 1950s. This is not to excuse the exhibition of its sentimentality and pro-imperialist agenda, but to recognise that the decisions Steichen and his co-workers made reflect their intention to provide for other possible meanings mobilised by the exhibition's themes, given the nature of the political circumstances under which it was seen. By the time it got to Paris where Barthes reviewed it, any implicit criticism of American foreign policy contained in the show would have been dissipated under the general feeling within Parisian left intellectual circles that this was an exhibition of state-sponsored imperialist ambitions.

I contend that in a period of open state censorship and aggressive anti-left realpoliticking, Steichen's humanism cannot be reduced in any simplistic fashion to pro-imperialist propaganda. When he talks in his introduction about 'explaining man to man',[20] he actually distances himself from those aspects of American foreign policy that would separate off those worthy of humanity and those who were not – those governments opposed to the munificence of American economic and cultural interests. This is not to stretch a point on the strength of one small piece of textual evidence. Although the majority of the photographs are from the USA and its satellites, there are twenty-eight images from China, the Soviet Union and other communist countries, making it conspicuous to the viewer that this was not an *anti*-communist exhibition. Similarly, in a period when the representation of black peoples in the illustrated magazines as other than victims or 'primitives' was practically non-existent, Steichen includes a number of non-stereotypical images of black Americans at work and play. In both cases these images may be subordinate to a white, middle-class view of US capitalism, but nevertheless it fissures the idea that collective human values are essentially white European and North American. This seems to me to be actually progressive in a period of violent anti-leftism and racism in the USA. There is a sense, then, in which the exhibition speaks out of a narrow ideological view of acceptable photographic practice, and at the same time resists it. I believe this has much to do with Steichen's wartime experiences and anti-fascist politics (Steichen was an aerial photographer in the First World War and served in communications as a Major in the Second World War). His sense of global political crisis proceeded directly out of the realities of fascism and not just in response to an abstract notion of the 'Soviet threat'.

In the mid-1950s, when national populist sentiment was being channelled towards highly chauvinist ends, *The Family of Man* constructs a view of human identity that is remarkably heterodox. In these terms the show can actually be read as a covert attack on the Cold War. This is given further credence by Steichen's demotic understanding of photography. *The Family of Man* was not curated as an exhibition of discrete photographs. It was curated as a photographic spectacle. Underlying this is Steichen's antipathy towards fine-art photography or aestheticism and his familiarity with avant-garde theories of extended montage. Designed by Herbert Bayer, the ex-Bauhaus photographer and designer, *The Family of Man* attempts to use the photographic exhibition as a form of montage in itself. As on the pages of an illustrated magazine, individual photographs are recontextualised into new chains of meaning. Photographs become interchangeable units of meaning.[21] *The Family of Man* uses these techniques to

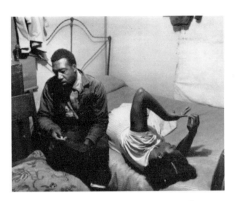
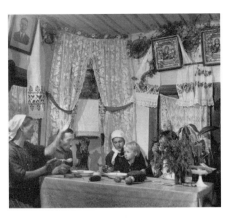

Fig 61 From *The Family of Man*, Wayne Miller, 1955 (© Wayne Miller / Magnum Photos)

Fig 62 From *The Family of Man*, Robert Capa, *c*.1955 (© Robert Capa / Magnum Photos)

construct an interactive framework for the photographic image, rather than using the public space of the exhibition to confer value on the individual author (although each photographer is credited in the book, their names are printed very small under each photograph). This was a radical move, aligning photography with mass culture's reliance on the rapid reading of anonymous images; as such under Steichen's tenure at MOMA Newhall's proto-Modernist fetishisation of the individual photographer and the 'quality of the print' practically disappeared. It is not too fanciful to say that one of the reasons that Szarkowski was appointed at MOMA was that such methods of presentation allowed too much space to the ideological function of photography. Subordinating author to a pre-given theme or set of meanings was too close to using photography for public argumentation. This, for the aesthetes, was simply Lewis Hine's social pedagogy in updated form.

Steichen was not a radical in the sense Hine was. He had to deal with powerful conservative forces on the board at MOMA, and operated within the terms they laid down. But he realised that what was significant about the critical legacy of the 1930s was that it had, briefly and inconclusively through the illustrated magazines, created a dynamic public space for photography. Hence, he understood that if photography was not to academicise itself as a highly codified set of aesthetic moves – as Newhall had openly advocated – then it had to retain its links to the social world. But it was impossible to do this through invoking the critical legacy of the 1930s. The only available public space for a photography of the 'everyday' was that which the new commercial photojournalism provided. The new photojournalism may have been excessively voyeuristic and prurient, but on the page it at least connected photography to the movement of wider social forces. Steichen's mass cultural appropriation of the image can be seen, therefore, as a displaced commitment to the social function of photography, in circumstances where to name such a thing was to invite the wrath of conservative opinion. Consequently, in their respective ways, Steichen and Szarkowski provided an ideological compromise with the factographic/avant-garde legacy. They both retained the idea of a photography of the 'everyday' but located it outside its determining context: workers' struggle.

In summary, I now want to return to Barthes's review of *The Family of Man*. The critical meeting between Barthes's writing and the exhibition is of considerable

importance in assessing the development of photographic theory out of the 1950s and the post-war period generally. In one sense it was absolutely imperative that Barthes attacked the exhibition in the way that he did. Humanism, in either its liberal or Hegelian-Marxist versions, had swallowed up much of the debate on culture in the period. There was constant talk of Man's essential human nature. To attack humanism then – as the structuralist and semiotic revolution in France did in the late 1950s and 1960s – was to disentangle 'false universals' from scientifically adequate ones, insofar as 1950s humanist culture was drowning in 'false universals'. It was necessary, as Barthes testifies, to open out a space in which the meaning of things might be distinguished according to different taxonomies and categories. That these moves seemed so radical shows how deeply positivism had burrowed into humanism, and how much of the avant-garde legacy of the 1920s and 1930s had been lost. However, it was not possible simply to recover the critical culture of the 1920s and 1930s, although that in itself became a priority for Barthes and his peers. There were residual problems with this legacy as well: with the exception of surrealism, the unconscious reliance on an undifferentiated account of the subject and an undifferentiated account of photographic realism or truthfulness. Barthes's attack on *The Family of Man* is one of the first – if not the first – post-war critique of photographic truth to reinscribe the problem of the subject. Who is talking? Who is the image being addressed to? And on what terms? Barthes's eventual construction of a theory of ideological interpellation – or the presence of myth as Barthes was to call it – produced a seismic shift away from a positivist model of photography in which images *reflect* the world to a social one. That is, the purported truthfulness of the photographic image is no less coded than other kinds of visualisation. For Barthes the photograph does not *represent* reality, but *signifies* it.

This now overly familiar and orthodox position is the basis of critical theory's exit from the 1950s into the 1960s, and to a wholly new kind of photographic theory in which images are read for their coded ideological content. There are adverse consequences from this position, though, which can be detected in Barthes's review of *The Family of Man*. At no point does Barthes seek to place his critique of the myth of a universal photographic realism within the political context that produced the claims of the show in the first place. And this seems to be a recurring problem in a lot of contemporary photographic theory that inherits Barthes's mantle. The *critique* of the epistemological inadequacy of the humanist/positivist account of realism comes before understanding the ideological materials out of which the work was made, consumed and *used*. In general terms, what this has produced is a top-heavy account of photographic practices as symbolic practices, at the expense of their dialogic and social functions. The result, inevitably, has been a downgrading of the factographic and documentary in favour of work that self-consciously addresses its own representational status. We might call this the *epistemologicalisation of reality* through photography, and it is treated as the legitimate heir to the avant-garde. However – and Rosalind Krauss's reading of surrealism is a good example of this – it fails to address the 'other' side of the avant-garde: its realist determination to use the archival powers of film and photography to reorder the 'everyday' in the interests of social emancipation.

Nevertheless, the ideological closures of 1950s photographic culture are real enough, and represent the extensive raw material on which the new photography has operated. In the next chapters, which deal with *post*-Modernist photographic culture, I want to look at this new photography and photographic literature in detail.

Notes

1 John Hill, *Sex, Class and Realism: British Cinema 1956–1963*, BFI 1986, p. 139.
2 Ken Worpole, *Dockers and Detectives*, Verso 1983.
3 Jean-Paul Sartre, *Existentialism and Humanism*, Eyre Methuen 1973, p. 52.
4 See Beaumont Newhall, *Photography: A Short Critical History*, New York 1938.
5 John Szarkowski, *The Photographer's Eye*, Museum of Modern Art New York 1966.
6 Allan Sekula, 'On the Invention of Photographic Meaning', in *Against the Grain*, Nova Scotia Press 1984.
7 John Szarkowski, *Walker Evans*, Museum of Modern Art New York 1971, p. 12.
8 *Ibid.*, p. 10.
9 *Ibid.*
10 *Ibid.*, p. 18.
11 John Szarkowski, *The Photographer's Eye*.
12 Szarkowski, *Walker Evans*, p. 15.
13 *Ibid.*
14 A. D. Coleman, 'Roy DeCarava: "Thru Black Eyes"', in *Light Readings: A Photography Critic's Writings 1968–1978*, Oxford University Press 1982, p. 19.
15 See Howard Zinn, *A People's History of the United States*, Longman 1980.
16 Roland Barthes, 'The Great Family of Man', in *Mythologies*, Jonathan Cape 1972.
17 Allan Sekula, 'The Traffic in Photographs', in *Against the Grain*.
18 Carl Sandburg, 'Prologue', *The Family of Man*, MOMA 1955, p. 2.
19 Roland Barthes, 'The Great Family of Man', pp. 100, 101.
20 Edward Steichen, 'Introduction', *The Family of Man*.
21 See Christopher Phillips, 'The Judgement Seat of Photography', in Annette Michelson, Rosalind Krauss, Douglas Crimp and Joan Copjec (eds), *October: The First Decade*, MIT 1987.

7

John Berger and Jean Mohr:
the return to communality

John Berger has worked as a painter, novelist and art critic since the 1950s. As far his theoretical work goes it has been his writing on photography that has received the most attention and acclaim. Since the publication of *Ways of Seeing* in 1972,[1] which has become a standard introductory text on semiotics, mass culture and visual ideology, Berger on his own, and in collaboration with the Swiss photographer Jean Mohr, has consistently sought to redefine a social role for photography. In the late 1960s and early 1970s he was one of the few art critics and cultural theorists, outside a coterie of conceptual artists in the USA and Britain, who took photography seriously as a critical practice. Photography for Berger was always a specific act of *sharing*, and it is this notion of photography as a form of social exchange that has dominated his photographic theory and distinguished it from much of the semiotic-deconstructive writing that overlapped with his own interests in the mid to late 1970s.

What makes Berger's work on photography interesting in the 1960s and 1970s is his understated attempt to extend the critical place of the archive within the legacy of the avant-garde. That is, Berger's dialogic account of photography is deeply indebted to the philosophical debate on realism – which he first engaged with around painting in the mid-1950s.[2] In Berger's writing, though, there is a novelistic bias to his thinking, which makes his appropriation of the idea of a counter-archive a highly literary project. This is largely alien to his conceptualist and deconstructive contemporaries. Indeed, despite Berger's debt to Walter Benjamin, Berger's understanding of the social function of photography is closer to that of Edward Steichen than it is to Heartfield or even the Photo League. Berger's book work with Jean Mohr on *A Fortunate Man* (1967),[3] *A Seventh Man* (1975)[4] and *Another Way of Telling* (1982)[5] offers a radicalised version of Steichen's and Bayer's extended image/text montage model.

The extended relationship between photographic image and text played a considerable part in defining a new aesthetics of the artbook and of popular political practice in the 1920s and 1930s – we can think of Heartfield's and Kurt Tucholsky's *Deutschland, Deutschland Über Alles* (1929)[6] – but much of this work was driven by

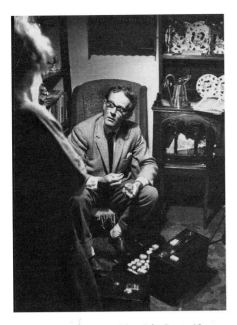

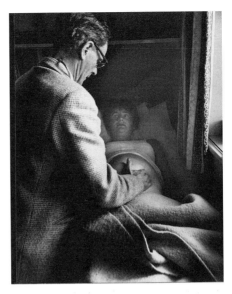

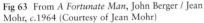

Fig 63 From *A Fortunate Man*, John Berger / Jean Mohr, *c*.1964 (Courtesy of Jean Mohr)

Fig 64 From *A Fortunate Man*, John Berger / Jean Mohr, *c*.1964 (Courtesy of Jean Mohr)

satire, parody and other deconstructive tropes. Berger's extended montage model has always been determined by a strong sense that what constitutes the cognitive base of realism is a participation in the lives of others, as a means of connecting our sense of the 'everyday' to the everyday experiences of others. In the early 1970s this laid him open to criticism which found his stories-and-images version of montage too close to the panaceas of socialist realism for comfort. This was unfounded, but it points to one of those sources of fictive identification that casts a strong light over his work: sentiment. Sentiment is a much used term of abuse. We call something sentimental when an attempt to move us is perceived as being founded on an unwarranted excess of emotion. Sentiment, though, also refers to a sense of shared intimacy with the emotional lives of others, of fraternity; and it is this potential fraternity of the photographic image that underscores Berger's writing on photography and the everyday and his meeting between the avant-garde and the realist demands of the archive.

A Fortunate Man, with photographs by Mohr, is the story of a country doctor, John Sassall, who was once a ship's doctor, but decided to leave the Navy and devote the rest of his life to a small, poor rural community. The narrative draws on the routine of Sassall's life and his relationship with his patients in order to deal with the themes of middle-class paternalism, class alienation, human fortitude and generosity. In many respects it is a story of the struggle for intimacy and humanity *out of* the limits of class alienation, that in this historical instance is early 1960s middle-class England. Berger notes that Sassall has gone to the isolated community in the hope of having his humane skills as a doctor thoroughly tested; he wants to be made irreplaceable, to feel that as someone who serves others he is stretched to the utmost of his physical and emotional being. As Berger says: 'The position can be described more crudely. Sassall can strive towards the universal because his patients are underprivileged.'[7] Sassall can enter the

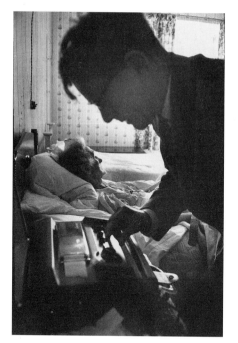

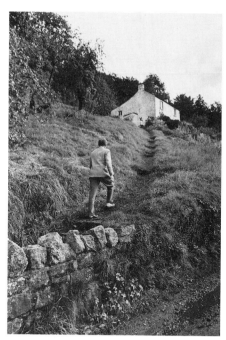

Fig 65 From *A Fortunate Man*, John Berger / Jean Mohr, *c.*1964 (Courtesy of Jean Mohr)

Fig 66 From *A Fortunate Man*, John Berger / Jean Mohr, *c.*1964 (Courtesy of Jean Mohr)

community, work for it, make himself indispensable, and transform himself in the process because he has the privilege to do so. The central concern of the book, then, is how the striving towards a universal humanity can only become sensuously concrete for all outside class relations. Sassall's working-class patients are not in a position to leave their class on a collective basis to 'find themselves' in the lives of others.

Berger's and Mohr's record of a life, its hopes, delusions and disappointments, finds an immediate echo in the extraordinary efflorescence of radical TV documentary work in Britain in the late 1960s. Berger's early work has rarely been discussed in this context; invariably Berger is seen as an *auteur* first, rather than as a writer-collaborator, both with those who share the production of the publications and those who are the actual subjects of his investigations. Berger's decision to pursue a collaborative practice as a crucial part of his activity as a writer is in this sense based on the desire to align himself with those early dialogic ideals of factography and radical documentary. But in the late 1960s in England, in that period that directly preceeded the avant-garde photographic revolution of the early 1970s, critical discussion of photographic reportage, let alone its relation to the avant-garde, was in complete abeyance. The only area where such ideas were up for discussion was in TV, where the documentary ideal of the 1930s was transmuted into a powerful 'state of the nation' source of consciousness-raising about pressing social problems. Berger's use of an extended montage model also needs, therefore, to be seen as a response to how much of the documentary ethos – to reveal, to inform – was being shaped by the 'real-time' complexities of TV. The new 'social problem' TV documentaries of the late 1960s and early 1970s prided themselves on their 'fly on the wall techniques', creating an unprecedented candour in recording the texture of everyday speech patterns and behaviour. For those still committed to the idea of realism this seemed far more

compelling than the still photographic tradition. Berger's recovery of the extended montage in book form – initially in itself a mimetic response to film – can be seen then as an acknowledgement of where the debate on reportage now was. However, this does not mean that Berger and Mohr set out to produce a comparable kind of brutalised naturalism that by the early 1970s had become *de rigueur*; but that an extended use of image and text in book form allowed for a greater reportorial mobility that much of the new TV had achieved through hand-held cameras, improved sound and lengthy real-time shots. Thus what links such ambitions to the early avant-garde is the possibility of utilising images and words that cut across the fetishised categories of the visual and the literary, the individual creative act and the collaborative project, the aesthetic and the non-aesthetic. To produce images and text as a collaborative book work is immediately to step outside the aestheticised categories of fine art and literature, to align the production of art with the reproductive and collective processes of mass culture. For artists and writers of the 1920s who saw the book from a similar kind of position, such as Heartfield and Tucholsky, or Benjamin and Tretyakov, these moves offered the possibility of the popular reinvention of literary and artistic skills. By the late 1960s, though, such encounters had become no more than an excuse to produce the small edition artist's book. As such in the 1960s Berger and Mohr set out to do three related things: to reclaim the avant-garde legacy of critical collaboration between writer and photographer; to defend reportage as a collaborative process with its subjects; and to stress the continuing critical role of the photographic archive *within* the political programme of the avant-garde. Thus *A Fortunate Man* was not produced as an artist's book, nor was it produced as a documentary account of the 'life of a doctor'. Rather, it tried to chart, through a poetic brevity of language and undemonstrative imagery, the subjectivity of a man caught between conflicting expectations. The result was a study based not simply on the facticity of Sassall's daily rounds, but on a reconstruction of those telling silences and intermittent losses of identity that make the subject a complex human being. A certain faith is being placed in the relationship between images and text to give us access to those areas of experience photography is conventionally unable to name: the emotions and psychological condition of the subject. This is a long way from the social anthropology of the 1930s, even from those photographers who took pride in their egalitarian collaboration with their subjects. From the beginning, in *A Fortunate Man* we are aware that the collaboration with Sassall is more than the product of formal consent. It is the product of intense involvement and empathy on the part of writer and photographer. Writer, photographer and subject have agreed that the finished portrait will be as much about pain and loss and confusion as it is about any confirmation of 'good character'. This does not mean that Berger and Mohr tell the truth of Sassall as a man and a doctor, but that they allow us to see in small quantifiable ways how the historical and social passes through individual consciousness.

In 1975 Berger and Mohr produced a follow-up publication to *A Fortunate Man, A Seventh Man*, which put into clearer perspective some of the themes that would come to dominate Berger's photographic writing, and introduced issues that would preoccupy Berger's other writing. If *A Fortunate Man* is concerned with self-imposed exile, *A Seventh Man* deals with the realities of enforced exile: the experience of migrant workers in Europe. In this there is a more explicit attempt to link individual consciousness to the forces of history. Yet the overall critical aim remains the same: the construction of anti-anthropological narrative that provides conditions of empathy for the spectator or reader

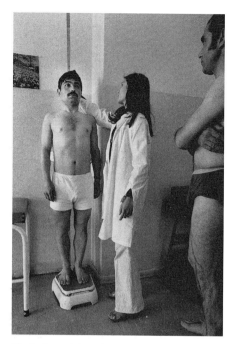

Fig 67 From *A Seventh Man*, John Berger / Jean Mohr, 1973 (Courtesy of Jean Mohr)

Fig 68 From *A Seventh Man*, John Berger / Jean Mohr, 1973 (Courtesy of Jean Mohr)

to have an open and non-paternalistic conversation with others. In *A Seventh Man*, though, this involves allowing the text and images to take on the *voices* of others. As Berger says: 'To try to understand the experience of another it is necessary to dismantle the world as seen from one's own place within it, and to reassemble it as seen from his.'[8] Dealing with the cycle of experiences of the Turkish guestworker in Germany in the 1970s – departure from Turkey, the experience of work and the return to Turkey – Berger adopts the subject position of an imaginary worker himself. Writers of fiction do this of necessity; writers of would-be documentary accounts of the lives of others, rarely. The effect is not simply a political identification with the oppressed, but an attempt to narrate the experiences of oppression from within its own experiential space. For Berger this is imperative because the act of empathy is based on the actions and speech of others, and not on their image as oppressed victim. Berger makes a distinction between a photography that reports on the world and a photography that is produced 'for those involved in the events photographed'.[9] The relationship between photograph and text is a centrally determining one, therefore. 'Photographs in themselves do not narrate.'[10] They need to be cognitively reconstructed and extended through language, in order that those who are represented in the photograph can speak back in a language of their own making.

In this regard Berger and Mohr in *A Fortunate Man* and *A Seventh Man* develop in a non-anthropological direction one of the key aims of reportorial practice since Lewis Hine and the development of the modern communications industry: the use of photography as a challenge to the *loss* of historical memory. Narrative reconstruction of the photograph actively breaks with the de-historical circulation of images under the effects of capitalist spectacle. The function of photography under the conditions of

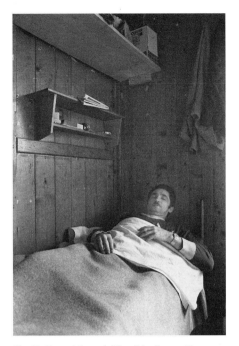

Fig 69 From *A Seventh Man*, John Berger / Jean Mohr, 1973 (Courtesy of Jean Mohr)

Fig 70 From *A Seventh Man*, John Berger / Jean Mohr, 1973 (Courtesy of Jean Mohr)

modern capitalism instates a grievous paradox. At the same time as the camera allows us to enter and re-enter the lives of others on an unprecedented scale, it also relieves us of the demands of historical understanding. As that which notionally connects us to the look of the past, photography also wipes the past clean of historical depth in a relentless overthrow of the present in the name of the 'new'. Theories of the spectacle from the Situationists to Fredric Jameson have emphasised this process of commodification as a de-historicising one: the commodity form lives out of an eternal present and the fluctuations of temporal desire. One of the functions of any counter-archive photographic practice is not so much to *resist* this – images cannot be expected to resist such forces – but to reorder the expectations of photographic spectatorship. Since *A Fortunate Man* Berger has used the narrative reconstruction of the photograph to *re-historicise* the photograph, to reconnect the recorded moment of the photograph with the larger events of which they are a part. The task, he says, of an alternative or counter-archival photography is 'to incorporate photography into social and political memory instead of using it as a substitute which encourages the atrophy of any such memory'.[11] In this sense it is possible to see Berger's use of photography and writing on photography during this period as an excursus on memory and time, and what might be construed as photography's privileged relationship to such issues, that is, before photography is anything else it is trace or index of a past moment. Time is inscribed in the very material presence of the photograph. This link between photography and 'what was' is something that all serious commentators on photography have addressed in differentiating photography from other visual practices. Berger likewise sees photography's relationship to time as one of its determining characteristics. But for Berger the 'moment' of the photograph is forever drifting into the *homogeneous time* of the time of the spectacle, the

Fig 71 From *A Seventh Man*, John Berger / Jean Mohr, 1973 (Courtesy of Jean Mohr)

Fig 72 From *A Seventh Man*, John Berger / Jean Mohr, 1973 (Courtesy of Jean Mohr)

time of a past without historical differentiation. As Barthes was to note, the photograph relieved of textual support easily becomes a signifier of 'pastness', a phantasmagoria of times past.[12] In a culture where these photographic moments of pastness have accumulated to fetishistic proportions, an alternative photographic line becomes a pressing requirement. Essentially Berger uses the notion of the narrativisation of the image beyond its phenomenal identity to create an anti-positivist account of the documentary time of the photograph. Thus in *A Fortunate Man* and *A Seventh Man* the diurnal time of the photograph is situated discursively within those orders of experience out of which the specific moment of the photograph is made: the economic, political and social. In an essay written soon after *A Seventh Man* Berger refers to these 'other' times of the photograph as establishing a radial system of meaning. In narrativising the photograph out of its inert empirical specificity, memory begins to work 'radially, that is to say an enormous number [of] associations' come into play.[13]

This process of narrative redemption takes us back to Tretyakov's notion of montage as 'sequential analysis', as much as it does to the avant-garde book experiments of the 1920s. Both attempt to place photographs against other photographs and against texts to open out the empirical moment of the photograph. As Berger argues: 'The aim must be to construct a context for a photograph, to construct it with words, to construct it with other photographs, to construct it by its place in an ongoing text of photographs and images.'[14] However, this intertextual radial system does not so much seek to reconstruct the photograph in the name of a general truth suppressed at the empirical level – something that defines the approach of Heartfield and Tucholsky: 'we want ... to extract the typical from the snapshots, posed photographs, all kinds of pictures'[15] – but operates as part of an open narrative chain of meaning. The meanings of the photograph

Fig 73 From *Another Way of Telling*, John Berger / Jean Mohr, *c*.1974 (Courtesy of Jean Mohr)

lie in how they are reconstructed discursively, and not in the discursive extraction of their truth content *from* the image. In this, Berger's radial system, as with earlier extended notions of montage, recognises the tendentiousness of photographic meaning, but does not assume that such an extended model of representation builds up a more expansively truthful picture of its subject.

These issues are explored in Berger's and Mohr's next collaboration, *Another Way of Telling*, which draws together many of the earlier themes, but in a more theoretically explicit fashion. Incorporating Mohr's own reflections on photography, an essay by Berger on time, memory and appearance, and a couple of short 'stories' by him on narration, in conjunction with an extensive photo-essay by Mohr on the experience of an anonymous woman peasant, the book acts as a kind of a second-order critique of conventional documentary practice. However, what distinguishes the book from the earlier work is the status accorded the naturalistic photograph itself. In the practice of *A Fortunate Man* and *A Seventh Man* and in his theory of photography as a radial system, although Berger is committed to the deconstruction of the reception of the image in fixed time, this does not extend to the breaking up of the spatial integrity of the naturalistic photograph. The reconstructive strategies of *photo*montage are absent from his extended notion of montage. This has everything to do with the political character of Berger's and Mohr's project, inherited in part from the documentary ideals of the 1930s: to break up the *look* of those lives that commonly lie outside prevailing systems of representation (for example migrant workers or peasants) would mean to continue to render the appearance of those lives invisible. For Berger the naturalistic image should be used as a changeable unit of meaning with other naturalistic images, but it should not be fragmented into smaller units. The radial system critique of documentary, then, lies principally in the way

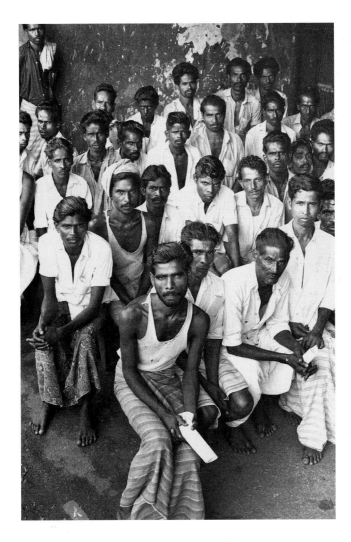

Fig 74 From *Another Way of Telling*, John Berger / Jean Mohr, *c.*1974 (Courtesy of Jean Mohr)

conventional documentary divorces itself from narrative meaning. In *Another Way of Telling*, though, the naturalistic image is given a very different kind of emphasis. Although the book is a good example of the radial system approach, part of Berger's essay on time, memory and appearance is taken up with suggestibility of the single, un-contextualised, un-narrativised naturalistic photograph, in a way in fact that echoes Salvador Dali's internal montage model. For Berger the photograph freezes appearances along a trajectory of past, present and future. Invariably the meanings of this moment remain opaque or ambiguous to us. But even so, without additional contextual information, we can still gain a provisional knowledge of the event from appearances. In the case of what he calls 'exceptional'[16] photographs, photographs that equalise the particular with the universal, this process of identification is even easier. Hence the world of appearances instates other events and references beyond the facticity of the photographed event: a process of 'simultaneous connections and cross references'.[17] Berger refers to this process as the quality of the receptivity of the photograph. 'We think or feel or remember *through the appearances* recorded in the photograph, and *with* the

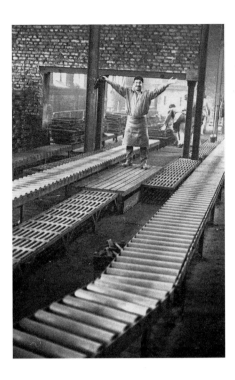

Fig 75 From *Another Way of Telling*, John Berger / Jean Mohr, *c.*1974 (Courtesy of Jean Mohr)

idea of legibility/illegibility which was instigated by them.'[18] The photograph, irrespective of contextualisation, confirms certain shared knowledges; and it is this confirmation which moves us despite us being unaware of the original context of the image. As a result the world of appearances rises to meet our knowledge rather than confounding it.

Clearly Berger is taking his distance here from the textual dominance of avant-garde photography that was widespread in the early 1980s in Britain and North America. As I explain in detail in the next chapter, this was an important precedent in recovering the critical content of archival work, in a climate that associated all forms of reportage with the objectification of social reality. Nevertheless, Berger's defence of the naturalistic moment puts undue strain on his commitment to an extended montage model. That is, problems arise in Berger's model when the narrative recovery of events is accompanied by the need for a critique of the dominant power relations of which they are an expression. Another kind of illocutionary force has to be adopted, so to speak, in which no image is safe from the glare of scepticism. This is the *interruptive* side of montage, and of Benjamin's concept of aesthetic fragmentation as a denaturing of the present, and a side that Berger continually underplays. In these terms, a radial system of image and text is subject not so much to the stable extension of the historical referent across time and space, but to the radical restructuring of the representation of historical time itself. Events or figures are pulled out of context, or subject to fictional re-presentation, in order to present an argument or story. Crucial to this logic of disruption and reconstruction is the break-up of any imagined unitary representational voice or method. In order to break up the symbolic continuity of the real the full range of representational devices have to be put in place, as a matter of demonstrating, in the classic left-avant-garde sense, that history is always a struggle *over* the real. The rhetorical figures of parody, irony and chiasmus (inversion), are not just optional extras for a critical practice of the 'everyday',

but the interrogative basis of an engagement with the symbols and language of domination; this was Heartfield's fundamental insight. It also informs the practice of a number of contemporary artists using photography whose work, like Berger's, has involved the development of an extended model of montage, such as Martha Rosler. As Rosler argued in 1989: 'documentary for me doesn't consist of a series of decisive moments; most of the work I would find interesting has multiple related images. But more importantly, images rooted in some kind of text – in, around, on the photos.'[19] Rosler adopts an extended model of montage as a fully interruptive radial system.

Why is Berger so ill-disposed towards this kind of extended montage or its variants? Because for Berger such methods essentially *destabilise* the shared receptivity of the naturalistic photograph. For Berger this has wide political and social implications. In the period from the late 1960s with the rise of the new deconstructive theories and the attack on humanism of all kinds, cultural criticism and aesthetic theory have been indefatigably linked to forms of interrogative scepticism, in which the ideological illusions inscribed in objects and processes are unpacked in the interests of rational appraisal and enlightenment. Berger's work undoubtedly participates in this critical programme, and contributes to it in significant ways. But at the same time he takes his critical distance from the professionalisation of this milieu and its specialist discourses, which so easily slide into the denigration of ordinary experiences at the same time as they are being read for their significances. At no point does Berger's writing aspire to the status of professionalised theory. What preoccupies him is how the art of criticism, of critical positioning and evaluation, can become an *act of love*. The idea of criticism as an act of love finds few sympathetic resonances in contemporary cultural theory, where professionalised forms of discourse, and a widespread metropolitan cynicism, embrace the arts of evaluation and discrimination as interspecialist forms of competition and nugatory self-display. Moreover, the very redemptive tradition of Benjamin, out of which Berger's writing has developed, may embrace the act of critical mourning as an act of love, but it is also not immune to an atomised negativity, particularly in its current deconstructive manifestation on the academic left. As Benjamin himself once said, the task of the critic is to refuse all blandishments about the spirituality of culture, because such judgements conceal the oppressiveness of bourgeois relations. Berger is not that kind of Benjaminian. Berger's critical task is certainly one of non-reconciliation with bourgeois culture, but his language and the wider shape of what such a task should be are founded on the nominalist Benjamin, the idea of criticism as an act of *naming*: naming what has been lost, disfigured or brutalised in an alien and inhospitable world. Photography itself then plays a singularly important role in this given its naturalistic basis. With its powers of close description and historical recall it provides an intimate point of contact with those forms of common experience that are continually being obscured by our spectacularised culture. This is a history of photography from below as mnemonics, in which the use of photography and criticism as an act of naming stands as a confirmation of human continuity and fraternity over and above the alienations of commodification. Redemptive criticism, therefore, is not about the undifferentiated absorption of the object of interpretation, it is about recognising that one of the tasks of socialist critique under capitalism is to use the arts of evaluation as a breach against pitilessness and bitterness. The act of naming becomes the desire to know and share those things and experiences that are *unnamed* in the culture, those things and experiences that the culture sees fit to deem sentimental, boring or worthless.

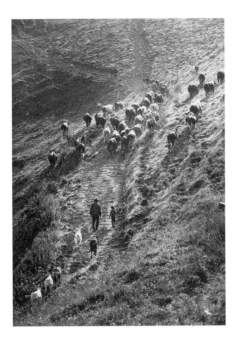

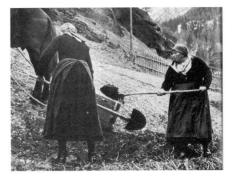

Fig 76 From *Another Way of Telling*, John Berger / Jean Mohr, *c*.1974 (Courtesy of Jean Mohr)

Fig 77 From *Another Way of Telling*, John Berger / Jean Mohr, *c*.1974 (Courtesy of Jean Mohr)

For Berger, since the mid-1970s, this has meant above all else the experiences of peasant life. Still central to much of rural life in Europe, but written out of the contemporary historical experience of Europe as a class in decline, the peasantry is something that shapes Berger's writing on photography and culture from the mid-1970s. The so-called cyclical time-scales of peasant life, the emphasis on physical attributes and skills as spiritual ones, the respect for the infinite variety of natural appearance, the dialectics of birth and decay, are all areas of peasant experience that increasingly underwrite Berger's desire for *another way of telling*. In fact, to say that Berger's understanding of the critical act as an act of love also has its origins in peasant experience may not be too far fetched. The peasantry's relationship to urban culture, historically, has been a sceptical one, repaid in kind by the urban left, who have invariably patronised peasant culture or fixed it in archaic forms of anti-intellectualism. Much peasant culture of course is obscurantist and reactionary, but the absence of non-scholarly knowledge in peasant culture reveals other orders of knowledge that cannot be easily dismissed as reactionary, orders of knowledge that are based on the non-individualistic accumulation of practical skills and expertise. A process based on the collective sharing of skills and expertise. Berger is not a naive pastoralist; on the contrary, he recognises that the peasant experience allows access to orders of facticity and fraternity with nature and other human beings that urban living obscures.

In a fundamental sense, Berger can only do this by shifting his focus of attention *away* from the industrial working class. The industrial working class has only made intermittent appearances in his writings since *A Seventh Man*. It is as if metropolitan living and the daily experience of the industrial working class are now incapable of sustaining his vision of sharing and fellowship. In the 1980s a great deal of writing on

culture and politics was the product of a widespread retreat from a belief in the political centrality of the working class. Berger's writing is no exception to the rule, although at no point has he made alliance with the New Social Movementists. Berger, essentially, is an old school socialist humanist who has shifted the focus of a critique of capitalist rationality to the non-industrial. In this there are certain affinities with the rural communalism of the 1930s and with the anti-industrialism of Victorian socialism, in particular William Morris. But Berger is not a Romanticist. On the contrary, his attachment to peasant culture is deeply melancholic, as if it stands as a compensatory gesture in a world that has less and less time and space for other ways of telling and being. This makes his humanism quite unlike its immediate socialist predecessors.

Berger's early writing on realism and painting was powerfully conditioned by debates on humanism and art emanating from the British Communist Party and European Communist parties. In the mid-1950s he contributed to *Realism*, the journal of the Artists' Group of the British Communist Party. The sense of optimism that carried the debates on humanism and culture forward at this time, in this journal and elsewhere, spoke out of a strong sense of expectancy about the left shaping a common, popular culture. Although Berger and others were involved in a losing battle with American Modernism, they nonetheless saw their humanist realism as part of a wider process of progressive social change. By the 1960s, though, this had been replaced by a growing sense of inertia and crisis as Modernism swept all before it, and the legacy of the 1930s became even more of a distant memory. The effect was an increasing emphasis on radical cultural work as a means of keeping faith with what had become lost in recent memory. This is why Benjamin was so important for Berger and other writers on the left, who still identified with the achievements of the 1920s and 1930s, but recognised there was no active, workable political context in which they could be sustained. Benjamin's radical emphasis on criticism as a redemptive practice (in unfavourable political conditions) allowed writers such as Berger to continue and develop many of the ideals of the 1930s as a form of critical identification and recovery. But what consequently enters this process is a powerful conflation of historical memory with melancholia. As Berger says in an interview in 1978: 'I don't see pessimism as a crime, or as counter-revolutionary – there are some comrades on the left who do think like that, which seems to be a heritage from some of the worst aspects of Stalinism – a totally false optimism.'[20] The narrative of loss that art experienced after the Second World War, therefore, produced a profound shift in orientation for those still committed to the factographic ideals of the 1920s and 1930s. Photography orientated itself to its revolutionary past as a counter-hegemonic *holding operation*. This idea of counter-hegemonic practice as the melancholic 'other' of a mass culture devoted to the loss of historical memory is largely what Fredric Jameson addresses in his essay 'Postmodernism, or The Cultural Logic of Late Capitalism' (1984).[21] Postmodernism is simply another stage in that long haul by capitalism after the Second World War to overturn the counter-hegemonic histories of the 1920s and 1930s in the interests of the stable mediafication of bourgeois history – a living grand narrative if ever there was one. Berger's sense of what photography might do is inseparable from this historical blockage.

Hence what draws Berger to peasant life is its capacity to give us a glimpse of social relations beyond this inertia. In an unprecedented move for a contemporary realist, Berger shifts the debate on photography and the 'everyday' from the divisions of the urban and industrial world – where it has been grounded politically this century – to the

continuities of the rural. Of course there are precursors here, particularly the FSA. But for Berger rural life and peasant experience offer not just a possible communal corrective to the atomising effects of the metropolis, but a different set of moral and aesthetic relationships to the physical world. In an advanced capitalist culture where 'now-time' sweeps relentlessly over the recent past, where intellectual homelessness is a badge of pride, cultural criticism needs to hold on to what is affective and what has duration if the subordination of history to the passage of time is to be denied. As he says in *Another Way of Telling*: 'Today what surrounds the individual life can change more quickly than the brief sequences of that life itself. The timeless has been abolished, and history itself has become ephemerality. History no longer pays its respects to the dead: the dead are simply what it has passed through.'[22] Berger presents us with a kind of paradox then. He turns to the peasant's relationship with nature, which is perceived as 'outside' of history, to challenge the loss of connectedness with the past that the reduction of history to the passage of time brings. The peasant's respect for duration becomes a utopian expression of a subjectivity free from the temporal violence of commodification. As I have stressed, though, this is not a Romantic critique of modernity. Rather, for Berger, it is a way of producing a practice and reading of photography that takes the counter-hegemonic beyond the *merely* deconstructive. Naming what has been lost to view under bourgeois progress, re-historicising the ambiguous discrete photograph, are acts which highlight interpretation as an art of critical preservation. For Berger, moreover, this has a vital spiritual content. In *Keeping a Rendezvous*, a collection of essays published in 1992, he outlines what is at stake:

> The credibility of words involves a strange dialectic. It is the writer's openness to the ambiguity and uncertainty of any experience (even the experience of determination and certainty) which gives clarity, and thus a kind of certitude, to his writing. He has to abjure words so that, abandoned, they join the 'object', the narrated event, which then becomes eloquent with them ... Any writer whose writing possesses the credibility I'm talking about has been moved by the simple conviction that life itself is sacred. This is the starting point.[23]

The sacredness of life and the exacting spritualness of interpretation clearly has an anti-materialist scandalousness to it, with which Berger no doubt enjoys cajoling the deconstructive left. In the context of his wider political project, however, it reveals a more secular face. To judge life as sacred is a commitment to the power of language and images to divest human beings of the carceral vision of capitalist time and space. The title *Keeping a Rendezvous* is instructive in this respect. Berger's insistence on criticism as an art of naming what is unnamed is also about naming what is as yet unnamed *inside us*. That is, naming what is unnamed is the first intersubjective step in establishing bonds with others, of breaking out of the bonds of a singular life. In an essay on cinema in *Keeping a Rendezvous*, he says, characteristically, that in the cinema 'people learn what they have been and discover what belongs to them apart from their single lives'.[24] The predominantly figurative arts of cinema and photography, then, are companionable arts, arts that focus our need for conversation (and hence their popularity). They achieve this because they can show what abides, or does not abide in us – to paraphrase Berger. The measure of the sacred is the measure of our social connectedness.

Berger's work as a whole, and his writing on photography in particular, addresses the

overriding concern of any practice which counts itself as counter-hegemonic: how might images make sense of the world, and in making sense of the world make sense of those lives who come into contact with them? How, in short, can photography bring a critical historical consciousness to bear on the 'everyday'? Berger was one of the few British intellectuals writing on visual culture in the 1960s to think these questions worth asking. However, his desire to link up an avant-garde insight into the means of representation with popular aspirations to the construction of a common culture found little resonance in left circles during this period. There was, in fact, no critical photographic culture to speak of in Britain between 1955 and 1967 (the period when French photographic theory began to flourish). With the exception of Berger's interventions around painting, the most interesting debates on realism, reportage and class were confined to TV and the cinema. This was the heyday of British independent film. Between 1958 and 1962, twenty-eight out of the thirty-seven most popular British films were independent productions.[25] If you look at the back issues of *Realism*, by way of a contrast, there is only one article on photography, a review of *The Family of Man* exhibition at the Royal Festival Hall in 1956 by James Boswell. This is a poor comparison, but it is a good indication of how weak the theoretical culture around photography still was by the mid-1960s. Berger did much to change this, insisting in the late 1960s, in a similar way to Barthes, that photography had to be assessed on the grounds of its social production, and not in terms of some inflated, aestheticised notion of authorship. By the mid-1970s, though, this task seemed onerous; *Ways of Seeing* had been relatively well received, but there was still no critical photographic community to talk of outside the theory being produced by a few conceptualists. Berger left Britain to live in a peasant community in France and concentrate on his fiction writing. To say he left Britain because there was nothing to build on is naturally only half the story. But Berger has gone on record as saying that his concerns found little connection in a culture whose art historical models were still dominated, even in the mid-1970s, by forms of traditional connoisseurship. Berger's commitment to photography did change as a result. There were no more big photo-text projects with Mohr in the vein of *A Fortunate Man* and *A Seventh Man* (*Another Way of Telling* was not strictly in this mode). What writing on photography he continued to do in the 1980s became almost gnomic: fragmentary, and sometimes ineffable, excursions around images. His writing on photography became, in the worst and best sense of the word, occasional.

Notes

1 John Berger, *Ways of Seeing*, BBC Publications 1972.
2 For a discussion of this see Geoff Dyer, *Ways of Telling: The Work of John Berger*, Pluto 1986.
3 John Berger and Jean Mohr, *A Fortunate Man*, Allen Lane 1967.
4 John Berger and Jean Mohr, *A Seventh Man*, Penguin Books 1975.
5 John Berger and Jean Mohr, *Another Way of Telling*, Penguin Books 1982.
6 John Heartfield and Kurt Tucholsky, *Deutschland, Deutschland Über Alles*, Neuer Deutscher 1929; English translation, University of Massachusetts Press 1972.
7 Berger and Mohr, *A Fortunate Man*, p. 144.
8 Berger and Mohr, *A Seventh Man*, p. 93.
9 John Berger, 'Uses of Photography' (1978), in *About Looking*, Writers and Readers 1980, p. 58.
10 *Ibid.*, p. 51.

11 *Ibid.*, p. 58.
12 See Roland Barthes, *Image-Music-Text*, Fontana 1977.
13 Berger, 'Uses of Photography', p. 60.
14 *Ibid.*
15 Heartfield and Tucholsky, 'Foreword', *Deutschland, Deutschland Über Alles*, p. 3.
16 John Berger, 'Appearances', in *Another Way of Telling*, p. 121.
17 *Ibid.*,
18 *Ibid.*, p. 124.
19 Steve Edwards, 'Secrets From the Street and Other Stories', an interview with Martha Rosler, *Ten:8* 33 (1989), p. 41.
20 Dave Taylor, 'Taking Time', *The Leveller* 15 (1978), p. 22.
21 Fredric Jameson, 'Postmodernism, or The Cultural Logic of Late Capitalism', *New Left Review* 146 (1984).
22 Berger, 'Appearances', p. 107.
23 John Berger, 'Lost off Cape Wrath', in *Keeping a Rendezvous*, Granta 1992, pp. 216–18.
24 John Berger, 'Ev'ry Time We Say Goodbye', in *Keeping a Rendezvous*, p. 24.
25 See John Hill, *Sex, Class and Realism: British Cinema 1956–1963*, BFI 1986, p. 139.

8

The rise of theory and the critique of realism: photography in Britain in the 1980s

In the early 1970s as Berger was reworking the photographic archive and distancing himself from Modernism, other photographers, artists and writers in Britain were looking back to the 1920s and 1930s to develop new critical identities for photography. In fact, in the period from the early 1970s to late 1980s, photographic theory in Britain underwent a radical transformation comparable to that of the inter-war European avant-garde, turning Britain into perhaps the major centre for theoretical photographic studies. With the work of Berger as a significant precedent, the focus of avant-garde discussion on photography and the 'everyday' shifted from France to Britain.

The origins of this are twofold: the radicalisation of a younger generation of artists and intellectuals in the wake of May 1968, keen to apply the new French theory (in particular Althusser and Lacan) to what was perceived as the moribund empiricism of British culture and imported American Modernism; and the entry of working-class and lower-middle-class students into higher education with little formal attachment to the virtues of high culture. The result was a powerful alliance of interests committed to the destruction of the aesthetic hierarchies of post-war Modernist culture. And, of course, crucial to this process was photography. The re-theorisation of photography as central to modern culture allowed artists to reconnect their aesthetic concerns to the wider ideological forces of society. The general effect of this was the immediate growth in photographic theory and criticism, as photographers took practical steps to move beyond the silences and omissions of Modernism. One of the major achievements, then, of post-1960s British culture – deepened and extended as it was in the 1980s – was the widespread theoretical accessing of photography. In fact, by the mid-1980s the Modernist 'miniaturisation'[1] of photography, to quote Simon Watney, that so many photographers and writers had complained about in the 1970s had, in important respects, been dispelled. This achievement is echoed from a more general perspective by Perry Anderson, one of the most respected historians of the post-1968 critical renaissance in British cultural life. As he concluded in 1990 in his survey of 1980s Britain, 'the arrival of the Thatcher regime, in effect did not undo these cultural gains. Put to the test, the

Fig 78 *Work and Commentary* (cover), Victor Burgin, 1973
(Courtesy of Victor Burgin)

critical zone not only resisted but grew.'[2]

With the rise of photographic theory, then, the 1970s and 1980s witnessed a substantive turn-around in critical agendas, attitudes and priorities in the practice and study of photography. The thematic diversification of the film journal *Screen* into photographic theory from the late 1970s, the emergence of *Camerawork*, *Ten:8* and *Block*, the growth of photography book publishing (*Photography/Politics 1 and 2* being key ventures in the 1980s) all contributed to breaking the hold of dominant positivistic treatments of photography; as such, a confident theoretical culture of the image began to take hold in the Academy *and* the photographic workshop.

Yet for all these obvious advances, the new photographic culture took a very different point of departure in its critique of positivism from Berger. For Berger the critique of positivism – as it was for the surrealists – is not interchangeable with a critique of realism. To defend realism is not to defend an unmediated notion of photographic truth, but to keep faith politically with the everyday world of appearances. The place of the working class may have narrowed for Berger as part of this, but, nevertheless, Berger recognises that realism is more than an aesthetic project. However, the main critical thrust of the new photographic theory, with its anti-humanist conflation of semiotics, psychoanalysis and discourse theory, has been the exact opposite: to identify realism *with* positivism. The photographic document has come to be seen as deeply compromised ideologically. This, I contend, is inseparable from wider political moves within the culture that the new photographic theory has embraced and developed. The result is a theoretical consensus that both discredits the very possibility of truth and further separates the avant-garde critic of positivism from working-class politics. Thus whether we choose to call this postmodernism or not, we are dealing with a set of claims and agendas that have more than a localised influence. The development of photographic theory in the USA in the late 1970s and 1980s tended to follow a similar kind of pattern, and with more institutional clout. We are talking, therefore, about a powerful radicalisation of the critique of realism. And, as such, a powerful cultural hegemony.

When Victor Burgin wrote his 'Commentaries' in *Work and Commentary* in 1973[3] and his short essay 'Art, Commonsense and Photography' in *Camerawork* in 1976[4] what was at stake for photographers and writers working out of the classic left-avant-garde legacy of the 1920s and 1930s was a rejection of the formalisation of mechanised reproduction as anti-aesthetic. Much of Burgin's own writing, rooted as it was in conceptual art debates about the ontology of art (what actually constitutes an artistic act?) sought to sever the binary opposition between photography as a realm of objective truth (science), and 'art' as the province of subjective expression (the aesthetic). As Burgin rightly noted, this division was as much a characteristic of the positivism of left documentary practice as it was of Modernist defences of the disinterestedness of aesthetic perception. Both, in effect, failed to ground the possibility of meaning in the operations of rhetoric (metaphor, metonymy, chiasmus etc.). Employing a quotation from Jacques Durand – which Burgin cites as a kind of manifesto – he argues that the way forward for photography is to consciously foreground and manipulate these rhetorical operations: 'rhetoric is in sum a repertory of the various ways in which we can be "original". It is probable then that the creative process could be enriched and made easier if the creators would take account consciously of a system which they use intuitively.'[5]

For Burgin, following Durand and Roland Barthes's *Elements of Semiology* (1967), the study of visual rhetoric implies a qualitatively different relationship between the image and the world, art and culture, from that held up by the frozen antinomies of reflection and self-expression; an image now lives and breathes (and dies) within the antecedent operations of governing social codes. In the 'Commentaries' Burgin makes clear what this means for artistic practice in the wake of the crisis of Modernism: a new *social contract* for art/photography. 'A job for the artist which no one else does is to dismantle existing communication codes and to recombine some of their elements into structures which can be used to generate new pictures of the world.'[6]

Burgin's introduction of the language-based model of semiology into the discussion of representation was, essentially, an attempt to create a new space of critical negotiation between art and the everyday experience of a media-based culture. From the mid to late 1970s in Britain he was not alone in this. John Stezaker likewise called on that 'volume of sociality'[7] that Barthes saw 'lying behind' images and texts to argue for a new space of popular engagement between art/photography and mass culture. Echoing Burgin's anti-Modernism, Stezaker argued that the formalism of Modernist painting had drained art of popular affect.

> The reflexes of aesthetic distaste for the familiar and the stereotypical are something to resist. They belong to a sphere of culture which has progressively buffered itself by the rarefied zones of modernism from any engagement, let alone involvement with the cultural forms which are the essence of social existence in the latter part of the twentieth century.[8]

Peter Wollen's essay 'Photography and Aesthetics' in *Screen* in 1978[9] in key respects summed up these early attempts to replace the aesthetic split between painting and photography with a general theory of the social production of meaning. Using an anti-Greenbergian framework that was to gain extensive ground in photography/art discussions in the early 1980s in Britain and the USA, Wollen talked, almost victoriously, of a 'crucial new direction for photography'.[10] With the crisis of Modernist claims on the critical importance of the (ineffable) formal presence of the artwork, the *social* effects of

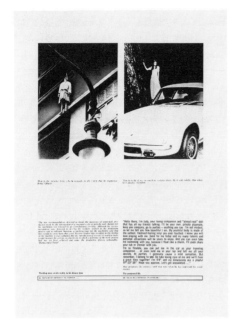

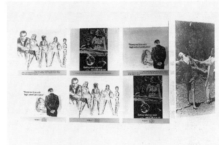

Fig 79 *A Magazine Photograph and a Newspaper Photograph Reconstruct One Another* (Part 3 of 4), John Stezaker, 1975 (Courtesy of John Stezaker)

Fig 80 *Who? What? Why?*, John Stezaker, 1975 (Courtesy of John Stezaker)

aesthetic experience that this Kantian emphasis on the thing-in-itself had so successfully suppressed could be put back on the historical agenda.

Looking back to Benjamin and Brecht and the early Soviet semioticians, Wollen discerned the lineaments of an avant-garde tradition that was sensitive both to the operations of visual rhetoric *and* the exigencies of politics. Greenbergian Modernism was vanquished through the theoretical return to the artwork as sign. For Wollen, Burgin and Stezaker, what was crucial to this perspective – dealing as they all were with photography from within the ideological confines of fine art – was what might be called a new *positional* logic for practice. Or rather a reorientation. A sense that photography as a series of practices tied to the external operations of representational codes was critically *inside* the operations of culture as a whole. All the externalising concepts of Modernism – 'resistance', 'anonymity', 'presence', 'non-conformity', 'originality' – disconnected practitioners not just from a sense of the symbolic indebtedness of cultural practices, but from the more crucial view that there was a critical struggle to be had *over*, and *within*, representation. As Wollen says as a coda: 'Photography, within art can ... reopen the closed options of ideological reading and understanding, the symbiosis of information with blocked knowledge and blocked desire.'[11] Photography was now firmly anchored in the transformation, or displacement, of the symbolic. This imbrication of psychoanalysis was, of course, to become the major theoretical plank of the engagement between photography and 'art' in the 1980s as the concern with semiotics and mass culture became specifically a concern with *men's* and *women's* psychic investment in the dominant codes of our culture. I do not, however, want to overleap my argument here; the development of Burgin's writing from a 'semiological perspective [which] calls for a

code-based taxonomy'[12] to a full-blown psychoanalytic model will be dealt with later.

Overall what the early Burgin/Stezaker/Wollen nexus produced in the mid to late 1970s was a transference of semiological themes from the burgeoning area of structuralist linguistics (via its application in film studies) and reinterest in revolutionary Soviet culture, to photography as such. In this respect, particularly in the case of Burgin and Wollen, they were as much engaged in the construction of a new sociology for photography as in laying down new ground rules for practice 'against the grain'. In a 'stable' bourgeois social democratic world where the ideological management of subjectivity was now a conspicuous problem for social transformation, the model of political confrontation and consciousness-raising so central to the documentary and reportorial traditions could only serve to reify the public effects of photography. The documentary and reportorial traditions presupposed a wholly voluntarist relationship between political effect and spectator, insofar as they retained an understanding of the photographic image within a pre-rhetorical, and therefore crudely hieratic, model of communication. The documentary and reportorial traditions possessed a given 'truth-value' that a self-present, self-acquainted spectator simply decoded. Following Barthes, a semiological-structuralist model on the other hand argued for the ideological *positioning* of the spectator; representations did not reflect the world but constructed our view of it. This now overly familiar argument became, however, far more than a theoretical injunction against reflectionist theories of realism, it became a *politics*. If representations positioned subjects ideologically then a politics of photography had a broadly political role to play in contributing to the transformation of dominant forms of subjectivity. It was less a case of theorising photography than placing photography in a theoretical relationship to politics. What was needed, it was argued, was a theoretical model that located photography not simply within the operations of antecedent symbolic relations but within preconstraining relations of social power.

It was John Tagg from the late 1970s on who largely fulfilled this role. Whereas the earlier Burgin *et al.* introduced key semioticians into the debate, Tagg was to employ expressly Althusser and later Foucault in the elaboration of an extended sociological model of power-relations. Less concerned with theorising the possibilities for new photographic practice, Tagg concentrated on the economic, philosophical and political history of the rise of conventional positivist accounts of photography. It was the institutionally embedded effects of conventional realism (be it in the form of the Town Hall or corporate archive, photojournalism, or amateur photography) that had to be recognised if an analysis of photography's social role was to move beyond the individualistic and aesthetic. Combining Althusser's 'Ideology and Ideological State Apparatuses' (1971)[13] with the Foucault of *The Archeology of Knowledge* (1972),[14] Tagg proposed that the conservative interests served historically by conventional realist-positivist models represented a 'new regime of representation'. Indeed, for Tagg the idea and ideal of documentation as the factual transcription of the world, from the nineteenth century onwards, has served to mediate conflicts between classes and social groups in the interests of social control. As he argued in *The Burden of Representation: Essays on Photographies and Histories* (1988), a collection of essays from the late 1970s and 1980s:

> In the context of [the] modern strategy of power, we can safely dismiss the view
> that the reversal of the political axis of representation in late nineteenth and

early twentieth-century documentation and the subsequent amassing of a systematic archive of subordinated class, racial and sexual subjects can be looked at as 'progressive' phenomena or as signs of a democratisation of pictorial culture.

If there is a continuity, then, it is that of developing systems of production, administration and power, not of a 'documentary tradition' resting on the supposed inherent qualities of the photographic medium, reflecting a progressive engagement with reality, or responding to popular demand.[15]

What is of crucial importance about a theory of power for Tagg is that it allows a semiological critique of the photograph as evidence to be redescribed in terms of evidence for *whom*, and for *what*? The photograph enters the world as a nodal point in the production and reproduction of power-relations. In these terms Tagg adopts an explicitly discourse-theory position. Following the *Screen* of the late 1970s, the photograph, like film, is not the inflection of a pre-photographic or pre-filmic event, but the production of a constructed and *specific* reality. 'What is real is not just the material item but also the discursive system of which the image it bears is part. It is to the reality not of the past, but of present meanings and of changing discursive systems that we must therefore turn our attention.'[16] The meanings of photographs are never constructed in a power vacuum, but in response to, and as a product of, prevailing discursive interests.

In line with other discourse-orientated concerns in other areas of cultural studies, Tagg's project as a whole has been to initiate a 'discursive revolution' in photographic study and criticism. As such he codifies a number of themes that became a large part of the 'commonsense' of the post-structuralist 'new left' in the English-speaking world in the 1980s.

What has been a key argument by defenders of discourse-theory is that a commitment to the discursive 'construction' of reality allows cultural intervention to be put on the same political level as other (industrial) struggles. The importance of Althusser for a whole generation of theorists in the 1970s was for exactly this reason. Althusser's emphasis upon ideology allowed theorists to engage with the specific forms of the cultural reproduction of bourgeois rule. As Tagg said in an interview in 1988: 'Althusser's theory made a cultural politics possible.'[17] However, for many on the left Althusser's anti-economism was not anti-economistic enough. For Paul Hirst and Barry Hindess, Althusser may have made a 'cultural politics possible', but he made it possible on 'impossibly' contradictory grounds. The relative autonomy Althusser accorded ideological apparatuses still maintained the idea that these apparatuses reflected power relations held in place at the point of production. As Hirst argued in 1977:

> the notion of *relative* autonomy is untenable. Once any degree of autonomous action is accorded to political forces as means of representation *vis-à-vis* classes of economic agents, then there is no necessary correspondence between the forces that appear in the political (and what they 'represent') and economic classes ... What the means of representation 'represent' does not exist outside the process of representation.[18]

The conditions of possibility for cultural practices, therefore, were not reducible in advance to an expression of the power-relations internal to the relations of production. On the contrary, the conditions of production and effectivity of cultural practices were always discursively negotiable and open. As Tagg says, in the spirit of Hindess and Hirst:

> There are no necessary and binding rules of connection between conditions of existence and modes of production and effects at the level of signification – no incontrovertible laws of relation, for example, between 'mass media', corporate ownership, and trivialisation and depoliticisation of meaning.[19]

Hence for Tagg there are no spaces that can be 'condemned in advance as unnecessarily a site of incorporation or privileged as the proper site of cultural action'.[20] This is purely 'pre-emptive theory';[21] what is needed are criteria that are sensitive to the availability of specific sites of intervention.

In terms of the potentiality for cultural intervention being a question of judging the availability of enabling conditions and resources, this is uncontroversial. But this in the end is to say very little, in fact as analysis it is tautological – the spaces for intervention are those spaces that are open to intervention; successful conditions of critical reception are those conditions that successfully enable critical reception. Tagg's anti-economism may have a valid point to make against those who would automatically hierarchise certain sites as being more politically effective than others (the street for example, within the documentary tradition), but this does nothing to alleviate this sense of 'openness' as being purely formalistic. In line with post-Althusserianism's autonomisation of ideology and politics as a whole, Tagg's weakening of the place of material determinacy simply leads to an indeterminacy of the social world. This is also in line with the growing influence of a culturalist reading of Gramsci's theory of hegemony within photographic studies in the 1980s: that the struggle for socialism under bourgeois democracy is a struggle for the popular across class lines. Hegemony thus ceases to be a struggle over the promotion of working-class interests, and becomes a Popular-Front-type strategy of constructing alliances. These two traditions in fact come together in a text that was to have a certain influence on theorists in the photographic community moving in this direction in the 1980s: *Hegemony and Socialist Strategy: Towards a Radical Democratic Politics* (1985)[22] by Ernesto Laclau and Chantal Mouffe.

If Althusser disaggregated elements of the social whole, and post-Althusserianism disaggregated those elements *from* the social whole, Laclau and Mouffe go one step further and unfix the identity of the disaggregated elements altogether. With, they claim, the autonomisation of politics under late capitalism, politics *is* the construction, articulation and re-articulation of identities. Once it is recognised that material interests in no sense determine political identity then there can be no recourse to an account of politics *following* material interests on class lines on any terms; if subjects are constructed in discourse, then, potentially political identities are 'incomplete, open and negotiable'.[23] 'Our analysis meets up with a number of contemporary currents of thought which ... have insisted on the impossibility of fixing ultimate meanings.'[24] Presumably this means we can look forward to the President of IBM joining workers on the picket line. In a critical atmosphere where Marxism has been misrepresented and distorted (economistic, historicist, sex-blind etc.), it is not surprising that such rampant idealism has had a considerable influence on photographic theory. Simon Watney, likewise, has not escaped the lure of confusing material determinancy with an *all*-explanatory concept of the economic. In his contribution to *Photography/Politics: Two* (1986) he echoes Tagg:

> This is why it is so important to reject any explanation of the 'role' of institutions which maintains the absolute primacy of the 'economic', either as the primary space for political interventions, or as the a priori determination

of all other social and cultural formations. As Laclau and Mouffe have incisively observed, 'what has been exploded is the idea and the reality itself of a unique space of constitution of the political'.[25]

Thus radical cultural practice may produce radical effects across various institutional sites, but any fundamental alignment between these practices and the democratisation of culture across class lines will mean more than the 're-articulation' of identities; on the contrary, it will actually mean recognising a primary reality, capitalist relations of production, and the necessity of their transformation. The supposed virtue of post-Althusserianism, its non-hierarchic analysis of the relationship between the cultural and the economic, is in fact its central weakness. The loosening of the cultural from the constraining powers of the relations of production simply flattens out the social world, forbidding the possibility, as Norman Geras has put it, 'that one thing might just be more important than others'.[26]

Tagg's post-Althusserianism also embraces another form of 'flattening' that was to have a wide currency with the rise of post-structuralism in the photographic community: the severance of the referential relationship between the photograph and its extra-representational objects. Tagg's understanding of photographic meanings as being discursively constructed in the process of their reception, commits him, as with Burgin, to a wholly reductivist view of realism. 'We cannot quantify the realism of a representation through a comparison of the representation with a "reality" somehow known prior to its realisation. The reality of the realist representation does not correspond in any direct or simple way to anything present to us "before" representation.'[27] What Tagg is effectively arguing here is that our recognition of the resemblance between a picture and its object plays *no* part in our cognition of that picture. This is plainly unsupportable. Post-Althusserian and post-structuralist critiques of reflectionism are clearly right in stressing the instability of conditions of meaning: that the signifier is open to discursive reframing. But what post-Althusserianism and post-structuralism do is inflate the transitive nature of the signifier over and above any possible stable conditions of referentiality. In effect what post-Althusserianism and post-structuralism discourse produces is a highly ideologised view of representation which blurs over fundamental distinctions between how we cognate pictures.

As I discuss below, knowledge of picture conventions is not a determinant requirement for recovering the pictorial content of pictures, insofar as the iconification-relation (what a picture is *of*) is not the same as the representation-relation (what the picture signifies). Moreover, and more particularly in this context, what post-Althusserianist and post-structuralist accounts fail to specify is that there may be pictures that do not participate in, or are fairly resistant to, ideological promotion. A photograph of an apple may be used in a particular culture where the eating of apples is banned, as a warning against the transgression of such a prohibition, but iconic pictures of apples are generally not subject to such extreme ideological conditions. An iconically replete photograph of an apple may be just that, a picture *of* an apple. In this sense the relation between an object and the form of its representation is not the same as between a picture and its ideological legitimation or manipulation. Just as a discursive system may encode the ideological interests of a given picture, a picture may have no determinate relation to sustaining ideological relations. To call a photograph of an apple realist, then, is not to mystify the power-relations in which such a photography might be embedded – for example that discursive system known as 'Western realism' – but to recognise that

photograph and depictum share a certain resemblance.

In essence discourse-theory reinforces the conventionalist pole of the representational triad (convention, resemblance, contiguity),[28] at the expense of the other two, as an overweening judgement on the photographic image as a site of power. Although Tagg has voiced self-criticism about the all-inclusiveness of his model, the post-Althusserianism still remains; discourse produces 'real objects'; representations construct subjects. It is revealing how little attention was paid to these problems in photographic theory and cultural studies in the 1980s. The steamrolling of anti-realism produced an unworried conventionalist consensus. Fruitful exceptions to this rule, though, were David McNeil's essay 'Pictures and Parables' in *Block* (1985), a defence of iconicity and representation as 'qualitatively different mechanisms of signification',[29] and Terry Lovell's anti-Althusserian, Roy Bhaskar-influenced *Pictures of Reality: Aesthetics, Politics and Pleasure* (1980).[30]

By the mid-1980s the conventionalist model, emboldened to a great degree by the rapid rise in the academic prestige of post-structuralism, was highly influential in the left-avant-garde photography community. However, it was Burgin who was the key figure in mediating its implications to practitioners, particularly through his work at the Polytechnic of Central London (PCL). When he argued in his introduction to *Thinking Photography* in 1982 that 'representations ... cannot be simply tested against the real, as this real is itself *constituted* through the agency of representations',[31] he was not just offering an academic defence of Hindess and Hirst, but providing a framework for photography from which to attack the political credentials of the documentary tradition. If the real was made in representation, then the naturalistic representation of subjects caught up in the play of dominant ideological relations could only reproduce and fix those relations. Documentary was incapable of resolving the conflict between the representation of identity and its critique. With the rise of the women's movement this was an increasingly pressing problem for photography. The massive ideological investment by commercial photographic practices in securing a *stereotypically* fixed divide in identity across the sexes (the 'feminine' and 'masculine') made it impossible to ignore that there was real political work to be done *inside* representation. From *Thinking Photography* on, Burgin's discourse-theory became increasingly entwined with a commitment to feminism, as the women's movement made its practical and theoretical demands felt on the photographic community.

'Any discourse which fails to take account of the problem of sexual difference in its enunciations and address will be, within a patriarchal order, precisely indifferent, a reflection of male domination,' said Stephen Heath famously in *Screen* in 1978.[32] If Heath was instrumental in 'feminist-ising' Lacan for film studies, Burgin along with art historian Griselda Pollock and artist/photographer Mary Kelly were instrumental in 'feminist-ising' him for the photography community. With the growing influence of Lacan through Heathian film studies, the influence of psychoanalysis became important in evaluating just what *kind* of everyday reality photographers were supposed to be engaging with and reconstructing. In the early 1980s post-Althusserian Lacanian psychoanalysis and feminism coalesced into a discourse-theory in which reality became *sexualised* reality.[33]

One of the most influential texts by Lacan at the time, given the space it devoted to desire and looking, was *The Four Fundamental Concepts of Psycho-Analysis* (1977).[34] With the entry of the subject into the symbolic, desire, Lacan argued, is immediately

grounded in all that is seen. But because the unconscious is inscribed in that desire there will always be what he calls a mis-seeing (a 'failure to recognise'). The unconscious and repression, lack and desire, form a dialectical interchange in each visual recognition. Lacan characterises this process in terms of a 'scopic drive', the search by the subject for the fantasy for him/her of the 'lost phallus'. He calls this fantasised lost part-object, *objet petit a* ('*a*' standing for *autre*). However, this drive is not rooted simply in pleasure-seeking, but is a result of the subject being 'caught up in' the divisions of the symbolic. As Heath says, 'the structure of a subject is a division in the symbolic'.[35] Desire, then, is that search within representation for an object always out of reach, always to be embraced as an absence. Every recognition is 'at once a finding and a failure to find',[36] to quote Elizabeth Wright: that severing of the subject from what Lacan calls the 'real' (that – utopian – realm beyond the reach of signification). Identity and sexuality for the Lacanians are not found or given in nature, but produced in division in signification. 'Sexuality is constructed in the history of the subject, with difference a function of that construction not its cause.'[37]

It is this structure of desire and lack within signification across the sexual divide that photography employs in staking out its interest in psychoanalysis. What is the spectator's psychic investment in certain kinds of image? What is returned to the look of the spectator? Consequently, Lacanian psychoanalysis offers, its defenders argue, a vocabulary for describing the connection between certain psychic investments in images and the ideological subject positions they produce and reproduce.

It was Burgin on the whole amongst male theorists/practitioners who took up the psychoanalytic mantle in the early 1980s. Psychoanalysis became a way of locating a specific kind of visual rhetoric, the rhetoric of the body: those psychic mechanisms – voyeurism, identification, disavowal – that positioned the body in relation to the 'other' political reality: the unconscious. As Burgin declared in an interview in 1982:

> A politics of representation has to be concerned with the phantasmatic – this can't in any way (shock-horror) be considered a concern secondary to the political issues of the day, the fetishised 'real struggles', conflicts which renew and repeat themselves endlessly precisely to the extent that the phantasmatic which informs them, remains untouched by them. We don't *simply* inhabit a material reality, we simultaneously inhabit a material reality – the former, in fact, being 'known' only *via* the latter. Psychic reality, the register of the subjective, of the erotic (including, of course, pleasure), is organised according to the articulation of sexual difference.[38]

It is little surprise, then, that in a photographic community that judged representation to have no referential relationship to its extra-photographic objects, that was inscribed by 'lack', the 'unknown' and the 'unstable', that allegory should enter the space of photography as a full-blown post-realist form of address. In certain respects Burgin's theoretical tenure at PCL in the early 1980s was concerned with reconnecting photography with what was perceived as its subtended allegorical impulse. As Laura Mulvey has said of Burgin's own photographic work, 'he frees the photograph from its command over historic time and space. Its indexicality now refers to things which, although real and concrete, are not actually visible.'[39]

Burgin's use of allegorisation to critique photographic naturalism has much in common with a broader allegorical impulse in recent cultural criticism that sees all

readings, even classic realist texts, as figural. The influential figure in this, at least for literary studies, is Paul de Man.[40] De Man's work is primarily concerned with a critique of the post-Kantian fetishisation of the aesthetic as a separate experiential category. Hence central to his writing is an insistence on the substantive link between meaning and the effects of rhetoric. The aesthetic *is* cognition, the pleasure of the text *is* our knowledge of the figural. This clearly has important implications for any materialist theory of reading and communication, and takes up important insights within the post-surrealist hermeneutic tradition. However, for de Man this process is fundamentally one of radical instability; meaning is never given 'in full' through an unravelling of the figural, rather we are always at the mercy of the indeterminate nature of language itself. Texts do not just figure meaning, but *dis*figure it, snare us in a labyrinth of aporias, gaps and subterfuges. If this presumes a certain kind of (complex) literary text on de Man's part, nevertheless it proposes a general problematisation of reading as a process of *naming* meaning. As with Lacan, de Man's model of meaning operates under the rule of the 'sliding' of the signifier over the signified. A word or image can mean anything, so long as all the other words or images in a given series mean something different. Quite rightly, as one critic of Lacan has said, this is a situation in which 'communication is precluded'.[41]

> It is enough to claim that there are social rules whereby signifiers do have the meanings they have. Of course, we can speculate as to why these signifiers do have these meanings, and even imagine their having completely different meanings. The relationship between this signifier and its signified is contingent: it could have been other than it is. But, the fact remains that, at this particular moment in a particular language, particular signifiers do mean particular things.[42]

Essentially, de Man exaggerates the contingent relationship between signifier and signified as a means of grounding communication in the *performative*. Reading is an intellectual argument with a text/image, a discursive struggle. And it is this performative tradition of rhetoric, the 'culturalist' side of discourse-theory that Burgin passes on to a younger generation of photographers: Mitra Tabrizian, Olivier Richon, Karen Knorr and Mark Lewis for example. In the play of image and text, a process in which 'associations of the text'[43] are linked to 'associations of the image',[44] the spectator is made more aware of having to *construct* meanings.

It was these allegorical moves, taken up by post-Heath *Screen, Block, Formations*, and to a certain extent *Feminist Review*, that increasingly came to dominate the foreground of would-be radical photographic practice in the early to mid 1980s. One of the other supporters of this work, who represents a similar kind of intellectual trajectory to that of Burgin, was Laura Mulvey. Mulvey's essay 'Visual Pleasure and Narrative Cinema'[45] had a considerable influence, along with Heath's 'Difference', on the formation of the post-Althusserian-Lacanian-feminist consensus.[46] For Mulvey the 'return to the studio' of necessity occasioned by the crisis of documentary and the rise of the women's movement allowed an unprecedented access to orders of experience outside the naturalistic. By producing constructed images in the studio 'the photographic image can be organised to express an abstract idea, an argument, the interior world of desire and imagination'.[47] With this, the studio becomes the controlling site of photography's 'psychoanalytic turn', the place where psychoanalysis's abstract categories – desire, the look, fetishism – could be given corporeal form and *performed* (in particular through the

Fig 81 *Police of Mind* (from *US77*), Victor Burgin, 1977 (Courtesy of Victor Burgin, from *Some Cities*, Reaktion Books, London, 1996)

staging/invocation of the gender relationships in advertising and the Hollywood movie). The studio in fact acts as a site of the imaginary itself, a place that in its staging of the dialectic between desire and lack foregrounds unreadability as the very condition of reading photographic images. Mulvey refers to this as a 'poetics of the unspeakable',[48] an image that generates enigmas and riddles, a 'trigger'[49] for reverie.

> This process carries the spectator into his/her psychic structure. The image itself only 'works' if its mystery or enigma generates introspection, or, indeed, an equally telling resistance. Decipherment is demanded, clues are offered, but the reveries and associations of ideas are specific to the individual. However, the shared psychic structures that trigger off the individual response bring the pleasures and anxieties of reverie back inexorably to problems of repression and desire as shared and social.[50]

This pursuit of a 'poetics of the unspeakable' took another turn in the mid-1980s: a feminist 'photography of fragmentation'. Less interested in constructing images *for* the camera, this kind of work looks to the legacy of Modernist collage to produce a new 'representational economy' for women artists. Influenced by the Modernist poetics of *Tel Quel* and Julia Kristeva, the semiotic fragment functions as an index of resistance to the objectifying powers of dominant perspectival realism, a 'regime' which historically has always grounded the subject position of men as *surveyors* of all they see. Implicit in this position is also a critique of Lacan's objectification of the symbolic in terms of women's submission to the paternal authority of the oedipal drama. Far from being fixed by this 'universal' structure, as 'other', women's 'absence' from symbolic power allows them a freedom of position beyond all authority or system. The fragmentary photography then metaphors this process of 'desire' as an escape from the coercive effects of all forms of

representation. When *Camerawork* shifted editorial line in the early 1980s to incorporate a Burgin/Stezaker/Wollen left Modernism, Yve Lomax was one of the main defenders of this type of position within the photography community. As she contended in an article 'Montage and Style' in 1982: 'There is a certain political effectivity in disrupting the *rule of perspective.*'[51] Consequently, montage allows the photographic process to blur binary oppositions, 'making it impossible to speak of the distinction between that which styles in terms of *the* feminine or *the* masculine'.[52] As such there is 'no pretence to make all the bits fit into a neat seamless whole'.[53]

In the early 1980s two shows in Britain, 'Beyond the Purloined Image'[54] at Riverside Studios (1983) and 'Difference: On Representation and Sexuality'[55] at the Institute of Contemporary Arts (1985) brought together a range of work indebted to the psychoanalytic/feminist engagement with the staged image and montage. Unfixing the feminine by rupturing 'the visual field before our eyes',[56] the work proposed, as Mary Kelly said in her gallery notes to 'Beyond the Purloined Image', 'the de-colonisation of ... visual codes and of language itself'.[57]

If this was the public highpoint of the allegorical/psychoanalytic turn of photography in Britain – the departure of Burgin, Kelly and Tagg for America in the late 1980s effectively evacuated the theoretical base of the post-Althusserian-Lacanian-feminist nexus – its deconstructive impulse was continued in work on the representation of race and sexuality. With the demise of *Camerawork* in 1985, *Ten:8* took up the bulk of this work.[58] Following in the footsteps of Homi Bhahba's psychoanalytic writing on the racial stereotype as a fixing of difference[59] the writers Kobena Mercer and Isaac Julien and photographer Sunil Gupta addressed the 'structured absence'[60] of race (and in particular the sexuality of gay black men) from debates on photography and culture. The unfixing of the black and female image from 'the image-reservoir of the white male imaginary'[61] was, it was argued, a priority for black photographers. Although not concerned solely with photography and representation, the cultural journal *Third Text* (founded in 1987) sought to extend this critique deeper into what was perceived as the Eurocentrism of the conventional realist tradition. Much of this writing openly embraced a discourse-theory model as a means of locating the unfixing and re-articulation of black identities within an expanded counter-hegemonic politics. In the writing of Mercer and Julien this expressly becomes a Laclau/Mouffe-type celebration of difference. As they argue in their contribution to *Male Order: Unwrapping Masculinity* (1988), 'Is it possible for a socialist discourse to articulate this concern for difference without reducing any one element of society to the privileged role of the singular agent of democratic revolution?'.[62]

The idea that perspectival representation, conventional realism, objectifies the world has been the demonised 'other' of Modernist art this century. Under the auspices of post-structuralist and post-Althusserian theories of representation, however, it takes on a particular institutionalised and hegemonic character or world-view: the monocular will to power of Western (male) reason. The *laissez-faire* capitalism of the nineteenth century needed a positivist system of representation in order to taxonomise those things and people that fell under its expansionist and historicist world-view.[63] The iconic legacy of Renaissance humanism, naturalised in photography's high-definition powers of resemblance, became the cornerstone of bourgeois rationality: 'the facts before one's eyes'. Foucault, Barthes and Kristeva have all talked about this legacy's faith in the transparency of representation as concretising subjection to dominant power-relations: Kristeva in terms of 'phallocentrism', Barthes in terms of the 'mythemes' of objective

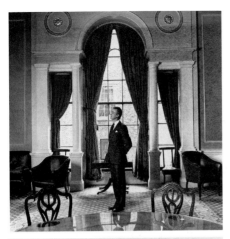

You may meet its Members
in London and Fiji,
in the Swamps and in the Desert,
in the Lands beyond the Mountains.
They are always the Same
for they are branded
with the Stamp
of the Breed.

Érotisme

Fig 82 *Gentlemen*, Karen Knorr, 1981 (Courtesy of Karen Knorr)

Fig 83 *Erotisme* (from *Interim*), Mary Kelly, 1985 (Courtesy of Mary Kelly)

science, and Foucault in terms of the rationalisations of modern social administration. It is the latter perspective, though, that has become the commonsense of the left-Modernist/discourse-theory critique of realism and the 'rule of perspective': the idea that conventional realism functions as a coercive 'epistemic order'.

The inflation of conventional realism to the force of a discourse-in-dominance is the inevitable consequence, as I have explained, of post-structuralism's and post-Althusserianism's separation of discourse from material interests. For if the real power in the world is the work of ideology imposed on every speaking subject 'as a set of anonymous historically determinate rules',[64] to quote Dominique Lecourt on Foucault, then the idea of a discursive *regime* seems plausible, and the breaking down of its representational effects held to be a political priority. The breakers and reconstructers of a dominant realism, in effect, become the breakers and reconstructers of the ideological 'cement' of capitalist relations. If this, admittedly, is to exaggerate the political self-image of those theorists who have followed in the discourse-theory tradition, nevertheless it points to the political implications that follow from the characterisation of the resemblance pole of representation as crude objectification. Reflection does not imply an *identity* between representation and its objects but a *point* of resemblance. The relationship between the economic base and cultural practices, therefore, is not simply a mirroring, but the result of a dialectical mixing of the representational triad (resemblance, convention, contiguity) in which resemblance plays a *preponderant* part. Consequently, social identities may be constructed in representation (convention) but they are not *just* constructed in representation; on the contrary they are subject to material interests and limits outside representation (the law of reflection). In fact, it is one of the paradoxes of the post-structuralist and post-Althusserian critique of conventional realism that they reduce its social effects to a crude causal economic relation. The rise of

Fig 84 *Office at Night #1*, Victor Burgin, 1985–86 (Courtesy of the John Weber Gallery, New York)

competitive capitalism and modern science produces representational forms that are developed in the interests of coercive social administration.

This determinism is at its most emphatic in Burgin's *The End of Art Theory: Criticism and Postmodernity* (1986),[65] a collection of essays which seeks to place the debates on photography in the 1970s and 1980s in a broad historical setting. In fact *The End of Art Theory* is highly paradigmatic, insofar as it does not just defend the claims of post-structuralism and post-Althusserianism for photography, but marshals them under the would-be cultural transformations of postmodernism.[66] Broadly speaking, Burgin defends a 'post-industrial' view of late capitalism, in which the emergence of 'new movement' politics effectively breaks down the 'productivism' and 'universalism' of the Enlightenment-Marxian legacy. Thus, as he contends, 'the programme of the Enlightenment ... is seen to have at best failed, or at worst to have been the *cause* of the ills from which the twentieth century suffers'.[67] What is required, then, is the 'refusal of *any* oppositional philosophy of strategy of the totality',[68] and the 'democratic (re)assertion of a plurality of interests'.[69] In short, Burgin argues that we are living in a very different world from that of classical capitalism. The 'triumph' of exchange-value over use-value under consumer capitalism (the expansion of a capillary network of points of identification with capitalist relations) displaces traditional class politics, creating the conditions for a new democratic micro-politics. As such it 'no longer makes sense to posit the market – the economy – as "Origin"';[70] on the contrary power is 'now everywhere and nowhere'[71] in the operations of the signifier. Thus it is the power of signification that sets the terms of politics. The 'products of the media and advertising ... are sucked into the subject'[72] in an endless process of misrecognition – 'an incessant sliding of the

spectacle over the real in which the referent ... is eaten *live* by the signifier'.[73]

This mixture of society of the spectacle hermeneutics, post-Saussurian/Lacanian notions of the radical disjunction of the signifier and the referent, and Foucauldian-type conjunctural politics, captured, as I have outlined, a large section of the cultural and political left in Britain (and America) in the 1980s. Its influence as a political model, though, stands in sharp contrast to empirical reality. 'Post-industrialism' is a myth tied (ironically) to a Eurocentric and workerist view of class relations and the world economy. With the increased globalisation and integration of the world market the world working class has grown enormously since the Second World War. The working class in Brazil alone today is larger than the world working class at the time of Marx's writing, just as trade union membership has grown in the newly industrialising countries (South Korea, Singapore etc.) and South Africa.[74] Likewise the *relative* decline of manufacturing in the West has not so much eroded the working class as recomposed it. All technologist arguments, of which Burgin's is a culturalist variant, collapse changing work patterns into changes in the relations of production; as if capitalism was slowly eradicating the labour power on which it rests. Similarly the assumption that collective class-consciousness has been vanquished by the fragmenting consumerist powers of dominant ideology fails to take account of the fundamental part material interests play in people's self-perceptions and capacity for resistance. What were the revolutions in Eastern Europe if not that? As recent empirical work on ideology has shown, ideological interpellation is a wholly contradictory experience; people are not so much 'sucked' into ideology as live it out in contradictory ways.[75] Moreover there is also a convincing argument to be had that it is not so much the 'seamless web' of dominant ideology that keeps the working class in its place, but the dull and relentless logic of the economic.[76] As a contributor to a round table discussion on Debord's *Society of the Spectacle* in 1990 argued, ideologist views of the world are essentially 'eradicationist'.[77] That is, they eradicate the force of all concrete experience.

The issue of an identity-based politics, in some sense 'taking' over class politics as a matter of liberation from the 'productivist' and 'universalist', is suspect on concrete, material grounds. In these terms post-structuralist and post-Althusserian claims to 'plurality' and 'difference' do not so much draw attention to the realities of power-relations, as empty them of effective content, insofar as treating class as one identity among many is a *withdrawal* from ascribing explanatory priorities. Terry Eagleton puts it very well:

> On the surface, the triplet appears convincing enough: some people are oppressed because of their race, some on account of their gender, and some in accordance with their class. But this is of course grossly misleading. For it is not that some individuals manifest certain characteristics known as 'class', which then results in their oppression; on the contrary, to be a member of a social class just *is* to be oppressed, or to be an oppressor. Class is in this sense a wholly social category, as being black or female is not. To be black or female is a matter of Nature as well as Culture.[78]

The contemporary concept of identity, then, has come, in the manner of the older sociological category of 'group interests', to displace class as an economic category. In this sense Marxism has little to do with class as a *political* category at all. Class, rather, is the product of a *divided mode of production*. Consequently the working class (as a

collectivity made up of women and men, black women and men, lesbians and gays etc.) is the potential for socialist change, not because the working class is more alienated than other social groups, but because it is in an objective position to transform the system given its *privileged* position as the creator of surplus value. The diminution or replacement of class by conceptually loose concepts such as 'identity' and 'difference' in the name of a revivified (social democratic) 'civil society' is, effectively, a *surrender* to capitalism. As Ellen Meiksins Wood has said, who has done much in her writings to counter the 'retreat from class': 'By all means let us have diversity, difference and pluralism; but not this kind of *undifferentiated* and unstructured pluralism.'[79]

Burgin's capitulation to an undifferentiated 'plurality' in the name of anti-economism and anti-historicism is in many respects the concretisation of a number of rightward moving intellectual strands in the photographic left-avant-garde community from the late 1970s onwards. For all the influence Althusser and Lacan, then Paul Hirst and Barry Hindess, then Foucault and recently Lyotard have had on shifting the photography debate away from empiricism and reflectionism, the inevitable result has been the lodging of photographic theory within a set of largely reifying and disconnected categories and conceptual frameworks. Moreover, the move between these categories and frameworks sets in motion a chain of fundamental contradictions. On the one hand Marxism is economistic, yet the society of the spectacle subjects everyone to its economic (commodified) powers. Class politics 'totalises' human identity, yet human relations are in thrall to the universal power-relations of the oedipal complex. Language and representation are alienated and alienating, but photography has a special part to play in a counter-hegemonic politics. In fact, the long march from causality, material interests and resemblance has produced a culture of the image that mirrors in obverse form the anthropologism that post-structuralism and post-Althusserianism detect in classical Marxism. Instead of a positive anthropologism based on a unified subject acting in congruence with a rationally transformable world, we have a negative anthropology based on a decentred subject, pulled this way and that in dysfunction with a fundamentally arational world. What is produced as a result, strangely enough, is a form of aestheticism; the world becomes conscious to the subject purely through the play and effects of consumption.

It is no surprise in the face of the theoretical onslaught of post-structuralism and post-Althusserianism that the documentary tradition went on the defensive in the 1980s. Although the magazines *Camerawork* and *Ten:8* under the editorship of John Taylor were committed to showcasing left documentary work, their editorial position was increasingly committed to the theoretical critique of the tradition. However, in the 1980s work continued to be produced: some regardless and in defiance of this critique, some in conscious response to it. I do not want here to discuss an array of individual practitioners. Rather, I want to concentrate on the theoretical implications of the post-structuralist and post-Althusserian critique of documentary photography on those seeking to retheorise its role and status.

One of the direct effects of the post-structuralist and post-Althusserian critique of conventional realism has been to monologise the documentary tradition. As I have explained, this has been achieved by breaking the link between photography's iconic content and knowledge; by weakening the resemblance pole of the representational triad, photography's effects are held firmly within the operations of the unconscious. As a result, as I have also outlined, the interventionist social claims of documentary have been

subject to a great deal of criticism. The interventionist claims of documentary, it is argued, are voluntarist, insofar as they invariably produce an overdetermined role for the politicised image. The representation of political struggle is no guarantee of political effectivity in itself; the idea that certain contents *presuppose* an organic link with a working-class audience is simply a culturalist projection of the notion of the 'class for itself' onto the notion of the 'class in itself'. There is much to be said for this latter criticism – too often left documentary practices have been prepared to subjugate the vicissitudes of use-value to the sentiment of intentions, as the 1930s show. The modern development of the productivist tradition (Tretyakov, Benjamin), in either its 'fine art' or community art versions, has often used the documentary image to *assert* an active engagement with the world. But in many ways this critique has been overstated, flattening out what the documentary tradition is best at. Thus when Burgin argues that 'the museum is no more "irretrievably bourgeois" than is, for example, the movie theatre, or the class room',[80] he is leaving a fundamental point out of the picture: that, although in leaving the bourgeois gallery you enter another institutional space, the different kind of audience you may encounter may potentially change the political use-value of the work *in the direction of* non-bourgeois forms of consumption. Post-structuralist and post-Althusserian arguments about the need for a sense of photography participating ideologically *within* the culture are obvious and correct. But, as the Burgin quotation reveals, this can also easily level out the ideological contact between photography and audience to the point where *all* spaces for intervention are 'bourgeois' or 'internal' to the system.

There is therefore a conspicuous irony about post-structuralism's and post-Althusserianism's dialogic critique of the class-based claims of the documentary and reportorial traditions. Radically committed to the performative aspects of communication – the social construction of meaning – they nevertheless fail to give due weight to this process in social *exchange*. Clearly, if you have a 'total system' view of capitalist relations in which the referent is eaten live by the signifier, then your view of the performative *is* going to be purely formulistic, a matter of *interpretation* rather than practice.

A dialogic theory of representation that is sensitive to the performative nature of meaning, yet refuses to monologise realism and the question of audience, is a priority if the debate on photography is not to continually boil down to 'deconstruction' versus community art.[81] In the 1980s such a position had a very low profile. The process of raising the theoretical debate has also been about firming up conceptual distinctions as a means of drawing up political battle lines. However, there have been crucial exceptions to this rule, in particular the work of Jo Spence. It is not my intention to single out her practice as in some sense exemplary, but rather to point to the fact that the questions she asked herself of her own involvement with photography kept open a dialogic base for the 'naturalist moment' and the possibility of a non 'artworld' audience in a critical atmosphere that was either highly antagonistic towards such categories, or fetishised them. As she said in an interview in 1985:

> I'm very interested in theories of literacy from people like Paolo Freire where images are used as basis for vocabulary building and the images will be grounded in people's everyday experience, though they wouldn't necessarily be taken by them. So let's say a picture taken on the street of people standing

around the Labour exchange would be the basis for *talking* before one teaches reading to adults. The vocabulary that comes out of the discussion of the photograph would be grounded in their own experience of expression, which would overthrow the idea of naturalism as we know it by bringing up contradictory readings.[82]

Although her dialogic model here is Freire, Spence was one of the few practitioners/theorists in the 1980s to recognise the importance of Valentin Voloshinov's dialogic theory of the sign. It is revealing how little attention Voloshinov's *Marxism and the Philosophy of Language* (1973)[83] received in the left-avant-garde photographic community in the 1980s, even though there is a certain overlap with various themes of post-structuralism. Allan Sekula is perhaps the only major theorist in the Anglo-North American orbit of photographic writing to incorporate Voloshinov into his practice. What is valuable about Voloshinov's performative theory of signification is that use-value is not just the free-floating product of the instabilities of the signifier (of interpretation) but a result of the contradictions of the material interests that cross and contain the image. Although, in fact, Voloshinov tends to go against the grain of his best insights by characterising certain practices as monologic in *themselves*, nevertheless what his theory generates is the possibility that certain forms (for example the conventional documentary archive photograph) might be open to redescription through the inspection of the material contradictions internal to them. This is very much the spirit that informs the Spence quotation above. It is also what informs a recent critique of the monologism of post-structuralist/post-Althusserian photographic theory by historian Steve Edwards.[84] Taking his cue from Sekula and Berger and Voloshinov's work on reported speech, he argues that the documentary photograph does not just contain the voice of the author (his or her powers of objectification) but the voices of those 'objectified'.

> Reported speech is, for Voloshinov, speech which enters discourse and becomes a constructional element within it while, at the same time, retaining some level of autonomy and coherence of the speech of another. Thus, the problem of reported speech is a question of the active interrelationships within discourse which operate as part of the overall production of language.[85]

As such, documentary photography for Edwards is always divided between 'the speakers' and those who are 'spoken', two kinds of utterances, divided by relations of power, but maintained within the same construction. Post-structuralist and post-Althusserian theories of domination, on the other hand, leave these voices either absent, or present but not their own. A dialogic account sensitive to representational positions locked together in struggle, however, allows us to conceive of reported speech in the photograph as the 'answering word of those who are imaged'.[86]

Edwards's essay, essentially, is a polemic against the 'return to the studio'. In the studio, social contradictions may be easily negotiated, but everyday social life is 'controlled and cleaned up'.[87] In this respect Edwards's intervention is timely. Yet, as with all polemics, he tends to push the stick too far in the opposite direction. Studios are not in themselves reactionary, nor is there a conceptual divide between the studio and the demands of the 'naturalist moment' – as Jo Spence's work testifies. Furthermore, Edwards's critique tends to actually reinforce that split between naturalism and early Modernism that Raymond Williams correctly sees as the product of dominant, conservative readings of Modernist history. Williams identifies five factors to back up his

argument: the admission of the contemporary, the admission of the indigenous, the emphasis upon everyday speech forms, the commitment to social extension, and the steady exclusion from representation of all supernatural references.[88] Thus to turn the political crisis of photography's audience into a dialogic defence of the documentary tradition actually smacks of that very thing that the documentary tradition has used to reify its own identity: the use of the 'everyday' as the privileged political signifier.

Nevertheless Edwards's essay draws attention to that area of discussion in the philosophy of representation that, as I have argued, has been consistently left out of the picture of photographic studies in the 1980s: the iconic. Edwards's defence of documentary practice is a long overdue corrective to the view that the epistemological relation between an iconic image and the world is *wholly* conventionalised. Without a theory of resemblance it would be impossible to understand why photography *has* been so successful at providing knowledge of the world. This, however, is not to argue for some newly minted version of photography as a 'universal language'. The no-decoding defenders of photography (late Barthes,[89] and now Gombrich,[90] surprisingly) are mistaken. Rather, it is to point to the fact that photography's iconic status triggers our recognitional abilities in ways that are not the result *simply* of decoding, as Berger realised. This means asking fundamental questions about photography and cognition, pictorial representation and language.

One of the chief intellectual absences in photographic theory and criticism in Britain in the 1980s is any real engagement with the analytic philosophy tradition, and those philosophers of representation who have been influenced by cognitive psychology. Central to the influence Wittgenstein has had on both these traditions has been a concern with our natural abilities as communicators. Wittgenstein denies that understanding pictures and words is a rationalistic process of interpretation. As he contends in the *Philosophical Investigations* (1974), 'When I obey a rule, I do not choose. I obey the rule blindly.'[91] By this Wittgenstein wishes to emphasise the *habitual* character of rule-following, the fact that understanding is not a private process of independent reflection, justifying the addressee in interpreting a sign in a particular way, but rather, as Colin McGinn puts it, 'an *ability* to engage in a *practice* or *custom* of *using* a sign *over time* in accordance with one's natural propensities'.[92] What concerns Wittgenstein, then, is the relationship between human nature and our training in our engagement with signs.

The link between our human capacities and culture and communication has not been a great concern of photographic debate in the 1980s. This has had much to do with the extensive culturalism of the left during this period, of which post-structuralist and post-Althusserian discourse-theory has been a determining force. As Perry Anderson argued in *In the Tracks of Historical Materialism* in 1983, though, a radicalised philosophical naturalism represents a 'powerful intellectual challenge'[93] to many of the preconceptions of the culturalist left. He may have been exaggerating the influence of such a force at the time, but nonetheless the reclamation of the idea of a 'certain natural autonomy or creativity in human beings'[94] is a pressing requirement in the face of the semiological/post-structuralist argument that human beings' capacities and understanding of the world are successful solely in terms of their access to representational codes. And I assume this is the point Edwards is making in his dialogical defence of the iconic resources of the documentary tradition. That is, the recognition of objects and events in a photograph of, for example, workers in struggle, does not need a theory of 'mutual knowledge' based on the decoding of the conventions of worker-

photography for the interpretation of the scene to *begin* to take place. Rather, it needs the recognition of a shared experience.

This is not to smuggle a notion of unmediated experience through the back door. Rather, it allows us to ground the cognitive operations of perception and understanding in the dialectical relationship between the natural and the cultural. Two books, quite disconnected in subject, and having no immediate bearing on photography, took up this theme in the 1980s: Flint Schier's *Deeper Into Pictures: An Essay on Pictorial Representation* (1988)[95] and Dan Sperber and Deidre Wilson's *Relevance: Communication and Cognition* (1986).[96] Flint Schier's *Deeper Into Pictures* looks specifically at iconification in order to separate it out as a special case of representation against the conventionalists. His target of criticism, though, is not so much post-structuralism, but Nelson Goodman's similar flattening out of resemblance into convention in *The Languages of Art* (1968),[97] a text that also has had surprisingly little impact on British photographic theory. For Goodman pictures, including photographs, more resemble other pictures – symbolic systems – than the objects they depict. This is exactly Burgin's and Tagg's position. Schier argues the opposite: 'If the resemblance of picture and depiction were determined by convention, even if only to some extent, we should need to learn which pictorial marks were conventionally accepted as resembling which features of the world before we could properly interpret them.'[98] In this sense Schier rejects the view that interpretation *precedes* our recognitional abilities. On the contrary, he argues that our interpretation of iconic symbols is in a crucial sense caused by, or brought about by, our recognitional abilities. Recognitional ability 'must play some causal role in producing the interpretation'.[99] Thus following Wittgenstein's notion of custom, our ability to recognise a depicted object explains our ability to interpret it, and not the other way around. 'I do not *notice* the play of my recognitional capacities: I simply infer to their activity as part of a satisfactory theory of iconic interpretation.'[100] The point that Schier is concerned to make is not that we spontaneously produce interpretations of the world, but that we spontaneously *enter into* the process of interpretation on the basis of our recognitional abilities. Hence:

> Once you have succeeded in an initial pictorial interpretation perchance as the result of some tuition, you should then be able to interpret novel icons without being privy to additional stipulations given only that you can recognise the object or state of affairs depicted.[101]

Schier calls this 'natural generativity': the icon 'naturally' elicits its interpretation from the viewer rather than being 'put in place' as an abstract process of intellection.

Schier's intention is not to dismiss decoding as an aspect of visual communication; rather, his aim is to criticise the argument that we need to know the use of particular sign-systems before we begin to recover the iconic content of pictures. What conventionalist or decoding models of perception fail to acknowledge is how our natural recognitional abilities are *engaged* in the process of interpretation. In this he is concerned to break the over-generalised link between pictorial interpretation and linguistic interpretation which has become enshrined in the language-based model of semiology. In classic conventionalist accounts of linguistic communication it is argued that speaker and hearer require a common knowledge of linguistic conventions (of vocabulary) for communication to take place. There is a prearranged signification that both speaker and hearer know. Pictorial communication, and specifically photography, on the other hand,

Schier insists, does not require a common knowledge of the producer's conventions or techniques for communication to take place. In pictorial interpretation there 'is no grammar specifying how to generate novel statements by certain contributions of symbolic elements'.[102] By this he means that unlike the interpretation of sentences, pictures are iconically significant when decomposed by the viewer into parts. Therefore the meaning of such parts must be *contextually* generated, rather than generated through a knowledge of the prearranged conventions of such parts. What he is advocating is not that conventions are inessential to the interpretation of iconic images, but that 'the retrieval of the iconic content does not presuppose them'.[103] Essentially, Schier's argument is concerned to draw attention to what he sees as an important difference in how we generate pictorial competence and linguistic competence. For him the naturally generated retrieval of iconic content presupposes that the moment of recognition is ontologically distinct from the linguistic operations of interpretation. 'Interpretative competence in natural languages is acquired piecemeal ... but interpretative competence in pictorial systems is acquired in one go.'[104] Although, of course, 'the recognitional competences which underlie pictorial competence are themselves required piecemeal'.[105]

Schier, I believe, overestimates the distinction between pictorial communication and linguistic communication. Yet this is not because of any fundamental weakness in his natural generative model of iconic interpretation, but rather, ironically, because of his characterisation of linguistic communication as being based on the learning and decoding of shared conventions. This model in fact is close to the conventional semiological one in which communication begins in the generation of a signal and ends in the recovery of a message. Thus what is important about the concept of natural generativity – its emphasis upon the process of interpretation as an *inferential* one – could be applied to ordinary language itself.

It is this very argument that is explored by Dan Sperber and Deidre Wilson in *Relevance: Communication and Cognition*. For Sperber and Wilson linguistic communication involves more than the decoding of signals; the semiotic approach has inadequately generalised the code model to all forms of communication, pictorial and linguistic. They even go as far as saying, 'the recent history of semiotics has been one of simultaneous institutional success and intellectual bankruptcy'.[106] What Sperber and Wilson object to is that the code model implies an identity in the process of communication between communicator and receiver. On the contrary, they assert, there is a necessary gap between the semantic representation of sentences and the thoughts communicated by utterances. It is this gap that Sperber and Wilson analyse – the space of *inference*. 'Utterances are used not only to convey thought, but to reveal the speaker's attitude to, and relation to, the thought expressed; in other words, they express "propositional attitudes", perform "speech-acts", or carry "illocutionary force".'[107] In short the receiver is left a certain latitude in the process of interpretation, which he or she must pursue on the basis of *non-linguistic* communication. As such Sperber and Wilson are highly critical of the notion that *mutual knowledge* grounds linguistic communication. 'Someone who adopts this hypothesis is thus inevitably forced to the conclusion that when human beings try to communicate with each other, they are aiming at something they never in fact achieve.'[108]

If this sounds like a version of post-structuralist linguistics, this could not be further from the truth. Sperber's and Wilson's emphasis upon the performative nature of language is not concerned with justifying how we fail to communicate, but rather with

how we *manage* to do so, despite all the gaps in knowledge and comprehension that form our intersubjectivity. In this they take their point of departure from H. P. Grice's theory of intentionality.[109] Communication is not successful because receivers are able to recognise the meaning of an utterance, but because they are able to *infer* the speaker's meaning from it. This is also largely Schier's model in *Deeper Into Pictures*. Human communication, both pictorial and linguistic, involves the recognition of intentions not as a learnt process of intellection, but as a matter of *ordinary human cognition*. Human interaction *is* the conceptualisation of intentions. Grice's idea is that once a

> certain piece of behaviour is identified as communicative it is reasonable to assume that the communicator is trying to meet certain general standards. From knowledge of these general standards, observation of the communicator's behaviour, and the context, it should be possible to infer the communicator's specific informative intention.[110]

Communication establishes conditions of expectation which it then puts in motion. 'Very often, it is because this possibility exists that the communicator engages in communication at all.'[111] If Grice's model is, likewise, far too symmetrical – speakers do not have to make their intentions clear in order for communication to take place, as Berger grasped in *Another Way of Telling* – nevertheless it captures what Sperber and Wilson judge to be the key to communication: the inferential. The importance of this is that communication is put on a more cognitively psychologically plausible footing; communication is never *just* a matter of coding and decoding. 'The fact is that human external languages do not encode the kind of information that humans are interested in communicating. Linguistically encoded semantic representations are abstract mental structures which must be inferentially enriched before they can be taken to represent anything of interest.'[112] Coded communication then is always reliant *on* the inferential process.

This is why Sperber and Wilson prefer the notion of mutual manifestness rather than mutual knowledge as a basis for understanding. What this specifies is a shared cognitive environment that communicator and receiver share but never share completely. On the strength of this a great deal can be assumed to be manifest between one person and another, but nothing can be 'assumed to be truly mutually known or assumed'.[113]

In essence Sperber and Wilson conclude that communication is a profoundly asymmetrical process, in which meaning is reclaimed through the exercise of non-demonstrative inference. Crucial to this is the formation of assumptions by deduction. These are in a sense learnt, according to class position, race, gender etc., but brought to bear spontaneously in the process of communication. The implication of this is that at the heart of linguistic communication is the human ability to perform a certain set of deductive rules when faced with new information. This naturalism, 'rooted in human psychology',[114] is very similar to Schier's claims about our interpretative pictorial skills being generated naturally out of deductive recognitional abilities. And this, broadly, is the point I want to make about the dialogic status of the documentary photograph. Briefly, the interpretation of the picture does not have to begin from the recognition of mutual *knowledge*, but, deductively, from the fact that photographer and spectator share a mutually *manifest* environment.

How do these arguments relate to the discussion above? How might the application of cognitive psychology to the study of representation and language extend our

understanding of photographic theory and practice in Britain in the 1980s? I think there are three points to be considered.

One of the main critical claims or assumptions of post-structuralist theory and the conventionalist theory of Goodman, is that resemblance-based theories of representation curtail an understanding of the *full* signifying powers of representation. Resemblance is not sufficient for representation; traditional reflectionist accounts of representation have ruptured the constitutive link between the meanings of an image and the mediations of language. As W. J. T Mitchell, one of Goodman's contemporary followers, has said, Goodman's writing helps us to understand the 'full complexity of either verbal *or* visual art'.[115] Resemblance is clearly *not* sufficient for representation; and the constitutive link between language and the image has been downgraded by traditional positivist theory (and conventional Romanticised Modernist theory); but what has resulted from these corrective moves is not so much the opening up of representation to its 'full complexity', but its closing down – the reduction of resemblance to the status of a furtive 'other'. What is required, and what this book has been concerned to argue for in its assessment of photographic theory and practice from the 1920s, is that there is no way we can talk about the 'full complexity' of photography's resources without reinstating the naturalistic photograph as a 'mode of knowledge'.

This relates to my second point. One of the consequences of the severance of the iconic from knowledge and the rise of various allegorical modes of representation is the actual downgrading of the rational cognitive aspects of communication at the expense of the operations of the unconscious. This was the reason for my excursion into the cognitive psychological end of linguistic and pictorial theory. Interpreting pictures is not just a matter of recognising or internalising 'loss' and 'lack', but of extending our understanding and representational control of the world, something that was taken for granted in the early documentary tradition. This is a far more 'democratic' and open way of judging perceptual skills than assuming that the image, in a sense, always defeats our comprehension. Sperber's and Wilson's defence of the inferential basis of human communication is importantly a rationalist and heuristic account of the subjective's cognitive abilities. Accordingly the notion of the individual engaging in the representation of the world as a process subject to critical modification resists a conception of the subject as constructed solely through processes of ideological misrecognition. Consciousness may be ideologically constrained – self-opaque – but this opacity is always subject to the contradictions of social existence. There is a heuristic process at work in the divisions of consciousness derived from material life that always challenges this self-opacity. Thus although there are powerful disorganising constraints on the subject's understanding of his or her 'real conditions of existence', the subject derives his or her sense of self from the will-to-knowledge. In this respect the study of photography needs a politicised psychology as much as it needs psychoanalysis, because in cognitive psychology the subject's cognitive skills are given a transformative agency.

Thirdly, the effect of post-structuralist and post-Althusserian critiques of realism is not just to do with a loss of the conceptual status of the extra-photographic object, but the material interests that are inscribed in the image, and therefore impose certain limits on interpretation. The result has been a photographic criticism that reduces the economic in the manner of Althusser to the technical. In the name of an attack on economism and 'totality' there has developed a fragmented conception of photography's function within capitalist relations of production. The defence of the representational triad, then, is a

commitment not simply to the 'full complexity' of representation, but to historical materialism's claim to analyse the interrelatedness of all areas of social and cultural life, and not just externally related 'levels', whilst ascribing explanatory priorities within that process. A defence of representation's 'full complexity', therefore, is not just a matter of affirming a conception of 'totality' or material interests in the abstract, but concretely, in the recognition that culture remains divided on class lines.

To conclude, the history of photography in Britain in the 1980s is a history of dispersed and embattled counter-hegemonic practices breaking out of the ideological confines of Modernism and positivism. As such, the 'return to the studio' allowed photographers to extend and transform the categories of the 'everyday' in conceptually unprecedented ways. For example, the studio allowed women photographers to reframe oppressive images of the feminine, taking the photographic referent into the *contradictions* of women's experience. The effect of this was to reinstate the crucial distinction the surrealists made between a cultural politics of the 'everyday' and a proletarianised Political Art; and to reconnect, therefore, the debate on representation with the study of rhetoric and allegory. But these moves, as I have explained, have not been without their problems. A good deal of the accompanying theory has been idealist, allowing the critique of positivism to slide into an undifferentiated critique of realism and class politics, weakening photography's cognitive relationship to an external world, and the political function of the archive. One of the consequences of this collapse has been the elision between the politics of representation and identity politics. This in turn has been characterised by the extraordinary growth of photographic work on body-image. It is of course impossible to imagine photography without the representation of the body. Yet, with the advent of identity-politics cultural theory in the 1980s, the body as theme and subject has taken on an unprecedented conceptual autonomy. The outcome has been an increasing shift of the contemporary categories of the 'everyday' into issues of personal identity, particularly sexuality. In the next chapter I want to look at these major developments in more depth, developments that lay claim to fundamental changes in the culture of photography.

Notes

1 Simon Watney, 'Crisis Course', *Ten:8* 21 (1985), p. 29.
2 Perry Anderson, 'A Culture in Contraflow – 1' *New Left Review* 180 (1990), p. 44.
3 Victor Burgin, *Work and Commentary*, Latimer New Dimensions 1973.
4 Victor Burgin, 'Art, Commonsense and Photography', *Camerawork* 3 (1976).
5 Jacques Durand, 'Rhetorique et Image Publicitaire', *Communication* 15 (1970), quoted in Burgin, 'Art, Commonsense and Photography', p. 2.
6 Victor Burgin, 'Commentary, Part 1', *Work and Commentary*, p. 3.
7 Roland Barthes, *Elements of Semiology*, Jonathan Cape 1967.
8 John Stezaker, *Fragments*, Photographers' Gallery 1978, p. 52. See also *John Stezaker: Works 1973–1978*, Kunstmuseum Luzern 1979.
9 Peter Wollen, 'Photography and Aesthetics', *Screen* 17: 4 (1978/79).
10 *Ibid.*, p. 27. Wollen's essay is largely a response to the work of Stezaker, John Hilliard, Alexis Hunter and David Dye.
11 *Ibid.*, p. 28.
12 Victor Burgin, 'Commentary Part II', *Work and Commentary*, p. 20.
13 Louis Althusser, *Essays on Ideology*, Verso 1971.
14 Michel Foucault, *The Archeology of Knowledge*, Tavistock 1972.
15 John Tagg, *The Burden of Representation: Essays on Photographies and Histories*,

Macmillan 1988, pp. 9–10.

16 *Ibid.*, p. 4.

17 Joan Lukitsh, 'Practicing Theories: An Interview with John Tagg', *After Image* 15: 6 (1988).

18 Paul Hirst and Barry Hindess, 'Economic Classes and Politics', in Alan Hunt (ed.), *Class and Class Structure*, Lawrence & Wishart 1977, pp. 130–1.

19 Tagg, *The Burden of Representation*, p. 30.

20 *Ibid.*, p. 31.

21 *Ibid.*, p. 28.

22 Ernesto Laclau and Chantal Mouffe, *Hegemony and Socialist Strategy: Towards a Radical Democratic Politics*, Verso 1985.

23 *Ibid.*, p. 104.

24 *Ibid.*, p. 111.

25 Simon Watney, 'On the Institutions of Photography', in Patricia Holland, Jo Spence and Simon Watney (eds), *Photography/Politics: Two*, Comedia 1986, p. 197.

26 Norman Geras, 'Seven Types of Obloquy: Travesties of Marxism', in Ralph Miliband and Leo Panitch (eds), *The Retreat of the Intellectuals*, Socialist Register, Merlin 1990, p. 9.

27 Tagg, *The Burden of Representation*, pp. 154–5.

28 This distinction is Charles Sanders Peirce's. See *Collected Papers of Charles Sanders Peirce*, Cambridge University Press 1932.

29 David McNeil, 'Pictures and Parables', *Block* 10 (1985), p. 11.

30 Terry Lovell, *Pictures of Reality: Aesthetics, Politics and Pleasure*, BFI 1980.

31 Victor Burgin (ed.), *Thinking Photography*, Macmillan 1982, p. 9.

32 Stephen Heath, 'Difference', *Screen* 19: 3 (1978), p. 53.

33 The influence of Foucault was also important for a number of theorists dealing with sexuality and representation during this period. Foucault's contention that power was a constructive as well as a negative force opened up discussion of female sexuality away from the view that photography objectified womens' bodies. See in particular Kathy Myers, 'Towards a Feminist Erotica', *Camerawork* 24 (1982), and 'Fashion "n" Passion', *Screen* 23: 3–4 (1982). As she says in the *Camerawork* article: 'To see objectification in essentialist terms is to deny the possibility of any alternative practice within the representation of women' (p. 16).

34 Jacques Lacan, *The Four Fundamental Concepts of Psycho-Analysis*, Hogarth 1977.

35 Heath, 'Difference', p. 59.

36 Elizabeth Wright, *Psychoanalytic Criticism: Theory in Practice*, Methuen 1984, p. 117.

37 Heath, 'Difference', pp. 65–6.

38 Victor Burgin, 'Interview with Tony Godfrey', *Block* 7 (1982), reprinted in Victor Burgin, *Between*, Basil Blackwell 1986, p. 135.

39 Laura Mulvey, 'Dialogue with Spectatorship: Barbara Kruger and Victor Burgin', in *Visual and Other Pleasures*, Indiana University Press 1989, p. 135.

40 See Paul de Man, *Allegories of Reading: Figural Language in Rousseau, Nietzsche, Rilke and Proust*, Yale University Press 1979. See also Christopher Norris, *Paul de Man: Deconstruction and the Critique of Aesthetic Ideology*, Routledge 1988.

41 David Archard, *Consciousness and the Unconscious: Problems of Modern European Thought*, Hutchinson 1984, p. 99.

42 *Ibid.*, p. 101.

43 Burgin, *Between*, p. 81.

44 *Ibid.*

45 Laura Mulvey, 'Visual Pleasures and Narrative Cinema', *Screen* 16: 3 (1975).

46 For a discussion of this formation see Catherine Lupton, 'Circuit-breaking Desires: Critiquing the Work of Mary Kelly', in John Roberts (ed.), *Art Has No History! The Making and Unmaking of Modern Art*, Verso 1994.

47 Laura Mulvey, 'Magnificent Obsession: An Introduction to the Work of Five Photographers', in *Visual and Other Pleasures*, p. 137.

48 Mulvey, 'Dialogue with Spectatorship', p. 134.

49 *Ibid.*

50 *Ibid.*

51 Yve Lomax, 'Montage and Style', *Camerawork* 24 (1982), p. 9.

52 *Ibid.*

53 *Ibid.* The emphasis upon aesthetic fragmentation as a rejection of the 'will-to-power' of all concepts of 'totality' had a broad influence on women artists using photography in the 1980s. See also the work of Susan Hiller.

54 'Beyond the Purloined Image', curated by Mary Kelly, Riverside Studios, London, August 1983. Artists included Marie Yates, Yve Lomax, Susan Trangmar, Mitra Tabrizian, Olivier Richon, Karen Knorr, Ray Barrie and Judith Crowle.

55 'Difference: On Representation and Sexuality', curated by Kate Linker, New Museum of Contemporary Art, New York, December 1984–February 1985; The Renaissance Society at the University of Chicago, Illinois, March–April 1985; and the Institute of Contemporary Arts, London, July–September 1985. Artists included Max Almy, Ray Barrie, Judith Barry, Raymond Bellour, Dara Birnbaum, Victor Burgin, Theresa Cha, Cecilia Condit, Jean-Luc Godard, Hans Haacke, Mary Kelly, Stuart Marshall, Martha Rosler, Philippe Venault, Jeff Wall and Marie Yates.

56 Jacqueline Rose, 'Sexuality in the Field of Vision', in *Difference: On Representation and Sexuality*, New Museum of Contemporary Art, New York 1985, p. 31.

57 Mary Kelly, 'Beyond The Purloined Image', gallery notes, Riverside Studios, 1983.

58 See in particular *Ten:8* issues 22 (1985) 'Black Experience', 27 (1986) 'Independence Days', and 31 (1987) 'The Promise of Pleasure'.

59 Homi Bhahba, 'The Other Question – the Stereotype and Colonial Discourse', *Screen* 24: 6 (1983).

60 Kobena Mercer, 'Imaging the Black Man's Sex', in Holland *et al.* (eds), *Photography/Politics: Two*, p. 68.

61 *Ibid.*, p. 64.

62 Kobena Mercer and Isaac Julien, 'Race, Sexual Politics and Black Masculinity: A Dossier', in Rowena Chapman and Jonathan Rutherford (eds), *Male Order: Unwrapping Masculinity*, Lawrence & Wishart 1988, p. 102.

63 For a Foucauldian view of this see Donald M. Lowe, *History of Bourgeois Perception*, Harvester 1982. See also Don Slater, 'The Object of Photography', *Camerawork* 26 (1983).

64 Dominique Lecourt, *Marxism and Epistemology*, NLB 1975, p. 202.

65 Victor Burgin, *The End of Art Theory: Criticism and Postmodernity*, Macmillan 1986.

66 Burgin was one of the first theoreticians in Britain to draw the debate on photography into the orbit of postmodernism. Although something of a commonplace in art criticism in Britain and the USA, the term had relatively little impact on photographic theory in Britain in the 1980s. In the USA the new photography's critique of positivism was largely conducted under the auspices of postmodernism. For a discussion of Burgin and postmodernism, see Jessica Evans, 'Victor Burgin's Polysemic Dreamcoat', in Roberts (ed.), *Art Has No History!*

67 Burgin, *The End of Art Theory*, p. 165.

68 *Ibid.*, p. 166.

69 *Ibid.*

70 *Ibid.*, p. 174.

71 *Ibid.*

72 *Ibid.*, p. 168.

73 *Ibid.*, p. 170.

74 See in particular, Nigel Harris, *The End of the Third World: Newly Industrializing Countries and the Decline of an Ideology*, Pelican 1986.

75 See Nicholas Abercrombie *et al.*, *The Dominant Ideology Thesis*, Allen & Unwin 1980. See also Terry Eagleton, *Ideology: An Introduction*, Verso 1991.

76 See Conrad Lodziak, 'Dull Compulsion of the Economic: The Dominant Ideology and Social Reproduction', *Radical Philosophy* 49 (1989).

77 Russell Berman, David Pan and Paul Piccone, 'The Society of the Spectacle 20 Years Later: A Discussion', *Telos* 86 (1990–91).

78 Terry Eagleton, 'Defending the Free World', in Miliband and Panitch (eds), *The Retreat of the Intellectuals*, p. 89.

79 Ellen Meiksins Wood, 'The Uses and Abuses of "Civil Society"', *ibid.*, p. 80. See also Meiksins Wood, *The Retreat from Class: A New 'True' Socialism*, Verso 1986.

80 Burgin, *The End of Art Theory*, p. 192.

81 Owen Kelly, *Community, Art and the State: Storming the Citadels*, Comedia 1984, tends to fall into this trap.

82 'Interiew with Jo Spence', in John Roberts, *Selected Errors: Writings on Art and Politics 1981–90*, Pluto 1990, p. 140.

83 Valentin Voloshinov, *Marxism and the Philosophy of Language*, Harvard University Press 1973.

84 Steve Edwards, 'The Machines Dialogue', *Oxford Art Journal* 3: 1 (1990).

85 *Ibid.*, p. 74.

86 *Ibid.*

87 *Ibid.* p. 64.

88 Raymond Williams, *The Politics of Modernism: Against the New Conformists*, ed. Tony Pinkney, Verso 1989.

89 Roland Barthes, *Camera Lucida: Reflections on Photography*, Jonathan Cape 1982.

90 Ernst Gombrich, 'Image and Code: Scope and Limits of Conventionalism in Pictorial Representation', in Wendy Steiner (ed.), *Image and Code*, University of Michigan Studies in the Humanities No. 2, 1981.

91 Ludwig Wittgenstein, *Philosophical Investigations*, Basil Blackwell 1974, p. 219.

92 Colin McGinn, *Wittgenstein on Meaning*, Basil Blackwell 1984, p. 42.

93 Perry Anderson, *In the Tracks of Historical Materialism*, Verso 1983, p. 81.

94 *Ibid.*, p. 82.

95 Flint Schier, *Deeper Into Pictures: An Essay on Pictorial Representation*, Cambridge University Press 1988.

96 Dan Sperber and Deidre Wilson, *Relevance: Communication and Cognition*, Basil Blackwell 1986.

97 Nelson Goodman, *The Languages of Art*, Oxford University Press 1968.

98 Schier, *Deeper Into Pictures*, p. 186.

99 *Ibid.*, p. 50.

100 *Ibid.*, p. 189.

101 *Ibid.*, p. 43.

102 *Ibid.*, p. 159.

103 *Ibid.*, p. 158.

104 *Ibid.*, p. 84.

105 *Ibid.*

106 Sperber and Wilson, *Relevance*, p. 7.

107 *Ibid.*, p. 11.

108 *Ibid.*, p. 19.

109 See in particular H. P. Grice, 'Utterer's Meaning and Intentions', *Philosophical Review* 78 (1969).

110 Sperber and Wilson, *Relevance*, p. 33.

111 *Ibid.*, p. 29.

112 *Ibid.*, p. 174.

113 *Ibid.*, p. 45.

114 *Ibid.*, p. 32.

115 W. J. T. Mitchell, *Iconology: Image, Text, Ideology*, University of Chicago Press 1986, p. 155.

9

Disfiguring the ideal:
the body, photography and the everyday

In the 1980s the study of the body developed into one of the major areas of critical concern for cultural theory and photographic theory in Britain and North America. There is now a literature on the body that is unparalleled, reflecting a clear and discernable shift conceptually to the idea of a 'new somatics'. These 'new bodies', then, are not just any old bodies. The long crisis of the humanist body's imputed physical and psychical integrity has been brought to fever pitch by the impact of post-structuralism's anti-humanism. The would-be autonomy of the humanist body has been opened up by the logics of destabilisation and deconstruction: the body not as natural 'fact' but as discursive construct; the body not as a site of an abstract freedom and agency, but as the complex 'effect' of power-relations; the body ideologically positioned, situated, inscribed. Indeed, this is where the majority of kudos went in cultural work – and particularly photography – in the 1980s: work which decentred the universalising assumptions of the male, white, heterosexual body in the name of other bodies, of multiple identities, sexualities and desires. There is, it is claimed, no such thing as the 'body', but various kinds of bodies situated by different needs and desires. Or as Terry Eagleton has put it, sardonically: 'There will soon be more bodies in contemporary criticism than on the fields of Waterloo.'[1]

As such, the critique of the philosophy of the subject has become widely identified with a new politics of the body. If humanism in its guise either of bourgeois rationality or traditional socialist affirmation enshrined the body as fount of virtue and labour, the new somatics celebrates vertiginous narcissism, sexual provocation, gender-confusion and disordered reason.

The renewed emphasis on the body, therefore, can be seen as the actual culmination of significant material and theoretical transformations in Western culture since the late 1960s. To focus on the body is to bring into view all the key moments of crisis and change in social and cultural life during this period: the rise – and fall – of the women's movement, black politics, gay and lesbian politics, the politics of disability, the new drugs culture, the proliferation of health consciousness, the new cosmetics and prosthetics,

biotechnology, the mainstreaming of pornography and the relaxing of censorship around the representation of violence. It is little surprise that a new somatics has exercised an enormous pull on photography and cultural theory: the desiring body and the non-integrated, post-classical body are everywhere pressing home their ideological demands. We only have to take the most casual look at the art and popular culture of the 1950s to realise how far the constraints on bodily representation have broken down. The pornographic body, the violently distressed or brutalised body, and somatic grotesquerie generally, have moved out of the shadows of aesthetic and sexual marginalia to dominate the themes of popular culture, and transform the critical, counter-hegemonic concerns of the photographic avant-garde.

Since the late 1960s, with the final erosion of nineteenth-century forms of deportment and dress and their neo-classical ideals of proportion and sexual reticence, the bourgeois humanist body has been subject to a thoroughgoing derealisation. Propriety and circumspection can no longer claim the moral certitude they once did. However, if in the 1960s the appeal was to the 'naturalism' and 'primitivism' of liberationist ideology – the display of the body as anti-repressive *performance* – in the late 1970s and 1980s the counter-hegemonic body shed its Romanticism to become the site of specific ideological demands. The women's movement, gay and lesbian politics, the anti-racist struggle lifted the counter-hegemonic out of a generalised anti-bourgeois rhetoric into the realm of contingent semiotic subversion. There could be no liberation of the body when the oppression of women and black people and gays and lesbians tied men and women to repressive forms of self-identity and models of behaviour. The struggle for self-determined forms of bodily identity, therefore, was where the site of resistance lay; to know who you were could not be separated from undermining the received image of who others thought you were. Thus, the turn to the body as a site of counter-hegemonic struggle over identity linked emancipation to the production of counter-*representations*. The body was understood to be something that was not simply repressed by bourgeois humanism, but was actually written upon, and constructed by dominant forms of representation. These forms were obviously sustained by bourgeois hegemony, but were not reducible to the actual experience of the bourgeoisie itself, insofar as the belief in and reproduction of such forms was not class-specific. Consequently, to resist the oppressiveness of such alien representations – heterosexualism, the stereotypes of masculinity and femininity – the body had to take up its *re*-presentation.

The principal demands of such struggles were the separation of sex from gender identity, and race from cultural identity. Masculinity and femininity could no longer be judged as the natural expression of sex, just as non-white skin colour was not symmetrical with traditional or 'primitive' cultural interests or predilections. On the contrary, sexual and cultural differences were socially produced and therefore subject to examination and change. The driving force behind these changes in the 1970s was, of course, the women's movement attack on essentialism. Women's identity was not confinable to biological 'predestination'; the 'feminine' was not inscribed in flesh, but constructed socially and culturally. Hence there could be no liberation of women's bodies until the hierarchies of 'masculine' and 'feminine' were reordered, that is, until the link between dominant representations of the female body as 'passive' or 'sexually available' was separated from the everyday practices of women.

For some artists antagonistic to what was perceived as the unbroken sexualised representation of women within the Western fine-art tradition since the sixteenth century,

and the pervasive sexualised representation of women within contemporary mass culture, the only option was the partial or complete rejection of the somatic representation of femaleness. Even to produce images of a positive figurative nature was to reinforce the dominant sexual visibility of women. Images of maternal strength and 'female power' were no less constraining than stereotypes of femininity. Not surprisingly, a number of avant-garde women artists in the late 1970s, in particular Mary Kelly, saw the non-figurative treatment of the female body as a deconstructive priority. In Kelly's *Post-Partum Document* the absent figurative body is given corporeal form by the display of the written word. However, in the 1980s this led to a fundamental conflict as the active demands of producing both new heterosexual and lesbian identities made any political moratorium on the representation of the female body appear self-indulgent and self-defeating.

In the mid-1980s the rapid incorporation of a 'new erotics' and the rhetorics of pornography into the debate on counter-representation soon brought feminist cultural practice into dramatic alliance and tension with the somatics of the new popular culture. The psychoanalytic categories that had largely structured the debate on representation and the female body in a negative form – voyeurism and exhibitionism – were embraced as the motive force of a new assertive sexual politics. Voyeurism and exhibitionism were no longer seen as connected to an oppressive, masculine, heterosexual desire, but to the production of new visible identities. Simply, it was argued, any absenting of the female body in the name of social critique rendered the destabilisation of the idealised body of bourgeois humanism a political impossibility.

The effect such ideas have had on the left have been enormous, particularly in relation to the status of pornography. Indeed, the debate on the representation of the body on the left has clearly shifted to a proactive view of pornography and overt images of sexuality. One of the most influential texts in this area has been Linda Williams's *Hard Core: Power, Pleasure and the Frenzy of the Visible* (1990).[2] Although the book appeared on the back of a good deal of photographic and film work by women in the late 1980s employing explicit sexual material, it has in many ways come to define a new agenda on sexuality, one not confined by the logics of 'female-lack' within the Freudian-Lacanian tradition. For Williams pornography is not in and of itself oppressive, but open to appropriation and recoding in the interests of women's pleasure. In this she divests its function from its monologic, patriarchal interpretation within the older feminist movement. Pornography does not fix or encompass a dominant male subject-position but is potentially polymorphous in its focusing and production of desire, depending on who is making the images and how they are consumed. This argument has two main threads. On the one hand, Williams is concerned to deny that pornography and overt images of sexuality are at the root of women's oppression, a position influential in the USA through the writings of Andrea Dworkin and Catherine MacKinnon. And on the other hand, Williams seeks to reconnect the acts of sexuality with the production of knowledge, something that has been completely abhorrent to radical feminism and the New Right. As she says, pornography is the viewing of sex. With this we are able to satisfy the desire not only for pleasure but for the knowledge of pleasure, the pleasure of knowing what pleasure is. Specifically, then, pornography has the capacity to display a detailed knowledge of women's pleasure in action. In fact, Williams goes as far as saying that pornographic film – whether made by men for heterosexual men or by women for heterosexual men and women or lesbians – overcomes the *anatomical invisibility* of the

female orgasm. This is not to say that pornography is consumed by women or men out of biological curiosity, but that in its focusing on pleasure it gives us a knowledge of the performance of female sexuality.

This argument is quite unprecedented in contemporary discussions of pornography, reintroducing an, albeit marginal, realist problematic into the debate on the representation of sexuality and the everyday. In opening up pornography to the orders of knowledge pornography is given a history and dialectical identity. Indeed, its conditions of production and consumption are subject in *Hard Core* to the same kinds of materialist analysis as any other form of cultural activity. In this respect Williams wants to move the discussion of pornography beyond its aberrant or 'unvoiceable' status into the realm of cultural theory's legitimate concerns. Fundamental to this is her understanding of psychoanalysis and sexuality. For Williams there is no stable, normative space of the sexual by which we can measure healthy or unhealthy desire. Insofar as sexuality involves a swerving away from an original lost object, *all* sexuality is perverse. To assume that pornography destroys some settled and naturalised world of the sexual is to forget this.

Similar kinds of arguments to these are used by the British group Feminists Against Censorship in *Pornography and Feminism* (1991),[3] and Lynda Nead in *The Female Nude: Art, Obscenity and Sexuality* (1992),[4] although Nead's area of concern is principally art history. As with Williams, Feminists Against Censorship refuse to accept that pornography is at the root of women's oppression. For these writers it is the family that remains the major site of women's oppression, particularly for working-class women. The effect of anti-pornography campaigns is not only to deflect attention away from these realities but to reinforce the idea of women as victims. 'We must go on the defensive and stop being baited by those who call our defence of our sexual images oppressive.'[5] Moreover, like Williams, the group identifies the radical feminist anti-pornography lobby as forming an unconscious alliance with a masculine high culture antagonistic to the embodied pleasures of popular culture. Pornography is dismissed as the lowest kind of entertainment, suppressing the possibility that women might actively enjoy representations of sexuality. This tension between pornography and 'legitimate' culture is also a concern of Lynda Nead's. Focusing on the history of art, she shifts the debate away from older feminist debates about the oppressive place of female nudity within the Western tradition, to a discussion of representation of female sexuality as formed out of the dialectic between art, power and pornography. From this she addresses how the boundaries of what is considered to be pornographic are continually changing, and in changing redefining the boundaries of art. 'Pornography sets the limits of the public (the visible) and the private (the hidden), but this boundary is continually changing in relation to new social, moral and political discourses.'[6] Thus art and pornography cannot be treated as separate orders of representation, but as orders which share a common cultural continuum with regard to what representations of sexuality should or should not be seen. In these terms the presence of the female nude within the Western tradition for the pleasure of men is the reality of art adjusting itself to the cultural demand for representations of sexuality. This demand may have been conducted solely on behalf of (heterosexual) men within Western art for a long time, but it does not alter the fact that the dominant aestheticising and idealising treatments of figuration within this tradition also conceal a view of motivating bodily pleasure borrowed from pornography. That is, the bodily, non-contemplative pleasures of pornography haunt the supposed 'higher' cognitive pleasures of aesthetic evaluation. What is being argued here, as in the case of

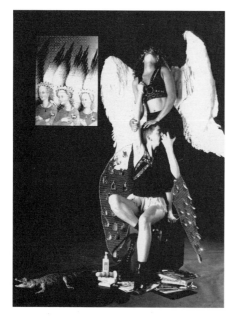

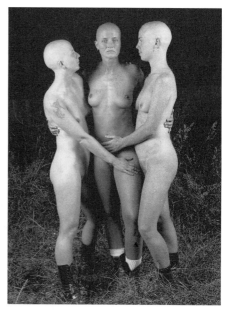

Fig 85 *Angelic Rebels: Lesbians and Safer Sex* (no. 5 of 5), Tessa Boffin, 1989 (Courtesy of OVA)

Fig 86 *The Three Graces* (from *Xenomorphosis*), Della Grace (Courtesy of Della Grace)

Williams, is the need for an anti-Kantian incorporation of bodily pleasure into the would-be physically unmotivated spectatorship of art as the basis for women to regain some control over the representation of their sexuality. Thus, to separate off the pornographic and the obscene from the legitimate concerns of women's experience is to deny not only how pornography locates the boundaries of the pleasurable, but also women's active sexual agency.

Like Williams, Nead is arguing not in a cultural vacuum, but in specific response to the work of a number of women photographers and film-makers. In the late 1980s there was an obvious narrowing of the gap between the cognitive demands of critical engagement in art, and the immediate, bodily pleasures of the pornographic and obscene as the crisis of the 'disembodied' desires of an older feminism became more evident. The appropriation of the would-be forbidden categories of the pornographic and the obscene have challenged not only public definitions of acceptable representations of women's sexuality, but what constitutes the acceptable boundaries between pornography and art. This no more so than in the representation of the sexuality of lesbians. Indeed, it has been the representation of lesbian sexuality that has been at the cutting edge of the 'new somatics' for women photographers. Tessa Boffin,[7] Della Grace[8] and the Canadian group Kiss and Tell have all adopted the codes of pornography as a means both of directly challenging demeaning stereotypes of lesbian life, and of showing what lesbians actually *do* sexually. This process of 'making visible' follows on the heels of gay photographers in the mid-1980s, such as Robert Mapplethorpe, who likewise appropriated the codes of pornography to open out an assertive space for the representation of gay lifestyles and pleasures. What is striking about the lesbian work, though, is how it has become an advocate for S/M, embracing many of the 'transgressive' moves gay men have adopted in the creation of a *theatre* of gay sexuality. However, for lesbian photographers something

Fig 87 *Lesbian Sex Scene*, Kiss and Tell (Courtesy of Kiss and Tell)

more is at issue than theatre in their identification with the secret pleasures of S/M. S/M acts as an imaginary site of the rejection of the essential maternalism of women, and an expression of the possibility of women as fetishists.

For Freud women cannot be fetishists;[9] for Lacan they can only exist as *disappointed* lesbians, as *aberrant* heterosexuals.[10] This is because, for Freud, the origins of fetishism are held to involve an aversion to female genitalia as the result of the male child's (symbolic) fear of castration on seeing his mother's absent penis. The fetish then (in Freud that which is remembered to be near the initial sighting of the absence) is a penis substitute, something that the boy recalls in the belief that the woman can be restored to masculine wholeness. As such the boy gains symbolic control over what is perceived to be an uncertain or ambiguous relationship between the sexes. The implication of this, as many critics of Freud have pointed out, is that as a compromise resolution of a perceived contradiction or absence, the power of the fetish is based on the misconstrual of the 'absence' of the penis as a 'lack'. The women's supposed absence of a penis leaves the boy fearful of what he imagines to be a threat to *his* wholeness. The effect is to place women outside of the domain of active symbolic agency, insofar as the position of symbolic absence attributed to women (women are simply the recipients of male desire) leaves women unable to experience their own identity. As Anne McClintock argues: 'Freud does not explain why the fetish object must be read as a substitute for the mother's (absent) penis, and not, say, as a substitute for the father's (absent) breasts.'[11]

Like Williams, McClintock refuses to accept the Freudian/Lacanian authority of the primal castration scene. Why should class or race not play an equal or more important role in the construction of subjectivity? She denies, therefore, that the fetish exists solely

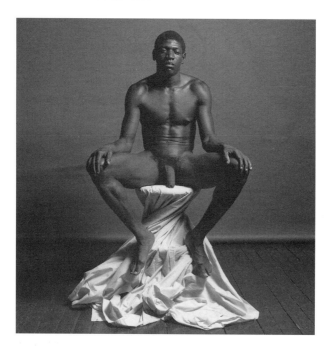

Fig 88 *Bob Love*, 1979 (1979 The Estate of Robert Mapplethorpe)

as the mark of a universal male desire for primal unity. Freud and Lacan normalise the compensatory gesture of the male fetishist. Divested of this misrecognition, the fetish's function as a substitute object for the evasion of the complexities of social and psychic relations can also find motivation as an agent of female desire. The pleasures of the fetish can serve as a positional affirmation of women's pleasure in their own bodies and others. Because the resistance to oppressive notions of the feminine cannot be pursued by recourse to any true notion of the feminine, the female fetishist is well positioned to destabilise the phallic devaluation of women as absence. Hence the significance of lesbian S/M, for S/M shows women as witness and author of their own desires. Crucial to these moves for photography, then, is the way that female fetishism dispenses with the objectificationist rhetoric of Lacanian post-structuralism in 1980s photographic theory. The photography of lesbian S/M, particularly by Della Grace in *Love Bites* (1991), invites recognition of the scandalous knowledge that women are capable of taking pleasure from the *controlled* objectification of their bodies. This is an unparalleled move. And this is what I mean by this new work on the body introducing a realist problematic into the discussion of photography and sexuality. In the refusal to be positioned as absent or other, lesbian photographers have looked to the objectifying, fetishistic powers of photography to open up a confident visibility to women's sexuality. As the Feminists Against Censorship declare, objectification 'may not always be sexist or demeaning to women'.[12] '"Objectification" occurs in the fantasies of many lovers of both sexes who treat one another as autonomous and equal.'[13]

 If women's photography has recently appropriated the codes of pornography in order to reassert the power of female fetishism, in the 1980s there was also a widespread development of an aesthetics of the grotesque and abject amongst women photographers as a means of de-fetishising the phallically feminised body. Cindy Sherman and Jo Spence

are perhaps the two most well-known names in this area. Sherman, for example, in her mid-1980s cibachromes of her prosthetically transformed body, produces a female body that is visibly disintegrating. The stuff that cosmetics is supposed to conceal – the fluids and bodily irruption – returns, bursts out, in a kind of hideous materialisation of the unconscious. Spence, likewise, de-fetishises the female body by displaying her mastectomy scars as a phantasm of male revulsion for the damaged or incomplete woman. According to Bakhtin's theory of the grotesque, the grotesque body is a body which is extensive of, and interactive with, nature. Sherman and Spence both employ this sense of the body in transition – as unassimilable to smoothness and impenetrability in Bakhtin's language – in order to display the fictional, *anti*-naturalist status of the feminine.

What this fetishising and de-fetishising work reveals is how far the self-representation of women's bodies in art has travelled since the 1970s. The nervousness that feminist art practices in the 1970s exhibited about desire and images of female abjection has now been completely dispensed with as the critique of femininity and masculinity becomes re-positioned under a form of radical 'perspectival switching'. The grotesque, the abject and the pornographic have become the categories *through* which the masquerade of identity is to be challenged, insofar as the grotesque, the abject and the pornographic are held to destabilise identity. They are excessive, unruly, infantile even. This is why images of lesbian S/M and women fist-fucking become the final transgressive deconstruction of femininity for their defenders. Women behaving *really* badly.

One of the results of this is the return to a quasi-liberationist ideology, in which the refusal of fixed identity (of masculine and feminine traits, of heterosexuality and homosexuality) exists as a site of imaginary freedom from identity politics altogether. In fact, for those at the cutting edge of sexual politics, such as the defenders of lesbian S/M, identity politics is now associated with an earnest 'political correctness'. Perspectival switching, or 'queer politics' to give it its more popular description, functions as a kind of utopian space in which identity and sexuality are never stable, always out to subvert or deny expectation in the name of the fluidity of all desire.

It is no accident, therefore, that despite the realist impulse to 'make visible' in this new work, a powerful neurosis attends the debate on representation and the body, as if the pursuit of polymorphous pleasure is where human freedom lives or dies. To know yourself, to live to the fullest extent, is to expose your body to the full intensity of the shifting play of identities. The current obsession with the body is certainly double-edged therefore. On the one hand it shows how deep iconophobia[14] has invaded Western visual culture, even within those radical traditions that claim to be emancipatory, and on the other hand it reveals how much of a repressive discourse 'body talk' actually is. As the intensified site of individual desire and autonomy the foregrounding of the sexual body claims the libidinal for the political, pulverising or displacing politics in the process.

However, this is not to argue that photography which deals with sexuality and identity desocialises the body, or does not at some level bear on issues of class-consciousness (as in Spence's work), but that we are witnessing through the thematisation of the 'body' a profound distaste for politics as a collective discourse. One of the immediate effects of this is the easy passage of radical narcissism (Mapplethorpe, Grace) into the commodified narcissism of mass culture (self-display as a form of celebrity). Indeed, the compulsive desire to define identity through sexuality points to a general failure of political nerve in the face of the commodification of sexuality, what Foucault

and Stephen Heath in their respective ways in the 1980s called the sexual fix, and what Heath himself has refered to as a 'new mode of conformity'.[15] The pursuit of beauty and health and sexual satisfaction are turned into the forever unfulfilled object of human happiness. The new photography and the new queer politics may dislike the worst aspects of this culture of self-improvement and self-display, but nonetheless it feeds into a sense that the primary pleasures of the everyday are those that we take from divulging the contingencies of our sexuality.

It is easy to strike the wrong note here or appear contradictory. This is *not* an argument about the dissipating effects of hedonism on photography, or some covert moral indictment of pleasure in the name of praxis. Such arguments only serve to mask what is dangerous, excessive and destabilising about the debate on sexuality. Rather, the argument is about how critical discussion of the body and its representation has passed into a general culturalist emphasis on sex-talk as that which *lifts us out of the ordinary*. In a period of intense critical revision of the representation of sexuality, the sexualised body has also become a *short-cut* to cultural visibility. This relationship of course has always been part of the history of commercial film and modern mass culture. But recently it has begun to determine the cultural ambitions of a great deal of contemporary photography, as the avant-garde increasingly relocates itself within the spaces of popular culture in reaction to the prohibitions of the 1970s. Thus, we cannot separate the aims of the 'new somatics' from this wider set of cultural adjustments. As such it can be argued that the new photography has had to appropriate the pornographic, abject and grotesque in order to *sustain* its cultural relevance in a period of crisis for the older avant-garde, as is implied to a certain extent in Williams's and Nead's anti-Kantianism. But in the process the generation of new pleasures brings with it a cultural capitulation to liberal notions of freedom through sexuality, which the capitalist sex and advertising industries are always happy to promote. Hence the disagreement here is not about the disruptive power of sexual representation, or the need to re-embody artistic practices, but the political character of the critical discourses that have come to dominate discussion of the body. In a period of political crisis and retreat for the left, the sexualised body and its representation has come to be seen as where the action is – where the only action is. For debates on photography the effect has been to produce an increasing identification between an art of the 'everyday' *and* the sexual. Even the realities of AIDS since the early 1980s have not altered this. Although HIV and AIDS have traumatised representations of the sexual – the widespread recourse to the abject has partly been to do with this – and as a consequence broken the link between the sexual and untroubled pleasures, the spread of the infection has brought a further extension of the real into the sexual. The prominence of lesbian S/M (and its radical heterosexual support) can be seen therefore as a liberationist response to this wider, medical crisis of the body. As a utopian, 'queer' space of women 'not' being women, lesbian S/M is a space of transgressive sexuality free from the threat of AIDS.

Generally, I would argue that from the late 1970s, we have witnessed a massive ideological reorientation of the categories of the 'everyday' for photography. Whereas in the period 1917–73 the political categories of the 'everyday' for photography were largely dominated by the labouring body and industrial culture – with the notable exception of surrealism – from the late 1970s the categories of the 'everyday' have become interchangeable with the sexual. To see this as bound up with the further extension of the categories of the 'everyday' does not alter the fact that the sexualised

body has come to suppress the labouring body, the dull repetitive body of the production process and the domestic sphere. This body, with all its conspicuous unpleasurability, has practically disappeared from the debate.

Now this is not to say that actual images of labour are completely absent from the culture of late capitalism, or that there are no longer photographers doing archival work on the labour process. (Ironically, to look at TV adverts these days is to see a large number of workers going about their jobs, from hamburger sellers to car builders.) But rather, that in a period of political crisis for socialists, we are witness to a widespread frustration with traditional political discourses of the body. Such discourses appear too inert, too constrained by the material realities of everyday living. The effect of this on the debate on the body and representation has not just been political in the narrow sense, but *ontological*. The practical disappearance of the labouring body from the debate on representation has also been the disappearance of the image of the labouring working-class body as evidence of the universal *unfreedom* of the body under capitalism.

There are a number of reasons for this beyond the rise of identity and queer politics: the changing nature of the labour process in the wake of the new industries and digital technology which weaken the reliance on older masculine images of labour as hard manual activity; the collapse of a public culture of the left in the West that would mediate the interests of the working class; and the increasing incorporation of popular culture into commodified forms of mass culture, making sexual (and violent) content almost an imperative for public interest.[16] All these transformations have made the representation of the working-class labouring body seem almost 'archaic', returning it to the space of the repressed 'other' as was the case at the beginning of the twentieth century. Of course politically conscious representations of the labouring body have always been repressed or marginalised under capitalism – Hollywood in the 1930s and 1940s, for instance, established strict protocols about the representation of industrial life – but nevertheless today there is a peculiar kind of amnesia about the issue as if bodies only had a sexual identity.

Furthermore, the absence of the labouring body, and by extension class, from the debate on photography and representation has also been the result of the exposure of theory to liberal sentiment. With the rise of critical theories of representation through the 1970s and 1980s the representation of the working-class labouring body has come to be marginalised through an overweening theory of the objectified victim. This is deeply ironic of course, given the shift in the late 1980s to an anti-objectivist position in debates on sexuality, pleasure and the body. It is as if objectivism has a selective agenda. Still, the result of the older position was to license the absenting of the everyday realities of labour in the form of an abstract political principle, which in the end did not so much protect the labouring body from voyeurism as remove it from the historical record altogether.

The net effect of these changes, therefore, needs to be assessed with historical judiciousness. The concerted opening up of the classicising, bourgeois humanist body through the cultural impact of the women's movement, anti-racist struggles, gay and lesbian politics, and the disability movement, has generated a huge compendium of de-fetishised and radically fetishistic images. This has expanded the ideological contours of the representation of the body into how it feels to be *inside* a certain kind of body. Key to this has been the identification between an extension of the categories of the 'everyday' and *self*-representation. The photographic process begins in the consciousness of the photographer as the subject of the photograph, or in the consciousness of his or her

subject. For example, David Hevey's work on disability imagery speaks for much of this legacy. His photographic work in the 1980s with the disabled on how *they* want to be seen shifts the photographic process into the realm of self-empowerment. 'A [shift] away from non-disabled transference' to an image of 'disabled self-empowerment'.[17] The subject of the photograph collaborates with Hevey on their self-image. Yet, no matter how transformatory this counter-representational work has been, it has not been the realist implications of self-representation that has dominated the 'new somatics'. On the contrary, the sexualisation of the everyday, and the drive to self-representation as self-display, has fed into that overly aestheticised treatment of the body characteristic of so much contemporary postmodernist and post-structuralist thought. In Lyotard, for example, it is the aesthetic intensities of the body that are celebrated over and above any knowledge of the body's material constraints.[18] The aestheticisation of the body as energised pleasure has clearly affected how the debate on sexuality, identity and representation is being positioned politically. The turn to 'queer politics' is pricipally an aestheticised dissociation of bodily identity from the material divisions of social life: a compensatory aestheticised cultural politics in which sexual transgression is identified with freedom.

We might say, then, that the debate around sexuality, identity and representation turns on how we conceive the pleasures of the body. For realists this of necessity means identifying the body not just as a site of aesthetic intensity but as an ethical agent. As such it means establishing a view of the body in which aesthetic and material considerations are in dialectical tension, not subject to egregious separation as in Lyotard. The best guide to this remains Marx, whose theory of the labouring body, contrary to popular misapprehension, is grounded in an aesthetic discourse of the body. For Marx, because wage-labour denudes the body of its sensitivity and autonomy, it diminishes essential human powers. The senses, he says, in the *Economic and Philosophical Manuscripts* (1844) are a 'prisoner of crude practical need'.[19] Emancipation, then, is not to be understood in one-sided terms as increased consumption, possession or having, but in the full development of human relations to the world. To live well is to live in the free many-sided realisation of one's powers. But if such an 'aesthetic' life is to be a possibility for all, thought, for Marx, must not be *prematurely* aestheticised. As Terry Eagleton argues in *The Ideology of the Aesthetic* (1992): 'Only when the bodily drives have been released from the despotism of abstract need and the object has been similarly released from functional abstraction to sensuously particular use-value, will it be possible to live aesthetically.'[20] That is, we cannot abandon the pursuit of truth *for* pleasure under a system that allows the freedom to be aesthetic to relatively very few.

Such an abandonment, though, is indicative of much of the new body talk. The intense war on universalism has brought about a sharp separation between counter-representations of the body and an ontology of *human* emancipation. Sexuality and the critique of identity have, consequently, taken on an atomised nature, as if the very assertion of difference was the guarantee of empowerment. Having said this, this is not a call for 'good' humanist images or some other act of pale virtue. There can be no prescriptive reordering of the sexual body for the labouring body or any other kind of body, as if the problems of representation and audience can be solved by hierarchising content, to paraphrase Benjamin. Rather, the issue lies in recognising that when we speak of bodies and their desires, we do not just speak of *bodies*, but of the constellation of their social relations. We do not need taxonomies of differences, therefore, but differences

in unities and unities in differences.

I now want to look at two photographers who address the body from within a realist perspective: Jeff Wall and Jo Spence. What is significant about their work for our narrative is that although operating out of very different sites of production they retain the representation of the body within the realm of social class.

Notes

1 Terry Eagleton, 'It is not quite true that I have a body, and not quite true that I am one either', *London Review of Books* 15:10 (1993), p. 7.
2 Linda Williams, *Hard Core: Power, Pleasure and the Frenzy of the Visible*, Pandora 1990.
3 Feminists Against Censorship, Gillian Rodgerson and Elizabeth Wilson (eds), *Pornography and Feminism: The Case Against Censorship*, Lawrence & Wishart 1991.
4 Lynda Nead, *The Female Nude: Art, Obscenity and Sexuality*, Routledge 1992.
5 Rodgerson and Wilson, *Pornography and Feminism*, p. 74.
6 Nead, *The Female Nude*, p. 101.
7 Tessa Boffin and Jean Fraser (eds), *Stolen Glances: lesbians take photographs*, Pandora 1991.
8 Della Grace, *Love Bites*, GMP 1991.
9 Sigmund Freud, 'Fetishism', in James Strachey (ed.), *The Standard Edition of the Complete Psychological Works of Sigmund Freud*, Vol. 21, Hogarth Press 1963.
10 Jacques Lacan, 'Guiding Remarks For A Congress On Feminine Sexuality', in Juliet Mitchell and Jacqueline Rose (eds), *Feminine Sexuality and the Ecole Freudienne*, Macmillan 1982.
11 Anne McClintock, 'The Return of Female Fetishism and the Fiction of the Phallus', *Perversity: New Formations* 19 (1993), p. 4.
12 Rodgerson and Wilson, *Pornography and Feminism*, p. 54.
13 *Ibid.*
14 See W. J. T. Mitchell, *Iconology: Image, Text, Ideology*, University of Chicago Press 1986.
15 Stephen Heath, *The Sexual Fix*, Macmillan 1982, p. 3.
16 For a discussion of these changes, see John Roberts, *Renegotiations: Class, Modernity and Photography*, Norwich Gallery, Norfolk Institute of Art and Design, 1993.
17 David Hevey, *The Creatures Time Forgot: Photography and Disability Imagery*, Routledge 1992, p. 116.
18 Jean-François Lyotard, *Libidinal Economy*, Athlone 1993.
19 Karl Marx, 'Economic and Philosophical Manuscripts', in *Marx: Early Writings*, Penguin 1975, p. 353.
20 Terry Eagleton, *The Ideology of the Aesthetic*, Basil Blackwell 1992, p. 202.

10

Jeff Wall:
the social pathology of everyday life

Jeff Wall's work emerges out of a similar set of avant-garde and realist concerns to those of John Berger and Jean Mohr. Like Berger, his work recognises the depth of the split after the 1950s between the debate on realism and a photography of the 'everyday' and the workers' movement. We noticed, for example, how debates on realism emerging out of film mutated in the 1950s, particularly in Britain, into the Realist Problem: that is, realism's crisis of social agency with the increasing dissociation between the representation of the working class and its collective interests. In the area of photography, as I have also explained, the debate on realism either became de-politicised with the North American institutionalisation of Modernism, or transmogrified through the construction of the category of documentary into the voice of the professional petitioner. In the late 1960s and early 1970s this gap between realism, the avant-garde and working-class politics was further opened up by the impact of consumerism and the electronic mass media. Whereas photography in the 1920s, 1930s and 1940s had been the principal means of dialogue with the experience of others – and therefore felt it could speak for collective working-class interests – in the late 1960s it began to feel disenfranchised as the electronic media extended their powers of news gathering and the state's ideological gate-keeping. It is no surprise, then, that critical debate on realism and photography retreated into the artworld, at the same time as it sought to renew its debt to the early avant-garde. Locked out into the political cold, critical photographic practices in the late 1960s and early 1970s became predominantly artworld ones. The museum, the studio, the art magazine and art journal became the crucial sites of production and distribution for the aspirant radical. Of course, the early avant-garde had its magazines and journals and studios, but these were not linked to a massive visual arts industry acting in concert with a massive communications industry. The 'epistemologicalisation' of the realist debate during this period, then, is not wholly detached from a shift in perception about the *limits* of the political visibility of photography, and therefore the critical autonomy the artworld provided for photography.

The Situationists' Lukácsian critique of capitalist spectacle (the product of the same

theoretical disenchantments as in Barthes in France in the late 1950s) was a turning point in the critical awareness of these transformed conditions. Following on from the Situationists, the critical use of photography became convergent with a general philosophical position about the derogation of meaning – and thus images – under capitalist spectacle. As such, at the same time as a new generation of artists turned to photography to reconnect fine art with the wider world of representations, the Situationist argument allowed these artists to see clearly for the first time that photographs were commodities subject to the same laws and logic of the market as any other cultural artefacts. It meant that political alliance with the workers' movement on the part of artists and photographers did not in and of itself guarantee conditions of critical reception for photography. As the split between working-class culture and the avant-garde/realist debate opened up, a photography of the 'everyday' produced in the interests of the working class was no less subject to the reifications of the market place than any other kind of image. It is no surprise, then, after Barthes's anti-humanist attack on realism, and the Situationists' attacks on capitalism-become-image, that photographic theory should reconsider its theoretical base. Unable to assert a confident social function for photography separate from the market place, avant-garde photography re-entered the artworld as a kind of fifth columnist. The Conceptual Art of the period 1967–75 is crucial in both justifying this move and recognising its limitations. Conceptual Art in this period was the first theoretically conscious attempt within art discourse to address the new conditions of capitalist culture. Although photography never played a central role in defining Conceptualism's identity, nevertheless its use by a number of leading conceptualists (such as Burgin and Stezaker) produced a significant critical realignment of the avant-garde with photography.

In 1984 Wall published an essay on the artist Dan Graham's architectural installation *Kammerspiel*, in which he engages with the legacy of Conceptualism.[1] For Wall the political location of Conceptual Art stood 'mid-way between the *Dialectic of Enlightenment* and the *Society of the Spectacle*',[2] that is, between what he sees as utopianism and defeatism. In Conceptual Art there is an open tension between the productivist desire for a social interventionist role for art and a Modernist self-dramatisation of modern art's inescapable ruin and social defeat. The 'dematerialisation' of art into theoretical language in early Conceptualism was an attempt, therefore, to avoid the dilemmas and bad faith of commodification: art's post-war incorporation into the bureaucratic structures of academic authority and knowledge, and the increasing corporatisation of aesthetic experience. Hence, for Wall, certain aspects of the Conceptual Art programme can be seen as an adaptation of the early avant-garde's urbanism.

> Through the appropriation of [new] media in antagonism to those of traditional art, conceptualism attempts to break out of the institutional enclave of 'Art' and intervene actively in the complex of social forces constituted by urban communication and representation systems. This intervention is constantly stimulated through critique of other art.[3]

It was these forces that photo-conceptualists such as Burgin and Stezaker embraced in the early 1970s.

But in advancing a way out of the social crisis of Modernism through the socialisation of technique, Conceptual Art simply deflected the critique of the capitalist relations of

production into the exhibitionist display of radical critique. As a result, Wall observed, there was a sharp collapse of the political ideals of Conceptualism in the mid-1970s, as the weight of these constraints positioned against the socialisation of art became unavoidable. This was the point when Conceptual Art transformed itself – for those artists who followed its initial moment of disruption – into a kind of virtuous and cosmetic anti-bureaucratism. Insofar as Conceptual Art 'was unable to reinvent social content through its socialization of technique, it necessarily fell prey to the very formalism and exhibitionism it began by exposing'.[4] In this respect Conceptual Art could not bring to the surface of its own conscious practice the force that propelled those social ideals of the early avant-garde to which it looked to transform the institutions of art: the international working class. As such Conceptualism represents the point where that alternative tradition of practices and techniques stemming from the early avant-garde is historically recovered yet, at the same time, historically remaindered.

It was around the mid-1970s, then, that a number of photographers who took their critical reference points from the early avant-garde and from the anti-bureaucratic cultural politics of Conceptualism began to rewrite the terms under which a critical practice of the 'everyday' might operate within advanced capitalism. If Conceptual Art had marked out the art gallery as a 'controllable' site of political intervention (as a place where the artist might begin to create a public rather than an audience for his or her work), 'post-Conceptualism' now took the museum, the art gallery and their market machinery as the governing sites of art's feasible critical interventions. For example, Hans Haacke's use in the 1970s of photographic document and sociological data to investigate and expose the gap between the museum's would-be liberal ideals (a home for all) and its corporate financial agendas. To show in the museum and public space at the same time as attacking them (which in Haacke's case many spaces allowed him to do) was not an *anti*-institutional gesture of Dada-type defiance, but a means of bringing the 'epistemological' revolution of Conceptualism (what, why, where?) into the line of vision of who might actually use such knowledge: an avant-garde-conversant, middle-class audience. In effect, although Haacke courts a certain notoriety through the threat of censorship, like many post-Conceptualists of his generation, the notion of intervention is confined to where art and its (middle-class) audience *finds* itself;[5] all else, it implies, is voluntarism. Hence, the complete lack of interest in Haacke's early work, with its forbidding amounts of difficult text, in making the work user-friendly for the casual, untrained spectator.

Jeff Wall's work is a response to, and product of, these closures. For Wall, learning from Conceptualism and post-Conceptualism meant learning that in the post-war world of the spectacle the circulation of images was controlled by bureacratic state institutions and propped up by consumerist ideology. But unlike many other photographers and artists who accepted this as an orthodoxy in Britain and North America in the 1980s, such as Victor Burgin, Wall remained committed to the realist voice within the avant-garde as a possible space of non-specialist inclusion. It is this that confirms Wall's affinity with Berger and Mohr, although, as I have explained, Berger has had no interest in using Conceptualism to focus on the contemporary problems of a critical practice of the 'everyday'.

Wall's large-scale back-lit cibachromes of dramatised everyday events, using actors, friends and extras, are in these terms a *conceptualised* realism. Using the fictive possibilities of the staged but seemingly naturalistic photograph, he enacts the historical

tension between the avant-garde's concern with the means of representation and the reportorial, popular aspirations of realism, *in* the image itself. The tension between representation and its critique is, of course, not confined to modern photography, but actually defines the point of Modernism's emergence, as Manet and his followers attempted to break with the academic painterly illusionism of the Salon. For Wall this is the moment where the professionalisation of the problem of representation begins to congeal in opposition to the 'everyday', as the advanced discourses of art seek to distinguish aesthetic quality from the ordinary and the common. For an anti-Modernist like Wall, therefore, the loss of the dialectic between representation and its critique has deep roots within the origins of modern culture, and as such, makes the absence and presence of photography within modern culture so crucial to addressing the wider developments of the production of images this century. To acknowledge the suppression of photography within Modernism, at the same time as recognising its critical presence in the avant-garde, is to begin to see how modern, Western, industrialised culture has been under-written by the split between representation as a source of common knowledge and representation as banal confirmation of the everyday. Thus, since the demise of the political avant-garde in the 1930s, modern art has suffered a profound schizophrenia over the question of realism. Reduced to positivism by Modernist painters and sculptors, realism became associated through photography with *mere* appearance. Yet, for conservative and some proletarian critics of Modernism, the would-be realism of the photograph became a sentimental club with which to beat 'difficulty' and abstractness. Realism's powers of communality were either fetishised or despised.

In this respect Wall sees the ideal of a practice of the 'everyday' – or in traditional terms a 'painting of modern life' – as the key aesthetic problem of image-making this century, and the problem that Modernism lost. Moreover, he sees the post-Conceptual avant-garde as contributing to this loss, in its inability to create a new public sphere solely through the deconstruction of the ideology in the photograph. As he argues:

> It seems to me that the general programme of the 'painting of modern life' (which doesn't have to be painting, but could be) is somehow the most significant evolutionary development in Western Modern Art, and the avant-garde's assault on it oscillates around it as a counter-problematic which cannot fund a new overall programme.[6]

Realism, then, for Wall, is less a matter of aesthetics in any narrow sense than a recognition of the deep historical connection between representation and the possibility of a public, not just a professional, culture for art. To defend the idea of the 'painting of modern life' is to retain a historical connection to the ideal of a non-bourgeois audience for art. Yet Wall chooses not to paint the 'everyday' or work as a documentary photographer, the two conventional options for the popular critic of the modern. He in a sense combines them. Thus, in taking the photographs he does, he commits himself not just to a continuation of the realist tradition, but to its qualitative transformation. In moving a factographic, archival concern for the naturalistic look of things and people *into* the theatrical space of the staged photograph, he moves photography into the popular spaces of capitalist spectacle. This is a 'realism' of the cinema, of the advertising hoarding and corporate photograph, those apparatuses of spectacularised absorption in the image that define the public forms through which modern capitalism reproduces itself ideologically. In this respect, a photography of the 'everyday' for Wall is about not simply

'shared meanings', but the shared conditions under which we experience and read the technologies of modern culture. Paradoxically, therefore, there is a way of reading Wall's back-lit transparencies as an actual critique of photography, that is, a critique of how the look of certain kinds of radical (black and white) reportage have come to stand in for the political and the everyday. Like many 1980s photographers more disposed to using the staged image as an out and out means of attack on the representation of the outside world, there is an undisclosed disdain in Wall's work for those forms of leftist purism associated with the older documentary tradition. Wall's conceptualised realism attempts to link the representation of the 'everyday' with the dominant fictionalised experience of the 'everyday' within advanced media-based culture. 'The opportunity is both to recuperate the past – the great art of the museums – and at the same time to participate with a critical effect in the most-up-to-date spectacularity.'[7] In one way this turn to the absorptive image presents a substantial concession to the post-Conceptualist critique of photography's privileged indexical relationship to the world. In another way, though, the use of the fictional device of the tableau actually dramatises the political crisis of photography.

Since the early 1980s Wall has been constructing elaborate scenes of social conflict and crisis: everyday events that invariably focus on acts of violence, or its impending outcome; or that show people under inordinate stress or expressing anger or frustration. These are scenes in which people are shown in coercive, repressive or exploitative relationships. As Wall says, this is a 'large part of the programme of what we used to call "realism", and I can adhere to that'.[8] Internal to many of these scenes, though, is a sense of bodily resistance, a sense of people surviving under pressure. In this Wall's work has less to do with the representation of subordinate class-consciousness as a collective experience, as in the documentary tradition, than in the representation of *unconscious class resistance*, those forms of struggle and disaffirmation that grow inevitably, organically out of the contradictions of capitalist relations. As such, Wall's 'decisive moments' are moments in many instances where the pressure of unfreedom and exploitation become visible, and as a consequence people undergo an experience which places their daily existence in question. These could be read as moments of class-consciousness. An example is *Milk* (1984), in which a man crouching next to a wall has just squeezed a carton of milk. The milk spurts out in a violent arc. We do not need to know what caused his compulsive behaviour, only that it represents an externalisation of repressed anger.

Wall's photographs take us back to the 'social somatics' of eighteenth- and nineteenth-century history painting, in which the smallest or most insignificant of gestures carries something of import for the overall interpretation of the picture. But, unlike the majority of this painting, Wall is not out to satirise certain kinds of gestures, or provide a visible system of social coding in which we can recognise 'social types' from bodily actions. Rather, he is concerned with how the gesture, small and compulsive, dramatic and aggressive, can function as a signifier of the external social relations of which it is a symptom. The gesture plunges us subterraneanly into the social. This representation of the gesture as symptomatic of undisclosed social structures and their relations is impossible, of course, without Marx's realism and Freud's psychoanalysis. As Freud declared in *The Psychopathology of Everyday Life*, nothing is ever *in*significant, the most seemingly inconsequential of actions or behaviour has a social root. To represent the repressive and exploitative relations of capitalism in terms of symptomatic

gestures is therefore to make a particular kind of claim about the available symbolic resources for photography and realism today. In a way I am reminded of the films of Mike Leigh. Like the characters in Leigh's films, many of Wall's figures live out the truth of capitalist relations without that truth passing through a process of critical reflection. Wall's work politicises human relationships without producing a didactic condemnation of capitalist relations. This position is undoubtably the product of our politically narrowed times, with its perceived loss of social agency. Through the process of reading political content deductively from physiognomy, we see a world in which humans are constantly defined in terms of their submission to the violence of external forces. This brings with it familiar accusations of objectification. As T. J. Clark puts it in an interview with Wall: 'in terms of the representation of subject positions, isn't there a danger that this imagery of the controlled, the contracted, the emptied, the rigid, the collapsed in the everyday life of late capitalism, will end up being read primarily in terms of your control of the tableau?'[9] Wall counters this by saying that the moments of breakdown or crisis do provide a workable knowledge of resistance for the spectator. The surface of the damaged life is shown to be on the point of critical transformation. This provides, in Berger's terms, not just an empathetic knowledge of the subject in his or her abjection, but the means by which the realities of everyday capitalist life can be judged from where most of the proletariat are at politically. That is, the subjects of his pictures are shown caught up *in* the historical process. They are neither victims nor self-conscious agents, but individuals struggling fitfully within a system that seems abstract and unfathomable. In this Wall's 'social somatics' are those of the conventional genre artist. He is not interested in deconstructing the alienations of everyday life through the decontextualised manipulation of signs, but in providing a space of literary identification in which such alienations can be *performed*. The use of genre therefore – defined as the arrangement of anecdotal appearances into categories of social experience – allows the artist to produce an image of the 'everyday' that does not rely on any initial specialist critical or artistic knowledge. By adopting genre-forms such as the 'conversation', 'the confrontation', 'the argument', the social becomes comprehensible through the anecdotal. As Tzvetan Todorov says, genre is speech on the side of the collective and social.[10]

The consistent use of such forms in Wall's work points to an explicit desire on his part to tie art to the dominant speech forms of contemporary mass culture – the fact that the success of the popular novel and cinema is due to their elaboration of genre as the most demotic of forms of address. However, Wall is not claiming that genre is uncoded or that it cannot be turned towards reactionary ends (to which a good deal of contemporary film testifies), but that in its staged naturalism it allows access to the image on terms other than those of acquired aesthetic understanding. Thus, given the dominance of genre-forms in popular literature and film, the use of genre in photography enables the collective aesthetic needs and expectations of a greater number of people to be fulfilled (and tested) in the image.

What is radical about Wall's work is that in its critique of post-Conceptualism it clears contemporary debates on photography of their avant-garde debt to the semiotic fragment. For Wall aesthetics after montage has become immured in an unexamined relationship to montage's would-be radicality. Far from arresting the ideological conflation between positivism and realism, it has produced a conformist reliance on Benjamin's belief in the greater cognitive veracity of the fragment. The return to genre, or rather the production of a conceptualised realism of the 'everyday', on the other hand,

re-establishes the pleasures of identification and visual 'mastery' over an event that the conventional naturalistic photograph brings. Yet he does this on very specific terms. Wall's use of genre as a conversational form is expanded in many instances into a panoramic realism. Thus, a number of his landscape images do not focus on a single identifiable event (as in monocular perspective), but on the dialogue and interaction of voices or points of view within a surveyable space. The process of reading is distributed across the space, as in *Eviction Struggle* (1988), for example, a middle-distance scene of a woman trying to prevent husband/lover from attacking the police who are presumably about to evict them. At the same time as our attention is drawn to this incident, we are given a large amount of information about the social setting in which the incident is taking place. Consequently, Wall's fictive naturalism is highly deceptive. We assume a spontaneous understanding of the image, but in fact, through the spread of incidents or details, we are led as in the cinema – where the modern spectator has now learnt to read the *mise en scène* as a field of signifying potential – to pick out the content of the work in a kind of scanning and re-scanning process. This implies that the would-be naturalism of the image is always threatened by the symbolic. Writers on Wall have compared this presence of multiple voices and dispersal of significant social detail to Bakhtin's dialogic theory of the novel. For Bakhtin the novel is profoundly dialogic in its form because of its potential conjunction of different voices from different class positions within the same narrative space. As he says of the eighteenth- and nineteenth-century English comic novel: 'In the English comic novel we find a comic-parodic re-processing of almost all the levels of literary language, both conversational and written, that were current at the time.'[11] For Wall something similar is at stake. 'If you look at the picaresque novel of the 17th century or the naturalist novel of the 18th and 19th centuries, it's quite common that those kind of tales [the everyday subjects of the life of all classes] are told.'[12] Thus, what the panoramic photograph allows Wall to do is to mimic the social inclusiveness of the novel, and by extension the cinema, within a single space. Moreover, this process of social inclusiveness is extended to the other non-panoramic images, insofar as their subjects contribute to the dialogic inclusiveness of the work as a whole. In this respect Wall's use of genre is the dialogic foundation of a dialogic whole. The dialogue between two individuals we find in many of his works, and the dialogue between their lives and the social setting we see them in, form the basis for the dialogue between multiple voices in the panoramic images and between the voices in different images themselves. People argue, confront each other, exchange stories in and across the images, in a kind of extended imaginary conversation with the spectator. From this Wall's images are very much to be overheard, in as much as the majority of them involve sound and speech.

This brings us to the principal concern of Wall's photography of the 'everyday': how might a model of social inclusiveness relate to the possible representation of the social totality. Wall may be a fierce critic of the privileging of the semiotic fragment, but his work is still very much connected to early avant-garde debates about photography, montage and the multiperspectival representation of the social totality. Montage still underpins his work. However, irrespective of these continuities, Wall has stepped into a debate that has recently been much discredited. The very notion of totality has come under a fierce amount of attack since the 1970s, with the rise of post-structuralism, New Movement politics and the drift to the right generally within Western academia. Totalities have become nasty, oppressive things, crude and imperious, eschewing difference in the chimerical pursuit of abstract universals. Moreover, to claim to speak of the totality of

social relations is to assume that language is capable of mapping out the 'truth' of all things. This is the standard objection to the notion of totality, and has found its way into all areas of contemporary science and philosophy. Essentially this attack has been an attack on Marxism; in deed the critique of totality has been interchangeable with a critique of Marxism. But invariably this critique has been based on a caricature of the concept of totality, taken not from Marx but from Lukács's Hegelian Marxism. Lukács's theory of the expressive totality, and Althusser's counter-arguments, have come to dominate the popular debate. For Lukács in *History and Class Consciousness* totality is an expressive relation between things: that is, elements in the social world are expressive of their underlying structures. For example, the development of the bourgeois novel after 1848 is expressive of the rise of the industrial bourgeoisie. In this regard, the presence of the totality is preordained, the totality always reveals itself through the elements that organise it. The result, of course, is the weakening of the relative independence of different levels of the totality. The initial merit of Althusser's work was to replace the Hegelian notion of expressive totality, with the scientific realist one of complex totality, in which the relations between things and their underlying structures were seen to be subject to multiple determinations. However, as I explained in Chapter 8, this was not without its problems, as Althusser's defence of multiplicity led to a weakening of the hierarchical evaluation of determination. Nevertheless, Althusser showed that the theorisation of totalities did not automatically suppress the movement of difference. In Lukács the opposite applied: difference was always the product of structure. The deterministic effect of this was reinforced by his theory of reification. If the working class is the only class which has a collective interest in understanding capitalism as a totality (in order to change it in the interest of all humanity), its actual day-to-day knowledge of capitalism as a total system is always partial and sectional. The reification of everyday life under capitalism makes it impossible for the working class to see capitalism *as* a totality. Such a knowledge can only be achieved through the revolutionary party. In Lukács, therefore, a real totalising consciousness is opposed to a fetishised kind, closing off practical links between them. As a consequence, the working class is defined as having no real independent will.

No wonder the concept of totality has come in for a bad press. Lukács's Hegelian Marxism initiated a split between knowledge and practice, producing a theory of totalities that is always reconciled to a deterministic and theoreticist understanding of the world. In these terms Lukács's expressive totality is a *vulgar totality*.[13] For Marx, however, the unities and levels of organisation in society exist only relatively. The problem of understanding them, then, rests on finding the means to conceptualise the relations between structures and the elements which constitute them without reducing those elements *solely* to those structures. Thus the behaviour or identity of one element cannot be explained by recourse to the laws governing one level of the hierarchy in which it is situated. In short, Marx's method resists the logistic levelling of reality in Lukács's theory, whilst at the same time respecting the hierarchical evaluation of multidetermination, largely absent in Althusser. Marx's complex theory of totality is a fallibilistic attempt to understand the specificity of the discrete ontological levels of society as a *historical process*. The question of human agency, then, is inseparable from this understanding, for social structures are seen as the products of human transformation even if that process of change is not reducible to the individual actions of agents.

This sense of totality as a unitary movement of things underscores Wall's dialogic inclusiveness and panoramic realism. The emphasis on different voices within the image, the concern with the movement and conflict of people and things within the metropolis, the foregrounding of the link between subjective states and social structures, the placing of human actions within recognisable social settings, the accumulated sense of the archival retrieval of the look of the built environment of late capitalism, all point to a self-conscious attempt on Wall's part to produce a picture of social relations which stresses difference and complexity, resistance and alienation, within the movement of the totality. However, this is not to say that Wall set out to *illustrate* some complex notion of totality. The work is not engaging in any explicit debate with the legacy of Lukács. This is work done without guarantees of working-class agency of any kind. Yet at the same time Wall is concerned to reconnect photography to the possibility of a totalising consciousness of social reality. In one sense this reflects an older avant-garde commitment to build up a repertoire of images of working-class struggle. But in another sense it reveals a qualitative transformation of that legacy. Wall's dialogic inclusiveness produces a totalising consciousness out of a multiplicity of subject positions *internal* to the working class and the dominated (Asian factory workers, native Indians, the unemployed, petty criminals, impoverished mothers). What this produces for the spectator is an accumulation of different voices within a shared space. Or rather different voices are linked to something larger than themselves. As Wall says, the withdrawal of legitimacy from representation under the impact of post-Conceptualism 'makes representations more visible now, more useful, more open to the aspirations of different people'.[14]

But who is in a position to use representation in this way? Critics of Wall's dialogic inclusiveness invariably criticise it on the grounds that it proceeds from the power of a white male middle-class subject position. The white male middle-class artist/intellectual has the power to survey and construct a totality of other voices. But this misses the point. For a start it can be argued that in the present period the political role of the white, male middle-class intellectual *is* the progressive identification of the aspirations of others, and secondly that the appeal to the figure of totality is an appeal to shared interests. As Robert Linsley puts it in an essay on Wall:

> For Wall, as for the great realist novelists and painters, the role of art is not to contemplate abstractions from a safe intellectual distance, but to approach people, to imaginatively step into their shoes, in other words to bridge difference. But this identification has to be attempted with the knowledge that distance will always be present within it. Critiques of the power relations implicit in objective representations overlook the fact that the objectivity and distance of the realist recognizes precisely that individuals can never be totally assimilated to any social or representational order. They will always have their own story to tell no matter how much the artist tries to mold them as raw material in his or her work.[15]

The totalising of consciousness for Wall, then, offers a particular dialogic address for the spectator. Wall is not just concerned with addressing the spectator as a political subject, as someone who is able to identify with a cause or injustice, but as a historical subject, as someone who in surveying the lives of others is able to situate themselves in historical reality. To quote Jerry Zaslove: 'The artist-author works with a spectator-reader

relationship to historical reality, rather than toward a patron-salon or museum reality.'[16] The relationship between realism and a concept of totality lies in the accumulated sense of participation *in* the social spaces of the modern world. Despite Wall's declared antipathy to montage, this links Wall's work to the avant-garde approach to totality and photography in one crucial way. For the early avant-garde an extended definition of montage was considered to advance the possibilities of 'realism' because of its capacity to connect, in atemporal sequences, different, discrete bits of the world, thus producing a would-be dialectical accumulation of those parts. This kind of approach to meaning is held by Wall. But in Wall's case what is of overriding concern is the capacity of the individual photograph to record a sense of *place*. Thus, the dialogic relationship between photographs may establish a montaging of elements, but the individual photograph itself remains a singular source of knowledge about a given locale; this is obviously very close to Berger's reading of montage.

The recording of place – overwhelmingly Vancouver in Wall's photography – is therefore fundamental to understanding his commitment to the panoramic, and as a consequence ties his conceptualised realism to traditional notions of representation as a form of honorific observance. In this sense the recovery of place marks for Wall what becomes increasingly lost in Modernism. If this connects Wall's work to Berger's reading of montage, it also connects it to Raymond Williams' reading of Modernism. For Williams, dominant accounts of Modernists as 'outriders, heralds, and witnesses of social change'[17] fail to recognise that the great social realists from the 1840s make Modernism possible. 'In excluding the great realists, this version of Modernism refuses to see how [the novelists such as Flaubert, Gogol and Dickens] organized a whole vocabulary ... with which to grasp the unprecedented social forms of the industrial city.'[18] For Williams the post-war suppression of the factographic presence in avant-garde culture – or what Williams calls the moment of 'naturalism' – results in the separation of the representation of social relations from the particularities of place and community. In neither Williams nor Wall, however, is this reading a conservative call for model images of community. Rather, particularly in the case of Wall, the violence of everyday life, the ruptures and fissures of our modernity have to be produced out of a strong sense of locale if the representation of such experiences is to avoid the anomie of dissociation.

Wall, like Williams and Berger, is involved in the reclamation and extension of naturalism within the experience of the modern. But as producer of staged photographs, Wall's appropriation of place goes well beyond the matter of providing anecdotal detail. If we have noted the relationship between voice and totality in his photographs, we need now to take note of the relationship between place and totality – although this of course is not to separate 'voice' from 'place'. What is clear from Wall's commitment to the panoramic and to the textures of everyday metropolitan living is how physical space is always *built* space, that is, how physical space is subject to the law of value. In this sense, at the same time as Wall is invoking a multiplicity of voices, he is making visible the topography of the new capitalism. This makes Vancouver significant for Wall in ways that Berlin, Paris, Moscow and Barcelona were for the early avant-gardists. As a buoyant Pacific Rim economy with extensive Asian immigration, a growing working class and a politically conscious native population, Vancouver reveals the extent to which European-type modernisation and conflicts have come to dominate so-called secondary cities. As Wall says: 'important historical experiences are now had in the secondary cities'.[19] Vancouver is a large port, and a centre for the new industries, as well as possessing, in

recent times, a rich confluence of cultural traditions. As such, what concerns Wall is the typicality of the city under the changes that have taken place in the world economy since the late 1970s. Vancouver becomes a site of familiar spatial divisions and boundaries, as property speculation and new industries transform the look of the city in line with the finance-capital fed corporatism of the 1980s.

As we noted in our earlier discussion of Henri Lefebvre, the struggle between classes (and between private and public capital) is fundamentally a struggle over space: who controls it, for what reasons and to what ends? To open up the social landscape of the city to representation, then, is to see the permanent or transitory result of the complex and ongoing struggle over the legal and symbolic ownership of place. That this process is invariably dominated by private capital and big business in conjunction with the state, does not mean that all spatial divisions and boundaries are controlled by such interests. Yet, on the whole, to look at the zoning and divisions of the modern city is to see the power of big business wedded to the interests of the state. How the city is represented as part of a given national culture tends, therefore, to be dominated by such interests. Imperial monuments, memorials to national power, patriotic landmarks, prestigious architectural projects, banks and government offices, serve to symbolise the city as the *home* of the bourgeoisie. The modern tourist industry and culture industry may have softened the contours of this by introducing into the public sphere, through the new museums and leisure parks, representations of working-class vernacular, the folkloric and the multicultural, but nevertheless the representation of the city within a national culture is marked by the power of the state and big business to exclude what it feels is not befitting its interests. Despite the enormity of this power, this reveals how much the occupation and representation of space is bound up with ideological assertion. This is why the early state practitioners of photography at the end of the nineteenth century were so keen to represent the city as the rightful and civilised home of those who could move freely through it: the bourgeoisie. The early photographic archivists of the city largely confined the representation of the working class and poor to their miserable places of habitation. The working class and poor were reduced to their abject surroundings, signifying to the bourgeois reformer and conservative alike that the working class and poor had no real legitimate place in the wider spaces of the public sphere. The class segregation in Victorian cities was matched by a segregation in representation. The bourgeoisie used photographic anthropology to taxonomise those who were and who were not considered to be citizens. As a result, the true modernity of the city was confined to those spaces *not* occupied by the working class. This was the period when the boulevard, the theatre, the café and other places of public pleasure became the sites of bourgeois self-display. Naturally, there was a mixing of classes on the streets, and this was a crucial part of the pleasures the bourgeoisie took from these changes, but these contacts were transitory, and necessarily so, as the city became the place where the fantasies of consumption outweighed the realities of production and the lives of those who laboured.

The 'taking back' of public space by the working class begins in this period, the Commune of 1871 being one key moment in this history. The destruction of government monuments, public buildings that symbolised authoritarian state power, brought into focus, in a way not seen since the French Revolution, how political and social emancipation were intimately connected with the restructuring of space. It was not until the 1920s and 1930s, though, with the impact of the Russian Revolution and the growing

European workers' movement, that these forces found their expression in photography. The working class's increased militancy and political power provided the basis for a new set of spatial contrasts between people and things. The working class was no longer symbolically confined to its places of work and habitation, just as its places of work and habitation were no longer seen as outside of the acceptable boundaries of the bourgeois city. New spaces of occupancy developed, resulting, in Europe at least, in the symbolic accommodation through photography of the spaces and forms of working-class life into the national culture.

Today, of course, this process of accommodation has become a settled part of social democratic consensus. But if the state no longer uses powerful images of class segregation to distinguish what is publicly legimate from what is not, the city is still shaped by familiar territorial boundaries of class and race. Engels's working-class ghettoes may have gone and those images of the pitiful 'other' that so horrified the Victorian bourgeoisie, but ghettoes and ostracised working-class housing estates exist in abundance, and continue to create similar kinds of horror-filled otherness for the middle class. What is missing from these new patterns of habitation, though, is any sense of control that their occupants might have over their environment; this is a defeated class occupancy. With the growth of the property speculation boom in Europe and North America in the 1980s, and the concerted economic attack on older working-class communities, particularly in Britain, as capital recomposes the working class socially and geographically, class divisions as spatial divisions have begun to reassert themselves. At the same time, this process of reconstruction has also been accompanied by an increased abstraction of spatial relations in the public domain. The rise of the out-of-town hypermarket and the proliferation of the inner-city shopping plaza and multiplex cinema across Europe and North America have turned the public spaces of the small town, in particular, into spaces in which those older and once confident forms of working-class occupancy are no longer recognisable.

We might argue, therefore, that one way of looking at photography's relationship to social power is to address how photography engages with/refers to dominant spatial relations and the struggle over space generally. What places and spaces are given visibility in the culture? In what ways does photography, unconsciously or consciously, pick out the changing spatial relations in the city and the countryside, under the impact of capital accumulation? Consequently, a politics of the everyday *in* photography might also be seen as a contestation over the social production and reproduction of spatial relations. Although Lefebvre does not discuss photography in *The Production of Space*, this view of photography is very much implied by his theory of a critical practice of space. It is the job of such an activity to locate and foreground 'implicit and unstated oppositions'[20] in social space, 'oppositions susceptible of orienting a social practice'.[21] Social space dissimulates social relationships. We need, Lefebvre argues, a political economy of space, which reveals the violence inherent in the production of the abstract space of the market. The processes of centralisation and monopolisation that underwrite capitalist competition produce direct (and indirect) spatial effects which transform lives at macro and micro levels. A critical practice of space would show how human relations are continually subject under market conditions to the contradictory forces of homogenisation and fragmentation.

Wall's extensive incorporation of Vancouver into his pictures can be read as an index of these processes. His photographs locate the process of social abstraction

(suburbanisation for instance) as the means by which the crisis of the self is rendered socially visible. For example, in *Eviction Struggle*, which shows a Vancouver suburb gone slightly to seed, the blandness and anonymity of the area is increased by the panoramic perspective. The man fighting off the police and the woman with outstretched arms are dwarfed by their surroundings. At first glance they are a barely noticeable blip of activity in the middle distance. In this Wall uses scale to emphasise how the ideal world of the suburb as a place of escape from the depredations and divisions of the inner city suffered a social crisis of its own in the 1980s as low wages and unemployment forced owner-occupiers into unprecedented debt. These are two people who have been literally swallowed by abstract space. This use of scale to suggest power-relations is also explored in those works which show derelict or discarded areas of land. The use of derelict or discarded areas of the urban landscape to suggest the repressed 'other' of corporatism and the market has been common practice in a lot of contemporary urbanist photography. In *Diatribe* (1985) Wall employs this contrast, but at the same time inverts its meaning to create a utopian sense of 'elsewhere'. The two women walking through the scrubland are 'impoverished mothers'. However, in this case, the interaction of the two figures dominates the space. The white woman is talking passionately to the black woman, suggesting, as the title implies, an argument or complaint. The original classical meaning of diatribe, though, is not an act of confrontation but, as Wall explains, a philosophical dialogue. *Diatribe* is meant to be read as a socratic-type dialogue between 'impoverished mothers, who aren't identified with philosophical knowledge and critique'.[22] Once we know this, the identity of the relationship between voice and place changes. The would-be impoverished content of the conversation becomes a dialogical ideal (the oppressed speaking with the confidence of their oppressors), transforming the locale from wasteland into a sylvan setting of almost classical proportions. However, this is not an act of political gesturalism on Wall's part. Rather, the voices of the women function as an imaginary source of the possible transformation of the uses of space. As such, this is the nearest we get in Wall's work to an open critique of abstract space.

The concern with the effects of social abstraction naturally tie Wall's work to the surrealists. Like the surrealists Wall looks to how capitalism's control of space contributes to that familiar loss of integration of experience under modernity. But unlike the surrealists Wall stresses how space is never 'empty', in that it is always occupied by the presence of social relations. In this sense Wall is principally concerned with linking up experience *to* space, to show particular experiences in particular locations, the intention being to connect the psychic to the social in palpable ways. But this does not mean that Wall's photography is a version of social anthropology Rather, what concerns him is how much of contemporary art has lost, or deliberately eschewed, the idea of art as the sharing of the experiences of others through the rendering of figures in recognisable settings. This means that place and voice, space and figure, become coextensive. But at the same time, to reiterate my point about Wall's political intentions, Wall does not represent a particular kind of figure in a particular setting as a didactic comment on social conditions. For example, he does not use the scrubland in *Diatribe* as a means of symbolising poverty. He does not use spatial contrast simply to point out social inequality. On the contrary, he uses certain kinds of spaces to suggest the generalised forces of violence of modernity. Wall's settings are deadening or oppressive in a *typified* fashion. Thus in contrast to the surrealists and other photographers of the 'unconscious city' (for instance Keith Arnatt's rubbish dump photographs of the late

1980s), Wall's work places no privileged emphasis on the marginal or derelict space as a space of freedom from, or critique of, abstract space. And this essentially is what characterises his sense of capitalist totality. The disordered/ordered distinction which played such a large part in Romantic and Modernist aesthetics (Szarkowski's Modernism was deeply attached to this spatial binarism) has become exhausted as a way of symbolising the law of value. Space has become commodified to an extent undreamed of by the early avant-gardists, bringing the liminal and the marginal under increasing symbolic control. Thus whereas in the eighteenth and nineteenth centuries spaces of disorder, such as working-class communities, festivals etc., were not completely integrated into the running of the state, today social integration through the market and bureaucratic state structures has turned such spaces of resistance over to the force of external administration. Similarly the identification of nature as giving us a glimpse of 'what we also once knew',[23] to quote Szarkowski on Ansel Adams, is implausible as a symbol of otherness once we acknowledge the vast encroachments of capital into the landscape. Wall, then, does not offer us images of the disordered as symbols of resistance to the process of capitalist abstraction. Rather, as is reflected in *Diatribe*, his intention is to show how resistance to abstraction is always a matter of political practice, and not symbolic identification or occupancy.

As I have explained, Wall's restoration of naturalism within an avant-garde framework is an attempt to recover an older dialogic content for art. As such, it can be argued that in 'clearing away' the aesthetic fragment from contemporary debates on art, Wall sets out to establish a historical practice that will restore the causal relations between voice and place, ourselves and the present, the present and the past. From this perspective Wall's commitment to the representation of generic situations rewrites the synchronic moment within the diachronic for photography. By this I mean that although Wall's dominated subjects are not fully class-conscious subjects (as if that was a real possibility for representation, as Benjamin asserted), nevertheless the crisis states of consciousness that Wall creates point to a sense of self directed outwards to the world. His subjects' crises of identity, then, seem to be crises of omnipotence, in psychoanalytical terms. As a result, the subject appears on the verge of being restored to a collective, historical space.

Yet renegotiating the emancipatory movement of the diachronic into the synchronic present is not something that can be conjured up in any programmatic sense. Wall realises this. Wall may give us glimpses of historical agency, but his work overall is determined by the disaffirmative need to make visible the coercive structures and pathological signs of modernity. But even so, in this recognition of the wider repressive connectivity of things lie Wall's critical intentions. In drawing together voice and place Wall produces a photography of the 'everyday' that connects the semiotic to the *objective dynamics* of capitalism. As the capitalist colonisation of everyday life advances, he reveals its secret and not-so-secret pathologies.

Notes

1 Jeff Wall, 'Dan Graham's *Kammerspiel*', in *Dan Graham*, The Art Gallery of Western Australia, Perth 1984.
2 *Ibid.*, p. 15.
3 *Ibid.*, p. 16.

4 *Ibid.*, p. 18.

5 See Hans Haacke, *Unfinished Business*, New Museum of Contemporary Art/MIT, New York, 1986.

6 T. J. Clark, Serge Guilbaut and Anne Wagner, interview with Jeff Wall, 'Representation, Suspicions and Critical Transparency', *Parachute* 59 (1990).

7 Els Barents, 'Typology, Luminescence, Freedom: Selections from a conversation with Jeff Wall', in *Jeff Wall: Transparencies*, Schirmer/Mosel 1986, p. 100.

8 Clark *et al.*, 'Representation, Suspicions and Critical Transparency', p. 6.

9 *Ibid.*, p. 5.

10 Tzvetan Todorov, *Mikhail Bakhtin, The Dialogical Principle*, Manchester University Press 1984, p. 80.

11 Mikhail Bakhtin, *The Dialogic Imagination*, University of Texas Press 1981, p. 301.

12 Bill Jones, 'False Documents: A Conversation with Jeff Wall', *Arts Magazine* 64:9 (1990), p. 53.

13 See Andy Wilson, 'Lukács and Revolution', unpublished 1993.

14 Clark *et al.*, 'Representation, Suspicions and Critical Transparency', p. 9.

15 Robert Linsley, 'Jeff Wall: The Storyteller', in *Jeff Wall: Storyteller*, Museum für Moderne Kunst, Frankfurt am Main 1992, p. 32.

16 Jerry Zaslove, 'Faking Nature and Reading History: The Mindfulness toward Reality in the Dialogical World of Jeff Wall's Pictures', in *Jeff Wall: 1990*, Vancouver Art Gallery 1990, p. 69.

17 Raymond Williams, *The Politics of Modernism: Against the New Conformists*, ed. Tony Pinkney, Verso 1989, p. 32.

18 'When was Modernism?', in *ibid*.

19 Jones, 'False Documents', p. 54.

20 Henri Lefebvre, *The Production of Space*, Basil Blackwell 1991, p. 65.

21 *Ibid.*

22 Barents, 'Typology, Luminescence, Freedom', p. 98.

23 John Szarkowski, *The Portfolios of Ansel Adams*, Thames & Hudson 1977, p. vii.

11

Jo Spence: photography, empowerment and the everyday

In a similar spirit to Jeff Wall and other photographers working in the wake of Conceptual Art, yet committed to some notion of realism, Jo Spence sought to connect a photography of the 'everyday' with the ideals of the early avant-garde. One of her influences, not surprisingly, was the factography of Dziga Vertov. As she outlined in an interview in 1985:

> I am coming from a position in film theory which is Vertov's work. One is working to produce a series of 'facts' and these are building blocks, so to speak, of what one wants to do. It means nothing is sacred and you can make your images mean what you want them to mean depending on where you place them. He talks about a 'factory of facts'.[1]

What was of particular importance about Vertov and the early avant-garde for Spence, therefore, was the insistence on photographic naturalism as a potential pedagogic force. Consequently, the post-1960s theoretical conflation of documentary with social 'objectification' was something she continually resisted, asserting that the photographic image was always a site of struggle over *who* defines the everyday. One of her early essays, which set out what was to become the political basis of her work in the 1980s, was entitled 'The Sign as a Site of Class Struggle'.[2] Owing much to Voloshinov's dialogic linguistic theory, it addressed the positivist crisis of conventional documentary practice through an analysis of Heartfield and the social relations of avant-garde practice of the 1920s and 1930s. Critical of both 'objectivist' approaches to documentary and contemporary deconstructive photography ('school' of Victor Burgin), she outlined the need for a photography that not only engaged with representation, but inserted itself into daily social practices. Out of this she wanted a photography of the 'everyday' that avoided both the sphere of the professional photojournalist and the museum and university.

In this, her reading of the post-war crisis of photography and the avant-garde is very different from Wall's. She does not see the disjunction between a critical photography of

the 'everyday' and the workers' movement as something that can only be addressed in theory as a matter of aesthetics, but as a series of obstacles that can be confronted in practical ways as part of a wider educational programme about capitalism and culture *within* the working class. Hence she always referred to herself, albeit with a certain amount of false modesty, as an 'educational photographer' rather than an artist, insisting that what she did was to provide an example for the empowerment of others. This is a crucial distinction between her work and most other critical photographic practice in the 1980s involved in the reinvention of the factographic. Although Wall insists on the democratic access at the heart of his photography, the spectacularised form and obvious expensive cast of his work do not make his work an easily imitated model. In fact, it could be said, in an ironic reversal of his claims, that his back-lit transparancies, like the film-form they mimic, induce an overwhelming sense of powerlessness in front of the image: for example, his mural scale *Dead Troops Talk* (1991–92), which involved the building of a stage set and the hiring of Hollywood make-up artists, and cost in the region of $250,000![3]

In these terms Spence's photography always saw itself as involved in a pedagogic exchange with its audience, in an attempt, in Benjamin's famous formulation, to create a set of critical skills that could be taken up and adapted easily by the spectator. However, this does not make her work indefatigably more virtuous than any other, or more 'politically effective' (these are always the voluntarist fantasies of cultural vanguardism), but rather it reveals the extent to which a critical photography of the 'everyday' needs to take seriously the distinction between audience and public if it is to be true to its own commitments. From the beginning of her career in the early 1980s Spence was concerned, first and foremost, to create a critical public for her work that would provide an active source of engagement for her interests. Her photography sought to intervene ideologically into areas of daily social practice with which a non-specialist public could openly identify.

After studying at the Polytechnic of Central London with Victor Burgin, in the early 1980s Spence began a series of collaborations with Terry Dennett on the ideology of the family album. This engagement with an ostensibly amateur tradition of photography offered her a rich source of connection between daily social practice and a critical photography of the 'everyday'. Everyone has a family album, or has been in one, most people take snapshots at some time in their lives. Yet the conventions upon which everyday snapshot photography is based have become naturalised, a set of unconscious structured aesthetic decisions about what is 'pleasing' and 'tasteful'. As Pierre Bourdieu argued in his writing on the amateur photography tradition in the 1960s, popular photography is a 'dominated aesthetic'.[4] That is, questions of aesthetics and imagination are rigorously subject to notions of function. Thus, in contrast to professionalised accounts of representation, popular photography does not see itself as signifying itself, but always, to quote Bourdieu, 'as a sign of something that it is not'.[5] The value of the picture lies in the legibility of its intentions. A good wedding photograph is the one that gets all the guests in the available space, at the same time showing everyone in a favourable light. This is not to say that aesthetic judgements do not come into play here, but they are grounded in the 'expressive adequacy of the signifier to the signified'.[6] Bourdieu sees this functionalism as having a particular class-composition. Traditional working-class valuation of empirically derived skills over theoretically sponsored knowledge is reflected in popular photography's search for a stable, natural set of

aesthetic guidelines. Such objective principles are the only things that guarantee shared meaning. The 'meaningless object' or signifier, then, is the object or image that disregards the social impulse of explicit function in the name of a specialised or esoteric process of signification. Such a process disrupts shared meaning for the sake of aesthetic self-assertion, producing what is seen as a conscious form of class exclusion. Hence the widespread antagonism or indifference on the part of the working class this century to modern art because of its radical refusal of demonstrable function. From this, Bourdieu argues that popular photography takes its values from sources other than aesthetics. Popular photography's functionalism rests on the powerful ideological role of photography as a social practice. Above all else, photography is a system of 'seeing' – a set of genres – which promotes ideological cohesion and stability. This process is focused principally through the family and its rituals, although not exclusively. However, the recording of family life is what mainly dominates working-class use of photography.

Popular photography defines itself through an overt identification of 'pleasure' and 'value' with familial and class inclusion. From this, popular photography for Bourdieu is closer to a 'ritual of solemnization and consecration of the group and the world'[7] than a source of aesthetic discrimination. Thus it is no wonder that it has been at the bottom of the list of legitimate visual practices in contemporary culture. Popular photography is so ideologically codified and stratified, it is argued, that it is impossible to bring it under disruptive ideological influence. The ideologies of the family, of aesthetic positivism, of photography-as-pastime, are so powerful that no bridges can be made from this into the critical world of photographic theory.

To accept this is to assume that ideologies are inert and static, and therefore not subject to internal conflict and crisis. However, as social relations change – as the ideal of the nuclear family becomes more of an anachronism, for example – what once seemed to fit ideologically begins to appear less and less plausible. This naturally is an uneven process, yet what it reveals is that to work on the meanings of the 'dominated' is to participate in a critical process that can have determinate effects on the way the world is perceived. When there is a conjunction between the critique of an ideology and the social crisis of that ideology (the critique contributing to that crisis), then transformations in social practices, such as popular photography, begin to occur. This was Spence's insight, derived largely from the workers' photography tradition of the 1930s, as she set out in the early 1980s to 'reframe' the conventions of the family album.

For Spence, as for Bourdieu, popular photography's production of a 'festive aesthetic' dissolves photography's powers of 'corrosion':[8] its capacity to arrest, disrupt and invert. Emphasising the need for a counter-photography of the family, Spence's work set out to challenge the boundaries of the 'everyday' on which popular photography based its ideological self-image. What does popular photography *leave out* of its consensual construction of family and class? Why are there not any photographs in family albums of the effects of family conflict, of emotional crisis and disappointment? Why are family albums so relentlessly comforting and optimistic? Why do the narratives they construct filter out so much of the lives of those whom they depict? These are simple, almost banal questions, but they uncover a whole area of symbolic life that had hitherto been barely addressed. Popular photography has been invariably dismissed or ignored as bad photography, and not as a complex site of ideological negotiation between family, class, gender and the social world. In fact, to recognise this is to begin to touch on the real historical consequences of the defeat of a popular factography, and therefore to realise

Fig 89 *Alternative Family Album* (photograph of Spence's brother's family), Jo Spence, 1982 (Courtesy of Terry Dennett and the Jo Spence Archive)

how much the extensive increase in popular use of representational technologies after the Second World War has been shaped by the powerful counter-ideology that access to technology is in itself a democratising process.

By this token, deconstructing the family album involves a double-move for Spence: the dismantling of prevailing cultural hierarchies about what has aesthetic significance, and the insertion of a conscious, critical agency into the representation of family life. This of necessity involved her working with families and their histories – in one case her brother, who was going through a divorce. However, this was not as a kind of photographic 'social worker', but as someone who suggested certain options and challenges. Naturally this process had to be reciprocated. For it to work as a collaboration, participants had to be willing to engage with questions of sexuality, family power-relations, love and hate in ways that directly affected their identity. Working with what is disavowed or forgotten, Spence's aim was to produce a *counter*-memory of the 'everyday'. One of the consequences of the conventional family album is to lock the past and its subjectivities into certain typifying narratives. Our memory of what 'we were like' and what others 'were like' is very much cushioned and protected by these narratives. The ideological force of family photography is always determined at a powerful level by the suppression of those memories that resist the consecration of family life, those memories that dissent from the mute, symbolic resolutions of family album genres. In these terms, to reinvent the dominant genres of the family album is to reinvent the family subject's relationship to their own history and therefore to the conditions under which knowledge of the self is produced. To intervene consciously into the process of family documentation means judging why certain actions and their outcomes should or should not be seen. The 'unthinkable/unspeakable/unknowable'[9] are made visible.

Spence's early work derives from the repressive/expressive model of the factographic

tradition. Bourgeois culture works to promote certain blindnesses about the real conditions of people's lives; socialist culture works to unveil these. By the late 1970s this model of critical recovery was undergoing a de-proletarianisation under the impact of feminism. If the early factographic movement talked about the suppression of the representation of everyday working-class life in bourgeois culture, the women's movement of the mid to late 1970s talked about how both bourgeois culture *and* factography or left documentary suppressed the realities of women's lives and the gendered nature of representation. Spence, though, did not take the route many women photographers committed to feminism and psychoanalysis took at the time: the staged deconstruction of 'masculinity' and 'femininity'. She wanted to retain the factographic link between photographic naturalism and a dialogical approach to the everyday. As such, she wanted to locate the insights of feminism and psychoanalysis within a form that maintained a class analysis of culture. Thus by 'reframing' the categories of the family album she sought to open up a practical connection between critical theory and those categories of the visual through which photography is judged and experienced by most people. The everyday uses of photography are connected to the undisclosed theoretical categories that underwrite them. In this, the pedagogic impulse of Spence's work is determined by the desire to include the spectator through a recognition of a shared experience: something that is obviously not particular to such work, but that is *encouraged* by the form of the family album.

There is much in Spence's dialogic approach to the critique of positivism that connects to debates on knowledge and representation in the 1980s, in particular the work of Greg Ulmer. Although Ulmer is concerned with new forms of academic address in higher education, his interest in teaching practices that promote communication between expert and popular thinking has much in common with Spence's rewriting of factography. In *Teletheory: Grammatology in the Age of Video* (1989),[10] Ulmer argues for the need to organise information through images and text in such a way that learning is not based on an initiation into a specialist discourse, but through shared points of entry via popular culture. He stresses the need to perform theoretical categories through the use of various rhetorics, such as wit, the joke and irony. In doing this, the everyday experience of the student can be employed as the *scene* of theoretical analysis. The communication of theoretical mastery is exchanged for a dialogic interaction between specialised discourses, popular culture and individual biography, allowing the life-story of the student to become a vehicle for theoretical research. Ulmer calls this 'mystory': a form of discourse that replaces the process of critical distance involved in theoretical learning, with a mode of learning and 'representing knowledge that is not organised in terms of an object presented to a subject positioned as the observer of a spectacle'.[11] In essence, as Ulmer says, such approaches address fundamental questions over how *knowing* is to be translated into *telling* in our 'post-literate' culture.

Although general levels of literacy have risen in the West since the 1960s, there is now an increasing gap between the theoretical skills and competences of the educated and the basic literacy skills of those who have not been through higher education. The problems of doing theory, as culture is subject to an increasing theoretical self-consciousness, have made the representation of knowledge a pressing issue. Ulmer's concern is how induction into a specialism might be translated into the *popularisation of research*.

In mystory, as an academic discourse, a disciplinary discourse is mapped out

Fig 90 *Alternative Family Album* (photograph of Spence's brother), Jo Spence, 1982 (Courtesy of Terry Dennett and the Jo Spence Archive)

onto the personal and popular registers in the associational mode of mnemotechniques, not for memorization, but to bring the dimensions of experience, imagination, and phantasy to bear on problem solving and disciplinary discovery, as recommended in prototype theories of concept formation.[12]

The *popularisation of research* is at the heart of Spence's photography. Thus it has been crucial that her deconstruction of the positivism of popular photography has been based on her own experience. Specifically, from 'Beyond the Family Album' onwards Spence began to include herself as the object of scrutiny and 'disciplinary discovery' of her photographs. For the photographer to place himself or herself into the picture is to immediately invert the place where truth supposedly resides. Instead of the image serving as the *object* of study, it becomes a shared process of understanding between the photographer/subject and spectator/subject, a process of transference between photographer and spectator in which what is being theorised is seen to be lived out on the part of the photographer. In Bourdieu's words, for those who distrust the mastery of the expert and the 'objectifying' theorist, this sense of inclusion is not to be underestimated in terms of its capacity to empower. However, if in the period of 'Beyond the Family Album' there was a theoretical commitment, so to speak, to break with 'objectivist' deconstructionist modes, in 1982 the voice of the photographer as subject became an emotional and political necessity.

In 1982 Spence was informed that she had contracted breast cancer. The trauma of the discovery forced her to address her own medical history – and abuse of her body – and as a result increased the political importance for herself of her own presence in the image. As she said in an interview with Jan Zita Grover in 1992: 'I thought immediately about how to be useful, how to turn my illness into something useful.'[13] That she also admitted that she committed another kind of abuse to her body in the process, however, does not alter the fact that she had reached a certain psychic and political threshold, in

which her own body, and what ill health and the medical profession had done to it, became the painfully raw material for photographic research into the everyday.

> During my recovery from breast cancer, I began to use the camera to explore connections I had never been anywhere near before – connections between myself, my identity, the body, history and memory. I'd never actually inhabited history before, and I was beginning to inhabit my own history and hidden parts of myself.[14]

To deal with the representation of her own cancer was to *become* the documentary object, and as such to feel the full weight of how such an illness has been invisible to everyday consciousness. Suddenly the issue of 'making visible', and extending the categories of the family album, became a highly emotive issue of self-description; theory was now grounded *in* the autobiographical. With this, Spence began to realise at first hand the distressing absence of any non-pathological images of the disease within the culture. Although cancer is a common part of many families' lives – particularly working-class families – the photographic representation of the effects and treatment of the disease are practically invisible, or subject to an institution-centred view of the patient as suffering victim. Spence set about contesting this as she underwent her treatment. Inevitably this was a difficult and hesitant process as she struggled to resist the infantilised position she was forced into in the hospital. Yet at the same time she could not reveal too much diagnostic interest in her own condition for fear of drawing critical attention to her use of a camera in the ward. She therefore had to evolve elaborate 'strategies for getting permission to take photographs'.[15] Like Hine's attempts at getting inside factories, she adopted various ruses and subterfuges.

This seemingly innocuous event – the taking of pictures inside a hospital – had profound implications for her future practice, and has had profound implications for contemporary debates on photography and the everyday. For it showed in stark ideological outline how powerful institutional boundaries are in denoting what is seen to be permissible *as* the 'everyday' and what is not. The voice of the expert, professionalised medical ethics, the view of the patient as observed supplicant, all made it impossible for Spence to openly confront the power-relations involved in the treatment of cancer. Patient welfare was not something that patients should worry themselves about.

What increasingly concerns Spence at this juncture, then, is the *under-narrativisation* of certain experiences in the culture from the perspective of those who undergo them. As Spence outlined in an interview with Ros Coward in the late 1980s: 'There are no images for what I want to say. I can't go to anything which already exists and either deconstruct and then reconstruct it, neither can I create images out of my imagination because they don't exist in the culture.'[16] Thus in an important sense Spence was confronted by the realities of her own repressive/expressive model of photography: she had to produce these missing images out of the pain of her *own* experience. Consequently, as I explained, we need to see this as a matter of necessity and not intellectual expediency or an act of bravery. Out of this counter-representational work on cancer Spence re-positions the voice of the photographic subject as a voice in its own right.

> I have photographed my operation from the patient's viewpoint, on my back, but done it in the style of a doctor/nurse photo-romance in order to make a rift in our perception of what we experience (but can't talk about), and previous

ideologies which we carry with us about the doctor as a romantic hero.[17]

Essentially, this process of self-inclusion involved a radical transformation of her self-identity as a woman and a cultural producer. Her own experience of her damaged body became an 'asset'.[18] She discovered that by using her own body without constraints, she could tell the stories she wanted to tell about her own history and communicate these to other people who had been through similar kinds of experiences. In these terms this kind of self-representation leaps over the separation of subject and object in conventional documentary, to assert the possibility of the subject taking some control over their self-image.

From the mid-1980s Spence began to explore this self-representational approach more thoroughly. Addressing herself to the particular conventions of portraiture, she developed her critique of the family album and the possibility of a photography of empowerment into the more general position of a critical photography of the self. Drawing more explicitly on the categories of psychoanalysis, she began to see empowerment through photography in terms of the potential psychotherapeutic encounter between the photographer and his or her subject – whether that subject is the photographer himself or herself or another person. Although others had recognised the value of phototherapy in psychotherapy before Spence, it was Spence and her early collaborator Rosy Martin who took the debate forward to produce an explicit interchange between photography and therapy. From this Spence advanced arguments about the need for a new kind of portraiture: a portraiture that was the result of an extensive intellectual and psychological collaboration with the subject; a portraiture that takes the representation of the self into the area of *active* self-dramatisation.

One of the fundamental problems of the photographic enterprise has been the question of how it is possible for photography to represent states of consciousness. In the nineteenth century it was commonplace to assume that 'interior states' could be read off from physiognomy; and this psychological 'primitivism' is still stock-in-trade for much of the high-street profession and amateur tradition. The face expresses the 'inner being'; and the good photographer is recognised, therefore, by his or her ability to produce the subjective essence of the subject. Spence rejects the whole theoretical armoury of this expressive approach by insisting that the representation of the self can only ever be a frozen moment in a non-linear continuity. The development of the techniques of phototherapy, then, is an open recognition of the obvious cognitive limits of portraiture, yet at the same time an attempt to use portraiture as a means to work through the relationship between images and personal identity. Instead of the highly codified and idealised moment of self-presentation in conventional portraiture, phototherapy involves the subject and photographer (or photographer as subject) in an extended process of self-questioning. To adopt such an approach is to 'get inside' the self-image of the subject, and its powerfully embedded histories. In an article written in 1985 Spence and Martin refer to this as a process of 'reframing', in which the subject is asked to examine aspects of their behaviour from old photographs of a personal nature.[19] These become cues to the acting out of the fears, traumas and desires that link the subject's present state of self-consciousness to their forgotten or disavowed past. In the language of psychotherapy, phototherapy operates as a permission-giving exercise in which the subject tries to find an external symbolic form for their emotions through acting out their fears, traumas and desires. For this permission-giving to work, the subject has to feel that they are in a supportive situation, in which no form of identity-projection is considered to be

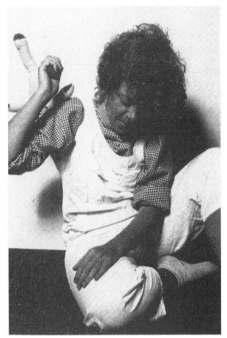
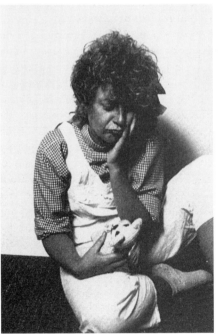
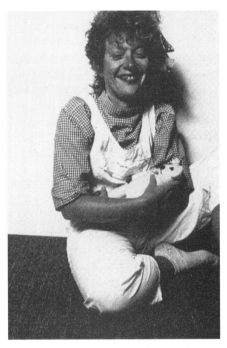

Fig 91 *Phototherapy*, Jo Spence / Rosy Martin, 1984 (Courtesy of Terry Dennett and the Jo Spence Archive)

impermissible. Once this security is established, the subject is able to take his or her first step towards unblocking their relationship to the present and the past. As such the photographs that the subject takes into the session establish a connative chain of memories that the subject works through.

> We believe that each of us has sets of personalized archetypal images 'in memory', images which have been produced through various photo practices – the 'school photo' used by Jo as her starting point is one example, the family album snapshot used by Rosy is another. Such photos are surrounded by vast chains of connotations and buried memories. We need to dredge them up, reconstruct them, even reinvent them, so that they work in *our* interests, rather than remaining the mythologies of others as photographic archetypes.[20]

Initially Spence and Martin worked with each other. For Spence this created a sympathetic space for an extension of her work on cancer, how she actually felt about her experience. The early phototherapy sessions were for her a 'way of having a strengthening and informative dialogue with myself about my own ability to survive such an ordeal'.[21] This eventually took her into work on her memories about her health as a child, which in turn involved her addressing feelings of rejection and of being unloved. Such negative self-images became the basis for her 'school photo' series, in which Spence presents herself as a fearful, hunched child and self-conscious schoolgirl.

In later work Spence was to collaborate with others, either in the role of subject or as 'therapist'. However, at no point during this period of work did Spence step over into the arena of professionalised phototherapy. She only worked with people who were already in therapy or counselling, as she did not consider herself adequately trained to deal with people who had no experience of counselling; in fact, a number of her subjects were therapists themselves. This reveals how much of her work on phototherapy was dictated by the discourses of photography and not medicine. Principally, Spence's involvement with phototherapy was an attempt to open up the critique of the family album by extending what we take to be the representation of the self. For Spence, the props and dramatics of the therapeutic encounter allow the subject to *redefine* or *rewrite* the family album that he or she 'carries' around in their head, at the same time as contributing to the possibility of another kind of album. In redefining images from the past, the subject is in a position to tell different kinds of stories about his or her family; the past as a space that is flattened by nostalgia is opened up to its hidden aporias and contradictions, aporias and contradictions which continue their subterranean effects in the present.

For Spence, one of the key areas of this psychic dredging, and what was to become one of the dominant concerns of her work before she died, was the issue of class. The early phototherapy work on health established the connection between her medical history and her own working-class history. This link became the basis for an increasing amount of work on the *subjectivities* of class, how individuals *think* class. However, dealing with class subjectivities as part of the permission-giving process of therapy was made problematic for Spence through the absence of any available images of class subjectivity that she could call on from her past. How did her mother feel as a mother, suffering bad health herself, bringing up Jo? As Spence said of this problem in 1991:

> There isn't any new language about class, so when I work on being my mother as a working-class woman for instance, I'm stuck with a range of stereotypes

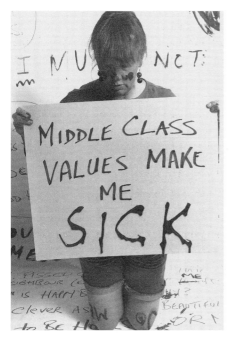

Fig 92 *Class Shame Series: Middle class values make me sick*, Jo Spence (Courtesy of Terry Dennett and the Jo Spence Archive)

Fig 93 *Class Shame Series: If I don't need to please … ,* Jo Spence (Courtesy of Terry Dennett and the Jo Spence Archive)

in which to speak about her visually. I then need to disrupt or de-naturalize the stereotypes, putting other images with them, transforming them.[22]

Spence called this ongoing project 'Class Shame', not in order to disavow her own class experience, but to actually re-ground it in the conflicts that produce and reproduce its effects. In this, Spence has been one of the few photographers to produce images of class-consciousness outside the would-be objective depictions of class-relations (conditions of employment, struggles at the workplace, intra-class conflict etc.). Working out of a recognition of the space of consciousness as a divided space, she set out to produce images that addressed the experience of class-*colonisation*, how she was born into a class and socialised through it, and how she left it (as a photographer/intellectual), and yet retained a memory of it, and a political commitment to its collective interests. If this is a familiar literary theme (the exit from the working class, and eventual reconciliation with it), it hitherto has not been something that photography has confronted. In these terms Spence asks a number of substantive questions about the representation of working-class subjectivities. How might photography represent class anger and its attendant sense of loss? How might the realities and memory of states of class-consciousness find their way *into* the image? Spence's solution, inevitably, was a non-mimetic one: she used text. In a series of works she produced just before she died in 1992, Spence scrawled various class-conscious slogans onto cards, which she held up to the camera during the phototherapy session. 'Middle class values make me sick.' 'If I don't need to please my parents any more, why the fuck should I worry about pleasing you middle class bastards?'[23]

To see this as the *mere* externalisation of class anger in textual form is to immediately see the series as a pictorial failure. However, in the work's rejection of expressive bodily

Fig 94 *Class Shame Series: Hate R.I.P off ...* ,
Jo Spence (Courtesy of Terry Dennett and the
Jo Spence Archive)

Fig 95 *Class Shame Series: I hate ...* , Jo Spence
(Courtesy of Terry Dennett and the Jo Spence
Archive)

form for the representation of such states of consciousness, Spence confronts the
limitations of a photography of consciousness. The only other possible solution to the
problem would be to *symbolise* such states (perhaps through the use of props). But this
would have traduced the emotive content of the slogans and Spence's actual desire to
proletarianise her voice in the image. In this anti-aestheticism there is a direct route back
to factography and Soviet productivism, a dislike of symbolic mediation and a respect for
the necessary textual support of the image as the basis for grounding the content of the
photograph. Yet to say that this work provides a new model for the 'representation of
consciousness' would be very misleading. The use of text cannot solve all
representational problems. But what the work does achieve is a kind of 'cognitive
realism' through the failure of photography to pictorialise consciousness. The refusal on
Spence's part to transform her 'class shame' into consumable images of a 'divided
consciousness' – and therefore consumable images of pity – provides a biting lesson in
realities of class politics. These images offer nothing but their own textual negation.

 With the increasing penetration of psychoanalysis into the production of
photography in the 1980s, the representation of the subjective voice has been widely seen
as a resolution to the would-be crisis of documentary practice. The return to the studio
amongst avant-garde photographers was an attempt to restructure the categories of the
'real' and the 'everyday' from within the subjective experience of socialisation. For this
new generation of photographers who were working not just with the categories of
psychoanalysis, but *under* its rubrics, the naturalistic photography merely *fixed* the
subject in its social setting. As I explained in Chapter 8, the divisions of social reality were
seen as representationally divorced from psychic reality. The aim of much of the new
photography, then, was bound up with displacing the older identification between the

'real' and the representation of individuals in their naturalistic social settings. The 'real' was taken to be not just what exists in a given physical space, but what exists in 'psychical space', those gendered processes through which the subject judges and desires. Essentially what was sought was a photography that could visually inflect the mismatch between the subject and the social world: that is, a photography that, in recognising the subject as divided and split, also recognises how the subject is, on an ontological level, in continual *conflict* with the 'everyday'. In this psychoanalysis is concerned crucially with the *failure* of the subject to adapt to reality; it studies how the socialisation of the subject continually breaks down. These developments in photography take on a particular political identity under the post-structuralist rereading of psychoanalysis. The failure of the subject to adjust to ideology becomes a means of justifying the essential openness of the social itself; the splitting of the subject always overrides the construction of a stable identity. As such, the construction of class-consciousness continually breaks down under the refusal of the working-class subject to be *named* as the exploited or oppressed.

Spence's use of psychoanalysis rejects this view. Her move to the studio and the production of a 'psychic realism' of the 'everyday' certainly recognises the emancipatory force of the subject's failure to adapt to reality, but at the same time she takes the material realities of her class background as something that inescapably names her as a class subject. In these terms we are meant to read her unfixing of the representation of class from the traditional concerns of documentary, from a particular political position. Her dredging up of her own internal class conflicts is not about the impossibility of the 'objective' class image, but about the need for photography to also speak *through* the experience of class in order to give social agency to class experience. This is where the phototherapy, the alternative family album and the factographic impulse to 'make visible' coalesce as a political project. In bringing the subject out of its fixed (though not mute) place in the naturalistic photograph, it is able to tell its own story.

We need to be clear, then, about the status of the staged image in Spence's practice. The staged image allowed her directly to include the speaking subject, and was not about privileging the studio as site of cognitive and aesthetic control. Thus, if her photography moved increasingly into this area in the mid-1980s under the demands of phototherapy, this did not weaken her commitment to the 'naturalistic moment' as part of a critical photography of the everyday. In fact it is her dialogic understanding of photographic naturalism that sets her apart from many of the other photographers who moved into the studio in the 1980s armed with psychoanalysis. As she said, naturalistic images offer an effective means of grounding discussion of shared experiences.

> You can't deconstruct something until you've already seen it and it has a currency. There are some experiences that have never been given credibility because they are continually suppressed in the image-making process. So the making of images that engage with these things at a naturalistic level could be quite useful.[24]

Throughout her work she was conscious of the importance of using the naturalistic image as a source of knowledge about the repressed and marginalised. Towards the end of her working life, though, her use of the naturalistic image took on a more extended theoretical profile in another collaboration with Terry Dennett on documentary as reporting the 'scene of the crime'.[25]

In this work with Dennett there is an explicit attempt to theorise the naturalistic

Fig 96 *Scenes of the Crime*, Jo Spence / Terry Dennett (Courtesy of Terry Dennett and the Jo Spence Archive)

image as the basis of a counter-memory of the 'everyday'. As such, the naturalistic image is re-connected to its key counter-archival role within the avant-garde. Juxtaposing images Dennett took on the streets of London in the late 1980s – a derelict doctor's surgery bordered up with corrugated iron, a homeless person camped out under a huge golfing-style umbrella – with images from Spence's cancer project. 'Scenes of the Crime' brings together the 'social' and the 'psychic' to produce a forensic and accusatory view of the historical moment. The pedagogic simplicity of the formula is deceptive, because it shows how much a naturalistic counter-archive of the everyday can accumulate a profound sense of critical interruption in normal, historical time. As Dennett says in connection with his own work, photographs of the ephemeral materials, objects and events of everyday life constitute a vivid counter-archive because of the way such photographs are able to retain an intimate, indexical relationship to the world.

> Photographic images made outside of the sanction of officialdom and of events censored from the press ... show things, so ordinary and everyday or so unique, that no one else has recorded ... Such material if it can be made to survive will give those who follow us the possibility of seeing other images, and hearing other voices than those of governments and 'official' artists of our day.[26]

This defence of an archive-from-below is not a naive recall of documentary to its classical petitioning or appelative role, but a recognition of the continuing power of photography to connect us to historical realities. The naturalistic image for Spence and Dennett, then,

Plate 1 *The Blues* (detail), Mitra Tabrizian / Andy Golding, 1986–87 (Courtesy of Mitra Tabrizian and Andy Golding)

Plate 2 *Untitled* (no. 161), Cindy Sherman, 1986 (Courtesy of Cindy Sherman and Metro Pictures)

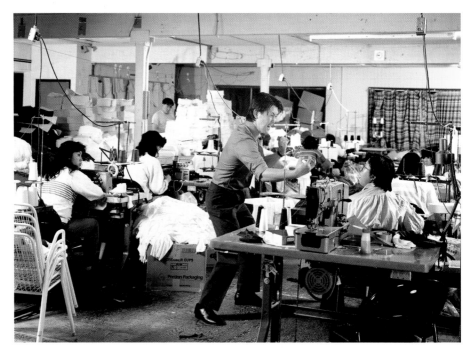

Plate 3 *Outburst*, Jeff Wall, 1989 (Courtesy of Jeff Wall)

Plate 4 *Mimic*, Jeff Wall, 1982 (Courtesy of Jeff Wall)

Plate 5 *Eviction Struggle*, Jeff Wall, 1988 (Courtesy of Jeff Wall)

Plate 6 *The Storyteller*, Jeff Wall, 1986 (Courtesy of Jeff Wall)

Plate 7 *The Stumbling Block*, Jeff Wall, 1991 (Courtesy of Jeff Wall)

Plate 8 *Coastal Motifs*, Jeff Wall, 1989 (Courtesy of Jeff Wall)

Plate 9 *Diatribe*, Jeff Wall, 1985 (Courtesy of Jeff Wall)

Plate 10 *Spence as a Girl*, Jo Spence, 1984 (Courtesy of Terry Dennett and the Jo Spence Archive)

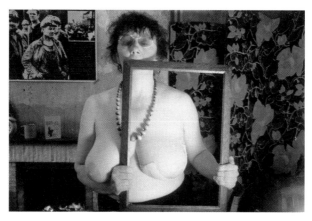

Plate 11 *The Cancer Project: Framing my Breast for Posterity the Night Before Going into Hospital,* Jo Spence / Terry Dennett, 1982 (Courtesy of Terry Dennett and the Jo Spence Archive)

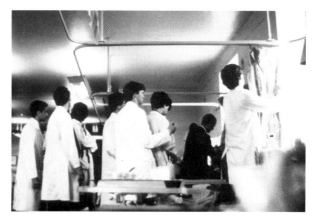

Plate 12 *Hospital Interior,* Jo Spence, n.d. (Courtesy of Terry Dennett and the Jo Spence Archive)

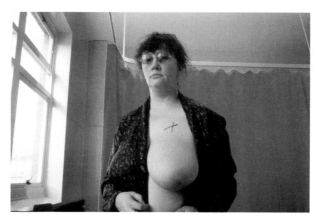

Plate 13 *The Cancer Project: Remodelling Medical History: Marked up for Amputation, Nottingham 1982,* Jo Spence / Terry Dennett, 1984–89 (Courtesy of Terry Dennett and the Jo Spence Archive)

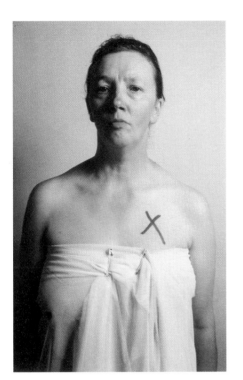

Plate 14 *The Cancer Project: Remodelling Medical History: Restaging the Drama of Going into Hospital and Being Infantilised*, Jo Spence / Terry Dennett, 1984–89 (Courtesy of Terry Dennett and the Jo Spence Archive)

Plate 15 *The Cancer Project: Remodelling Medical History: The Doll Series*, Jo Spence / Terry Dennett, 1984–89 (Courtesy of Terry Dennett and the Jo Spence Archive)

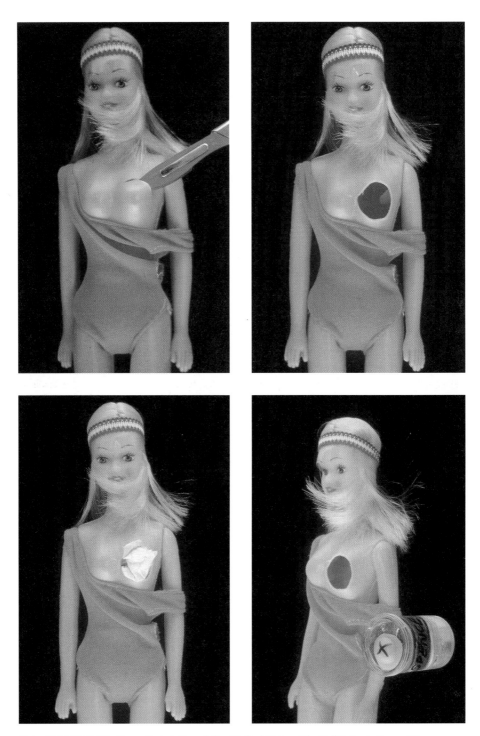

Plates 16,17,18,19 *The Cancer Project: Remodelling Medical History: The Doll Series*, Jo Spence / Terry Dennett, 1984–89 (Courtesy of Terry Dennett and the Jo Spence Archive)

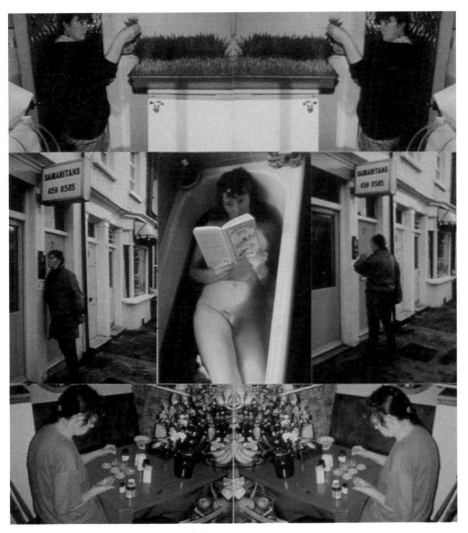

Plate 20 *The Cancer Project: Remodelling Medical History: The Doll Series*, Jo Spence / Terry Dennett, 1984–89 (Courtesy of Terry Dennett and the Jo Spence Archive)

Plate 21 *Heaven's Gate*, Jeffrey Shaw, 1987 (Courtesy of Jeffrey Shaw)

only has a notional relationship to 'now-time'. What is of greater significance is its syntagmatic function as a historical resource, a set of images that can be used and re-used in second-order ways; a Vertovian use of 'facts' rather than a Bergerian one. Hence, documentary photography may have lost its appellative function, but this does not mean that naturalistic photography does not contain a suppressed dialogic content which can serve as a source of knowledge 'from below'. The naturalistic photograph sequentialised in the form of an archive functions, then, as a historical *deposit* which can be discursively manipulated and re-animated. Yet this is not to academicise this process. For Spence and Dennett the taking and collating of photographs of the 'everyday' is a direct, existential response to their own experience of social and historical crisis. To build up an archive of images of the structured alienation of daily living is to take the idea of an alternative family album as the basis for a self-transformative practice. Thus, the production of a counter-archive stems not from what they call 'correct positionism' – the detached political impulse to document social contradictions – but from the desire to incorporate their 'lived experience in crisis management with diverse theories of the visual'.[27] The result is that the naturalistic photograph is *de*-positivised through the re-positioning of photography as a social practice. In producing a counter-archive of the 'everyday' (whether that is based on self-representation or the representation of others or of objects), the photographer necessarily enters into the lives and events of his or her times.

However, finally, what characterises the radicality of Spence's rewriting of the factographic tradition is the introduction of an abject or distressed self-representation into the space of the archive. Her extension of the repressive/expressive model of representation into a self-performative aesthetic represents a key moment in what became a fundamental transformation of photograph in the 1980s. But, as I explained in Chapter 9, this is not problem-free. On one level it signifies the impact of the women's movement on the reordering of the categories of the 'everyday' (the opening up of the 'everyday' to the particularities of female subjectivities), but on another level it signifies the increasing incorporation of photography – even would-be avant-garde practice – into the logics of the spectacle. Spence's radical commitment to what remains under-narrativised in our culture takes its place within these wider moves within the culture to confessional display as entertainment. Clearly Spence is not producing her own confessional 'psychic realism' solely out of an eroticised desire to be valued for what she has suffered, yet at the same time the work's realism is caught up in a logic of gruesome visibility not of its own making. Out of the crisis of conventional documentary, the demand for anti-positivistic practices has brought a photography of the self in line with the transgressive impulse that now dominates the new 'culture of uncertainty' of capitalism. As I have also argued, the boundaries of taste around the bodily image have shifted enormously in European and North American culture since the 1970s. The demands of popular culture for novelty and the transgressive have fed into a developing sense in art that certain 'stable' or naturalistic images of the body are unable to reflect what is perceived as the increasing violence and alienation in the world since the 1970s. Whether Spence's 'psychic realism' actively courts these moves or not, her incorporation of the grotesque and abject produces a familiar form of dramatic fascination with the incomplete and wretched.

Horror film is invariably based on the revelation of what is feared (death, decay, physical incompleteness), positioning us as the repulsed but captivated spectator. Spence's revelatory photography (herself as a disfigured cancer patient, photographs of herself on

Fig 97 *Jo Spence on a 'Good Day' Photographing her Visitors. Marie Curie Hospice, Hampstead, London, June 1992*, Terry Dennett, 1992 (Courtesy of Terry Dennett and the Jo Spence Archive)

her death bed, photographs of her lover on the toilet etc.) induces a similar fascination with what is considered to be unspeakable. However, I am not saying that Spence's work is the result of a fixation with the codes of horror fiction, but that capitalist culture needs to transform all areas of human experience into tangible, communicable experiences in the journalistic interests of 'truth', even those experiences that are the most extreme and painful. The recent spate of programmes on television which reconstruct violent incidents and misfortunes and the growth of a confessional home-video culture is an indication of this. To note this, though, is not to adopt a moralistic position on the narcissism of late capitalist culture (to *be* is to be *seen*). This kind of critique feeds too easily into an anti-representational politics, which marches hand in hand, when pushed, with the censorship lobby. Rather, the demands of the performative need to be assessed dialectically. The shift to forms of grotesque and abject self-display are as much about a defiance of the McDonaldisation of reality as they are a ratification of managerial narcissism. To echo Lefebvre, a critical practice of the everyday has in certain circumstances to pass through the process of *fetishisation* if the work is to succeed in demonstrating what it is negating. Spence, in effect, places herself at the disposal of a performative aesthetic, in order to re-present her damaged body for political identification rather than narcissistic self-affirmation. Whether or not we are prepared to accept this depends upon the judgement we make about her *relations of production* as a photographer. All Spence's work was produced out of an engagement with non-artworld audiences. Although she showed in galleries (as is necessary), her work was on the whole directed towards groups in education and sections of the labour movement that might benefit from exposure to the work (women's health groups, the medical profession, amateur photography groups, and adult education classes, women's photography groups, etc.). This makes the critical reception of her work very different from what it would have been if it was only destined for the walls of the MOMA in New York. It also makes Spence's extension of self-

representation into the space of the archive one of the most critically influential of photographic practices in the 1980s.

In Jeff Wall's and Jo Spence's work we see two very different approaches to the contemporary crisis of the self and the political crisis of photography. Yet both are united in a realist commitment to photography's powers of 'making visible'. The aesthetic strengths of their work attest to the continuing intellectual vitality of the avant-garde appropriation of the photographic archive. Such strengths, though, have hardly met with approval from the dominant post-structuralist culture which I have dwelt upon. In fact such strengths now face yet another attack, as the philosophical and political claims of realism are lined up for further shredding by the new computer technologies. In my final chapter, therefore, I want to look at the exponential rise of the new digital culture, and what is claimed to be the final nail in the coffin of realism.

Notes

1 John Roberts, 'Interview with Jo Spence', in *Selected Errors: Writings on Art and Politics 1981–90*, Pluto 1992, p. 154.
2 Jo Spence, 'The Sign as a Site of Class Struggle: Reflections on Works by John Heartfield', in Patricia Holland, Jo Spence and Simon Watney (eds), *Photography/Politics: Two*, Comedia 1986.
3 See *Jeff Wall: Dead Troops Talk*, Kunstmuseum Luzern 1993 (produced 1991–92).
4 Pierre Bourdieu, *Un Art Moyen*, Les Editions de Minuet 1965; English translation, *Photography: A Middle-brow Art*, Polity 1990.
5 Bourdieu, *Photography*, p. 92.
6 *Ibid.*
7 *Ibid.*, p. 94.
8 *Ibid.*, p. 76.
9 Jo Spence and Terry Dennett, 'Remodelling Photo History 1981 to 1982', in Jo Spence, *Putting Myself in the Picture: A Political, Personal and Photographic Autobiography*, Camden Press 1986, p. 121.
10 Greg Ulmer, *Teletheory: Grammatology in the Age of Video*, Routledge 1989.
11 *Ibid.*, p. 85.
12 *Ibid.*, p. 196.
13 Jan Zita Grover, 'The Artist and Illness: An Interview with Jo Spence', *Artpaper* 11:5 (1992), p. 12.
14 *Ibid.*
15 'Body Talk? A Dialogue Between Ros Coward and Jo Spence', in Holland *et al.* (eds), *Photography/Politics: Two*, p. 6.
16 *Ibid.*, p. 36.
17 *Ibid.*, p. 38.
18 *Ibid.*, p. 36.
19 Rosy Martin and Jo Spence, 'New Portraits For Old: The Use of the Camera in Therapy', *Feminist Review* 19 (1985).
20 *Ibid.*, p. 67.
21 *Ibid.*, p. 73.
22 Jo Spence, 'Cultural Sniper', *Ten: 8* 11:1 (1991), p. 9.
23 See John Roberts, *Renegotiations: Class, Modernity and Photography*, Norwich Gallery, Norfolk Institute of Art and Design, 1993.
24 Roberts, 'Interview with Jo Spence', p. 141.
25 Terry Dennett and Jo Spence, 'The Crisis Project: Scenes of the Crime', in *Real Lives*, Museet for Fotokunst, Odense 1992.
26 Terry Dennett, 'Virtual Reality', in Roberts, *Renegotiations*, p. 25.
27 Dennett and Spence, 'The Crisis Project', p. 49.

12

Digital imagery and the critique of realism

As the tentacles of the market and the effects of an 'older' modernity stretch to all corners of the earth, the prospect of a new order of cultural modernity is unfolding: the electronic creation and manipulation of artificial worlds. We have been aware of the theoretical possibilities of this from the late 1950s. Today, though, we can actually *visualise* it as computer-produced imagery gives form to the science of artifical intelligence. Much has been said about the potentially revolutionary nature of the new technologies, in particular the 'world-switching' capabilities of virtual reality machines. The power of these machines to conjure up 3-D simulations of environments that the spectator enters and interacts with has generated an extensive 'new world' technical literature. However, as the most cursory glance at the history of technology shows, what advantages new forms of technology bring are always determined by the prevailing relations of production under which they emerge and are developed. As Raymond Williams once said, 'any new technology is a moment of choice',[1] a choice, we might add, that is heavily weighted in the favour of the accumulation of capital and the profit motive. The new computer-aided visual technologies cannot, then, be assumed in advance to be offering us access to an unprecedented world of freedom and pleasure.

There are three dominant, and largely opposed, conceptions of technology and modernity, this century and last: a romantic and dystopian one, as expressed in the writings of Heidegger, Weber and recently Foucault, Baudrillard and Paul Virilio; a futurist and utopian one, as in the followers of Saint-Simon and Marshall McLuhan; and a dialectical one, as in the writings of Marx, Benjamin and Williams. The first two positions have tended to dominate popular thinking on technology, reinforcing perceptions of technological advance as either a 'good thing' or 'bad thing', as if technological development were solely a matter of technical transformation, and not embedded in the conflict between the productive forces and relations of production. Uncontrolled technological development is extremely destructive for capitalism, creating dangerous instability in the labour process. The problem for capitalism is how to pursue technological innovation without unnecessary disruptions to the labour process and the

'smooth' sustained accumulation of capital. This is not an easy path. As David Harvey says: 'The remarkable thing under such circumstances is not that capitalist society is technologically dynamic, but that its dynamism has been so muted and controlled.'[2]

Nevertheless the view of technology as 'autonomous' is the one that sustains the popular imagination. This creates a powerful ideological bifurcation between the dystopian view of science and technology as being 'out of control' and a utopian faith in science and technology as the bearers of freedom and pleasure. The first position is now most associated with the ecology movement, spawning a variety of anti-technological manifestos and visions, be they from a nostalgic organicist position (sections of the Green Party for instance), or from a feminist anti-masculinist position (science is the alienated province of men). The end of the Cold War, though, has weakened the more apocalyptic variants of these views – which may have something to do with why there is so much enthusiasm for the utopian position at the moment. The interactive possibilities of the new technology, in particular the new computer-generated visual technologies, have become the bearers of all kinds of social and cultural ideals – despite the fact that (as with the whole history of visual technologies) most of the advanced research in the area continues to be funded by the military.[3]

What has occurred is the re-opening of the imaginative investment in the social uses of technology: a vision which has not been felt with such force since the 1960s. Consequently this is where a dialectical perspective on technology and science has its efficacy. For what the utopian view of the new technology encapsulates is how certain technological changes bring into view the possibility of humans' control over their environment and an extension of humans' well-being and creativity. These changes are obviously exaggerated by the utopianists, but they nevertheless reconnect the development of technology to its possible non-instrumental uses. The job of the dialectical theorist of technology, therefore, is to recognise this *without illusions*. Thus if culture itself is the development and struggle over technological relations *as* social relations, then Williams's 'moment of choice' (as with Marx and Benjamin) is always a projective one, irrespective of the powerful market forces weighted against the 'non-instrumental uses of technology'. Benjamin's position is undoubtedly one of the most instructive on this. Benjamin developed what might be called a 'double-coded' notion of technology, in which technological development was *both* the empty space of bourgeois-development-in-time, and the continually renewed projective possibility of the non-alienated use of technology.[4] Each important technological advance for Benjamin put this possibility on the historical agenda. And strikingly this is what all the contemporary discussion on the new communication technologies engenders. Prospects for cultural democracy, interactive communication, and the breakdown between art and science, are all back on the cultural agenda as part of the debate on the new technology. In the following I want to look at the weaknesses and strengths of this debate as it has come to shape contemporary discussions of photography and realism.

The growth of the literature on the new visual technologies and the 'end of photography' has been vast, particularly in the USA, where most of the technology has been developed. I plan to concentrate, however, on a cluster of early manifestations of the debate in Britain from the beginning of the 1990s – the exhibitions 'Photovideo', at the Photographers' Gallery (1991),[5] and 'Outer Space', at the Laing Gallery, Newcastle upon Tyne (1991),[6] and the 'Blue Skies' conference on art and technology also in Newcastle (1991).[7] These two shows and conference were the first serious attempts in Britain to

open up a public space for a discussion of the cultural impact of the new visual technologies. Moreover, they have come to represent an emergent orthodoxy on the new technology and photography: a combination of a utopian perspective with a *mélange* of post-structuralist politics and aesthetics.

'Photovideo', organised by Paul Wombell, stands out as the intellectual focus of these early manifestations. Seeking a kind of pedagogic role for itself in the manner of those popular exhibitions of the 1860s showing the newly wondrous delights of photography, 'Photovideo' presents the use of slow-scan video, bio-optics, computer image-making and animation by artists as forms of technical demonstrations. The aim was twofold: to show the increased distributive powers and powers of image-manipulation available to the artist from the new technology, and to propose that these resources represent a fundamental cultural transformation, in short the demise of chemically produced photographs. According to this perspective we are undergoing a qualitative *and* quantitative transformation in forms of visual reproduction that matches the superimposition of the new typography on an older chirographic and oral culture during the Renaissance – a process which radically transformed how knowledge was generated, systematised and stored.[8] Knowledge became a matter of formal analysis, being standardised through reproduction rather than as a result of rhetoric and disputation. The use of computers for image production, manipulation and storage presages, it is argued, a similar kind of qualitative transformation in the representation of knowledge and our knowledge of representation. As Paul Wombell and Steven Bode state in their introduction to the accompanying book to 'Photovideo', in a discussion of the new video-still camera (which converts light entering the lens into electric signals in order to be recorded on magnetic floppy disc):

> It is ... possible to output [the] signal as an image to be shown on a television screen or, using a suitable photocopier, produce 'hard copy'. Once it is stored electronically it is also possible to either edit or enhance that image in a number of different ways. Consequently, one can foresee the processing and printing of photographic images moving out of the darkroom and taking place by the light of the computer screen.[9]

This of course is more than a prediction. Images are now processed and manipulated *on* screen and transmitted instantaneously as part of a global communications network. Computers have completely changed the parameters of the production and distribution of the image. Taking Wombell's and Bode's argument further, the computer is now held to be at the *centre* of the debate on representation, disturbing not just those old assurances about photographic truth but the role of the photographer himself or herself. As with the scientists developing and exploring 3-D simulation and virtual reality, the power of the computer is seen as revolutionising the activity of the scientist and artist alike.

The central problem for computer scientists in the USA in the 1950s critical of the narrow way in which computers were perceived by the scientific community (as mere calculating machines) was how to develop them as 'intelligence amplifiers'. The challenge was to produce data in viewable real-time form that would allow the user to interact manually with the computer. For, whereas computers are far better than humans at storing large amounts of information and evaluating computations, humans are far better at pattern recognition, and planning and retrieving information in context. As one of the

pioneers in computer simulation, Fred Brooks, has said:

> [we gave] emphasis to rich manual interfaces with lots of joy sticks and sliders and knobs and manipulator arms and cueballs and things in which people directly manipulated objects in three dimensions without doing anything differently from what they would be doing with a *real* object as opposed to a *virtual* one.[10]

The possibility of building such machines, though, had to wait for the advances in microelectronics. Whereas the first valve computers could perform hundreds of operations per second, by the 1970s computers could perform millions per second. Today the successful illusionism of 3-D simulation is directly dependent on the speed of such computations.

At present, levels of 3-D computational power are still relatively low, although the development of the science of transputers – a system of computing devices that employ the parallel use of microcomputers to increase overall computing power – promises to increase this rapidly. Nevertheless, if the operational power of 3-D simulation machines is still fairly primitive, the third computer revolution is distinguished by the unprecedented ability of such machines to produce complex non-linear models of the world in human, sensible form. Since the 1970s a new process of scientific *visualisation* has been underway. This has meant that the domination of mathematics in science can no longer be seen as producing an irreconcilable split between scientific knowledge and visual apprehension. The contention that contemporary science is in retreat from the directly sensible is actually out of step with the abilities of the new computers. 'At one time scientific instruments such as the telescope and the microscope could have been considered a direct extension of the senses, but today the connection between experimental apparatus and human experience is becoming increasingly remote.'[11]

Such a view is in open contradiction with the 'learning through doing' of computer simulation. In the application of computers to molecular science, for example, it is now possible to produce multidimensional simulations of molecules that can be physically manipulated and 'docked'. As tools for making 'imperceptible phenomena visible',[12] the new-generation computers allow vision and touch to be a driving force in scientific analysis and modelling.

The new computers' power to render the invisible visible, their ability to simulate objects three-dimensionally, and their capacity to network such images instantaneously, are seen by those who take the cultural implications of the new technology very seriously as producing a dynamic materialisation of multiperspectival cognition. In fact the new visual technologies are judged as having given concrete and user-friendly form to the multiperspectival 'revolution in time and space' of the new physics that the early avant-garde could only gesture towards. The functional link between reality and the complex multiperspectival modelling of objects is now a practical possibility. As such one of the major concerns of the new technological literature is the notion of the *re-spatialisation* of cultural relations. The non-linear, non-syntagmatic spatial effects of the new computers have created a palpable view of culture as a set of interactive processes, rather than as discrete, externally related objects.

Accordingly the issue of re-spatialisation is viewed as a matter that relates to both the internal *and* external transformation of the identity of the photographic image and the artwork. Internal, insofar as the new computer techniques transform relations *within* the

image (extended forms of image-mixing, for instance), and between the spectator and artwork (the development of new interactive aesthetic resources through the use of virtual reality and 'hands-on' interface technology). External, insofar as the transmission of images through space, and the reality of an art without objects, creates the possibility of a truly portable and temporal-based culture of art – the science-fiction dream of the 1960s: the artwork as a communicable presence in many places simultaneously and therefore unbounded by physical place. Consequently, much of the new literature emphasises the fundamental 'unstable' or fluid nature of 'inside' and 'outside'. Thus what seems to have an explicit indexical relationship to an 'outside' – the photograph – becomes divorced from this relationship once it goes inside the computer to be manipulated, just as the 'outside' of the artwork (its physical boundaries) becomes impossible to map once it is distributed through a thousand computer terminals as an electronic signal to be manipulated by others.

Thus if there are dystopians, following the hypersimulationist theories of Baudrillard and Virilio, who talk egregiously about such changes drawing us deeper into the lures of ideology, there are others, less apocalyptically inclined, who see the opening up of such boundaries from a more progressive perspective. An art without walls through networking and intermedia experimentation allows artists and non-artists to engage in forms of co-production and information exchange that bypass both the mass media and the official artworld. Hence the view of the Net as the Great Communicator. Nevertheless, both positions tend to share a common perspective on the philosophy of representation. Both argue that a profound transformation of the culture is being put in train by computers, in which notions of 'truth to reality' are put to the test. Both are fundamentally sceptical of representation's referential relationship to the world, the former position on the grounds that in computer space there is always a convergence of identity between conceptual scheme and the real, and the latter on the grounds that the meaning of the artwork in electronic space is always in indeterminate process.

In these terms, 'Photovideo' embraces the concept of re-spatialisation very much as a critique of what is perceived as an 'older' and outmoded set of cultural arrangements: the claims of photographic realism, and the formal integrity of the individual aesthetic object. With the technological supercession of the chemically produced photograph, the dominant monocular pictorial tradition is *finally* and *incontestably* buried.

As one of the contributors to the *Photovideo* book, Fred Ritchin, argues, computer simulation and the instantaneous transmission of images produce a fundamental degradation of documentation. Now that naturalistic-looking images can be *made* rather than taken, belief in the photographic referent disappears.[13] 'The electronic image', to quote Karin E. Becker, 'eliminates the possibility of catching any changes that violate (the real) because the original images, the standard of "reality" is gone.'[14] Benjamin's well-known notion of the dispersal of the aura of the original artwork through mechanical reproduction has come back to haunt photography itself. The implications of this, of course, are ideological as well as philosophical: the increased possibility of censorship and media 'agenda setting' through extended powers of editorial control over images. In the 'Photovideo' exhibition we are given two vivid examples of this process: the removal of the black power salutes of American athletes on the winners' rostrum at the 1968 Olympic games, and the removal of the brave and lone student facing the tanks at Tiananmen Square. A news agency sympathetic to the Chinese regime could easily remove this evidence of resistance.

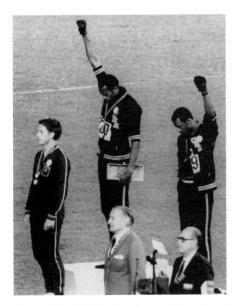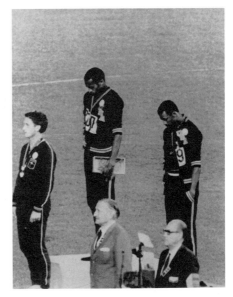

Fig 98 *Digitally Manipulated Image of US Athletes at the 1968 Mexico Olympics,* Manipulation by Paul Wombell, 1991 (Courtesy of Paul Wombell)

It would be foolish to underestimate the implications of these changes – with the attack on the media unions in the USA and Europe in the 1980s and 1990s and the growing monopolisation of the media on a global basis, the use of new technology has clearly shifted in the interests of management and conservative forces generally. (It is these forces that very much underlie the Baudrillard/Virilio view of computer simulation.) However, the cultural impact of these changes has been exaggerated, as if pre-digitally we were living in a golden age of photographic truth. One of the ironies of the debate on simulation and the chemical photograph is that all those who previously took documentary photography to task for believing in the 'truth-value' of the naturalistic image, now talk nostalgically about the disappearance of documentary's reportorial and archival role. This is a bit like those former socialist critics of Stalinism who now talk melancholically about the death of Stalinism as the death of socialism. In essence, what the new imaging techniques produce is not the death of the 'truth' of the photograph, but the cultural displacement of the indexicality of the photograph as an *automatic truth-effect*. The easily manipulable image, then, *relieves* the photograph of the burden of veracity, leaving the image open to a recognition of the relationship between the 'real' and its discursive construction. In consequence, the image will become a more direct focus of struggle over the political demands of interpretation, as is reflected in the widespread scepticism in the culture about the objectivity of the media. Moreover, there is no *cultural* guarantee that the degradation of documentary will actually translate into the marginalisation of the conventional naturalistic photograph. There is every good reason in a world of increasing media simulation to suppose that photographers and artists will look to the indexical resources of photography as a critical antidote to such effects, as I have asserted in this book.

The residual strengths of the monocular tradition can also be seen in the muted impact the new technologies are having on commercial cinema. The attempt to extend the cinema to an 'all-round' sensory, multi-screen experience has been a technical

possibility since the 1930s. The new technology, in the shape of the state-of-the-art multiperspective cinemas such as the Omnimax near Paris, updates this in a highly sophisticated way. However, as far as narrative cinema goes, the sense of disorientation that such 'all-round' experience creates has not been popular and therefore considered to be not worth developing commercially. The proscenium screen has continued to dominate cinematic display despite its formal conservatism. Clearly there are massive economic considerations at stake here – the film industry is a notoriously conservative investor in new technology – but even so, public resistance to multiperspective projection is a good indication of how successful the window-picture has been in securing the interests of the spectator. The residual strengths of monocular vision, then, have much to do with human cognitive capacity, how we successfully and efficiently compute information. Yet I am not arguing that the non-linear capabilities of computer-imaging and multiscreen projection are antithetical to aesthetic pleasure. Far from it. The non-linear possibilities of the new technology vividly reveal how the monocular tradition has presented a highly attentuated view of space. Rather, I believe that we are now witness to a developing orthodoxy that consigns the monocular and the naturalistic to the realms of the primitive, without looking at the social context in which such work might be productively inserted. This is the strength of Berger, Wall and Spence.

Similarly the idea of 3-D simulation promoting a retreat from reality is overstated. It is clear, through the extensive capital funding of the American entertainments industry, that the trivial and narcotic qualities of virtual reality will have enormous ideological effects on the somatic relationship between the individual and the world. It is no fantasy to argue that home-based VR environments (imaginary worlds you can inhabit and interact with) and teledildonics (sex at a distance via the wearing of body suits packed with sophisticated sensors) are real commercial possibilities. VR will take us not only out of our heads but out of our bodies as well. But 3-D simulation is also a means of visualisation driven by realism as heuristic principle of discovery. Medical imaging techniques, for example, are concerned with the accurate previsualisation, before operating, of the body in three dimensions. Thus with the development of haptic simulation surgeons will be able to operate on and *feel* the body in 3-D. Computer scientists working on these problems talk about grasping reality through illusion, indication that they see VR as an extension of human beings' capacity to rationally control nature and reality.[15]

In essence simulation does not necessarily lead away from a rational control (or critique) of the world, but is dependent on the scientific and artistic 'driving problems' to which it attaches itself and the social context in which they are employed. That VR is and will be used for conservative ends does not mean that the technology is in itself narcotic. As ever it is the human programmers (subject to social relations not wholly of their own making) that are the creators of technological use-values. Imagine Jeff Wall's *Dead Troops Talk* as a VR environment, and you get quite a different picture of VR's potential from that given by Epcot or Disneyland.

Any discussion of the re-spatialisation of the cultural, then, needs to be treated with critical circumspection, and a respect for the structural constraints of the market. Much of the current literature is weightless in its radical rhetoric. This is no more so than in that potentially major area of spatial extension, image-networking or telematics: the production and instantaneous distribution of the artwork on screen. This is where debates on post-photographic art and the new visual technologies attach themselves to

an almost proselytising defence of a new set of spatial relations emergent in the culture. Indebted to the same assumptions about simulation evacuating the real and the certainties of monocular vision as many other artists and commentators keen to see computer-imaging as a break with the past, telematicists emphasise as their cultural *raison d'être* the vast democratic potential of computer-networking. The new computer technologies, they argue, create a new language of co-operation across time and space. This was very much the theme of the 'Blue Skies' conference – and probably every art and new technology conference since. One of the key speakers at 'Blue Skies' was Roy Ascott, one of the leading figures in the area of art and telecommunication. For Ascott the new computer technology 'empowers the individual to connect with others'.[16] 'In telematic art there is no creation without participation, there is no participation without distribution.'[17] In this sense, art, like science, becomes a research-based means of communication in which the individual producer is subjugated to the collective interests of the group. Accordingly, the new science has opened up art via computers to a new world of electronic space and molecular-time that makes the object-based aesthetics of painting and photography (whatever their critical content) increasingly redundant. Interactive art, he contends, is concerned with the distribution of the human presence as a means of enacting the artwork as event (in the same way that the new physics sees the world of matter as a series of interconnected micro-events).

> In a state of distributed telepresence, whether mediated by computer networks, interactive video, slow-scan television, fax, digital image transfer, videotex, teleconference, videophone or online communications by means of telephone, cable or satellite link, has huge implications for art, for its institutions, its protocols, its markets, its makers and its consumers.[18]

In this respect Ascott and others are using the extended distributive powers of the new technology to connect art to the technological ambitions of the early avant-garde: the breakdown between art and science, and ultimately between art and life. The new technology, they claim, is in an unprecedented position to do this. Thus, as various contributors to a special issue of *Leonardo* on art and telecommunication in 1991 declared, we are entering a new era of human exchange. 'The aesthetics of communication holds the hope for a new unity of the human species ... It aspires to the reconciliation of technology, science and the arts.'[19] 'Technology is emulating our psychological drive for instant gratification, as time, space and matter provide less and less resistance to the expression of our wishes.'[20] Reality is 'no longer defined as an object but a process'.[21] Artists are now in a position to 'explore the new ways art can enter people's homes'.[22]

This 'feel good' technologism and McLuhanesque idealism is common to much of the telematic literature. In fact a great deal of the writing on art adopts an explicit techno-avant-garde position. After a period of intense scepticism in Western culture over art's emancipatory relationship to technology, the early avant-garde's utopian love affair with the machine is being renewed. As such, for the telematicists the issue of re-spatialisation is about the renewal of the connection between technology and a critique of the monadic identity of the artwork – a critique that early avant-garde intermedia initiated (productivism, the Bauhaus) and 1960s Conceptualism continued. In the early avant-garde, the environmental extension of the artwork (through either the multiperspective photographic installation or the multimedia construction) was defended in terms of the

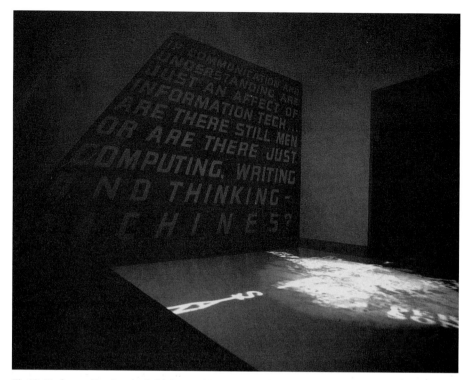

Fig 99 *Maelstrom: Max Laughs*, Judith Barry, 1988 (Courtesy of Judith Barry) (© Photograph: Edward Woodman)

breakdown between object and subject, artwork and the 'real' world. New kinds of social relationships were claimed in the move away from the free-standing discrete artwork, the commercial gallery and the 'passive', 'static' spectator: a new democracy of vision. Telematics refigures this through a defence of the computer as the agent of a *global* source of democratic, 'post-monadic' interaction.

But for all these dialogic virtues, this merely reinvents the technological fantasies of the avant-garde. As with many early commentators on the technologies of the second industrial revolution (film and photography), the new technology here is valorised separately from questions of access and conditions of use. We might describe this inflation of technology as media globalism; and media globalism always views the world from the position of the even distribution of technological use-values. The history of technology, however, has always been a history of the *uneven* distribution of use-values. Thus, the use of photography may now be a popular phenomenon on a global-wide basis, but far from being a source of critical reflection and exchange it is in most people's lives a means of ritual domestic confirmation. It is this reality of the uneven distribution of use-values that underpins Pierre Bourdieu's work on popular photography. As Bourdieu puts it in *Photography: A Middle-brow Art*: 'It would be naive to believe that photography has made aesthetic experience available to everyone, in fact, the same principle leads to photography being both a popular practice and very seldom an opportunity for aesthetic experience.'[23] The same could be said about the extensive home-use of the camcorder in the 1980s and 1990s, and video consumption generally. The increased consumption of video may break with 'real-time' patterns of TV watching

and therefore allow a more 'interventionist' approach to watching moving images – as Sean Cubitt has said, 'through video, TV can cease to be a slave to the metaphysics of presence'[24] – but what is available off the shelves of your local video store remains very narrow indeed. Video, the would-be great democratiser of aesthetic use-values, has largely become the distributor of Hollywood films.

The contention, then, that the new generation of computers offers us a new sense of community without walls, is yet another version of a familiar and threadbare story in which the critical possibilities of new technology are prised loose from access to knowledge and the monopolistic tendencies of the market. We have a situation, therefore, in which what is *hoped* for from the new technology dominates the utopianist position. This is very much the remit of 'Photovideo' and it is very much the remit of 'Outer Space'.

'Outer Space' includes work by European and North American artists using different photographic technologies. As with 'Photovideo', it argues that the new visual technologies locate us within a 'post-monocular' space. Unlike 'Photovideo', though, the show is expressly concerned to link up the re-spatialising possibilities of the new technology to the general theoretical notion that the meanings of images are generated in social exchange outside of their actual phenomenal appearance. Hence the title; meaning is always elsewhere. However, this is given a particular postmodernist-poststructuralist reading. For the organisers the radical strengths of the new technology lie in the 'idea of the nomad'.[25] Given that the life of the image exists in imaginative space – conceptual space – the meaning of the image is always in flux. The meanings we produce as art, therefore, are the result of a network of shifting, intertextual nodal points and not the product of any determinate process of reflection on an external world. As such, 'Outer Space' takes its place within that broader non-linear, multiperspectival line on the new technology, a position that might be summed up as the 'horizontalising' approach to the production and distribution of art. Just as meanings float freely from the referent, according to this perspective, art is held to maximise its resources through the intermixing of forms, technologies and genres. This is why the paradigmatic multiperspectival or 'horizontal' form – as it was for the technologists of the early avant-garde – is held to be the installation. As the organisers say, artists who produce installations 'do not seek to occupy a privileged position outside or divorced from the cultural mores which surround them';[26] as with the telematicists the breakdown of the monadic identity of the artwork is treated as a democratising move. Thus although, in fact, there are only two artists in the show using the new technology as a form of installation, the possible link between new technology and installation is very much the focus of the show's spatial concerns.

Judith Barry's computer-generated compendium of various graphic animation techniques, *Maelstrom: Max Laughs* (1988), presents a walk-through 'experience theatre' that physically breaks with the monocular cone of vision model of perspective. As Barry says, the installation allows the viewer 'to experience an image world that is no longer framed as a television set but surrounds the body as a virtual reality'.[27] Likewise, *Heaven's Gate* (1987/91) by Jeffrey Shaw (who contributed to 'Blue Skies') uses digitally manipulated imagery in order to create a multiperspectival theatrical experience. By projecting digitally reworked images of satellite pictures of the earth and Baroque ceilings downwards onto a mirror which the spectator leans over and peers into, Shaw creates a genuine theatre of the sublime. The emergence and disappearance of the picture of the earth produces a space without temporal ground, a space of disorientation and

dissolution.

For the users of the new technology these techniques and effects release the image into an *extended* conceptual space, diminishing the sense, in our visualisation of the world, of physical reality being related to the scale of the human body. In Shaw's and Barry's case, then, the 'dissolution of boundaries' is not simply a matter of mixing media and genres as some vague gesture towards deconstructing the hierarchies of art, but of utilising the power of the computer to extend image-making *across scales*. And this perhaps will be seen, when all the technologist rhetoric has died down, as one of the technology's most significant resources. What computer-imaging allows producers to do is to scale up and scale down things simultaneously and multidimensionally in very precise ways. The very small and the very far can become the very large and the very near. One does not have to see this as the 'end of photography' as we know it, to realise that such powers of manipulation displace the static image from the centre of art's formal concerns in a way that video never managed. For computer-generated imagery is essentially a visualisation of the world in multiperspectival *movement*. As such this is where the connections between computer technology and multimedia installation art currently meet up with VR research.

Shared-video spaces (spaces in which spectators can talk to each other), interactive computer-controlled light-sound environments (in which spectators inhabit a space that responds to human action) and media-room simulation (the exploration and navigation of a virtual representation of a place through stereographic 3-D technology and video disk image storage) are all areas of scientific research where the pursuit of the 'total artwork' meets the VR dream of the *inhabitable* simulated space. In this respect the move into the area of computer-generated environments by artists becomes a way of engaging/fascinating the spectator through the creation of an aesthetically integrated audio/visual sensorium. The idea of the art experience as a 'responsive environment'[28] clearly lies behind the selection of Barry and Shaw. It is also reflected in 'Photovideo': Sonia Boyce's darkened booth with fuzzy slow-scan images of herself; Simon Robertshaw's sensor-operated film of a bi-optic probe of a human intestine; and Keith Piper's four computer-generated images of a head revolving constantly at different angles and overlaid with diagrammatic lines as if the heads were being measured for racial categorisation.

Important developments in technology are always accompanied by scientists and artists celebrating a new dawn. The new generation of computers is no different. As Kevin Robins says: 'What is desired in this world view is the revitalisation and re-enrichment of reason.'[29] But it is a revitalisation and re-enrichment of reason that for the most part substitutes the democratic potential of a changed technological apparatus for changes in the use-value of technology. This is why so much energy and imagination is invested in the prospect of technological change. For technological change appears to show a culture and society in movement in the actual absence of structural social change. Technological transformation, then, is always a concretisation of the contradictions of the capitalist mode of production. As I have outlined, it releases a welter of utopian impulses at the same time as reinforcing a whole range of conservative opinion. This is why it would be foolish to deny that the new computer technology has important implications for photographic practice. We are clearly entering a new phase of cultural development, where the relations between the production and consumption of the image will be radically affected by simulation and telepresence. But the effects should not be

exaggerated, or be assumed immediately to lead to a given set of cultural conclusions. Thus computer-generated imagery may weaken the function of the static photographic image to carry a sense of modernity, but it does not supersede it, just as the celebration of the multiperspectival can become an empty formalism, as the history of the early avant-garde shows. Hence one of the weaknesses of much of the literature on the multiperspectival effects of computer-generated images is the undifferentiated notion of interaction, as if being surrounded by many images and different kinds of audio stimulation was compelling in itself. This may be an obvious point, but the concept of interaction, particularly within the telematics community, has become emptily talismanic. In fact what occurs with unthinking regularity is the lining up of a defence of art-as-process and an attack on monocular perspective, with an attack on representation as such. Most writing on computer-generated art has been all too willing to conflate the non-linear resources of the computer with post-structuralist notions of the death of the referent.

Thus, if we should be resistant to the idea that the new technology is going to lead us to an 'interactive nirvana', we should be equally resistant to the idea that it inevitably reinforces the nominalism of late capitalist culture: the endless celebration and diffusion of the present. The technological pessimists have had a field day in describing the montage effects of the new technology as ensnaring us further into the depthlessness of the new, what Fredric Jameson has referred to in a discussion of contemporary video as the 'ceaseless narrativisation of already existent narrative elements by each other'.[30] On the contrary, the use of such effects can also involve the *interplay* of time-scales in a way that allows the opening up of the present and the past in critical ways. Benjamin's notions of 'dialectical montage' are no less applicable to the new technology than they were to early film and photography.

Clearly there are intimations of this across a whole range of contemporary photographic practices. But the 'crisis of the referent' theme that characterises much of the new technology literature claims to have opened up a fundamental gap between the new technology and 'older' critical/realist functions of representation. As Yve Lomax argues in her essay which accompanies 'Outer Space', 'there is always more than one story which can be told'.[31] Yes of course, but sometimes some stories are better or more interesting than others. The history of photography, the new technology and the everyday, as other than the 'death of realism', is one such story.

Notes

1 Raymond Williams, *Towards 2000*, Chatto & Windus 1983, p. 146.
2 David Harvey, *The Limits to Capital*, Basil Blackwell 1982, p. 122.
3 For a discussion of this, see Paul Virilio, *War and Cinema: The Logistics of Perception*, Verso 1989.
4 Walter Benjamin, 'The Work of Art in the Age of Mechanical Reproduction', in *Illuminations*, Fontana 1973.
5 'Photovideo', organised by Paul Wombell, Photographers' Gallery London, November–December 1991.
6 'Outer Space', organised by Yve Lomax and Alexandra Noble, Laing Art Gallery, Newcastle upon Tyne, September–November 1991.
7 'Blue Skies', Newcastle Museum of Science and Technology, Newcastle upon Tyne, 25–27 September 1991.

8 See Donald M. Lowe, *History of Bourgeois Perception*, Harvester 1982.
9 Steven Bode and Paul Wombell, 'Introduction: In a New Light', in Paul Wombell (ed.), *Photovideo: Photography in the Age of the Computer*, Rivers Oram 1991, p. 2.
10 Fred Brooks, quoted in Howard Rheingold, *Virtual Reality*, Secker & Warburg 1991, pp. 38–9.
11 David Bohm and F. David Peat, *Science, Order and Creativity*, Routledge 1987, p. 45.
12 Warren Robinett, quoted in Rheingold, *Virtual Reality*, pp. 25–6.
13 Fred Richin, 'The End of Photography as we have Known it', in Wombell (ed.), *Photovideo*.
14 Karin E. Becker, 'To Control Our Image: Photojournalists Meeting New Technology', in Wombell (ed.), *Photovideo*, p. 27.
15 See Rheingold, *Virtual Reality*, in particular Part 1: 'A Microscope for the Mind'.
16 Roy Ascott, 'Editorial: Connectivity: Art and Interactive Telecommunications', *Leonardo* 24:2 (1991), p. 115.
17 *Ibid.*, p. 116.
18 *Ibid.*
19 Mario Costa, 'Technology, Artistic Production and Aesthetics of Communication', *Leonardo* 24:2 (1991), p. 125.
20 Derrick de Kerckhove, 'Communication Arts for a New Spatial Sensibility', *Leonardo* 24:2 (1991), p. 133.
21 Don Foresta, 'The Many Worlds of Art, Science and the New Technologies', *Leonardo* 24:2 (1991), p. 141.
22 Stephen Wilson, 'Noise on the Line: Emerging Issues in Telecommunications-Based Art', *Leonardo* 24:2 (1991), p. 176.
23 Pierre Bourdieu, *Photography: A Middle-brow Art*, Polity 1990, p. 71.
24 Sean Cubitt, *Timeshift: On Video Culture*, Routledge 1991, p. 36.
25 Alexandra Noble, 'The Galaxy Within', *Outer Space*, South Bank Centre 1991, p. 7.
26 *Ibid.*, p. 6.
27 Judith Barry, Statement, *Outer Space*, p. 11.
28 See Rheingold, *Virtual Reality*, in particular 'Breaking the Reality Barrier'.
29 Kevin Robins, 'Into the Image: Visual Technologies and Vision Cultures', in Paul Wombell (ed.), *Photovideo*, p. 58. For a discussion of the epistemological implications of the new technology see also *Bioapparatus*, The Banff Centre for the Arts 1991, Philip Hayward (ed.), *Culture, Technology and Creativity in the Late Twentieth Century*, John Libby 1991, and Michael Benedikt (ed.), *Cyberspace: First Steps*, MIT 1991.
30 Fredric Jameson, *Postmodernism, or The Cultural Logic of Late Capitalism*, Verso 1991, p. 88.
31 Yve Lomax, 'Outer Space', *Outer Space*, p. 31.

Index